JACQUES HENRI LARTIGUE

THE INVENTION OF AN ARTIST

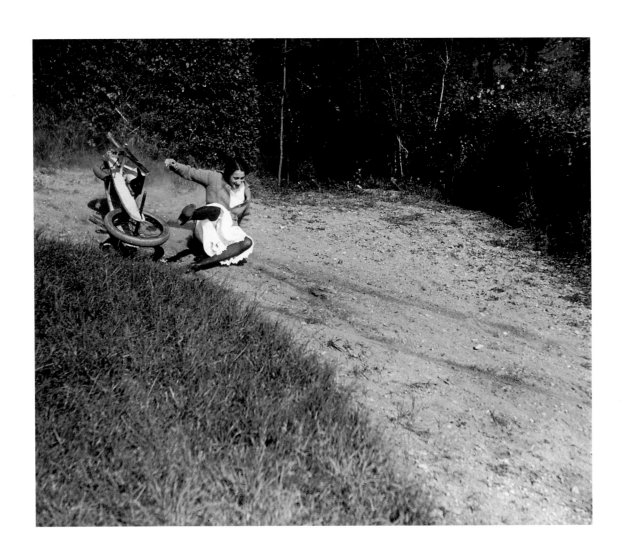

JACQUES HENRI LARTIGUE

THE INVENTION OF AN ARTIST

KEVIN MOORE

PRINCETON UNIVERSITY PRESS PRINCETON AND OXFORD

FOR HENRY

Note about the captions: Lartigue printed his photographs in many sizes throughout his life. Therefore, dimensions of original negatives are specified in the captions. When a specific print is discussed, dimensions of the print, in addition to the negative, are noted.

Front cover: *Paris, June*, 1911 (detail of plate 72)
Back cover: *Tupy*, 1912 (detail of plate 35)
Frontispiece: *Simone, Rouzat*, 1913 (plate 71)

Published by Princeton University Press, 41 William Street, Princeton, New Jersey 08540
In the United Kingdom: Princeton University Press, 3 Market Place, Woodstock, Oxfordshire OX20 1SY
pup.princeton.edu

Publication of this book has been made possible in part by a grant from the Publications Committee, Department of Art and Archaeology, Princeton University.

Designed by Carolyn Eckert
Composed by Tina Thompson
Printed by Trifolio, Verona, Italy

Printed and bound in Italy
10 9 8 7 6 5 4 3 2 1

Library of Congress Cataloging-in-Publication Data
Moore, Kevin D., 1964–
 Jacques Henri Lartigue : the invention of an artist / Kevin Moore.
 p. cm.
 Includes bibliographical references and index.
 ISBN 0-691-12002-1 (cl : alk. paper)
 1. Lartigue, Jacques-Henri, 1894– 2. Photographers—France—Biography. I. Title.

TR140.L32M66 2004
770'.92—dc22
[B] 2003068991

CONTENTS

7 INTRODUCTION—*Lartigue's Invention*

FORMATION: LARTIGUE AS AMATEUR, 1894–1922

17 ONE—*Amateur Photography*

71 TWO—*Sport and Fashion*

129 THREE—*Cinema*

TRANSFORMATION: LARTIGUE AS ARTIST, 1963–1979

163 FOUR—*Lartigue at MoMA*

195 FIVE—*Lartigue after MoMA*

215 CONCLUSION

218 *Appendix A: Key to Names of Lartigue's Family, Friends, and Pets*

219 *Appendix B: 1963 MoMA Exhibition Checklist*

221 *Chronology*

223 *Notes*

255 *Acknowledgments*

256 *Bibliography*

266 *Index*

272 *Photography Credits*

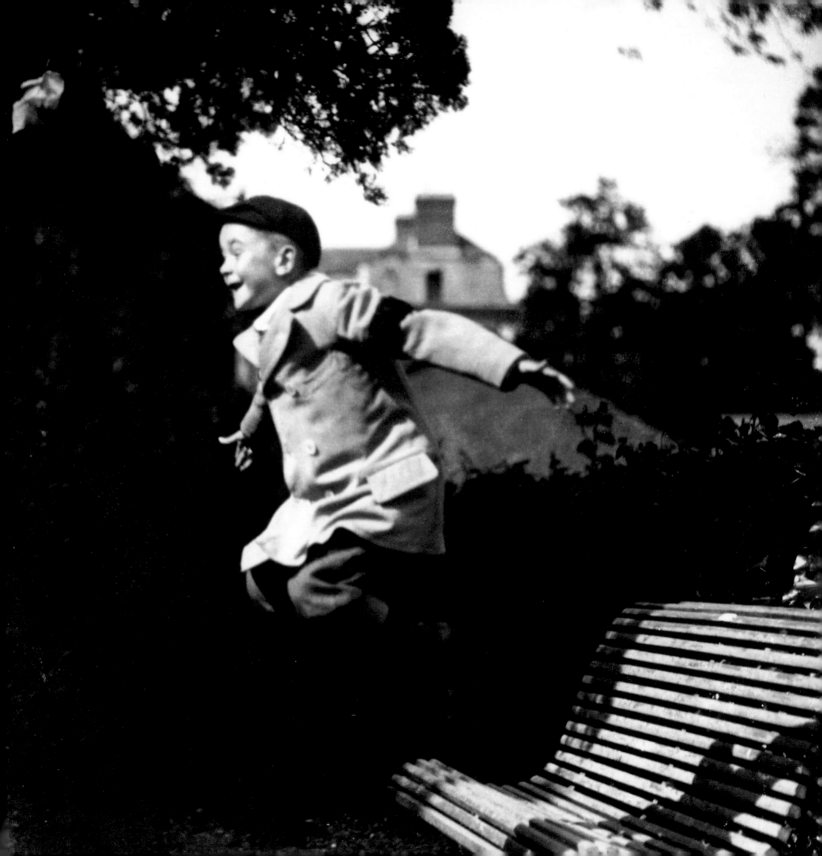

INTRODUCTION

LARTIGUE'S INVENTION

WHAT MAKES AN ARTIST? Talent? An abundance of talent? Or a special kind of talent, the kind that bypasses conventional forms of expression to uncover new ways of seeing the world? Cynics might say that talent alone does not make an artist, that it's more a matter of historical and geographical fortuity—being in the right place at the right time. Why is it that some artists with talent languish in obscurity, while others are anointed, celebrated, and passed down for generations? Maybe the question is not so much what makes an artist but who makes an artist? Who determines greatness, how do they promote it, and to what end? For photography especially, scorned as an art form for most of its history, recognition has been elusive—though fame has come to some. For Jacques Henri Lartigue it came in a torrent, but only toward the end of his life. Was it the pictures, the timing, the influence of the promoter? Or was it a combination of these that made Lartigue, rather suddenly, one of the twentieth century's most iconic photographers?

Lartigue's story is blissfully repeatable. He was a sensitive little French boy, son of a wealthy banker, a scion of the belle époque. So enamored was he of automobiles and airplanes, fashion and farce, that he set about recording his life, obsessively, in photographs. First, Lartigue photographed his domestic circle: his benevolent parents; his older brother, the poseur and inventor manqué; a swarm of aunts and uncles and frisky cousins, many of them beautiful, all exceedingly well-dressed. And there were nannies and chauffeurs, dogs and cats, each bequeathed with fashionable, mock-infantile nicknames such as Zissou, Dédé, Plitt, and Bichonnade. Later, Lartigue ventured out, photographing auto races in Auvergne, bathers at Deauville and Biarritz, airplanes at Issy-les-

Detail of PLATE 7

Moulineaux, winter sports in Switzerland, drag races in Auteuil. And there was the endless social parade, "the bustling life of people with nothing to do," as Colette described it, assembling daily in Paris at the Bois de Boulogne, migrating south to Nice and Monaco during the off-season.[1] Lartigue's youth was enviably idyllic, so fabulously lucky that it can't have been true—yet there's more.

It was on a vacation to America in 1962 that Lartigue, then sixty-nine, stumbled into the offices of a New York photography agent and sent art directors scurrying all over town. Not known as a photographer—not even as a painter, which he had been all his life—Lartigue saw more than forty of his earliest photographs exhibited on the walls of the Museum of Modern Art (MoMA) in June 1963 and, later that same year, a modest selection of them appeared in the pages of *Life* magazine. By the close of the following year, "Lartigue" had become one of the boldest, most stylish names in the United States; in ten years time, he would be one of the most famous photographers in the world.

Where had Lartigue come from? For John Szarkowski, curator of the MoMA exhibition, Lartigue was a "true primitive," a photographer raised in the wilderness of amateur photography as it had been practiced a half century earlier. He was apparently untrained, and this was good. Only a child at play, reasoned Szarkowski, could have been at liberty to ignore all existing aesthetic formulas and to invent this pure, photographic way of seeing.[2] What Szarkowski discerned in Lartigue's images was a template for photographic modernism, an early expression of the "camera values" so resonant in the work of contemporary photographers such as Henri Cartier-Bresson and Garry Winogrand. Yet these photographers, and a handful of others like them, were fully cognizant, full-swing photo aces—they knew exactly what they were doing. Lartigue, as Szarkowski conveyed in the exhibition catalogue, had started at age five; moreover, he had done what no one else had done before: he had caught on film a world in flux, a modern world of mechanisms, movement, and social hijinks, and he had done this all purely by instinct.

What Szarkowski and others captivated by his photographs didn't quite realize was that Lartigue was no naïf. This son of a wealthy banker was also the son of a serious amateur photographer: Lartigue *père* owned numerous state-of-the-art cameras and maintained a darkroom, which he freely shared with his sons. Moreover, Lartigue was photographically programmed. Born in the last decade of the nineteenth century, he was among the first generation to be brought up on

photography-based mass media. This included photographically illustrated magazines such as *La Vie au grand air*, *Femina*, and *Je sais tout*, each of which arrived by subscription at the Lartigue's home in Paris's sixteenth arrondissement, and the cinema, which emerged as the most modern of pastimes during the first decade of the twentieth century. By his seventeenth year (his age, on average, when the majority of the photographs in the MoMA exhibition were taken), Lartigue was having pictures published in sports and fashion magazines, was operating a motion-picture camera, and had long since developed an artistic logo, "Pic," which he signed at the bottom of his drawings—he had already invented his identity as an artist.

Szarkowski's idea of Lartigue as a snapshot "primitive" made for a great story. The public was enraptured by Lartigue's playfulness and sense of humor; young photographers in particular drew inspiration from Lartigue as a fount of creativity. But Szarkowski's motives were larger. The 1960s was a period of radical transformations, and photography was no exception. Interest in photography was intensifying as waves of students, collectors, and museums began scrutinizing the medium. For those paying attention, Szarkowski's assimilation of Lartigue (a so-called child amateur) into the modernist art canon was a brash and exciting move, one that demanded a new approach to contemplating photography as a whole. Part of what Szarkowski was up to in exhibiting Lartigue was metaphysical; besides unveiling a "lost master," he was also questioning the nature of photography itself: what is photography? what constitutes the medium's unique aesthetic identity? Moreover, he was asking viewers to consider photography's history, both past and future, and to consider a wider body of work. Besides the formal masterworks of artists such as Alfred Stieglitz and Edward Weston, Szarkowski was cultivating recognition for "vernacular works"—nineteenth-century geological-survey photographs; documentary images of changing Paris; anonymous news photographs; and, of course, snapshots by unknown amateurs. How did these examples fit into photography's larger aesthetic evolution? Lartigue became a poster child of sorts in a campaign to broaden awareness and understanding of photography's aesthetic history.

Conceived in a flash, Szarkowski's Lartigue has proven to be surprisingly durable. In 2003, almost forty years to the day after Lartigue's debut at MoMA, an ambitious revisionist retrospective of Lartigue's work occupied the walls at the Centre Georges Pompidou—and the press response sounded much the way it did

in 1963. The exhibition, one reviewer wrote, highlighted "Lartigue's simple motivation for taking photographs: to capture the happy moments of his life . . . his childhood in a prosperous family, his love of fast cars and early airplanes, beautiful women, vacations, sports, painting, friends. It was the work of a gifted amateur. In fact, some of its naïve charm disappeared when he became a 'photographer.'"[3]

Much of the credit for this enduring image goes to Lartigue himself, who was actively involved in directing his legacy as a photographer and public figure. Before his death in 1986, Lartigue donated to the French state an enormous body of carefully arranged and annotated material, including photographs, albums, diaries, and just about everything else someone anticipating posthumous fame might leave behind. Lartigue had reinvented himself as an archive.[4] From the historian's perspective today, these materials are as invaluable as they are dauntingly voluminous and perilously misleading. Indeed, the vast majority of material found in the archive is irrelevant to the questions posed in this book. Shortcuts are tempting, but not recommended. To take one example, Lartigue published the first volume of his memoirs in French in 1975, a romantic chronicle of a belle époque childhood based loosely on his actual diaries, which he had commenced writing in 1911. Unlike these methodical diaries (in French, *agendas*, i.e., daybooks arranged according to the hours of the day), the memoirs are infused with a Proustian sense of passing time and loss. Sometimes the embellishments are innocuous enough, as when Lartigue the memoirist dramatizes an event, such as air maneuvers at Issy-les-Moulineaux (7 January 1911), or fleshes out his descriptions of past acquaintances, for example, his science tutor Monsieur Aubert (28 January 1911). But other embellishments are plainly disingenuous. Lartigue writes in his memoirs on 30 January 1911:

> Apparently if I keep my diary in pencil it will eventually be erased. . . . It makes me a little sick at heart! It makes me want to throw up, as always when something doesn't go well. The other day, with my citrate photos—it's impossible to redo them all. Now today, my little diary! I'll have to go over it again now and then in ink! It sickens me a little, knowing that things deteriorate (I never thought of this before).[5]

The diary entry for that day, by contrast, records business as usual—weather, walks, and lessons.[6] Apparently, it was the pencil Lartigue had used to write the

original, considerably faded by the 1970s, that inspired this meditation on tran-
sience. The double deceptiveness of this passage lies in its infantilizing style
(exclamation points almost never occur in the diaries) and in the general anxiety
over *temps perdu*.[7]

There are similar pitfalls in the albums. Lartigue remade his albums at least
twice, most recently during the early 1970s, when his fame as a photographer was
mounting. Even an eye not trained in distinctions between photographic print
processes will note prints of all sizes and colors, printed on different kinds of
papers, and will note that these are mixed freely within the albums. Often, a
large, modern gelatin-silver print shares the page with a small citrate print from
the early decades of the century.[8] And yet, in nearly every publication on
Lartigue the albums are accepted as products of the belle époque, the original
fabrications by the young Lartigue. Why is this problematic? As with the mem-
oirs, these "new 'old albums,'" as Lartigue refers to them in 1972, pretend to be
something they are not: the product of a child with a premature nostalgic bent.[9]

Who, then, was Lartigue? A precocious sophisticate, visually sensitive and
socially aware? A naïve genius, precursor to modern photography? Or a natural
self-promoter and nostalgic raconteur, prone to mythologizing his life? For read-
ers open to such incongruities, Lartigue is certainly each of these individuals; for
the historian working with a slightly different vocabulary, he represents a tear in
the fiber of historical identity. How, then, to proceed? How might that tear be
repaired—or should it be?

THIS BOOK, structured around Lartigue's "formation" and subsequent "trans-
formation," has two very different goals: to present an accurate account of
Lartigue's engagement with photography during the first two decades of the
twentieth century, and to consider MoMA's founding mythology of Lartigue as
a modern primitive within the context of American art photography of the
1960s. The headings, of course, serve to emphasize division rather than recon-
ciliation—an appropriate emphasis, for Lartigue is a bifurcated figure, at least in
the history of photography. He is seen, on the one hand, as a photographer
whose principal body of imagery was created outside the currents of art pho-
tography, someone who recorded his life as a hobby; and, on the other hand, he
is known as a precursor to modern photography, a figure kidnapped from one era
and smuggled into another for the purpose of bolstering photographic mod-

ernism in America. As a photographer relevant to the history of photography, Lartigue must be understood as an awkward hybrid of these two component parts. To consider Lartigue solely as a photographer of his own day would be to miss his relevance to American art photography of the 1960s, as well as his importance to French patrimony of the 1970s; but to consider Lartigue as MoMA's snapshot "primitive" would be to swallow a myth, hook, line, and sinker. An elucidation of the two concepts central to this book should help to clarify the point.

By "formation" I am referring to Lartigue's technical and visual acculturation in France during the early part of the twentieth century. This aspect of Lartigue has been conspicuously neglected by enthusiasts to date. In this section I try to uncover and describe, insofar as this is possible, the historical Lartigue, a Lartigue formed by the ideas, aesthetics, social conventions, and moral imperatives of his milieu. "Formation"—which in French means training or education—is Lartigue undergoing his own cultural construction. The term also circumscribes a part of the lengthy Lartigue biography, the part that covers his first extended involvement with photography, the years between his eighth and twentieth-eighth birthdays (1902–22). This is the period during which he produced his best-known works—his "boyhood photographs," as they are generally known, first exhibited at MoMA in 1963.

"Formation" suggests that my focus is on an early phase of the artist's career, a phase directly preceding a period of mature productivity. I invoke this meaning teasingly. As in standard histories of art, Lartigue's formation is to be understood as the awkward yet inspired period leading toward the eventual production of an intelligible, coherent, mature oeuvre. The mature oeuvre in question here, however, is not a second body of photographs produced at a later date but the photographs of the early period transformed by context into a ripened oeuvre. My point, mischievously phrased, is that Lartigue's formative period is distinguishable only through a deconstruction of the puppet figure erected by MoMA in 1963.

"Transformation" has many of the same properties of "formation." It, too, is a process, one that implies the existence of another, related period. Specifically, the transformation I have in mind is MoMA's exhibition of Lartigue's photographs. Nearly seventy years old at the time, Lartigue witnessed an extraordinary renaissance of his work, transferred to an altogether different context and

carrying an entirely new set of cultural meanings. Thus, I use the word "transformation" to circumscribe another significant period in the Lartigue biography—this time a sixteen-year period commencing with Lartigue's debut exhibition in 1963 and terminating with the donation of his work to the French government in 1979, the moment of the photographer's repatriation, as it were.

"Transformation" is an apt term because, by definition, the process involves considerable and rapid change in appearance or character, and it also implies that this process was brought about by an outside agent. MoMA, with its formidable power to bestow critical legitimacy on modern artists, was able to achieve in New York in 1963 what the editors of French magazines had failed to accomplish in France during the 1950s.[10] Szarkowski constructed a lapidary artistic identity for Lartigue as a photographer, and he accomplished this almost overnight. This construction, formulated in the hothouse of American postwar formalism, was geared more to the issues and expectations of a new and spirited generation of American curators, artists, and critics, and less to a broader empirical idea of Lartigue as an actual individual shaped by another era and culture. Here lies the conceptual fault line on which this book rests. With Lartigue there are two countries, two temporal moments, two historical contexts. There are two Lartigues: the one undergoing formation in France during the belle époque, the other undergoing transformation in America—and, eventually in France—during the 1960s and 1970s.

FORMATION

LARTIGUE AS AMATEUR, 1894–1922

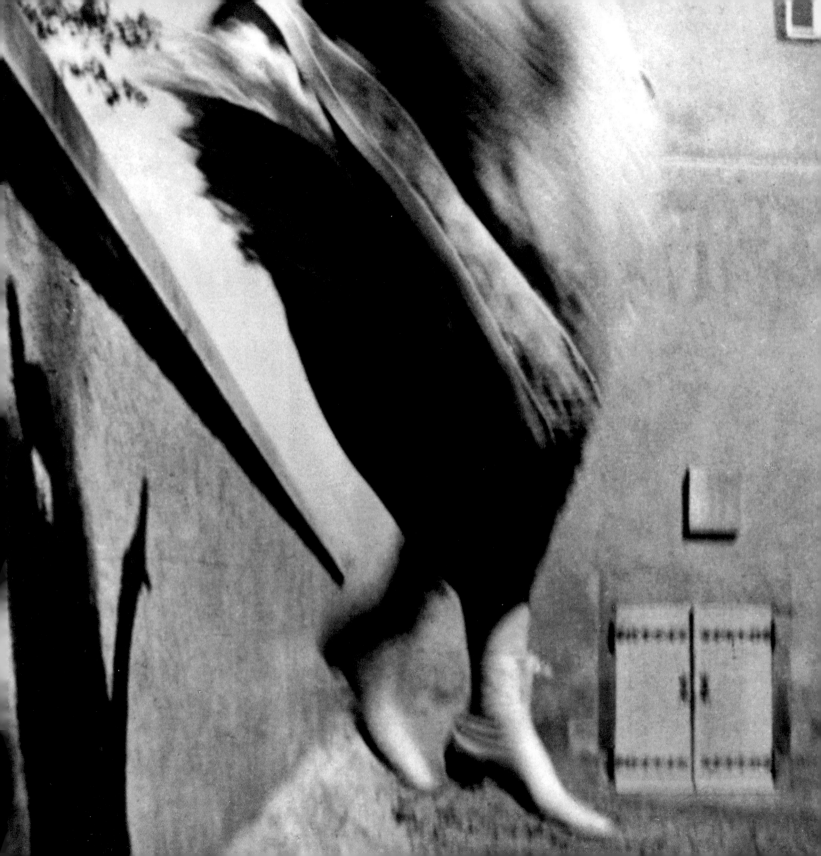

CHAPTER ONE

AMATEUR PHOTOGRAPHY

AT THE TIME of Jacques Henri Lartigue's birth in June 1894, the newborn's father, Henri Lartigue, was an amateur photographer of considerable talent and ingenuity. Numerous extant photographs by Henri (which his son designated retrospectively "photo Papa") attest to his technical and aesthetic competence: a photograph from 1890 of Lartigue's older brother, Maurice, nicknamed "Zissou," in his bath, an image displaying all the tenderness, tranquillity, and visual complexity of a Vermeer painting; a portrait of a pregnant Madame Lartigue in the garden of the Lartigue family home in Courbevoie, her plump figure positioned attentively before a sumptuous background of flowery meadow, brick wall, and dark verdure; a landscape taken in Pont-de-l'Arche, in 1902, in which clumps of trees, boats, and their reflections are organized with deft precision; a pair of photographs taken in Malo-les-Bains, in 1893, in which Madame Lartigue and her relatives pose for the camera, posteriors turned lensward in irreverent glee.

And his father also took numerous photographs of the young Lartigue. A photograph made at the beach in Ambleteuse, in 1896, shows Jacques (as he was referred to by those who knew him throughout his life) and Zissou squinting patiently alongside their uncle Marcel, the three figures grouped within a nebulous atmosphere of liquid and light (plate 1). Similar clarity is noted in a photograph of Lartigue in the garden at 40, rue Cortambert, Paris, where the boy, his cat, and a pet pigeon perched atop his head balance neatly in a composition bisected by sun and shade. Another group portrait, this one centered around the structure of a ladder, is a droll orchestration of cooperative children. (For a guide to the names of Lartigue's family and friends, see Appendix A.)

Detail of PLATE 10

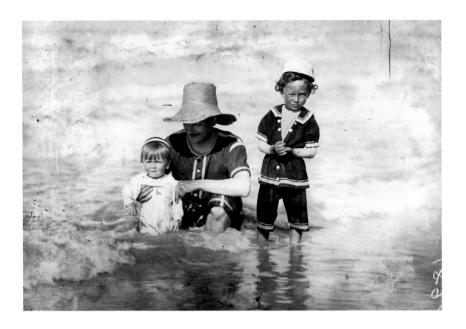

Aside from his photographs, little is known about Henri Lartigue and his involvement with photography. What is known comes from Lartigue, who romanticized his father ("Papa: he looks like God")[1] in numerous publications during the 1960s and 1970s, most thoroughly in his memoirs published in 1975. The core example is this passage, written in the seventies, in which Lartigue, simulating the voice of a child, describes his father at work behind the lens:

> Pont-de-l'Arche. For many years now, Papa has done photography. Photography is a magic thing. A thing that has mysterious odors, a little strange and frightening, something one quickly grows to love. Under the black veil, Papa lifts me up so that I can see the image that he is going to take: a marvelous little picture, with all the colors, dazzling, alive, but upside down. A little image, truly prettier and clearer than the piece of reality that one sees. When I am the one posing for Papa, I can't move at all while he counts: "One . . . two . . . three, it's done!" Each time, though, my eyes disobey and seek amusement by wandering.[2]

Further down the page, Lartigue describes his father at work in the darkroom:

Afterward, in the darkroom, under a little red light, I watch Papa's hands as he puts the large green plate, now almost white, into the basin. We wait, and suddenly it starts: the image appears! Slowly at first, then much more quickly. The plate darkens and one can no longer see anything. Papa rocks the basin continuously in order to agitate the liquid; this annoys me and keeps me from seeing very well. Finally, the plate is moved to the basin in the middle, then it is placed in the third basin. Papa says: "It's a success." And we wait in the dark, with nothing to do, unless we begin again right away to develop another photograph.[3]

Lartigue's writing conveys with splendid economy the magic of photography at a young boy's first encounter with the process, even while obfuscating the facts about whatever elements may have been drawn upon to supply the image. One point is clear, however unremarkable it may seem: Lartigue's father taught him photography. Contrary to MoMA's invention of Lartigue as a naïve genius, a construction that remains little tarnished after nearly half a century, Lartigue was a knowing and cultivated photographer. It was not divine inspiration that guided Lartigue through the technical and aesthetic rudiments of photography but a father who was clearly knowledgeable about the latest equipment and techniques of a medium that, like other technologies at the turn of the century, was developing at a startlingly accelerated rate. Indeed, from the time of Lartigue's birth, Lartigue *père* was trundling into the household a steady stream of photographic equipment, literature, and practitioners as au courant as the dresses he provided for his status-conscious wife. Lartigue's instruction by his father should not be seen as a simple act of familial benefaction, like a father teaching his son to shave, but as the passing on of an entire burgeoning culture of amateur photographic knowledge. What kind of photographer was Henri Lartigue, and what did he teach his son about photography? One must search beyond the limits of the passages cited above and look in the literature on amateur photography at the turn of the twentieth century to appreciate fully Lartigue's earliest formation.

Lartigue père

Even as an adult, Lartigue seems to have known little about his father outside the domain of the domestic sphere. Henri Lartigue's descent from a family of engineers and railroad men, and his own often controversial career as an engineer-

cum-financier—he was the general director of the Compagnie Franco-Algérienne during the 1890s and early 1900s, then vice-president of the Société Française de Constructions Mécaniques in the teens—seem to have scarcely penetrated the consciousness of his sheltered sons.[4] Nouveau riche (the Lartigue fortune was reportedly the eighth largest in France before World War I),[5] Henri Lartigue and his wife determined that their children should enjoy a noble upbringing, which meant that like the children of aristocrats they should remain blissfully ignorant of commercial affairs. When, for example, an attempt was made in February 1914 on Henri Lartigue's life at the Place de l'Étoile, Paris, an act that *Le Figaro* reported was motivated by the gunman's desire to avenge financial ruin, twenty-year-old Lartigue hadn't the faintest idea what the crime was about. All he could conclude in his diary was that the aggressor was "half crazed."[6]

But this was public life. At home, where days were passed in the pursuit of leisure—perusal of journals, attendance at cinema screenings, outings in the Bois de Boulogne, and trips to fashionable resorts such as Deauville, Nice, and Chamonix—Henri Lartigue made frequent appearances, often bearing elaborate devices such as kites, bobsleds, bicycles, and cameras, ostensibly for the amusement of his sons. These inventions, the stuff of scholarly articles and heroic experimental fascination, appeared as modern novelties in the leisure zone of bourgeois life. If he was harangued by the boys' grandmother for spoiling his children with these technological expeditions, activities that cost money and lured the children away from more serious pursuits such as schoolwork and religious observance, it was because Henri Lartigue could barely contain his own enthusiasm for the new mechanisms being proffered. Lartigue's famed passion for technology, it must be emphasized, was inherited from his father.

Whereas Henri Lartigue functioned as a kind of worldly emissary, introducing his sons to technologies imbued with a certain masculine aura circulating outside the home, Madame Lartigue took charge of the boys' formal education—although it could scarcely be called formal. The Lartigue brothers were educated on the English model of the idle rich, which prepared them for a life of superior deportment rather than serious application; formal schooling remained a secondary concern. In the home, Lartigue received infrequent instruction in math, German, and other basic subjects from a parade of hired tutors accustomed to frequent cancellations due to indolence as much as anything else.[7] Marie Lartigue's family had sophisticated cultural ambitions. Her father, Auguste

Haguet, had his portrait taken by Nadar.[8] For her, the "parlor arts"—music, poetry, and painting, each pursued in a nonchalant way—were vital to the cultivation of refined young gentlemen. If Henri inspired in his sons a passion for modernity, his wife held the boys fast to an attitude of elevated aristocratic indifference. The Lartigue family was modern, but the fashion of taking nothing seriously was the order of the day.[9]

Henri Lartigue, unlike his protected sons, was of another generation, one not so gorged on the complacencies of prosperity stemming from France's political stability and economic surplus under the Third Republic.[10] He was, according to the classifications of political historian André Siegfried, an *haut bourgeois*.[11] Ranking one level below the *grande bourgeoisie* (a group comprising old, wealthy families such as the Rothschilds), the *haute bourgeoisie* was a class composed mainly of bankers and engineers who amassed considerable fortunes, often through foreign investment, during the latter half of the nineteenth century.[12] Politically they were moderate and adaptive, converting to republicanism at the start of the Third Republic, and even though their seventeenth- and eighteenth-century forebears had rejected religion in favor of positivism and science, most members of both the *grande* and *haute bourgeoisie* looked on the Catholic Church as a respectable institution. This was a class that cultivated what one historian has called "a genteel pattern of entrepreneurship," which held in esteem the model of the businessman as a "'rounded,' civilized individual, not enslaved by wealth, but master thereof to spend it in the fashioning of an elegant, cultivated existence."[13] For the Lartigues, like others of their class, respectability depended on a delicate balance between detached aristocratic equanimity and uninhibited capitalist ambition. This was most readily accomplished along the generational divide. "I have quite enough money," Henri Lartigue is said to have proclaimed. "My children should learn how to spend it, not earn it."[14]

In keeping with the prolific accomplishments of his paternal forefathers who, throughout the nineteenth century, maintained a sure and steady presence as innovators in the fields of transport and communications, Henri Lartigue was a man primed for success in science and in business.[15] For him, like many men of his class, photography was more than a hobby. Outside the medium's evident capacity to amuse, photography was part of a broader field of technological advances in engineering, chemistry, and industrial manufacture—all of which, in the eyes of Henri and other engineer/entrepreneurs, displayed impressive

investment potential. During the span of the two decades that form the hinge between the nineteenth and twentieth centuries, advancements in engines, tire manufacture, electricity, telecommunications, photography, photo-mechanical printing, cinema, and other distinct areas of technological exploration generated great creative ferment among a singular group of inventors, engineers, investors, and manufacturers.[16] Parts and techniques jumped technological boundaries, as did participants. In the realm of locomotion, for example, parts for automobiles, cycles, and airplanes were often interchangeable, as were the operators of these contraptions.[17] Nor was it uncommon for disparate technologies to be paired in new and exciting ways. One example was the combination of photography with aviation to produce aerial views, which would prove useful during World War I.[18]

Such breadth of scientific interest can be seen in the pages of *La Nature*, an illustrated science review founded in 1873 by Gaston Tissandier, who was himself an amateur photographer, among other things.[19] The most popular science publication of its day, *La Nature* featured articles on a surprisingly broad array of subjects, ranging from legitimate advances in transportation, telecommunications, bridge construction, explosives, agricultural systems, and optics, to more fantastic subjects (these more likely illustrated), including zoological oddities, fashion history, "flying men" (these aided by rudimentary hang gliders), and fireworks. Photography, meriting a regular column written by Tissandier himself, inspired numerous articles—on new color technologies, magnesium flash, microphotography, etc. Significantly, among the advertisements for items such as binoculars, kites, and compasses in the back of each issue, photographic products outranked others two to one.[20]

La Nature illustrates well the dual aspect of popular science during the late nineteenth century in that the material the magazine presented was both technologically challenging and unashamedly entertaining. This marks a general difference between father and son in their approach to photography. The young Lartigue thought of photography as a chic popular entertainment, like cycling, the technological side of which was only moderately interesting in relation to the medium's expressive capabilities. Henri Lartigue saw photography as part of a larger wave of mechanical innovation and thus, like other men of his class, regarded it as an offspring of science. Photography for him was more than a picture-making system; it was a site for considering breakthroughs in chemistry, optics, and mechanics as well.

From 1911, the date when Lartigue's extant *agendas* (diaries) commence, Jacques describes his father experimenting with magnesium flash (9 July 1911); constructing specialized equipment, such as an apparatus for reducing prints (9 August 1911); and operating numerous cameras of varying formats, including a large camera of 24 x 30 centimeters (7 August 1911), a 20 x 30 cm camera (9 August 1911), an 8 x 16 cm camera (5 March 1912), and a 6 x 13 cm Spido, manufactured by Gaumont (21 June 1912). We also read about him overseeing the purchase of various new photographic technologies for his son, including autochrome plates (16 March 1912), a Cinématographe (Christmas 1911), a motion-picture projector (3 May 1912), a Pathé Professionel (Christmas 1912), and various lenses (such as a telephoto lens, 2 June 1911) and accessories, including a veil for changing lenses (Christmas 1911) and a studio lamp (24 January 1913). When Lartigue resisted having his teeth fixed in 1912, his father offered "to pay" him with a 6 x 13 cm camera; the bribe didn't work, and Henri gave his son the camera anyway, "right away and without conditions."[21] These are only the transactions recorded after 1911, when Lartigue was in his late teens, with a decade of photographic education already behind him.[22] If Lartigue's memory is accurate, his father had pretty much given up photography by around 1910, preferring at that point to pass his time testing the potential of the Cinématographe (a combination movie camera and projector), various experimental forms of locomotion, and new business ventures;[23] that said, Henri's pre-1910 involvement with photography was undoubtedly passionate and thoroughgoing.

So far as is known, Henri Lartigue was not a member of any photography clubs, he did not participate in regular amateur events such as exhibitions or lantern-slide projections, nor did he contribute to *L'Amateur photographe*, *Photo-Gazette*, or other amateur photography journals. This is surprising considering the extent to which he was involved with photography and the omnipresence of outlets for photographic pursuits. From the late 1880s on, amateur photography clubs were a burgeoning phenomenon in France and in other parts of the Western world. Between the covers of numerous photography annuals published in France around the turn of the century,[24] one finds listings for photographic societies of every stripe, from the oldest and most venerable of French photographic institutions, the Société Française de Photographie (founded 1854); to more recently formed clubs, such as the Société d'Excursions des Amateurs Photographes, known as the "Excursionists," founded in 1887 by a group of men dedicated to

cavorting with photographic equipment *en plein air*; and the Photo-Club de Paris, organized a year later (in reaction against the lowbrow objectives of groups like the Excursionists) to pursue photography as Art. The Photo-Club would become the center of Pictorialist activity in France by the turn of the century.

Besides these well-known organizations, there existed others of a more parochial nature. There were, for example, clubs for young people, such as the Société des Jeunes Amateurs Photographes; commercial organizations such as the Chambre Syndicale and the Syndicat Général de la Photographie, both based in Paris; as well as countless regional societies found all over France, Switzerland, and Belgium.[25] No matter who you were or where in France you lived, there was a photography club suited to your class and level of technical expertise.

Why is it that the name of Henri Lartigue, a man of evident talent who was clearly abreast of the latest photographic equipment and techniques, never appears in these annuals, either as a club member or as the author of an article on photographic research or technique? He certainly fits the profile for inclusion espoused by the 1903 *Annuaire des amateurs de photographie*, the most comprehensive of photographic annuals: "For us the amateur photographer—the true one, the only one—is someone who makes of photography a daily, or at least a frequent, occupation or distraction, who possesses one or several 'serious' cameras and knows how to use them, who is interested in the diverse manifestations of our Art and seeks to turn those to good use, who follows the progress of photography, and who applauds and insures its dissemination."[26]

Indeed, Henri Lartigue could be called the archetypal amateur. While he never made photography an occupation per se, he approached it seriously as a distraction, photographing frequently—if not daily, as during the summer holidays—in a variety of modes, producing sophisticated portraits and group portraits, landscapes, genre scenes, documentation of his family's leisure activities and amateur theatricals, and stop-action photographs of cars and airplanes, much like those that would become the trademark of his son's photographic oeuvre. Lartigue *père* owned at least six "serious" cameras by around 1911, and demonstrated a technician's intimacy with their capabilities. These were not cheap Kodak Brownies (a child's camera, really, offered at nine francs in 1913), or even the Glyphoscope Richard, advertised at only 35 francs in 1913.[27] His cameras were state-of-the-art, "les nouveautés photographiques," proffered by Gaumont, outfitted with the highest-quality lenses and shutter releases by Krauss-Zeiss and

Klapp, respectively. For a 6 x 13 cm Spido-Gaumont, "the perfect hand-held camera," one paid 550 francs in 1913.[28]

Of course, being able to afford the latest equipment was no guarantee of success ("Get a basic darkroom," sniffed an advice columnist for *Photo-Revue*, "and you'll have magnificent results automatically").[29] One required, too, knowledge and enthusiasm in order to pick one's way through a snarled field of photographic products and services.[30] Henri Lartigue, always up on the latest technological advancements and novelties, possessed such virtues in abundance. He mastered cameras of varying formats, from the hand-held, rapid-fire "Block-Notes" by Gaumont to the slower, more cumbersome view camera, intransigently bound to its tripod, plus the various motion-picture cameras and projectors that came out a short time later. He tested the capacities of new processes at their debut, like magnesium flash and autochrome plates. He occasionally built his own photographic equipment, had equipment constructed according to his own needs and specifications, and repaired equipment fallen into disrepair. Moreover, he had an eye for composition and a taste for the artistic as well as the technically astute photograph. Most important of all, Henri Lartigue developed and printed his own photographs in his own darkroom, which is to say that he understood not just the mechanics of photography, but also the chemistry. This is not something to be taken for granted when considering the abilities of amateur photographers of this period; indeed, it defines him as a particular kind of amateur.[31] As for his support of the medium and its distribution, what better exemplar could the *Annuaire* have had in mind than a man such as Henri Lartigue, so unrestrained in his consumption of photographic products and so generous in his distribution of these products into the hands of others—not only his son, but everyone else who ventured into the exuberant Lartigue family circle?

One might argue that Henri Lartigue had no need for a photography club, as he was already at the center of his own band of passionate photo-amateurs. He consorted informally, though regularly, with other photographers on a day-to-day basis. Marius Aubert, for example, professor of mathematics at the Sorbonne and tutor to young Lartigue, was a regular guest at the Lartigue home in Paris and at the Lartigues' summer home in Rouzat, where he joined efforts to photograph every billiard match, every go-cart run, and every game of water polo.[32] Aubert, it seems, was an assistant to Gabriel Lippmann, one of the inventors of color photography.[33] This connection was an apparent source of interest

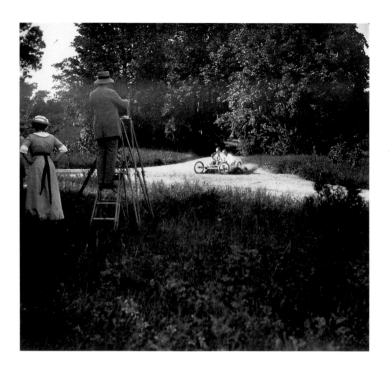

PLATE 2. Louis Ferrand, *September, Rouzat (Photo taken by Louis with my camera, Papa filming Rico and me)*, 1913. Glass stereo negative, 2⅜ x 5⅛ in. (6 x 13 cm). Association des Amis de Jacques-Henri Lartigue, Paris

for Henri Lartigue, and an inspiration for his son, who notes on at least one occasion having seen examples of Lippmann's color photographs and once took home from his lesson a precious liter of distilled water with which to prepare his next batch of developer.[34] Another photo-amateur who frequented the Lartigue circle was Hubert Laroze, a friend of Henri's. Like typical members of a photography club, Laroze and Henri often photographed together, shared darkroom secrets, conferred on new techniques and equipment, and, of course, discussed one another's photographs; Lartigue was present for these exchanges, and notes them in his diaries.[35]

One of the most regular figures in the Lartigue home was Henri's private secretary, Monsieur Folletête, nicknamed "Plitt" by Lartigue.[36] One of Folletête's specific duties as secretary was to play gadabout with Lartigue on his junior society ramblings. "I don't think he minds that Papa often tells him to spend time with me instead of working as secretary in the office," recounts Lartigue in his memoirs.[37] Apparently, Folletête, son of a notable Swiss-Catholic politician, was hired not only for his skill at office work but also for the patrician example he set

for the teenage Lartigue. Even without Lartigue's retrospective account, the wholesome tenor of his days with Folletête is clear: On 13 September 1911, he goes to Plitt's to photograph lightning; 30 October 1911, develops photographs with Plitt; 6 May 1912, cuts and arranges photographs in albums with Plitt; 9 May 1912, prints photographs with Plitt; 11 June 1912, attends an athletic competition with Mr. and Mrs. Plitt; 19 June 1912, goes with Plitt and Papa to Tiranty to have a camera repaired; 24–26 June 1912, goes with Plitt to the Tréport Grand Prix; 28 June 1912, photographs fashion with Plitt at the drag races in Auteuil; July 1912, vacations in Rouzat with Plitt. Besides these photo-specific outings, there were cinema screenings, other sporting events, winter holidays, and shopping expeditions. It was a routine that would continue into the late 1910s.[38]

"Clearly," notes Charles Mendel, concluding the Introduction to the 1903 *Annuaire*, "our annual is woefully incomplete, as today there are few people in the leisured class, in the liberal professions, in industry, in banking, who have not one day or another had occasion to take a picture."[39] Just a glance at a photograph of a Lartigue family outing, taken in 1913 (plate 2), which shows Lartigue behind the wheel of a go-cart, Henri on a ladder filming his son, and Lartigue's friend Louis Ferrand photographing the entire scene with one of Lartigue's own cameras, makes it clear that amateurs were as numerous as they were impossible to categorize. "Amateur photographer" was not a demographic a single volume could contain.[40]

As noted earlier, Henri's interest in photography began to diminish around 1910. This date is significant, for it signals a generational divide between the photographic sensibilities of father and son, a point at which their photographs begin to become distinguishable from one another. The year 1910 also marks an important divide within the realm of amateur photography. Henri's waning interest in photography is typical of photographers of his generation, whose enthusiasm for the technical potential of their medium had by then just about run its course. Similarly, the young Lartigue's growing interest, fueled by increasing contact with professional operators and manufacturers offering technical instruction, is typical of his own photographic milieu. Lartigue's formation under the aegis of two distinct, though closely related, amateur regimes is a defining feature of his development as a photographer. The significance of this can be discerned only by examining the broader context of amateur photography in France at the turn of the century.

Amateur Factions

The amateur movement in France is one of those topics in the history of photography that remains conspicuously understudied. The vagaries of the category itself—"amateur" serving as a term for such diverse photographic sensibilities as Excursionist, Pictorialist, and Kodaker—has exacerbated the problem, both in the primary and secondary literature.[41] At one time, *amateur* held a distinct and useful meaning—it denoted "nonprofessional." This was before photography was revolutionized during the 1880s by the widespread commercial success of the dry plate, an industrially manufactured, pre-sensitized glass negative, which dramatically simplified photography, set off a wave of innovation in cameras and processes, and brought a larger public in on the secrets of the "dark chamber."[42]

While rapid in its progress, this was not a transformation that occurred overnight. Nor was it a transformation propelled by the efforts of a singular body of inventors or manufacturers. During the 1880s especially, technological developments were generated by a markedly diverse collective of photographic partisans. Albert Londe, waxing nostalgic in 1908, recalled that exciting decade: "Everything had to be created, invented—processes, methods, cameras. It was a period like no other; one witnessed during this period an unparalleled competition among industrialists, manufacturers, professional photographers, amateurs. Each sought the best plate, the most practical camera, the most perfect lens."[43] By the early 1890s, however, ripples began to appear on the broad surface of free-wheeling group sentiment. "A rupture" occurred around 1892, remarks Cédric de Veigy, one of the few historians to address the amateur question specifically, "between those who practiced for the improvement and perfection of the process, and those who practiced to defend the legitimacy of photography as a medium of artistic ambition."[44] The proponents of science and of art had staked out their positions and would grow mutually antagonistic over the following decade.

The "serious amateur" (or "competent amateur," as he was sometimes called; unlike other amateur groups, this was a caste almost exclusively male)[45] was a figure conceived during the first wave of enthusiasm surrounding the dry-plate process. The commercial availability of the process alone did not spark such widespread interest; rather, it was the highly publicized, scientific investigations into the nature of movement by Eadweard Muybridge and Etienne-Jules Marey during the late 1870s and early 1880s that spurred the vogue for instantaneous photography—stop-action images of people and objects that expressed the era's evident

fascination with cultural and material progress. As André Gunthert has shown, through the efforts of Muybridge and Marey, photography assumed its role as a legitimate tool of science. It not only showed what the eye could not see, but set a new standard altogether for scientific observation.[46] At the same time, photography offered a fashionable entertainment—it provided, in the words of Albert Londe, "an agreeable pastime, an intelligent occupation."[47] For men of a certain mind-set, one matured in an environment of popularized science, photography was the obvious leisure activity, combining rigor and reverie in a single pursuit.

The visibility of the serious amateur movement can be discerned in the many publications that came into being during the 1880s and 1890s. There were manuals, many of them enjoying a run of several editions, dense with abstruse technical information and good-humored advice for achieving artistic effects: Léon Vidal, *Manuel du touriste photographique* (1889); Albert Londe, *La Photographie instantanée* (1886) and *La Photographie moderne* (1888); Josef Maria Eder, *La Photographie instantanée* (translated from the German, 1888); Paul Chaux, *La Photographie instantanée par les appareils à main* (1894); Frédéric Dillaye, *L'Art en photographie, avec le procédé au gélatino-bromure d'argent* (1896); Emile Giard, *Lettres sur la photographie* (1896) and *Le Livre d'or de la photographie* (1902); Albert Reyner, *Manuel pratique du reporter photographe et de l'amateur d'instantanés* (1903). There were reviews, annuals, and bulletins, these offering the last word on products, processes, and practitioners: *Annuaire de la photographie* (1892–93); *L'Amateur photographe* (1884–1901); *L'Année photographique* (1899–1905); *Photo-Gazette* (1890–1905); *Annuaire général de la photographie* (1892–93); *Les Nouveautés photographiques* (1893–1914); *Annuaire général et international de la photographie* (1893–1905); *Union Nationale des Sociétés Photographiques de France, Annuaire* (1900–1902); *Photo-Magazine, complément illustré de Photo-Revue* (1904–14). This was the textual milieu of Henri Lartigue—and of his son, at one remove: a lively conversation among like-minded amateurs about a spectacle of the latest gadgets, ingenious inventors, daring manufacturing schemes, and the laws of physics.

By contrast, artistic amateurs, or Pictorialists (as they were known in France as elsewhere in the world), insisted on the aesthetic potential of the photographic image. These were high-society practitioners, "les snobs de photographie," a phalanx among the serious amateurs with artistic sensitivities and a social station to protect.[48] From their elite outpost, the *Bulletin du Photo-Club de Paris* (launched in 1891, three years after the Photo-Club's debut), the Pictorialists

identified in the activities of their peers several nodes on which to focus their disapproval.[49] For example, they claimed that the recently increased facility of photography (relative, of course, to the difficulty of the medium before the dry-plate process) fostered a narrow criterion for success, one founded on technical dexterity alone. "It is the triumph of physics and chemistry, nothing more," concluded one skeptic in 1894.[50] Moreover, they saw the hand-held camera as a reckless instrument. Because of its portability and its capacity to hold multiple plates, the hand-held camera, argued some, encouraged careless shooting (i.e., too much shooting), impolite shooting habits (women in swim attire were a favorite target), and a willful disregard for established pictorial conventions.[51]

More egregious than these technical improprieties were the aesthetic shortcomings observed in the final prints of serious amateurs, shortcomings that artistic amateurs regularly dismissed in tones ranging from mild condescension to bald castigation. The aesthetic differences that mark these two groups can be seen in choice of subject: serious amateurs preferred family life, travels, or the unexpected event, such as an accident; and technical challenges, such as unusual weather conditions, were particularly sought after (plate 9). Pictorialists, by contrast, favored evocative, murky landscapes, studio pieces unabashedly fashioned

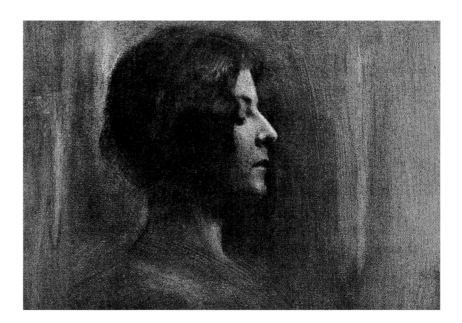

PLATE 3. Robert Demachy, *Severity*, 1904. Halftone reproduction after a gum bichromate print. Published in *Camera Work* 5, 1904. Houghton Library, Harvard University, Cambridge, Mass.

after Dutch painting, and artistically draped, allegorical figures (plate 3).[52] And while Pictorialists expeditiously eliminated what they viewed to be a problem blocking photography's achievement as a serious art form (namely, an annoying overabundance of detail) by adjusting the focal length of the lens to make the image out of focus, serious amateurs celebrated sharp focus and detail as the very telos of their medium. "I see every day a majority of operators enraptured over the marvelous detail of an impeccable portrait, but is it really artistic beauty? No, a thousand times no!" shrieked Ernest Boivin in 1888.[53] Such disagreements could appear petty. An anonymous, ostensibly impartial observer writing in 1897, the moment of greatest animosity between the two groups, sighted two ships of fools on the horizon of amateur photography: "There are two very distinct classes of amateurs adept at photography: those who consider only the appeal of processes and the perfection of cameras . . . , flung down the fatal slope of process-philia and camera-mania. There are others still . . . , a small class of hollow dreamers, who envisage only their own pleasure, and not the pleasure they should reasonably inspire in others. These are generally people who worry little or not at all about processes."[54]

Here it should be emphasized that while the distinctions between these groups were often made along ideological axes—technique versus effect, technician versus artist, hand-held practitioners versus tripod diehards, *nettistes* versus *flouistes* (proponents of sharp focus versus proponents of blur)—the distinction remained at heart one of social difference. The Photo-Club de Paris, with its aristocratic, Anglophilic name, was mostly an upper-class affair. Businessmen, bankers, and engineers—the likes of Henri Lartigue—would not have been welcomed into their ranks.[55] Although Pictorialists advocated greater aesthetic sensitivity, and even went so far as to offer advice to serious amateurs on composition, choice of subject, and printing, serious amateurs risked opening themselves up for ridicule by breaking social caste in aspiring to produce aesthetic photographs. "Faire le monsieur" (playing at being a gentleman) was something most serious amateurs would not have wanted to be accused of doing.[56] Apparently, this was reason enough for many to avoid the temple of Art.[57]

There was, of course, another type of amateur photographer, this one more prevalent and perfidious than either the serious or artistic amateur. This was the "mass amateur," the Sunday snapshooter born out of the success of Kodak, and looked upon by some circa 1900 as the Frankenstein's monster of the amateur

PLATE 4. Anonymous snapshot, from a French photo album, c. 1900. Gelatin silver print, 1½ x 2 in. (3.8 x 5 cm). Private collection, Paris

photography world (plate 4). Paul Nadar, son of the famous portraitist, and, as it happens, an Eastman Kodak representative in France, presented the first Kodak camera—the 100 Shot—to the Société Française de Photographie on 7 December 1888. Other models and equipment appeared over the next decade: the Daylight Kodaks, A, B, and C (1891); the Bull's Eye (1892); cartridge film for the Pocket Kodak (1894); the Folding Pocket Kodak (1897); and the famed Brownie (1900), so easy to use and priced so low (one dollar in America) that it set a whole new standard for mass-market capitalism.[58]

George Eastman's most daring innovation in the realm of photographic merchandising was to eliminate the burden of all post-production work—the onerous tasks of developing and printing exposed negatives—theretofore done by amateur practitioners. Before Kodak, amateur photographers could be aesthetically naïve but never technically ignorant. Eastman himself described the difference in his preface to *The Kodak Primer*, his user's guide to the Kodak system: "Yesterday the photographer, whether he used glass plates or films, must have a dark room and know all about focusing, relation of lens apertures to light and spend days and weeks learning developing, fixing, intensifying, printing, toning and mounting before he could show good results from his labors. Today photography has been reduced to a cycle of three operations: 1: Pull the String, 2: Turn the Key, 3: Press the Button."[59]

Here, rather suddenly, was a whole class of amateurs without any particular knowledge of technique or aesthetics, nor any claim on economic privilege. The serious amateur, caught without his armor of specialized knowledge to distinguish him, would founder. Similarly, artistic amateurs would be forced increasingly toward aesthetic refinement as a point of distinction. By 1909, the year Alfred Stieglitz published his "Twelve Random Don'ts" (a list of admonishments to mass amateurs), the divisions in amateur photography had shifted from serious versus aesthetic to mass versus aesthetic. "Don't believe," warned Stieglitz, "you became an artist the instant you received a gift Kodak on Xmas morning."[60] Artistry and ease now occupied either side of the not-equal sign, while technique rested outside the equation altogether.[61]

Serious Amateur Typologies

Lartigue's early work (1902–10), which he made under the supervision of his father, is so like the photography of his father—whose work is like that of other

serious amateurs—that the two remain difficult to distinguish. Technical challenges associated with lighting, trick photography, and instantaneous photography in particular, and recurring themes such as excursionism, the seaside, children, and animals preoccupied the serious amateur who, more than other amateurs of his day, contributed—if unwittingly—to the assemblage of a modernist iconography as it came to be known. Lartigue, who has often been held up as a pioneer of such innovations, was actually part of a much larger movement, one that remains poorly defined and woefully uncredited in the literature on photographic modernism.

Just as the arc of Henri Lartigue's interest in photography adheres precisely to that of the serious amateur, so his allegiance to this group is also apparent in the patterns of his photographic output—in the themes he addressed, the technical problems he tackled, the effects he sought in his prints. As noted, an array of technical problems occupied the serious amateur. In the amateur periodical press, article after article appeared announcing new papers, developers, and viewfinders; and there was diagram after diagram outlining methods for capturing movement, effective backlighting, and proper placement of subjects in stereoscopic photographs; even advice on aesthetic problems, such as composition, was presented in a technical vocabulary replete with pseudoscientific formulas.[62] The technological minutiae of these articles may appear at times tedious and anecdotal, but certain topics did tend to recur. For example, attempting to photograph under unpropitious circumstances, such as low light under forest cover, was repeatedly addressed. In addition to the technical advice proffered to meet this challenge, new printing techniques facilitated reproduction of successful photographs. In his book *L'Art en photographie* (1896), Frédéric Dillaye offered one of his own photographs, a "study with backlighting," as a successful example for amateurs to emulate.[63]

Henri Lartigue was apparently quite proficient at shooting under forest cover, as demonstrated in a series of photographs made at Châtelguyon in 1904 (plate 5). The poise and intent of these works are evident in the positioning of the boys (Lartigue and his brother), with their white hats and shirts illuminated in broken sunlight, marking a strong contrast against the dark, surrounding forest. Moreover, an awareness of Barbizon painting is evident in the silvery details and graceful compositions. Clearly, Henri's aptitude for photography was as dramatically pictorial as it was technically enterprising.

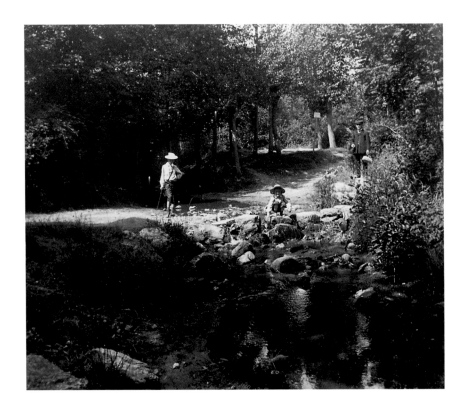

Amateur publications are full of suggestions concerning what to photograph. At the top of the list, even above domestic life, was the category of plein-air subjects. Excursionism, tourism, leisure—these activities, still germinating during the 1890s, constituted the domain of the serious amateur. The Excursionists, who established the model of the science-minded photographer attempting to perfect photography through the methodology of the picnic, outlined patterns of conduct for independent photographers in search of similar experience.[64] *L'Amateur photographe,* the editorial staff of which was closely associated with members of the Excursionists, ran a series called "Excursions photographiques." This series offered advice on equipment and accessories suitable for plein-air photography, suggested where and what to photograph, and supplied the occasional aesthetic pointer.[65] More impressive is the abundance of texts that propose a particular type of site—the seashore, the countryside and, for those of more modest means, the park—a specific camera, and a reper-

toire of standard images.[66] Of these, the seaside was most ardently recommended. Pictures of bathers, such as Henri Lartigue's photograph of his sons and his brother at Ambleteuse (plate 1), were the *steak-frites* of amateur periodicals of the 1890s.

Bathing was the ultimate expression of the new leisure culture, one that embraced as its motive the novel idea of doing nothing in particular. From the amateur photographers' standpoint, the bright light, minimal landscape, dramatically changing weather conditions, and animated figures provided an ideal circumstance for practicing their craft. "Pay tribute to the beach," E. Giard advised in his *Lettres sur la photographie* of 1896: "At each step you will find tableaux completely composed, thanks to the bustling anthill unfolding its insouciant gaiety on the sand. What pretty groupings of babies, of children, of carefree and beautiful youth, forgetful for the time being of the constraints of cities! And the conversations under brightly colored tents, the flirting near discreet changing rooms, the donkey races, the frolicking of the bathers, the offshore excursions . . . !"[67] Giard's commentary, verging on satire, is itself a typology of the seaside photograph. In Henri Lartigue's photographs of bathing children, of women installed in beach chairs, wrapped like beekeepers to protect them against the elements, of fishcarts pulled by donkeys, of luminous seascapes, one discovers the full range of the seaside experience. This, of course, is also true for the younger Lartigue's own photographs of the early period, such as his beach scenes taken at Villerville (plate 66), classics of the seaside genre.

Another standard, photography of children and animals (no doubt favored because of the availability of subjects), posed a particularly enticing challenge for devotees of the dry-plate process. Josef Maria Eder, in his manual *La Photographie instantanée*, published in French in 1888, devotes an entire chapter to the problem. "There was a time," he observed, "when the presence of a child in the studio produced for the photographer the same impression as the appearance of a Medusa's head."[68] Children were difficult to photograph because they could not hold still; moreover, they were not always aware or respectful of adult conventions for posing. Certainly, the slow exposure times of large-format cameras contributed to a prevalence of solemn faces in portraiture, but so, too, did prevailing assumptions regarding social propriety and respectability.[69]

This began to change with the advent of the hand-held camera. Once studio portraitists were armed with faster films and cameras with quicker shutter speeds,

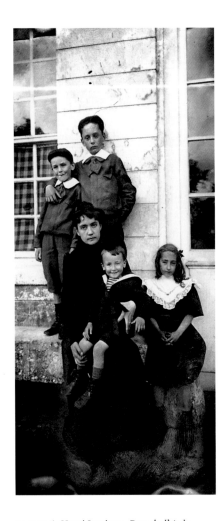

PLATE 6. Henri Lartigue, *Pont-de-l'Arche,
with Zissou, Aunt Yéyé, Dédé, Marcelle*, 1903.
Glass panorama negative, 2 ⅜ x 5 ⅛ in. (6 x
13 cm). Association des Amis de Jacques-
Henri Lartigue, Paris

children became their darlings. And as de Veigy argues, this resulted not only in more photographs of children, but also a budding appreciation for more spontaneous expression in portraiture—laughing, crying, or just looking natural.[70] Just how one achieved this kind of picture became a frequently debated issue. Even with faster techniques, photographers still faced the challenge of arranging the scene and directing the tots. And there was the question of when to release the shutter—how to capture the "decisive moment," as it were. This time-based operation was not something photographers were accustomed to thinking about in 1888. Thus, naturally, it became the very challenge that captured their imagination. Among all of Eder's words of advice—distract the child with music and toys, work quickly so that the child does not lose his good humor—one stands out: "The first shot is generally the best."[71]

Of course, the technical challenges of child photography were not the genre's only attraction. Fathers photographed children then for the same reasons they photograph them today: to document the precious, fleeting moments in the child's life. The late nineteenth century was the great era of embourgeoisement, the period of solidification of the bourgeois family, and photography was a valuable tool for shaping and sustaining an image of family solidarity.[72] Henri Lartigue's engagement with photography illustrates this principle with elegance and exactitude. A group portrait of Jacques with his brother, aunt, and cousins, taken at Pont-de-l'Arche in 1903 (plate 6), is a benchmark image separating old and new sensibilities in portraiture. The dignified figure of Henri's sister, Geneviève Haguet ("Aunt Yéyé" to Jacques), evinces standards of nineteenth-century studio portraiture: she is seated, solemn, iconically maternal; her pose suggests a long exposure time and drawing-room formality. The children, by contrast, convey a franker attitude, one presumably nurtured by the casual mode engendered by the hand-held camera. The youngest child, "Dédé" (André Haguet) seated in his mother's lap, is alert and animated; his sister, Marcelle, is awkward and demure. Jacques and his brother, standing behind their aunt, pose as a pair of brazen gamins. Even the background— backdrop, it could almost be called—is a sieve of time and illusion, the elements of the architectural facade severed and made abstract, the grass underfoot, the bright natural light, all betraying an outdoor setting, selected for its blankness, its geographic non-specificity, like a studio backdrop painted to look real. It is the photography studio turned inside out, and peopled with a band of streetwise Lilliputians.

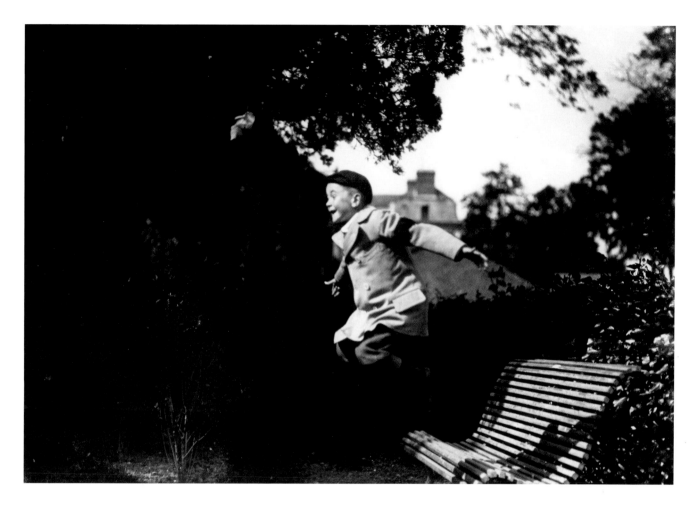

Many of Henri Lartigue's photographs of children, however, like those of his son, stretch the iconographic limits of the family portrait. A photograph of Jacques, taken in 1903, shows an exuberant six-year-old frozen at the apex of a leap from a park bench (plate 7). Whether attempting to capture facial expression or bodies in flight, the real challenge of child photography was the challenge of the instantaneous photograph. During the 1890s, the instantaneous photograph became the main obsession of technically minded practitioners (plate 8). As Albert Londe bluntly observed, instantaneous photography "seduces amateurs."[73] The genre was hard to define. "What is an instantaneous photograph?"

PLATE 7. Henri Lartigue, *Pont-de-l'Arche* [Jacques Henri Lartigue], 1903. Original negative unlocated. Association des Amis de Jacques-Henri Lartigue, Paris

PLATE 8. "Prints obtained with the 'Detective,'" from the *Annuaire général de la photographie, 1896*. Société Française de Photographie, Paris

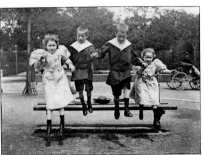

asks a writer in the *Annuaire général* for 1896, when the craze was at its height: "It is, properly speaking, a photograph of objects in movement."[74] But, the author continues, the margin of difference between a shutter release of a half second and one of one-thousandth of a second left the definition ill-defined. Léon Vidal, in his book *Manuel du touriste photographe* (1889), wrote "The word *instantaneous* indicates only a relativity," and advised his readers to use the term only with the duration of exposure specified.[75] Discussions of the issue—really more philosophical than mathematical—turned to aesthetics. How might one achieve a pleasing, well-composed image out of flux? Or was such an image even worth attempting? This was the great controversy among amateur photographers during the 1890s.

For the most part, the debate was divided along lines separating serious and artistic amateurs (mass amateurs did not concern themselves with such questions). Serious amateurs tended to pursue instantaneous photographs like hunters shooting grouse, and the amateur press displayed their quarry on a regular basis (plate 8).[76] Criticism of the trend was couched in just such terms: "Instantaneous photography," remarked Dillaye, "is only a kind of sport."[77] Dillaye and other proponents of Pictorial photography deplored the serious amateur's simpleminded quest for such images, a venture that vaunted the primacy of the negative and contradicted Constant Puyo and Robert Demachy's famous dictum, "The shot is nothing, the print is everything."[78] Other critics even went so far as to claim that the instantaneous photograph was the absolute opposite of art in photography. Giard remarked contemptuously, "Art as direct representation is far from being found in accord with Truth. Is there anything more ridiculous than the four feet of a horse jumping an obstacle, than the flight of a bird or the stride of a man, petrified by a shutter!"[79]

The note of contention here lies in the denotative aspect of photography—in its literal, mechanical transcription of the exterior world onto the sensitive plate. Art, evoked as a fundamentally idealizing endeavor, was seen to be at odds with the awkward poses found in most instantaneous photographs. Just as Alberti had scorned excesses of expression in Renaissance art, arguing that painters guilty of this were just showing off at the expense of their medium's "dignity," instantaneous photography was disparaged by aesthetes for exceeding the limits of good taste.[80] Examples frequently showed grown men in flying squat positions, or stooped below the body of a leaping dog; from the perspec-

tive of an art tradition that favored classical nudes and picturesque landscapes, such images were beyond the pale.[81]

Other critics of instantaneous photography, though drawing the same conclusions, adopted a different form of logic, claiming that the image of a body frozen in time and space was not so much awkward or ugly but simply did not achieve its overt pictorial objective: the expression of movement. Dillaye, for one, argued that instantaneous photographs were not artistic because they were not true to this purpose:

> The image of movement . . . presented in instantaneous photographs rarely gives us the sense of movement. Besides grace, missing so often from instantaneous photographs, we find ourselves in the presence of a deceitful truth. Alliance of contradictory words. Real alliance nonethelessThis arrested movement, this frozen image, leaving us with no memory of that which preceded it, nor arousing any presentiment for that which will follow, becomes the very negation of movement. [This is] the disagreeable and anti-artistic effect of our instantaneous photographs.[82]

Perhaps the most common form of criticism leveled against instantaneous photography was the assumption of chance it conveyed. Chance was the Achilles heel of photography, a mechanical medium regarded increasingly as a process so simple even a child could do it. As one critic wrote in 1894, "Now children of ten show their fawning families images that they declare to be superior to works by the most skillful artists. Not only is this not an art, it is no longer a métier, since no learning is required."[83] Chance signaled the very antithesis of skill, knowledge, intentionality, and taste—all the things serious photographers claimed as vital to their art. And chance, it was argued, was a crutch relied upon especially by the devotee of the instantaneous photograph. The perception was one of excess and ignorance: bands of reckless photographers shooting wildly at moving targets, taking hundreds of random shots, then rushing back to the darkroom to see if anything had been caught. As Paul Chaux, a defender of stop-action photography, argued, "the *instantanéiste* should not necessarily be considered a spoiler of plates"—yet this perception remained hard to shake.[84] "Abandon nothing to chance," advised one author; and another remarked, "Beautiful work should be not the exception, but the rule."[85] Chaux's advice for capturing good

instantaneous photographs was this: stand a good distance back, compose a pleasing landscape, and catch your subject as it passes through the center of the view-finder.[86] Images produced by following this method (as both Lartigue father and son did) could be considered a product of calculation and strategy, regardless of how one ranked the aesthetic merits of the result.

Aesthetically inclined experts offering counsel on instantaneous photography advised restraint and recommended the goal of producing a tasteful instantaneous image, one exhibiting a more "natural" appearance. This was a picture such as the group portrait by Henri Lartigue described above, in which the subject was carefully arranged but apprehended with a natural expression. Achieving such natural expression was increasingly sought (appreciation for it was growing even among aesthetes), but the approach recommended was essentially conservative in its adherence to conventions of studio and landscape photography. Londe, for example, advised: "If we were to define the instantaneous print, we would say that it should have the qualities in terms of finesse and depth of a posed print, with the addition of movement, whatever it may be."[87] From a technical standpoint, natural results were best achieved through avoidance of overly fast shutter speeds. "Necessary for documentary photography," argued Dillaye, fast shutter speeds were nonetheless "wrong for artistic photography."[88] Just what speed was too fast was never made clear, although procedural disparities between slow and fast flush out a more telling difference, one of pictorial mind-set: makers of so-called natural instantaneous photographs were executing studio tableaux outdoors, while makers of other kinds were onto a new idea altogether—an iconography of modern dynamism. As de Veigy puts it, those who aspired to making naturalistic instantaneous photographs were instructed to cultivate "a prowess for setting the scene [*mise en scène*] more than framing the shot [*mise en cadre*]."[89] The former was premeditated; the latter, despite the sureties offered by experts, was still a grotto of chance.

The balance, however, was tipping. By the final years of the nineteenth century, recognition of the value of chance, accident, and surprise in picture-making was growing as an iconography of instantaneity took root, especially among enthusiasts cognizant of modernization and technological progress. As Gunthert explains: "One must remember that there wasn't yet in photography a trend corresponding to the dynamic iconography that would eventually develop around the dry-plate process. Engraved illustrations reproduced in journals, plays, or novels had for a

long time presented a repertoire of people who ran or dove, kissed or stabbed, speeding trains or horses at a gallop . . . all at a time when the universe described by photography still appeared as a calm and meaningless world."[90] According to Gunthert, it was Muybridge's and Marey's images of movement, paraded before the public as scientific documents, that started the revolution. Serious amateurs, supplied with dry plates by the 1890s, nurtured the seeds of an iconographic revolution through the widespread production of instantaneous photographs; by opening up photography to a broad range of animated subjects, they created a new visual code. And as modernity, speed, and technology became increasingly recognized as flash points for a distinct aesthetic iconography, the impulse to discover modernity through the accidental was consciously pursued. Gunthert concludes: "Much more than a representation of movement—a task strictly impossible for the still image—the instantaneous photograph established a repertoire of surprise and accident, which lasted through to the debut of the twentieth century, and on into photojournalism and New Vision photography as well."[91]

"Surprise." "Accident." Gunthert is talking here not of the natural instantaneous photograph, but the other kind, the curious stop-action image produced in emulation of Muybridge and Marey—the kind that showed men, animals, and mechanisms splayed provocatively in mid-propulsion. De Veigy finds at the core of this type of image what he defines as the "incidental posture," a conscious incorporation of the accidental into the process of picture-making.[92] This attitude may be seen as a direct assault on conventional aesthetic modes. If the natural instantaneous photograph breathed some life into stale beaux-arts formulas, changing youngsters' expressions from dour to gay, the incidental posture was like a mistral wind, arriving from some unknown exotic source, and threatening to blow the roof off the academy.

The striking thing about Henri Lartigue's photographs, including both varieties of instantaneous photographs, as well as landscapes and portraiture, is how well-composed they are. They generally feature balanced masses, architectural elements, reflections in water, poised sitters, thus demonstrating exemplary visual competence. Other serious amateurs apparently did not have the same instincts for the aesthetic aspect of their hobby. As early as 1888, before Pictorialists had developed a fondness for advertising the aesthetic defects of their technically oriented colleagues, experts were urging crash courses in taste. There is a "necessity," argued a pair of writers for *L'Amateur photographe*, "to develop in

ourselves a feeling for the beautiful through the study of books, through associating with trained artists, and by looking at great works of art by painters or draughtsmen, as much as by observing nature. It is, in our opinion, the sole means, even for those endowed with the greatest intelligence, to achieve, from the point of view of art, progress in relation to that of photographic science."[93]

Fortunately, for those without the inclination to embark upon this kind of personal transformation, basic instruction in composition was a staple of the amateur photography periodicals. "Are there rules for composition?" asked a writer for *Photo-Magazine*, giving the entirely expected answer, "Yes."[94] Authors generally agreed on a few simple guidelines: do not put the horizon line in the center of the picture plane; do not put the subject in the center of the picture; strive for unity and balance, but also variety—principles exemplified by the images in plate 9. The cardinal rule was stated simply by one expert: "Make all the lines of the landscape converge toward the most interesting point, which should not be found at the center of the view."[95] Other suggestions included animating the landscape with a figure, and posing the sitters for a group portrait in triangular arrangement after old master painters like Rubens.[96] Certain choices of subject were suggested

PLATE 9. Frédéric Dillaye, some examples of "Big Effects," from lesson six, *Principes et pratique d'art en photographie*, Paris, 1899. Harvard College Library, Harvard University, Cambridge, Mass.

as well: a bend in the road, a carriage animating a landscape, reflections on the surface of water. Most authors provided diagrams to illustrate their recommendations, which demonstrate the maladroit as well as the tastefully composed. Such illustrations, one suspects, were etched in the minds of many amateurs.[97]

With very few exceptions, Henri Lartigue's instantaneous photographs are of the natural variety.[98] Two exceptions stand out: the photograph of his son leaping from a park bench, mentioned earlier (plate 7), and another of his son coasting across the picture plane on his bicycle. Although conceived in the spirit of the incidental posture, little that might be described as incidental appears in these works. The boy's flying figure is as carefully composed—caught at what Giard termed the "dead point," the silhouette seized "as much by experience as by divination"[99]—as the overall composition. The margin of chance in these works, though present, is extremely narrow.

The younger Lartigue's early instantaneous photographs, by contrast, ramble more freely between the natural and the incidental posture. If there is a formal suggestion of naïveté in his work, it is restricted to the early (pre-1910) works—pictures that he took between the ages of eight and sixteen, before the emergence of an identifiable aesthetic sensibility. Hovering around the distorted figures, streaked backgrounds, and odd perspectives of these early works flutters a residue of chance. A headless female drifting downward from a wall (plate 10), a pair of bedsheet ghosts shrouded in a haze of stained and mottled gloom, a carpet's-eye view of an auto rally dwarfed by a towering side table—these are images of objects photographed to see how they will look photographed, and chance is largely responsible for their charm. Yet charm is a quality both exclusive and migratory; it depends on who is generating it, and when and where it surfaces. More specifically, charm is a matter of cultural consensus.

Judged by serious-amateur standards, which include aesthetic standards as well as typological conventions for picture-making, many of Lartigue's early photographs are outright failures, accidents, flops. Yet these pictures are rescued, eventually, by hindsight—not just the hindsight of posterity, but the hindsight of the photographer himself, who, visually underdeveloped at the time these pictures were taken, made rapid progress soon after and, importantly, developed a fervent interest in the earlier work. Lartigue's photographs—and this is true of the entire oeuvre, not just the early pictures discussed here—are the product of a long process of revision, narrative revision as well as pictorial. As the vital prelude

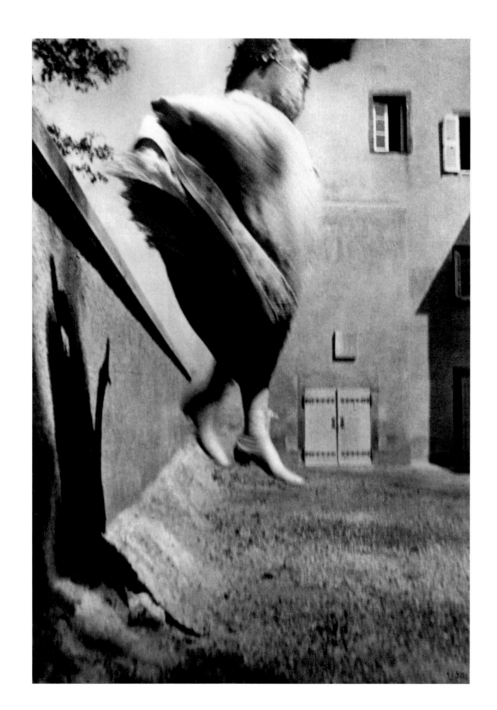

PLATE 10. Jacques Henri Lartigue,
Bouboutte, Rouzat, 1908. Glass negative,
1¾ x 2⅜ in. (4.5 x 6 cm). Association
des Amis de Jacques-Henri Lartigue, Paris

to a later, mature body of work, albeit a body of work still ascribed to the instincts of a child, these early attempts have, through the luxury of reconsideration, found their place in a larger narrative, and chance has proven itself commodious as an agent of meaning.

Here lies the real distinction between the photographs of father and son: whereas Henri Lartigue's instantaneous photographs are carefully preconceived, those by his son might be termed "postconceived." Made with an eye for the novel and the unexpected, saved and reconsidered in relation to an evolving idiom of spontaneity, dynamism, and, eventually, artlessness, Jacques Henri Lartigue's photographs are like reflections in water, their surfaces rippling with random patterns, broadening over time, breaking eventually on the shores of modernist transformation. Faults, the products of chance, came to signify instinct and naïveté.

Was Lartigue's sensibility the easy result of childish incompetence, primal instinct, naïveté, as has frequently been postulated by later interpreters of his oeuvre? Or was it a conscious quest for the surprise, the accidental, the ill-composed? A more enlightening question might be: What is it that is intentional, pursued, or attempted across the landscape of his early works, and, more important, what lies outside the boundaries of these intentions, and what meaning may be ascribed to such aberrations? By scrutinizing Lartigue's photographic practice in relation to that of his father, one begins to perceive an answer.

Lartigue's Early Efforts

Lartigue's first attempts at photography—beginning in 1902, at the age of eight—took place on family outings, most of which occurred near Pont-de-l'Arche, where the family maintained a summer residence until the acquisition of the château de Rouzat in 1905. These early works are in an unassuming notebook, a thin sheaf of lined paper, yellowed and curled by age and handling, identified in elegant script on the title page, "Photographies diverses, 1894–1903."[100] The handwriting is Lartigue's mother's; this is indicated in a note by Lartigue, written much later: "Mother's old notebook, with first photos." Inside is a mixture of photographs, most of them by Henri Lartigue, which depict the family on holiday at various seaside resorts; landscapes made around Pont-de-l'Arche; Rouen cathedral; and innumerable individual portraits. Lartigue's contribution comprises just three photographs: a landscape, a group portrait, and a portrait of his parents, each of these identified by inscriptions from the period in

the hand of Madame Lartigue.[101] The notebook also contains some of the earliest extant drawings by Lartigue, child's drawings of boats and seashells, ramparts and bicycles, drawn in scribbles, yet demonstrating a surprising awareness of form and spatial depth.

If the notebook seems to announce the stirrings of an artistic consciousness, it also reveals a consciousness largely dominated by adult sensibilities. These thirty-odd pages, arranged by no evident method or rule (not even chronology), perfectly represent Lartigue's early dependence on the photographic knowledge of his father—that is to say, the notebook and its contents are constructions of Henri Lartigue. At best, the photographs identified here as being by Lartigue *fils* are the result of collaboration.

For example, Lartigue's first photograph, identified by Madame Lartigue as "Group by Jacques"—and more pointedly identified by Lartigue in the 1960s as "First photo, made absolutely alone"—comes with a telling, self-contradicting coda: "aided by Papa."[102] Another example, a tender portrait of Lartigue's parents, inscribed "By Jacques" by Madame Lartigue, is described elsewhere by Lartigue in this fashion: "Papa's the one who suggested to Mama, 'let's pose like this.'"[103] Collaboration is also evident in others of these early photographs. Another portrait of Lartigue's parents, *Pont-de-l'Arche, Mama and Papa*, from 1902, not included in the notebook, was posed by Henri, the shutter released by his son, and the print made by Henri.[104] A pair of group portraits from 1905, taken aboard a friend's yacht, *La Suȝon*, best illustrates Lartigue's early role in picture-making. These two portraits (one by Lartigue, the other by his father) are nearly identical, except for the presence of Lartigue in the father's version. The considerable challenge of the backlighting (with the group posed under a canopy and backed by a brilliant band of light) compared with the considerable success of the print, suggests a common scenario, one in which the father is skilled, the son merely present.[105]

Almost all of these examples suggest conventional amateur typologies orchestrated by Henri Lartigue, but one of them is significantly different enough to warrant special comment. At the center of an innocuous landscape entitled *Pont-de-l'Arche*, 1902, and identified by Madame Lartigue as "Photographic attempts by Jacques," there is a cat, visible as little more than a white speck in a field of brume and gloom (the citrate print by the eight-year-old Lartigue is noticeably bad) (plate 11). If not for the presence of the cat, this image might be

seen as a conventional landscape. An inscription, however, penned many years later by Lartigue, exercises considerable sway over one's reading of the composition: "My little cat (look at the bottom of the tree)." Lartigue's note calls attention to the fact that the photograph's ostensible subject, the little cat, is not given the size and weight it might hold in an otherwise competent amateur composition. This is where, through what might be called the rhetoric of naïveté, the picture gains its precise significance. The charm of the print, one is encouraged to believe, originates in the boy's ineptness. At last, it seems, one is looking at an honest-to-goodness photograph by Lartigue himself, a picture in which the boy's own sensibilities seem to crawl out from under the weight of the father's technical and aesthetic example.

The power of Lartigue's inscription should not, however, sway us from an equally plausible, entirely compatible reading. For if the inscription is ignored, if its rhetoric of naïveté is set aside, another layer of narrative emerges. Taking into consideration the clearly stated attribution to Lartigue *fils* by his mother, and the obscurity of the center of interest, Lartigue would seem to have both conceived the picture and determined the position of the camera. One is reminded, however, of Lartigue's anecdotal account (c. 1962) of his early experiences tak-

PLATE 11. Jacques Henri Lartigue [?], *Pont-de-l'Arche* [cat in a landscape], 1902. Gelatin silver print, 4⅝ x 7 in. (11.7 x 17.8 cm); original negative unlocated. Private collection, Paris

ing pictures, in which he would order his father, "Photograph this, and this, and this . . . ," to which his father would respond, "Yes, all right."[106] The picture, in this sense, might best be regarded as the site of a family romance, the intersection of convention and skill (the father's) with curious ineptitude (the son's)— an arrangement, not incidentally, that underlines an indiscernibility fundamental to photographic authorship. Lartigue *père* is clearly behind the technical production of the image, for the 13 x 18 cm camera was big, sat on a tripod, and required considerable preparation. Moreover, the post-production work in the darkroom was complicated as well as dangerous. Lartigue may have watched or "assisted," handing off tools, agitating trays, hanging prints to dry. As for conception and composition, the inclusion of "my little cat" in the scene is likely Lartigue's choice (even if "chosen" in retrospect), yet the overall composition, even the distanced perspective, is the work of the father. The cat's obscurity should not be viewed simply as a fault, least of all a charming fault of inexperience, but a delicate detail, for the picture is entirely intimist in conception. The family garden, a shady, sheltered space, atmospherically illuminated by light penetrating the leafy canopy above, is a cloister set off against the distant rolling landscape. Focus is carefully centered on a young tree, its branches fanning gracefully near the top of the picture frame, and on the cat placed at the foot of the tree. Depth of field is shallow, and, with the aid of the filtered light, it lends the scene a romantic glow. This is a photograph made under forest cover—another backlit tableau by Henri Lartigue—and hardly a bad print by his son.

The notebook contains other photographs attributed to Lartigue, but the authorship of these works is dubious. As with the retro-inscription "my little cat," these attributions were made long after the assembly of the notebook, perhaps even after Lartigue's death, for the handwriting is that of Lartigue's third wife, Florette. In all, there are twelve photographs attributed to the young Lartigue by her, including a group of portraits which, like those by Henri Lartigue, center on an architectural conceit—a garden gate, a hedge, a window. While the immediacy and simplicity of these works seem to support (or, at least, do not discourage) attribution to an eight-year-old, it should be recalled that these are portraits composed in the same vein as others by Henri Lartigue, in which sitters are posed outdoors, centered within a framing device, and given something to do with their hands (grip a railing, balance an umbrella, hold a cat). And yet, even if these portraits did involve his son's participation, as in the legitimate examples previously

discussed, it is clear that Henri's involvement in their making was considerable, for he held all the knowledge, technical as well as aesthetic.

Still, among this dubious group there are two puzzling exceptions. The first is a photograph of the back of a child's head, the large form blurred due to its placement in the extreme foreground (plate 12). The child gazes toward a boat in the distance. The effect is one of oversight or accident, the kind associated with mass amateurs of the 1900s and 1910s. It is, however, an idiom rather alien to serious amateurs, who purposefully avoided gross distortions caused by close proximity of subject to lens and strove instead for scrupulously choreographed arrangements, in which subjects appeared facing the lens, placed carefully in selected environments. (The effect is as rare in the work of Lartigue as it is in that of his father.) The transgression of the blurred head might be seen to invite interpretation as an inadvertent meditation on juvenile desire. The boy's gaze, trained intently on the boat, expresses a sentiment of (gendered) adolescent longing, while the technical ineptitude of the blurred head conjures, naturally, the rhetoric of naïveté. Recalling, however, that only Florette Lartigue's inscription claims this photograph as being by Jacques, and observing that the particular sentiment

PLATE 12. Jacques Henri Lartigue [?], *Pont-de-l'Arche, Louis*, 1902. Gelatin silver print, 4¾ x 6⅝ in. (12.1 x 16.8 cm); original negative unlocated. Private collection, Paris

embodied in the image ("summer days," nostalgia for childhood) encourages, illogically perhaps, an assumption of child authorship, sole attribution to Lartigue *fils* should be held in reserve. Skirting the rhetoric of naïveté, other explanations emerge for consideration.

To begin with, Henri was often playful and sentimental in his photography, especially when depicting the world of his children. In one example, a picture of Jacques bending over to reveal a tear in the seat of his pants, Henri engages an idea later developed by his son: photography of the derriere.[107] Furthermore, the boat in the picture is a specific kind of boat, a steamship; as an engineer who specialized in transportation, Henri would have found this vessel at least as interesting as his sons did.[108] Finally, and most important, the blurred image of a head in the foreground was quite common in another medium familiar to Henri, the cinema.[109] Early cinema, as film historian Tom Gunning has shown, introduced a strain of formal chaos into picture-making, in which figures moved close to the camera, in and out of the frame, and away into the distance. This boy gazing at a boat is not at all unlike early stills from the Lumière brothers' films, in which spectators invade the foreground, constituting surrogate viewers, in effect.[110] Thus, whether the image was made by Jacques or his father (it is, in all likeli-

hood, the product of a combined effort), the motif has a widely available, highly plausible precedent.

The second puzzling example from the notebook is a so-called phantom photograph, in which Lartigue, semitransparent, poses with friends (plate 13). This is an image normally understood as an expression of childlike wonder over photography's aberrant capacities, for is it not generally true that children, having learned a process, will immediately break whatever rule they have been taught? Here, the long exposure time is exploited—a posed trio, an uncovered lens, a rush to the center of the picture.[111] Again, the attribution of the photograph to Jacques is based only on Florette Lartigue's inscription, although here the boy's visible participation as phantom photographer does seem to make clear the precise nature of his role. And yet, the technical difficulties, such as the installation of the camera on its tripod, preparation of the plate, and development in the darkroom, required the presence of Henri. More compelling, of course, is the powerful rhetoric of naïveté. In this instance, the photograph does not convey formal innovation through ineptness; it does, however, suggest child authorship through—besides the presence of children—the quality of the idea. The premise here is the visual prank, the kind associated with the mischievous boy, a common motif of the period, especially in the milieu of amateur photography.[112] And yet, as Gunning has shown, this was an attitude common among (adult) serious amateurs, who expressed through picture-making "a simple visual curiosity, a search for knowledge . . . more voyeuristic than scientific."[113] Nowhere was this attitude more apparent than in the bizarre realm of "recreational photography," advocated in France by C. Chaplot.

Chaplot was games editor for *Photo-Magazine* and author of the popular *La Photographie récréative et fantaisiste*, in which recipes for making trick photographs—such as phantom photographs—were reproduced.[114] *La Photographie récréative*, photography's answer to the home-science kit popularized by Tom Tit during the 1890s, was the workbook of secret pleasures for serious amateurs, and also a decadent sign of the group's decline.[115] The trick photographs that fill the book's two hundred pages instruct readers to cast aside all rules governing "correct" photography and loll in the frivolity of comically distorted faces, colossal tomatoes, and photographic lampshades. These might strike us today as amusements intended for children, yet the book is dedicated to "true amateurs," specified—because "amateur" always required specification—as "those who

PLATE 14. H. Fourtier, wood engraving of a "spirit photograph" from *La Nature*, 13 January 1894. Harvard College Library, Harvard University, Cambridge, Mass.

practice photography as a favorite pastime, without hope of financial gain . . . those who, in a word, turn to photography for artistic pleasure, for the satisfaction of applying—or to discover, perhaps—a new process, an unpublished technique, a curious or amusing trick."[116] Here is a full-grown serious amateur still pursuing photography as a hobby, mildly aspiring to art, and running short on fuel for inspiration.[117]

It is impossible to know whether Henri Lartigue owned a copy of this book, or a copy of *Les Récréations photographiques* (a competitor in the genre by A. Bergeret and F. Drouin), or if he read *La Nature*, which ran a regular feature on photographic oddities.[118] What is clear is that many of the early photographs attributed to Lartigue *fils*—the pictures that seem to demonstrate the greatest sense of visual wonder, pictorial invention, and boyish mischief—are garden-variety photographic amusements.

"Spirit photography," invented by William Mumler in America, was the most common of trick photographs.[119] There were different spirit motifs, including (after Mumler) subjects "haunted" by superimposed, semitransparent portraits of deceased loved ones; subjects interacting with skeletons; or subjects crying out in horror at a shadowy, draped figure (plate 14). This last is the model for a photograph in which Jacques plays the startled sleeper opposite his brother Zissou dressed as a phantom (plate 15). This photograph, like numerous others in which he appears, has been habitually—and cursorily—credited to the young Lartigue. Although the remote shutter release was an available technology at the time, one observes neither cable release in his fully visible hands, nor cord trailing off the porch toward the camera resting on a tripod. Moreover, the method for producing such an image—two exposures, with Jacques, opaque, immobilized on the settee for the duration of both, and his brother, translucent, on camera for only the second—rules out the possibility that he choreographed the image.[120] A third party is present: the man behind the camera is in all likelihood Henri Lartigue, judging by the skillful use of the porch as a framing device and the artistically arranged fabric cascading off the steps.[121]

One finds among the instructions for trick photographs, surprisingly perhaps, standard advice for standard picture-making: "Art in Photography," "The Instantaneous Photograph," "The Genre Subject," "The Open Air Portrait"—these are some of the chapters proffering directions for reproducing classic amateur fare.[122] However, subversive practices nip at the heels of such chapters, for

fundamental to the recreation sensibility is violating the existing formulas. Chaplot, introducing a chapter entitled "Lies of Photography," wrote, "Photography, contrary to popular opinion, isn't always the expression of pure truth."[123] A photograph of a man leaping off a sawhorse in profile, published by Bergeret and Drouin in 1891, provides an example of a classic instantaneous photograph. When this kind of photography was at its zenith during the 1890s, amateur photographers routinely captured their subjects in direct profile or head-on as they jumped off chairs, benches, or walls, much as Muybridge had composed his sequential action photographs of a running horse. The idea was to record maximum clarity of form, vital to scientific analysis; thus, respectful of their serious, ostensibly scientific purpose, subjects typically projected an air of restraint and concentration.[124] This image-type became amusing with the addition of a curious, humorous, or fake element. Chaplot offers several travesties of the instantaneous photograph, such as *Diving*, which features a spectacular leap, and *A Monumental "Wipeout,"* which presents a faked bicycle wreck.

PLATE 15. Jacques Henri Lartigue [?], *Zissou as a Phantom*, 1905. Original negative unlocated. Association des Amis de Jacques-Henri Lartigue, Paris

PLATE 16. Jacques Henri Lartigue,
Bichonnade, Rouzat, 1907. Glass negative,
1¾ x 2⅜ in. (4.5 x 6 cm). Association
des Amis de Jacques-Henri Lartigue, Paris

Another example explains how to contrive a portrait of a friend as a cyclist taking a tight curve.[125]

Many of Lartigue's instantaneous photographs start with a trick premise and adapt this to a personal end, such that the standard jump-in-profile becomes a boy as an airplane, a girl in a nice dress, a head separated from a falling body. In one well-known example from 1905, Zissou parachutes (from a chair? a wall?) with an umbrella, a pretend act represented by an illusionistic technique. Significantly, the full negative of this image reveals Lartigue on camera stage right, and thus his father as the author, casting a shadow of doubt onto other early works regularly attributed to him.[126]

Chaplot's section on the "Art of Misrepresenting [*travestir*] the Model" (*travestir* has a dual meaning in French: to dress up and to misrepresent) reads like a manifesto for Lartigue's approach to photographing people, especially women. The "photo caricature," generally achieved through the use of costumes, lens distortions, and odd, unflattering perspectives, is structured around a transgression of the traditional portrait. Chaplot's phrase "to denature the model" (to represent the model in an "unnatural" way) constitutes an institutionalized assault on the natural style of portraiture enjoying a vogue at the time.[127] Often, the elaborate garbs and pretentious mannerisms of women ignited a self-travesty on their own, as Lartigue's photographs of the early 1910s shrewdly convey. But for the early photographs, those conceived in a recreational mode, the travesties are more physically compromising: Bichonnade (his cousin Madeleine Van Weers) flying down a stair, Guitty (Folletête's cousin Marguerite Bourcart) caught in the surf, Bichonnade down for the count (plate 16). This last image, which shows Lartigue's cousin poetically unseated from her bicycle, is also *A Monumental "Wipeout"*; faked or not, it was a theme in wide circulation.

Trick motifs show up in numerous other works. In Lartigue's oeuvre, there are prints with decoratively clipped edges, traps for triggering flash and shutter so that animals inadvertently photograph themselves (Chaplot suggests deer; Jacques and his friends tried for rats), and photographs of fireworks and other sources of artificial light, including the moon.[128] Besides lies perpetuated in shooting the photograph, such as *A Monumental "Wipeout*," there are also lies concocted in the printing. A common trick related by Chaplot was to rotate the print slightly in order to steepen the angle of the horizon line. *An Intrepid Ascent*, which shows a horse-drawn cart making its way "uphill," illustrates this drama-enhancing effect.[129]

PLATE 17. Jacques Henri Lartigue, *Downhill Race*, 1905. Gelatin-silver contact print, 1¾ x 2⅜ in. (4.5 x 6 cm). Association des Amis de Jacques-Henri Lartigue, Paris

PLATE 18. Jacques Henri Lartigue, *Downhill Race*, 1905. Gelatin-silver print, 3½ x 4⅝ in. (8.8 x 11.8 cm), from a glass negative, 1¾ x 2⅜ in. (4.5 x 6 cm). Association des Amis de Jacques-Henri Lartigue, Paris

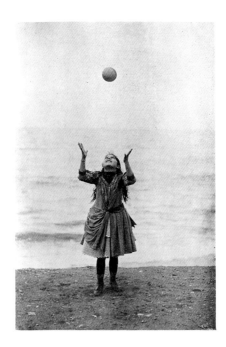

Among Lartigue's photographs, crop lines drawn in blue on citrate prints show his familiarity with this technique; *Downhill Race* (plates 17, 18), picturing a bicycle race from 1905, demonstrates the peculiar efficacy of this pictorial maneuver.

A particularly widespread photographic amusement demonstrated with perfect clarity a point fundamental to the making of good instantaneous photographs. "At the Beach" (plate 19), published in the *Annuaire général* for 1896, shows a girl tossing a ball straight up above her head. The shot was made at the precise moment the ball reached its apex, at the dead point, when all action is suspended. Finding this instant of stasis in the midst of movement was the first lesson of instantaneous photography, and this particular image, which circulated widely, represented an elemental drill for aspiring photographers of instantaneity. *My Garden, Pont-de-l'Arche* (1904), featuring a fountain, is Lartigue's assisted version of the same image, in which the apex—a water jet in this instance—is perpetually regenerated by an uninterrupted column of water. That same year, he shot *My Nanny Dudu* (plate 20), an instantaneous portrait of his nanny, a classic of the genre, and *My Cat Zizi* (1904), a less controlled variation on the same theme.

Acknowledging the origins of these pictures does not diminish their charm, any more than questioning the complex process of how they were made—and by whom—would necessarily imply fraud or deflation of value. Trick photography, admittedly the common result of amateur photography's schlockier instincts, should not be denied as a factor in the production of Lartigue's early works, nor should the involvement of his father in transmitting photographic ideas, equipment, and techniques. This only suggests that Lartigue, like other sentient photographers, had to first absorb an existing photographic process before evolving into the independent, perspicacious photographer he would eventually become.

IN 1902, as one version of the story goes, eight-year-old Jacques received a 13 x 18 cm camera from his father.[130] Manufactured by J. Audouin, the 13 x 18 was a large wooden camera that sat on a tripod. It had no shutter; exposure was made manually by lifting and replacing the lens cap by hand. As Lartigue later recalled, he required substantial aid from his father to operate this primitive giant.[131] The cameras that followed, some borrowed, were increasingly lightweight, smaller in size, and faster in speed. There was the Jumelle, a hand-held camera with 9 x 12 cm glass plates, acquired in 1903, when he was nine. The Jumelle, which had a maximum

PLATE 19. M. Rougé, "At the Beach," from the *Annuaire général de la photographie, 1896.* Société Française de Photographie, Paris

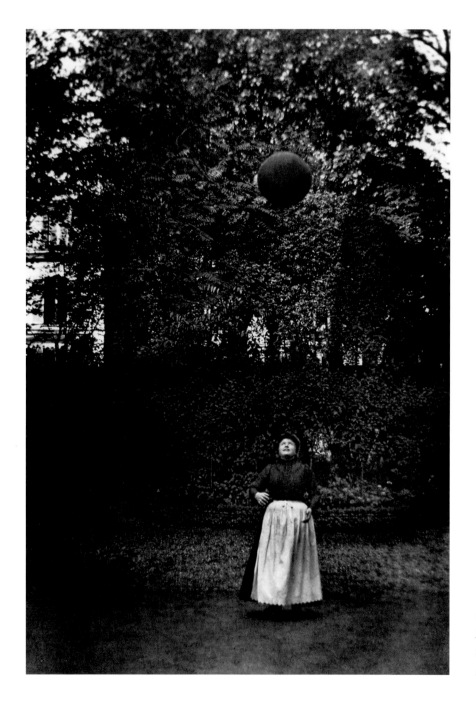

PLATE 20. Jacques Henri Lartigue,
My Nanny Dudu, 1904. Roll-film negative,
2⅜ x 3½ in. (6 x 9 cm). Association des
Amis de Jacques-Henri Lartigue, Paris

shutter speed of 1/50 of a second, was boxlike and, volumetrically, about the same size as the boy's head. (This is the camera that he holds in the well-known portrait of 1903 [plate 94], in which he appears with his mother, grandmother, and, in some versions, brother in the Bois de Boulogne.) The following year, Jacques received a Block-Notes Gaumont, which also took glass plates, but these were only 4.5 x 6 centimeters in size. He received a Folding Kodak Brownie No. 2 in 1905, at age eleven—a roll-film camera producing images 6 x 9 centimeters in size. Both these cameras had shutter speeds of 1/100 of a second, although he apparently acquired an updated model of the Block-Notes with a speed of 1/300 of a second soon after. Even though the roll film was substantially lighter in weight than the glass plates, the chassis of the Brownie was considerably larger than that of the Block-Notes. Moreover, the Folding Brownie No. 2 was much larger and heavier than the classic Brownie, the one made for children.[132] By contrast, the Block-Notes, as advertisements liked to emphasize, was so small and light that it could rest comfortably, like a pair of opera glasses, between a lady's fingers. He also occasionally borrowed his father's 6 x 13 cm Spido-Gaumont stereo, which had a shutter release of 1/300 of a second, and, from Plitt, the Vérascope stereo, a less expensive camera with a slightly slower shutter speed.[133]

From 1902 to 1910, Lartigue's output was inconsistent.[134] Whether this was due to variations in his arsenal of equipment, uneven involvement by his father in the photographic process, the probability that work from this period comprises multiple authors (others in the family circle were avidly photographing by then), his inexperience, or some combination of these factors is not entirely clear. It is striking, however, that the Block-Notes 4.5 x 6 cm, by far the lightest and smallest camera within reach, and the one that he used most frequently during this time, is not the technology behind the best-known pictures from this early period.[135] Consider, for example, the works in the MoMA exhibition of 1963, of which only two photographs from this early period were taken with the Block-Notes, while five were taken with other cameras—four with the Brownie No. 2, and one with the Vérascope, on loan from Plitt.[136] Consider, too, his rare, early iconic photographs that gained fame later on, all taken with larger cameras: besides the large-format works in the notebook, there is *Mardi Gras* (1903), shot with the Jumelle, when Lartigue was nine; *My Nanny Dudu* (plate 20), shot with the Brownie No. 2 a year later; and *My Cousin Bichonnade* (1905) and *Oléo* (1908), both of which he took with his father's Spido-Gaumont stereo. And yet, in the

archive, there are multitudes of lesser-known pictures made with the Block-Notes: many pictures of dogs and cats, all far less appealing than *My Cat Zizi* (1904); a self-portrait taken in the bath with a toy hydroplane, made with the help of Lartigue's mother (1902); a portrait of Zissou with a kite (1905); *Portrait of Louis* (1904); a large series of photographs of model airplanes, both static and in flight, many of these assembled together in an aviation album (now at George Eastman House, Rochester); a pair of images of Zissou and Louis with their bicycles (1906). And there is Bichonnade fallen from her bicycle (plate 16); *Kätchen* (1908); Bouboutte (his cousin Marthe Van Weers) jumping from a wall (plate 10); *At Luna Park* (1909); *James and Rico* (1909); legions of photographs of go-cart races, aquatic maneuvers, and general hijinks, all taken at Rouzat—these are only the more notable examples.[137] In sum, the Block-Notes pictures are not the formal masterworks exhibited by MoMA. Moreover, unlike the photo-

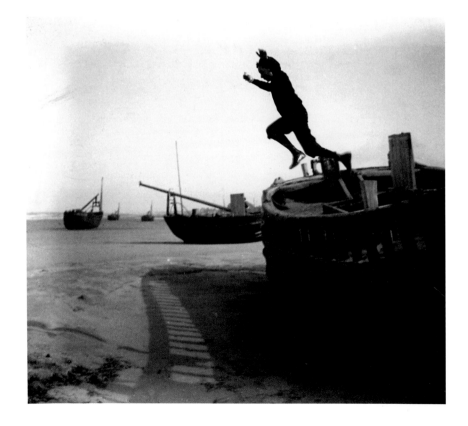

PLATE 21. Jacques Henri Lartigue, *Zissou Takes Off*, 1904. Glass stereo negative, 2⅜ x 5⅛ in. (6 x 13 cm). Association des Amis de Jacques-Henri Lartigue, Paris

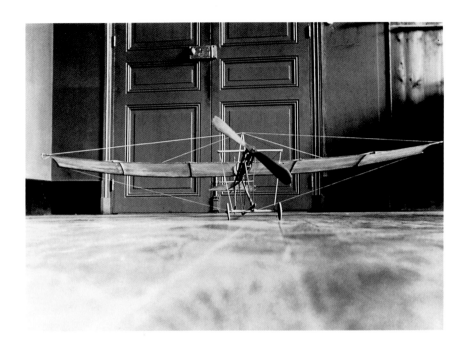

PLATE 22. Jacques Henri Lartigue, *A Reduced Model*, 1908. Glass negative, 1¼ x 2⅜ in. (4.5 x 6 cm). Association des Amis de Jacques-Henri Lartigue, Paris

graphs made with the Brownie No. 2, which involved commercial development, the Block-Notes pictures are often blurred, smudged, and soiled—Lartigue's fingerprints, literally, cover the negatives.[138]

Is the disparity between the Block-Notes pictures and those made by other means due to a qualitative difference in technology—that is to say, the bigger the camera the better the picture? From a technical standpoint, bigger cameras do make better pictures; with their larger negatives, they make pictures with greater detail and luminosity. Certainly, the larger cameras at Lartigue's disposal did produce sharper, brighter images but, more significant: they also required help to operate. If the myriad Block-Notes photographs are of lower quality than their rarer, large-format cousins, it is because Lartigue's operation of these cameras merited an occasion, a special circumstance, for which he was supervised and aided by his father, or by Plitt or other photographing superiors in his circle. When he photographed Zissou leaping from a boat hull with his father's Spido-Gaumont (plate 21), he was a protégé (or even, perhaps, a bystander), trying to get it right, to make an instantaneous photograph just like those made by his father. When he photographed one of his brother's model airplanes with his

Block-Notes (plate 22), he was an independent operator, free to photograph what he liked, how he liked. Lartigue's airplane picture, taken from the floor—from a "child's-eye view"—is droll and unconventional. It does what it sets out to do: it records an object on film. The instantaneous photograph of Zissou, with its careful balance of form and precisely laid silhouette, is constructed like a clock.

It is difficult to say which is the typical work. On the one hand, the Block-Notes photographs seem the truest marker of Lartigue's progress circa 1909, for he was photographing his world, liberated by the small size of the camera, freed for the moment to photograph outside his father's control. On the other hand, the photographs he made under the shadow of serious-amateur rules seem to augur some of the best images to come. They exhibit the qualities that the photographs from 1910–14, Lartigue's mature period, display more consistently—that is, good composition, an interest in instantaneity, and social humor. More generally, the photographs of this early period, whether they avoid, flout, or (most often) fail to measure up to amateur pictorial conventions, share a common origin in the teachings of his father. Lartigue's awareness of standards should not be underestimated, for it is a sensibility that runs right through the mature oeuvre as well.

In 1910, when Lartigue was sixteen years old, his father bought him another camera, a 9 x 12 cm Takir-Klapp with Krauss-Zeiss lens fittings, which featured the remarkably fast shutter speed of 1/1000 of a second. This instrument was not quite as small as the Block-Notes, but it was light and flexible, the latest in hand-held camera technology. In 1912, after consulting with a reporter-friend for *La Vie au grand air*, Lartigue acquired a 6 x 13 cm Klapp-Nettel, a stereoscopic camera, which, at the flip of a lever, converted to a single-frame panorama. The Klapp-Nettel had an even faster shutter speed of 1/1200 of a second. For this reason it was the instrument of choice for press photographers, particularly sports photographers during the first decade of the twentieth century.[139]

The significance of these faster instruments, developed in tandem with faster films, cannot be overemphasized. The old Block-Notes, with its slow release of 1/100 of a second, still required a great deal of light and stability in order to secure an image, while Henri Lartigue's Spido-Gaumont, seemingly so quick at 1/300 of a second, was hardly better. For garnering instantaneous photographs, obtaining the faster cameras was like exchanging an ancient scythe for a modern combine. The Klapps (Klapp was a line of German strut cameras, and

Nettel was a brand name)[140] eliminated the need for perfect conditions, extensive plotting, and an abundance of luck. Thanks to faster shutters, combined with increasingly sensitive negatives, it became less essential to remain completely still while shooting, to locate the "dead point," and to have bright sunlight. Subjects could be caught at just about any moment, which dramatically enlarged the range of postures and expressions, not to mention the chances of getting a legible picture in the first place.

The size of the Klapps was, in fact, a diminishing issue for Lartigue, since the hands that held the new camera had grown dramatically in a short span of time. Around his sixteenth year (1910), Lartigue underwent a remarkable growth spurt. As portraits of him show, he changed from a thin, delicate-looking boy in knickers to a courtly young man in English trousers, collar, and tie. Lartigue's social circle was also shifting. By 1910 Henri Lartigue had taken his work outside the home and Folletête, his secretary, with him, enabling Jacques to escape, little by little, and to pass his time in the company of a group of boisterous young men: his insouciant older brother Zissou (Maurice Lartigue), aged twenty in 1910; his cousins Biclo (Jean Haguet), seventeen, and Oléo (Raymond Van Weers), nineteen; and his childhood friends Loulou (Louis Ferrand), eighteen, Bobino (Robert Ferrand), twenty-three, and Rico (Henry Broadwater, an American), seventeen. His cousin Dédé (André Haguet) was the tagalong ten-year-old.[141]

Among this hormone-driven cadre, the fashion for taking nothing seriously was carried out with madcap fervor. Lartigue's photographs from around 1910, which show these young swells dancing the cakewalk (plate 70), running footraces, leaping rows of chairs, tormenting the girls, driving go-carts, launching kites, and generally strutting, spitting, grinning and guffawing, overdressed for every occasion, are often mistaken as the products of a child at play. They are, more precisely, images of privileged young men at play. The nicknames—Jacques himself was referred to variously as "Pic" and "Coco"—reinforced the elite nature of their social group, one in which such infantile-sounding monikers signified their modern, sophisticated, and enviably leisured status. "Playboy," the neologism that arose to identify the type, could hardly be more fitting: "a rich young man who cares chiefly about having a good time."[142] Lartigue, at sixteen, still may have been calling his father "Papi" and his mother "Mami," but, like Sebastian's continued attachment to his teddy bear in Evelyn Waugh's novel *Brideshead Revisited*, this was mostly just twee affectation.

Beyond the escapades Lartigue engaged in with his circle of friends, he was venturing out into the city more, frequenting the Palais de Glace, the Racing Club de France (where he became a full member in 1913), and the Bois de Boulogne, not as an escorted child, but as an heir, a claimant, a player on the social field. Moreover, he was pursuing his interest in photography with a different attitude, dropping in on the editors of photo magazines, consulting technical experts, mulling over new equipment and supplies, and squeezing professionals for connections and advice. A career in photography, like the socially prominent young ladies encountered while strolling in the sentier de la Vertu, suddenly beckoned as something brilliant and obtainable.[143]

Lartigue's new camera and his passage through the gates of young adulthood coincided with the arrival of a mature compositional vision. It can be seen occurring already at the end of 1909, in a series of photographs of snow that he shot in the Bois de Boulogne, some of the last pictures he would take with his Block-Notes (plate 23). Unlike his photographs of the previous years, which featured as their subject an exceptional person, object, or event—President Loubet passing in a carriage, toy cars arranged on the floor, a dirigible in the skies over Paris—

PLATE 23. Jacques Henri Lartigue, *Paris, Snow*, 1909. Album page. Association des Amis de Jacques-Henri Lartigue, Paris

Lartigue's pictures of snow in the park show a new formal awareness. Snow, it is true, is the featured object or event (it snows rarely enough in Paris), but because it is everywhere, because the goal is not simply to get closer or to halt movement at just the right instant, in these photographs Lartigue considered the entire frame. With whiteness as his subject—the subject sublimated, extended to the four corners of the frame—the challenge became one of composition. Here, the image has expanded. It is more than just a picture of something; it is a picture.

Lest this example seem arbitrary, the same transformation can be seen in Lartigue's drawings, the earliest of which date from 1905. In his drawings, Lartigue's abilities and intentions are stated with absolute clarity, for unlike the photographic process, with its technological mediations and openness to collaboration, drawings reveal the idiosyncratic impulses of a single hand. As in his photographs, Lartigue was fixated on automobiles, airplanes, caricature, and fashion. The objects of his attention are meticulously drawn, with spokes, dust, feathers, and monocles all precisely noted. In some examples, particularly in the automobile drawings, a background is suggested, but in most cases subjects appear alone, as the full realization of the drawing. However, in 1909, when Lartigue was fifteen, backgrounds start to fill up and pull forward, buildings and trees begin to frame fashionable pedestrians (plate 52). Other drawings are clearly based on photographs (Lartigue's own), mimicking the arbitrary imbalance of subject and peripheral detail, as in a pencil drawing from 1909 in which a tiny airplane appears above a black mass of roofs and chimney pots. (In Lartigue's comparable photograph, the airplane is smaller, suggesting that the drawing was made as a corrective to the intransigent lines of the photograph.) In one remarkable ink drawing, from 1909, a row of trees along a riverbank is replicated exactly in its reflection in the water in the foreground (plate 24). As in the snow photographs taken in the Bois de Boulogne, there is in this drawing an understanding of the picture as a picture in and of itself.[144]

Lartigue's sense of composition in both photographs and drawings is conventional, following the example established by his father. It is a style derived from amateur photographic culture, derived in turn from beaux-arts principles of composition. Still, the compositions of his early photographs are inconsistent. Schematically, his development might be explained thus: In his earliest photographs (c. 1902–5), the staging of which his father oversaw, composition is solid, direct, and competent. This attentiveness to composition recedes, however, in

PLATE 24. Jacques Henri Lartigue, *May,* 1909. Ink drawing, 2⅝ x 4⅛ in. (6.7 x 10.4 cm). Association des Amis de Jacques-Henri Lartigue, Paris

1911_8-25AVRIL: NICE

NICE-CIMIEZ

* NICE

JEAN·ZISSOU·LOUIS

the Block-Notes images (c. 1906–10), when Lartigue is presumably photographing more independently. Among these photographs, objects invariably find their way to the center of the pictures and composition figures little into the equation; like specimens pinned to velvet in the center of a display case, subjects are located, caught, and fixed. This approach begins to change around 1910. If one accepts composition as the true gauge of the aesthetic faculty—demonstrating an artist's intentionality, sophistication, and maturity—Lartigue really arrives as a photographer in 1910, at age sixteen.

By the next year, when the albums expand to two volumes per year, photographs that are carefully composed follow one right after another. In a group of photographs of Nice, for example, taken in April 1911 (plate 25), Lartigue treats the landscape as a collage of abstract forms, lumping masses and voids graphically, gracefully. A series of photographs taken from the Eiffel Tower in 1912, when Lartigue was eighteen, are worthy of comparison with similar abstract aerial views made by Alvin Langdon Coburn, also in 1912, taken from the pinnacles of New York's skyscrapers.[145] Lartigue's images that predate this fixation on composition are little more than documents or drawings of things that he loved. If a pre-1910 picture strikes us as formally astute, it may be, in some sense, the product of a rare, visual instinct, but it is more often the result of chance, counsel, or recomposing. The first two have been addressed; the last requires elaboration.

Although the rules for composition have remained largely the same over time, the physical act of composing a photographic picture in 1910 was a very

PLATE 25. Jacques Henri Lartigue, *Nice*, 1911. Detail of an album page. Association des Amis de Jacques-Henri Lartigue, Paris

different experience than it is today. Whereas the clearly visible interior frame has defined with exactitude the parameters of the field of exposure for post-Leica photographers who began photographing during the 1930s, such as Henri Cartier-Bresson, early hand-held cameras were equipped with the most primitive of viewfinders.[146] In using big cameras on tripods, one simply stuck one's head under the veil and inspected the image reflected onto the glass. For hand-helds, however, the viewfinder was an absurd-looking mechanism attached to the exterior of the camera, flimsy and hinged, dangling like an afterthought. To compose a picture, one relied on an eyelet about the size of a crochet hook, which popped up on the back of the camera. This was aligned with a metal or wire frame, which popped up on the front of the camera. The viewing operation, with its essential challenge of placing the eyelet over the heart of the subject, was closer to aiming a gun than framing a picture. Both the Klapps and the Block-Notes used this kind of viewfinder, known as a "sports finder."[147] Understandably, composition, especially the composition of instantaneous photographs, was a fundamentally flawed operation. The Cartier-Bresson model of the photographer shooting "while dancing"—turning here, bending there—which resulted, almost miraculously, in perfect, instant compositions achieved within the set parameters of the negative, is not an accurate description of the same activity twenty years earlier.[148] Lartigue, frustrated in his attempts to photograph cats at play in 1914, fashioned his own viewfinder out of small pieces of wood.[149] That's how primitive composing a picture could be.

The greater mobility of hand-held cameras was perceived only in relation to the larger studio cameras still in circulation, but in some ways their operation was not so different. Liberated by lighter chassis and faster shutter speeds, users of hand-held cameras still had to take the time to prepare their shot and to stand stock-still, their bodies functioning as living tripods. For shooting instantaneous photographs, particularly the kind not strictly choreographed—such as automobiles rounding a curve or horses jumping a hurdle—the photographer had to situate himself as close to the action as possible, settle on a general view, wait for the moving target to enter the viewfinder, and release the shutter at exactly the right moment as it rapidly passed by. One could pivot during this operation in order to maximize the chances of securing a legible exposure, as illustrated in Lartigue's *The Grand Prix of the A.C.F.*, 1913 (plate 38), but the operation was essentially one of set and snare. Much of the outcome was still left to chance.

Lamenting these troubles, Paul Chaux complained of the disparity between the image visible in the viewfinder and that imprinted on the plate, and he anticipated improvements in viewfinder technology. For moving objects especially, an ideal viewfinder, he said, should "allow things to be photographed in large dimension, fixed on the plate with only a few millimeters to spare, thus helping the photographer avoid the senseless and infuriating cruelty associated with all sorts of decapitations and amputations."[150]

Indeed, if one examines negatives of the period, most of the images (including Lartigue's) consist of a small point of action amidst a large expanse of uninteresting background. Subjects appear whole yet at a distance, their contours padded against the edges of the picture plane. To compensate for this problem, the fine-tuning of the picture (namely, the composition itself) was left largely to the post-production phase of the work. Technically, what one considers composing a photograph today was back then an act of cropping performed with scissors on the final print. "Snip, snip your prints, have no fear. . . . Compose, compose your subject, but with your scissors."[151] In 1910, the decisive moment may have been the issue of greatest concern, but it was not equated with composition—that

PLATE 26. Jacques Henri Lartigue, *Bobsled Race, Louis, Jean,* 1911. Glass negative, 3½ x 4⅝ in. (9 x 12 cm). Association des Amis de Jacques-Henri Lartigue, Paris

act so closely associated with the instant today—which was an altogether different operation.[152]

When it came to recomposing his prints, Lartigue had no fear. He also had no choice, as most of his negatives, unlike Cartier-Bresson's, were filled with large patches of uninteresting, unwanted information. Two examples exhibited at MoMA in 1963 make the point: *Dédé, Renée and Jean, Rouzat*, 1911 (MoMA exh. no. 19) and *Bobsled Race, Louis, Jean* (MoMA exh. no. 34; plate 26), both of which, in the full negative, are imbalanced by large, empty foregrounds and have been cropped significantly in the final prints. Unlike the high-modernist photographer, whose accurate viewfinder supported the luxury of composing tightly on the fly, which in turn encouraged an uncompromising reverence for the negative, photographers of Lartigue's generation (those interested in instantaneity, at least) had to rely upon other means.[153] Writers on photography, such as Chaux, advised essentially to try getting it right in the first place, but, given the limitations of the equipment, this was difficult to achieve.

Lartigue stepped up his recomposing around 1910, as this was the period when he began assembling his now revered albums of photographs. Not coincidentally, parallel to this activity, he began keeping his diaries. (Journal writing, apparently, was an activity commonly promoted by the Catholic Church for controlling the awakening desires of young people, vulnerable to new instincts.)[154] Although the original album pages no longer exist—these were taken apart and reorganized during the early 1970s—it is clear from the diaries that the process was lengthy and involved. To assemble an album, Lartigue culled through his most recent photographs, or photographs pertaining to a theme, made a selection of images, and ordered new prints from the commercial developer Poulenc in the rue Vieille-du-Temple.[155] Lartigue regularly developed his own negatives, and frequently made small citrate prints that served as working prints similar to today's proof or contact sheets, but when he wanted enlargements (i.e., the prints he eventually glued into the albums) he sent the negatives out to the commercial printer.[156]

Lartigue's obsession with this task is clear. In the diaries, one finds him engaged daily not only in photographing, but also in developing, classifying, filing, arranging, cutting, pasting, and labeling photographs. Albums, often comprising photographs by both himself and his father, were compiled with the help of his mother.[157] The number of photographs accumulated this way became so great—

Lartigue records having taken a total of 1,097 photographs in 1912—that Lartigue's father had a special armoire built for housing them; Lartigue received this for Christmas in 1912.[158] Exasperated by her son's unchecked production of prints and consumption of supplies, Madame Lartigue is reported to have exclaimed, "When are you going to stop? You're going to ruin us!" This may not have been complete hyperbole, for the pages of Lartigue's diaries suggest that he was hauling in negatives to Poulenc by the hundreds.[159]

This marks an important stage in the construction of Lartigue's oeuvre, when, beginning in October 1911, an active, though random, impulse to make photographs became a complete artistic operation. The recomposition of images and, to some extent, their careful preservation in albums, signifies, in terms of the technical and cultural criteria of the period, a crucial last step in the process of making a photographic work. Thus, to speak of Lartigue's compositions is to talk about a temporal process comprising an ability to conceive of a general angle on his subject; to capture the subject at a pleasing or provocative moment, usually the dead point; and to compose a picture from a working print, either by means of crop lines given as guidelines to the printer, or by cutting down commercially produced prints, often made years after the negative. The added fact that Lartigue continued to commission new prints from old negatives throughout his life has, in some instances, the convoluting effect of drawing the process out to more than a half century, as in the case of prints made for his exhibition at MoMA in 1963.[160] One must bear in mind that, with Lartigue, age is always the most fluid of variables.

LARTIGUE'S EARLIEST pictorial instincts were, on a primary level, the same as those of his father. Yet what began as a standard approach to photography—an inheritance of the technical and aesthetic goals of serious amateurs—eventually turned, after a period of aesthetic and social maturation, into something else altogether. By his late teens, Lartigue had adopted the pictorial goals of other belle époque image makers—namely, photo-reporters, satirical illustrators, and budding cinematographers—and was adapting them to suit his own purposes. Equipped now with a firm understanding of photography's basic principles, Lartigue was ready to ply his own vision of a rare, spectral world.

CHAPTER TWO

SPORT AND FASHION

IF AMATEUR PUBLICATIONS such as *L'Amateur photographe*, *Photo-Gazette*, and *La Photographie récréative* constituted the photographic milieu of Henri Lartigue, his son's inspiration came through another set of publications: magazines on sports, fashion, and high-society life. Though not about photography per se, these were publications replete with photographs. In the roiling domain of the illustrated press, sensationalism offered an edge in the race to augment sales, and photography, as was increasingly recognized, supported this end. Photographs, which began appearing in magazines at the turn of the century, provided something that other forms of illustration, despite their strong graphic appeal, could not deliver: visual authenticity. If the bold, seductive graphic images produced each week by such well-known illustrators as Fauret, Scott, and Sabattier moved people to keep buying copies of *L'Illustration*, *Le Petit Journal*, and *Le Petit Parisien* at their corner newsstands, photography's contribution was to show the actual—the faces of murderers, the clothes of royalty, the smashups of aviators and race-car drivers—to an expanding audience of shamelessly voyeuristic "readers." *L'Illustration*, which had developed its own arcane woodcut printing method to perfection, and had avoided printing photographs in the new halftone process for aesthetic reasons as much as anything, began publishing photographs in 1903, largely in response to public demand.[1]

Lartigue's first published photograph, a picture of an airplane in the skies above Paris, appeared as a frontispiece in the sports weekly *La Vie au grand air* on 24 January 1912.[2] The magazine published more of his photographs over the next several months: another photograph that he took of an airplane appeared as a frontispiece on 10 February 1912 (plate 27) and a photograph of an airplane

Detail of PLATE 56

La Vie au Grand Air

ABONNEMENTS | PIERRE LAFITTE & Cⁱᵉ, ÉDITEURS | AVANTAGES AUX ABONNÉS

SIMON FAIT SON VOL EN SPIRALE (!)

PLATE 27. Jacques Henri Lartigue,
frontispiece for *La Vie au grand air*,
10 February 1912. Association des Amis de
Jacques-Henri Lartigue, Paris

constructed by his brother was published in the next issue, a week later; there was an instantaneous photograph of a bobsled on wheels in March 1912; and one of a paddle boat invented by his brother appeared in April 1912. Two years later, a photograph of a tennis player, captioned "A Beautiful Smash by Canet," was published in *La Vie au grand air* in May 1914, just before the magazine, like others, was forced to near extinction by the war.[3]

La Vie au grand air (Life in the great outdoors) and *Je sais tout* (I know everything) were magazines put out by the publishing house Pierre Lafitte. With offices on the fashionable Champs-Elysées, Lafitte managed an elite media empire, with titles directed toward every member of the high-society household. By 1910, when *L'Excelsior*, Lafitte's illustrated daily, made its debut, Lafitte had six magazines in circulation, offered an ambitious list of books on various themes, operated a theater, ran a photography gallery and studio, and hosted a series of bimonthly *galas sportifs*. The company's motto, "for all tastes," was no mere boast—especially where the Lartigue household was concerned: the refined French mother read *Femina* and *Musica*, the father *Fermes et Châteaux* and *L'Excelsior*, the boys *Je sais tout* and *La Vie au grand air*, and the entire family regularly attended Les Vendredis de Femina, a variety show held each Friday at the Théâtre Femina on the Champs-Elysées.[4] Although many other periodicals besides these six gained entrée into the Lartigue residence (Lartigue mentions about twenty in his diaries, including *L'Illustration*, *L'Auto*, and *Tennis et Golf*), it was the worldview conjured by Lafitte that best represented the interests and aspirations of the Lartigues and others of their class.

Lafitte, himself a kind of prodigy of the publishing world (he founded *La Vie au grand air* at the age of twenty-five),[5] envisioned a type of journalism geared to appeal to high society, devoted mostly to fashion and leisure rather than politics and controversy. In the debut issue of *L'Excelsior*, Lafitte vowed to "reduce to summary proportions accounts of bloody or scandalous events [*faits divers*], the horror and vulgarity of which," he reasoned, "are so frequently injurious to people of taste." What he proposed instead was to cover, with "rigorous impartiality," all the "brilliant and diverting transformations of contemporary society."[6] The publishing house's impartiality might be questioned, but never its judgment at discerning the "brilliant and diverting" aspects of contemporary life. These were often staged at the Maison Lafitte itself, which opened on the Champs-Elysées, "the most famous avenue in the world, and the most suitable

for the elegant note of our magazines," in 1907.[7] Attendees at the opening included opera conductor André Messager (Lartigue's future father-in-law), novelist Henry James, and actress Sarah Bernhardt, as well as the Baron de Rothschild and Count Robert de Montesquiou.[8] Intended as a hub—both as a meeting place and as a promoter—for society interests, Lafitte modeled itself after the "good taste" of its readership, while simultaneously influencing taste through its own editorial dictates. If Paris socialites thought of themselves as elegant, modern in spirit, and unequivocally elite, Lafitte, in the pages of his magazines, made sure that they saw themselves represented that way. Lartigue, who turned twenty just before the outbreak of World War I, continued to incarnate these values long after the publishing house and the belle époque itself were gone.[9]

Lafitte's publications were deluxe in quality. He employed the best-known writers and illustrators of his day, and then boasted of their allegiance in editorials and on mastheads.[10] However, Lafitte took the most pride in his company's technology-related advances. As a publishing house with a modern self-image, it not only adopted new techniques for image production, but also shared with its readership the banal details of how its publications were produced. This had the effect of conferring modernity not just on the magazines, but on subscribers as well. Thus, in such articles as "The Creation and Launching of a Magazine" and "Laid Paper, Mirror of Beautiful Engravings," filled with awe-inspiring statistics ("For 700,000 copies of *Je sais tout*, it takes 350,000 kilograms of paper; the heaviest bell in the world, the Kremlin, only weighs 201,266 kilograms!"), one is confronted with all the technological minutiae fit to print.[11] And yet, Lafitte did have something to brag about. *La Vie au grand air*, when it appeared in 1898, was one of the first of its kind, a magazine illustrated almost entirely with photographs. (Lafitte's claim that it was the "first journal entirely illustrated by photography" was a slight exaggeration; photographs had appeared in other places, and *La Vie* was never "entirely" illustrated with photography.)[12] Lafitte's magazines' paper was finer, the pictures snappier, the stories more respectable. While *L'Illustration* was preoccupied with grotesque incidents and lurid disaster stories—snakes eating rats, humans at war—Lafitte was publishing stories on the richest man in the world and art forgeries, and doing it with higher production values.[13]

In a photograph of Lartigue's bedroom, taken in 1906, several large, full-color, foldout illustrations of airplanes and automobiles are visible on the walls. These "centerfolds," engravings harvested from special editions of *La Vie au*

PLATE 28. "Le Grand Prix de la République,"
cover illustration for *La Vie au grand air*, 12
May 1904. Association pour la conservation et
la reproduction photographique de la presse,
Marne-la-Vallée, France

(Tous les Jeudis) **40** centimes

LA VIE AU GRAND AIR

AU PARC DES PRINCES
LE PRIX DES ÉTRANGERS
RUTT BAT ELLEGAARD ET
BARDGETT

Pierre Lafitte & Cⁱᵉ, Éditeurs,
9, Avenue de l'Opéra, Paris, *Le Grand Prix de la République - La grande Semaine d'Epée - St-Cloud, Enghien et Longchamp*

grand air, were by some of the best-known illustrators of the day: Bateman,
Caran d'Ache, Lelong, Cappiello, Géo Dupuis, Orazi, Macchiati, Lorenzi.[14] Like
most of their academic colleagues, the names have fallen into obscurity. This is
largely because illustrators have traditionally occupied a lower rung on the lad-
der of artistic value; even so, their work reached a wider audience and, formally

speaking, was often much more innovative than that of their academic counterparts.[15] While academic painters labored over stolid portraits and cloying mythological scenes weighted with outworn iconographic programs, illustrators were depicting modern life in a bold graphic style equal to the contemporaneity of its subject matter. By the turn of the century, artists specializing in book illustration, public posters, and magazine illustration (Pierre Bonnard's covers for *La Revue blanche* spring to mind) were producing simpler, clearer designs, optimizing negative space for full graphic effect, favoring a brighter color palette, and using the frame as a vital component in graphic composition—all calculated to attract notice in the competitive world of print media.[16] Indeed, illustration had become a bastion of avant-garde activity by the turn of the century. As the split between the French avant-garde and traditional patronage widened, avant-garde artists turned to the burgeoning world of print media as a source of employment. As Patricia Eckert Boyer argues, editors and publishers of progressive magazines, books, and posters were increasingly assuming the role of arts patron.[17] Lafitte's periodicals were not, admittedly, the most avant-garde of publications; even so, the illustration style was fresh and modern, and readers such as Lartigue could not have avoided the aesthetic reprogramming that this mass-media-driven movement prompted.

Art editors on the staffs of magazines at that time were in the habit of adapting for photographs—particularly photographs appearing on the covers of *La Vie au grand air*—certain formal strategies used by illustrators. A cover from 1904, for example, shows the action inside a velodrome (plate 28). The figures, both cyclists and spectators, are photographic, yet their forms are flattened through shading and sharply delineated in black outlines. By contrast, the space itself, a highly compressed, graphic view of the track and fence (which carries the *Vie au grand air* masthead), is hand drawn. This illustrates an important point: during this period of photomechanical reproduction, art illustration and photography were essentially hybridized media. Illustrations could take many forms. Besides the combining or collaging of media, as in the previous example, hand-drawn illustration and photography could imitate effects produced by one another. Illustrators commonly drew upon effects popularized by instantaneous photography, as in another cover for *La Vie au grand air*, which shows a split-screen view of roaring autos and racing horses (plate 29). Likewise, photographs were commonly doctored to incorporate effects native to the graphic arts. A pho-

PLATE 29. Macheçert, cover illustration for *La Vie au grand air*, 15 July 1913. Association pour la conservation et la reproduction photographique de la presse, Marne-la-Vallée, France

PLATE 30. André Schelcher, "A Conversation
in the Clouds," from *L'Illustration*, 13 April
1912. Harvard College Library, Harvard
University, Cambridge, Mass.

tograph of two men in a balloon basket, captioned "A Conversation in the
Clouds" (plate 30), is softened to look like a pastel drawing through the suppres-
sion of photographic detail. Such interventions were the product of both aesthetic
preferences and technological capabilities. As engravers processed photographs
for reproduction, there were numerous opportunities for hand retouching: sup-
pressing details to bring the subject forward, combining photographic figures into
collages and placing them against photographed or hand-drawn backgrounds,
adding in dust clouds or lines to emphasize movement. Readers such as Lartigue
were thus conditioned by a new form of synthetic image, one that capitalized on
the qualities of both the hand-drawn and the mechanical to achieve a look that
was arrestingly modern.

In addition to photography's adaptability as a graphic medium, it offered its
own set of qualities that Lafitte astutely cultivated. Indeed, Lafitte understood
early on that photography was one of his magazines' strongest suits. "What a
priceless result: the true document, incontestable, taken from life," wrote Lafitte
in a self-promotion piece (illustrated, it should be noted, with numerous, fanci-
ful, hand-drawn illustrations, and a few pedestrian photographs).[18] The key to
Lafitte's success is simple: he mixed photography and other forms of illustration
effectively, pairing the fantasy and style of drawing with the authenticity and

novelty of photography. This was a combination that precisely suited the tenor of the first decade, one flushed with optimism over modernity, particularly over technological progress, yet clinging at the same time to traditional modes. The word *moderne*, employed with great frequency during this period, was never used without some ambivalence, especially among the rich, for whom it signaled not only exclusive and expensive recreations, such as motoring, but also labor movements, women's suffrage, new wealth—in short, the threat of the social order capsizing.[19] As Lafitte well knew, the way to sidestep this difficulty was to keep the illustrations both progressive and comprehensible to an *haut bourgeois* audience, and to keep the cameras trained on only the most exclusive of events—society galas, presidential cavalcades, certain boxes at the horse races.

Lafitte naturally sought to employ the photographers capable of garnering the best pictures. While the logic in this may seem self-evident, finding photographers in 1898 was not such an easy task, as most professional photographers made portraits in studios, and most hand-held practitioners—which is what Lafitte needed—were amateurs, Excursionists, Pictorialists, and the like. Although most of these photographers went right on photographing ladies on a Sunday afternoon, despite the sharp criticism of satirists in the press, many of them felt that to accept pay for this activity would have made them scoundrels indeed.[20]

Unlike writers and illustrators, who were simply lured away from competing magazines with money and perhaps the promise of greater prestige, photo-reporters were hard to come by; in fact, they scarcely existed as a profession before 1900. Only in 1903, when Albert Reyner published his *Manuel pratique du reporter photographe*, did the profession gain any real visibility. In his introduction, Reyner first notes the mechanical conditions favoring the birth of the profession. Photolithography, he explains, not only encouraged the growth of the book industry, but also served as the point of departure for a new kind of publication, one in which illustration assumed a larger role. Thanks to the incessant material progress of printing, photographs began to infiltrate the daily papers. Striking a brave-new-world note, Reyner predicts what must have appeared obvious, yet unthinkable, at the time: "From this transformation is born a new variety of journalist, the photo-reporter. Today the photo-reporter is still rare; the illustrations inserted in magazines, reviews, and newspapers are provided by a dozen experienced technicians, old comrades, most of whom have been my collaborators on various publications. Tomorrow the photo-reporter will be legion,

as a whole group of amateurs is already in the habit of rushing to the editorial offices to offer editors their newsworthy shots."[21] Reyner's mention of "old comrades"—the etchers, engravers, and illustrators soon to be out of work—reminds us that change came at a price. The regret that Reyner cannot conceal here is that, despite the opportunities and challenges ushered in by this new profession, photo-reporters looked like a flock of overexcited half-wits (he later refers to amateurs as "sheeplike"), requiring instruction in manners and (as always) good taste. As an alternative, the model of the gentleman photo-reporter is proposed, for which Lartigue might have served as prime exemplar. In truth, the profession did not quite pan out that way.[22]

Lafitte's photo-reporters, who came from a range of social backgrounds, received galvanizing support from their employer. Fighting against a wave of negative opinion prompted by the sudden intrusion of photographers at public events,[23] especially those that society considered bastions of taste and propriety, Lafitte sought to bolster the public image of his photography staff. As a countermeasure, he founded the cult of glamour around the photo-reporter, which swiftly claimed the romance of the war correspondent as its shared domain. In an article published in 1905, in the debut issue of *Je sais tout*, the author describes the dangers of the war photographer in worldly tones: "To get that view of the Russo-Japanese war, the correspondent assigned to cover the battle, his Kodak in hand, performs nothing less than a heroic act: he could be shot through the heart at the instant he presses the shutter release; he risks death, that is understood, but he also endures overwhelming fatigue."[24] Photo-reporters, of course, weren't using Kodaks (the Kodak referred to here, one presumes, is mentioned to gain the readers' empathy). According to Reyner, photo-reporters were best served by small-format stereoscopic cameras: 6.5 x 9, 9 x 12, or 13 x 18 cm. He also recommended taking along a small pocket camera, such as a 4.5 x 6 cm, like Lartigue's Block-Notes. Roll-film cameras (Kodaks) were discouraged because faulty crankshafts sometimes caused images to overlap, the film was slow, and the discrepancy between the image in the viewfinder and that exposed on the film was particularly great.[25] The main concern was that cameras should be portable, so that photographers could dodge bullets, run from bandits, or escape reprisal from Parisian socialites annoyed at having their pictures taken.[26]

Generally, the dangers were exaggerated to widen the eyes of armchair adventurers. In another article appearing in *Je sais tout*, "Soldiers of the Instan-

Curiosités

SUR LE CAPOT D'UNE
AUTOMOBILE EN VITESSE
*Allongé dans une position
plus pittoresque que confortable,
le reporter photographe prend,
imperturbable, des instantanés sensationnels.*

Les Soldats de l'Instantané

taneous Photograph," photographers are pictured lying across the hoods of moving cars, hanging from ships' masts, sharing a cage with testy lions, and crawling through sewage tunnels—camera in hand, fearlessly pursuing the "sensational shot" (plate 31).[27] Most of these scenarios, one notes, are fake: studio stills made to look action-packed, or ordinary cut-and-paste jobs, as with the photographer in the lion's cage. Others, such as two images of photographers clinging to steel girders photographing New York from above, are clearly authentic, and their presence exposes the tinny hyperbole of the rest of the piece.

In a shifting economic landscape where the family business was still the norm, yet where businesses were sinking and surfacing with routine regularity, enterprising teams of photographer brothers were a common sight. The Séeberger brothers (three of them), who made their reputation taking fashion photographs outdoors for the freshly launched *Vogue*, are now the best known.[28] Lafitte had the Simons brothers, a ubiquitous duo in rumpled trenchcoats, who made their reputation with spectacular sports photographs, which appeared regu-

PLATE 31. "On the Hood of a Speeding Automobile," from "Soldiers of the Instantaneous Photograph," *Je sais tout*, 15 December 1906. University of Minnesota Libraries, Minneapolis

larly in *La Vie au grand air*. Perhaps their team approach gave them an edge; the Simons brothers (whose first names are never given) are the most frequently credited photographers in *La Vie au grand air*. And in advertisements for Lafitte publications, such as a poster for *L'Excelsior* with the slogan "Our photographers are everywhere," one of the Simons brothers is identifiable, high among the telephone wires, in his distinctive, soft-brimmed hat.[29] Perhaps because they were always photographing each other in risky situations, in effect constructing their own mythology of daredevilry, the Simons brothers are invariably given the full heroic treatment. In "Soldiers of the Instantaneous Photograph," for example, it is a Simons who is hugging the hood of a speeding car (plate 31), a Simons standing atop a burning shed, and a Simons in the lion cage—photographing, imperturbably, in every case.[30] It is little wonder that the pair was deemed (collectively) by their peers "The King of the Instantaneous Photograph."[31] Twenty years later, they would have been the heroes of their own comic strip.

Lartigue's first documented contact with one of the Simons (which one is not clear) was at an auto rally, the Circuit d'Auvergne, in 1905. At that event, a race through the dusty mountainscape of southern France, Lartigue photographed— besides the automobiles—this Simons brother himself: Simons photographing next to the Mercedes of Jenatzy, Simons posing with the Mercedes of Burton, Simons amidst all the Mercedes. The following year, Simons is caught with his 13 x 18 cm camera shooting the first Grand Prix of the A.C.F. (Auto Club de France). And in 1907, we find him at the Critérium de France, loitering at the prints and photographs booth. According to Lartigue's memoirs, it was Simons who obtained a press pass for him, granting him access to the airfields at Issy-les-Moulineaux and Bagatelle in 1906.[32] After 1911, when Lartigue's diaries commenced, Simons became a regular part of Lartigue's world. It was Simons who advised Lartigue, in 1912, to try the Nettel, "the camera for sports photography," as the advertisement claimed.[33] Simons not only suggested the camera, but lent Lartigue his own for a trial run. Lartigue's Nettel, acquired one month later, came equipped with a Lacour-Berthiot F/4 lens, which, Lartigue points out, was faster than Simons's, "an F/6 or 7, instead of an F/3.8 like he told me." As a congratulatory gift, Simons had made for Lartigue a special camera bag.[34]

Over the next few years, Lartigue sought out Simons regularly for technical advice and professional connections. Lartigue visited the studios at Lafitte headquarters on the Champs-Elysées (close to the Lartigue residence, which was then

at 17, rue Leroux, just off what is today the avenue Foch) to look at Simons's photographs (9 October 1912); to talk about reductions and enlargements (22 March 1912); and to discuss equipment (5 October 1915). During the war, Lartigue was discouraged to learn that Simons could not help him get into the Service Photographique Militaire; instead, Lartigue became a dapper (and delinquent) military chauffeur in Paris, much to his parents' relief.[35]

Did Lartigue want to be a photo-reporter? Judging by his dogged pursuit of newsworthy shots and editors' attentions, one might think yes. Between 1911 and 1914, he was particularly fixated on these activities. At the peak of his enthusiasm, a month could look like this:

> January 27, Saturday. I print 2 interesting photos from Thursday for Exelcior or for la Vie au gd. air.

> January 28, Sunday. Zyx [Zissou] sends my 2 photos of Simon [the aviator, not the photographer] to Exelcior.

> January 30, Tuesday. Mamie and Zyx; we go to la Vie au gd. air where they tell me that my 2 photos will appear the 8th of February on a full page (chic!).

> February 9, Friday. I go with Zyx to la Vie au gd. air to take them my photos of Rouzat (go-carts, waterslide, boats, looping the loop [a cycling stunt], etc.). . . . I return with Zyx to la Vie au gd. air; we see Mortane who takes my photos and tells me that they might be published.[36]

> February 15, Thursday. I see in la Vie au gd. air one of my photos of Rouzat; it's Zyx aboard his glider (in the Bloc-Note section).

> February 16, Friday. We go to Femina [a Friday performance at the Théâtre Femina at the Lafitte offices on the Champs-Elysées]. I go up with Zyx to get my 20+ from la Vie au gd. air.[37]

As a connoisseur of *La Vie au grand air* and other such publications, Lartigue, like many young amateurs, was photographically programmed. Having passed

his childhood and his formative years looking at these magazines, the typology of the photo-reporter was as legible to him as Web sites are to teenagers today. We know from the diaries, but also from the photographs themselves, that Lartigue understood what, within the world of the illustrated press, constituted a sensational instantaneous photograph—not just the subject matter but the aesthetic and the technical means. Indeed, prototypes for Lartigue's own photographs exist throughout the pages of Lafitte publications.

Subject matter, of course, was easiest to identify and to imitate. Like the amateur photographic periodicals of the 1890s, illustrated magazines are full of pictures of the seashore, leaping horses, beautiful women, and landscapes populated by excursionists. The difference is that the illustrations in photography periodicals are simply pictures, whereas the ones in illustrated magazines are pictures of *something*. An image of the seaside in *Je sais tout* is not an exemplar of proper backlighting and composition, but a specimen of social observation and fashion.[38] A leaping horse in *La Vie au grand air* is not an "amusing instantaneous photograph," but a document useful for comparing the jumping power of man versus horse.[39] A portrait of a beautiful woman is not a model of correct lighting and posture, but a glimpse of society in the fashionable Bois de Boulogne.[40] A landscape is not an exposition on pictorial harmony, but a lifestyle piece or an auto rally roaring through a scenic provincial village.[41] While the photographs and illustrations appearing in the illustrated magazines display, in compliance with readers' expectations, an optimum degree of pictorial allure, their message is emphatically social. The movements of these pioneers of modern life—their dress, their playthings, their achievements—were what readers cared about. Photography had passed from being a modern wonder in and of itself to a humble vehicle of modern wonders.

More pointedly, Lartigue's photographs follow the ebb and flow of various themes as they occur throughout the illustrated press. In the domain of sport, models for his photographs are abundant. Both *La Vie au grand air* and *Je sais tout*, for example, were prone to exhibiting new, odd-looking sports apparatuses. These often appeared in "Bloc-Notes of the Week" and "Curiosities," respectively, a kind of gallery of sporting oddities. The "rubber pocket," an inner tube outfitted with rubber legs, appeared as a curiosity in *Je sais tout*, here presented as an aid to duck hunting. Lartigue's photograph of his brother, who has installed himself in this object and is posturing in tweeds rather than shooting at ducks, was

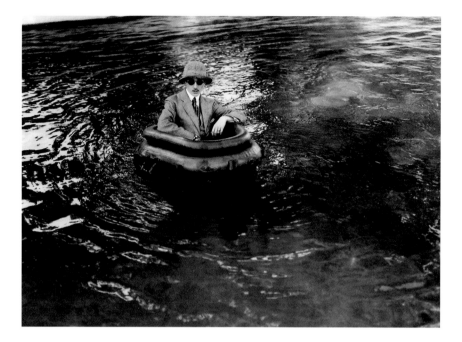

taken soon after (plate 32).[42] The "dry feet," a pair of water ski/floats invented by "engineer R. Davis," appeared in 1909, soon after the Lartigue family had built their swimming pool at their house in Rouzat, where the "dry feet" and combinations of skis, rafts, ramps, and bicycles were used for less sober purposes.[43]

These examples, of course, are not alike as pictures so much as they are alike as activities, and it is important to recognize that the magazines promoted the purchase of such gadgets as well as their use and their documentation in photographs. This triad, if one had the means, could be enacted on a much grander scale. Airplanes, for example, became all the rage in 1908. Wilbur Wright was in France topping aviation records, the first Salon de l'Aéronautique was held in Paris at the Grand Palais in December, and the first aerodrome opened just outside Paris the following spring, an event that attracted sixty thousand spectators.[44] Tangential to the excitement, enthusiasts were constructing their own models, flying them, and—in Lartigue's case—photographing them in the parks around Paris. The fetishism of Lartigue's photographs of model airplanes, immobile on the floor in the house (plate 22) or on the bare ground in a park, seems explicable perhaps only within the narrative of a boy in love with his toys.

PLATE 32. Jacques Henri Lartigue, *Zissou*, *Rouzat*, 1911. Glass negative, 3½ x 4⅝ in. (9 x 12 cm). Association des Amis de Jacques-Henri Lartigue, Paris

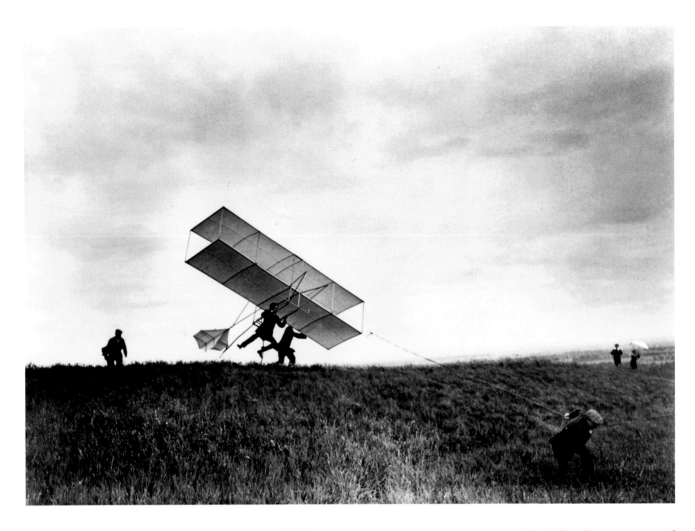

PLATE 33. Jacques Henri Lartigue,
The Zissou 24, 1910. Glass negative, 3½ x 4⅝
in. (9 x 12 cm). Association des Amis de
Jacques-Henri Lartigue, Paris

Models, however, were an important component in the trial-and-error process of
the inventor competing in the desperate race to create a winning design. *La Vie
au grand air*'s 1909 article, "How Will We Fly in the Coming Year?" displays
eighteen models as current contenders, each the invention of a prominent engi-
neer or aviation enterprise.[45] Later that year, the magazine published an article
entitled "How to Construct an Airplane," which outlined the basic principles and
provided diagrams of the wingspan, and so forth.[46] When his brother Zissou
took up airplane construction at just this moment (1908, when Lartigue was four-

teen), Lartigue had his camera ready, photographing the process from model to test flight, mimicking the coverage provided by *La Vie au grand air*.[47]

Other common themes included the motorcar breakdown, which afforded writers and photographers a modern subject, yet one that begged slapstick treatment.[48] Here was urbanity reduced to absurdity, one of Lartigue's favorite themes, and he photographed it often.[49] A related theme was that of an animal behind the wheel of a car. In *La Vie au grand air* and *L'Illustration*, one finds chimpanzees, lions, and even an elephant, each taking a spin.[50] Lartigue and his circle staged and photographed this, too, using various farm animals on hand. Most striking was the fad for "looping the loop," for which an enormous cylindrical track was constructed, a black line painted down the middle, and a cyclist pushed toward it to take his or her chances with centrifugal force. "Le Looping"— referred to using the English word, just as "le smoking" was a jacket and "le footing" meant jogging—is easy to comprehend as one of the fads of the moment for 1903, for it maintained the ideal blend of sport, scientific experiment, and breathtaking spectacle.[51] At Rouzat, where the stunt was elaborately replicated by the Lartigue circle in September 1911, all the peril fell on the shoulders of a hapless rabbit and duck, but the scientific spirit of the original was conscientiously maintained. A glimpse at the pupils of the animals affirmed what was roundly suspected: stuff a small animal into a wooden car, whip it around upside down, and it will show signs of fear. A second conclusion: a cat will refuse to be subdued for such purposes.[52]

The technical tricks for obtaining successful, magazine-quality photographs, especially unique instantaneous photographs, define another layer of Lartigue's identification with photo-reporters. Reyner outlines several conventions which, when one starts to look, appear over and over again in magazine photographs and in Lartigue's. One tactic involved the question of where to place the horizon line. Reyner suggested keeping it low so that, in an image of a leaping horse, for example, the animal would appear to be much higher off the ground than it actually was. Furthermore, the silhouette of the animal would be projected against a blank sky, thus appearing airborne and clearly defined.[53] Lartigue photographed horses infrequently, but he did apply this strategy to smaller animals (such as Folletête's dog, Tupy), to divers, and to airplanes. The most dynamic of Lartigue's airplane pictures, such as *The Zissou 24* (plate 33), put this principle to good use. By positioning the camera just downhill from the action, Lartigue captures the flier's aspi-

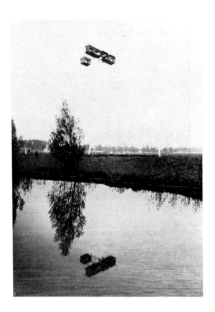

PLATE 34. "The 'Voisin' of Paulhan above the Orge," from *L'Illustration*, 16 October 1909. Harvard College Library, Harvard University, Cambridge, Mass.

rations as the glider lifts above the horizon line; a helper struggles with a towline in the foreground, marking the disparity between earth and sky, toil and freedom.

Another strategy of the photo-reporter was to make use of reflections in water.[54] This motif, a sure mark of a photographer's pictorial ambition, appeared frequently in illustrated magazines, where it was usually deployed beneath airplanes (as in plate 34). Lartigue repeated the technique in a series of photographs of Tupy leaping a stream (plate 35). His renderings of this in the diaries—in drawings made from the photographs, and not from memory, as is commonly assumed—erase all doubt as to whether the reflection was intended.[55]

Reyner also advised foresight when photographing anything that would be following a predetermined route, such as a parade or an auto race. Scout the scene and find the best landscape composition, he recommends, and then wait for the "propitious moment," when the cortege passes by, to secure the image.[56] This is really the secret of Lartigue's success in his auto-rally photographs and in his images of women in the Bois de Boulogne. To follow the trail of his photographic sorties is to find that he would identify a picturesque point along the route, compose a landscape, and trip the shutter as the action passed into view. This is visible in the series of photographs Lartigue took at the 1913 Grand Prix of the A.C.F., where he produced his well-known photograph of the same name (plate 38), in which a speeding auto passes out of the picture frame.[57] It is also visible in a series made along the avenue du Bois de Boulogne in 1911, in which a single stretch of sidewalk supports a routine runway show of haute couture creations. Simons's practice of climbing on top of sheds and parked automobiles in order to get an advantageous angle on his subject must have inspired many a photo-reporter manqué to do the same. Lartigue's personal connections in this milieu, which got him into the press boxes—that is, close to the action and elevated—gave him a great advantage over other amateurs of his ranking.[58]

By far the greatest challenge to photographers and illustrators during this period, especially for those who worked for sports magazines such as *La Vie au grand air*, was the question of how to represent movement. With so many men and machines taking to the land, sea, and air, breaking records almost daily for speed, height, and depth, illustration was faced with something of a crisis, just at the moment of its greatest popularity. One mode for representing these achievements was the illustrated graph. Graphs, comparative by nature, showed human figures—swimming, running, skating, cycling—next to steamships, automo-

biles, and locomotives in order to represent different capacities for speed.[59] A variation of this uses collaged photographs to show the "recordmen of the world" in an imagined race, with walking champion pitted against airplane pilot. Below the frozen figures, in the caption, speed per hour is abstractly noted.[60]

Comparative methods may have helped readers understand the mathematical difference between foot-generated and wheel-generated locomotion, but were incapable of capturing the excitement of bodies in motion. The instantaneous image—whether photographic or hand-drawn—seemed to offer the best solution. But, as discussed in chapter one, this kind of image offered just the opposite of what it set out to represent: where viewers looked for movement, they saw stillness instead. Worse, it was an eerie, distorted stillness, in which human bodies appeared in impossible, grotesque postures not normally perceptible to the naked eye. Machines fared little better, their rigid lines elongated and compressed by imperfect lenses, slow shutter releases, and panning. Automobiles suffered the worst distortions. Because most cameras were outfitted with a curtain shutter, which rapidly dropped open and closed, in effect photographing the top of the picture before the bottom, moving autos wound up with elliptical wheels.[61] It did not take long, how-

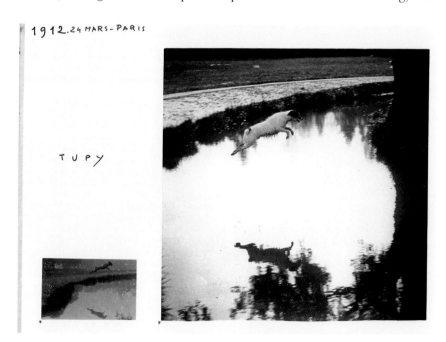

PLATE 35. Jacques Henri Lartigue, *Tupy*, 1912. Detail of an album page. Association des Amis de Jacques-Henri Lartigue, Paris

PLATE 36. René Lelong, "The Grand Prix of the A.C.F.," cover illustration for *La Vie au grand air*, 29 June 1907. Association pour la conservation et la reproduction photographique de la presse, Marne-la-Vallée, France

ever, before the elliptical wheel was recognized as a sign of movement itself. The distinctive forward lean of photographed automobiles, countered by a backward lean of stationary, background objects, like trees and spectators, inscribed an urgency over otherwise inflexible contours—a sense of the vehicle needing to press ahead, past the edge of the picture frame, and on to the end of the race.

This strategy was increasingly combined with others. In an article appearing in *La Vie au grand air* in 1908, the question was raised: "What are the impressions of drivers when they hit top speeds?" Illustrating the verbal testimonials are numerous photographs. The lead image, a photograph of the race-car driver Nazzaro, taken at 1/2000 of a second, is a remarkable representation of speed, not only because the distortion is so pronounced, but also because the vehicle is pushing toward the edge of the picture frame, as if the photographer had almost missed the shot.[62] This is an effect observed with some frequency. A photograph featuring the truncated bulk of a speeding auto for a 1903 advertisement for Pneus Continental (Continental Tires) gives one the impression that the photographer *did* almost miss the shot (plate 37); and in a cover illustration by Lelong in 1907 (plate 36), the effect is unmistakably intended, and understood to be a representation of impossible speed.[63] In this context, Lartigue's *The Grand*

PLATE 37. Sigriste, "M. Farman in the Panhard-Levassor Automobile," advertisement for Continental Tires, from *La Vie au grand air*, 5 June 1903. Association pour la conservation et la reproduction photographique de la presse, Marne-la-Vallée, France

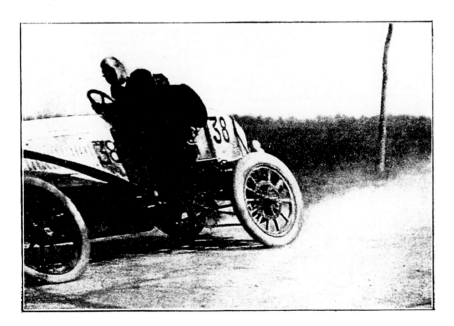

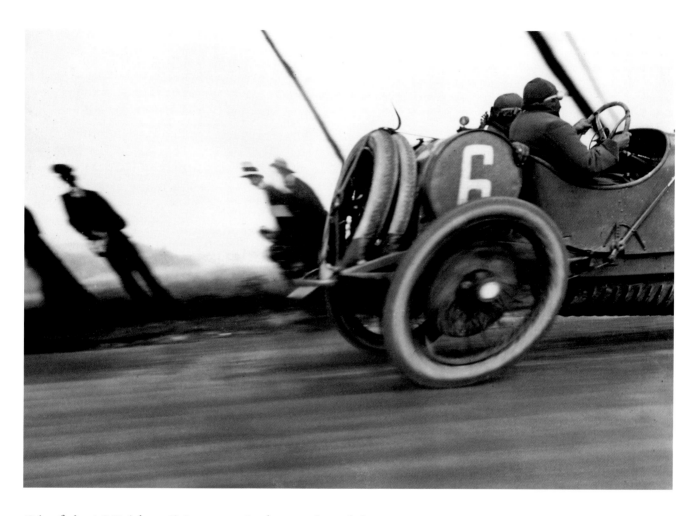

Prix of the A.C.F. (plate 38) is seen as simply executing existing tropes, not inventing them. If this photograph seems to share something in common with the work of avant-garde artists of the 1920s, such as Man Ray's *To Francis Picabia at Great Speed* (plate 39)—a photograph of a speeding automobile that exploits these techniques to the fullest—it is because Lartigue, like Man Ray, understood both the expressive potential of his medium and the viewing habits of his contemporaries.

While much hand-drawn illustration of the late nineteenth century was clearly imitating instantaneous photography, depicting frozen figures in careful

PLATE 38. Jacques Henri Lartigue, *The Grand Prix of the A.C.F.*, 1913. Glass negative, 3½ x 4⅝ in. (9 x 12 cm). Association des Amis de Jacques-Henri Lartigue, Paris

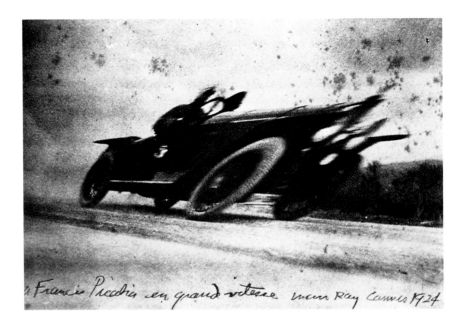

PLATE 39. Man Ray, *To Francis Picabia at Great Speed*, 1924. Published in *La Révolution surréaliste*, 15 January 1925. Original print unlocated

detail, illustrators of the early twentieth century can be seen as having adopted another system of notation. Trailing striations, for example, came into fashion as a way of showing automobiles in motion. An illustration in a Pirelli tire advertisement, for example, shows a vehicle in profile, with lines trailing like streamers from the wheels, chassis, and driver.[64] Dust that billowed behind moving automobiles, however, was considered by some (Reyner, for example) to be a problem for photographers in pursuit of a clear image. Others, though, saw in it an index of speed, power, and the romance of modern technology.[65] In many automobile photographs, the dust cloud is incidental, while in others it is clearly cultivated as an effect. In a double-page illustration of the Gordon Bennett Cup race, a car is shown speeding through a dark landscape (plate 40). A large, white cloud of dust menaces the center of the composition, while the auto, delineated only by white highlights on the hood and wheels, veers off toward the edge of the frame. Here, the cloud makes visible the image's true subject: movement. The automobile itself is only a vehicle, so to speak, of abstract energy.

Another motif could well be the descendant of a photographic recreation: the tilted frame. Pictorially speaking, this created an artificial incline, which could be used to express a tenacious climb, a fast descent, or simply a sense of

turbulence.[66] Lartigue used this strategy with regularity, as pencil renderings of photographs and crop lines on citrate prints show. A boat, for example, speeds diagonally across the picture plane in a drawing in the diaries.[67] A fledgling aircraft is given an extra boost by tilted crop lines, which eliminate the base of the slope and throw the plane higher in the air.

Of course, combining two or more of these strategies multiplied the effect. An illustration of motorcycles from *La Vie au grand air*, like the ones hanging on the walls of Lartigue's bedroom, combines a tilted frame with a cloud of dust and elliptical wheels.[68] The cover of a June 1912 issue combines elliptical wheels, clouds of dust, and a truncated vehicle.[69] Lartigue's photograph, *The Grand Prix of the A.C.F.*, 1913 (plate 38), combines elliptical wheels, tilted frame, and truncation. In this instance, an absence of dust allows the distorted spectators, visible on the low horizon line, to lend formal ballast to the speeding automobile.[70]

Representation of the human body in motion developed its own set of conventions. As in amateur photography publications of the 1890s, bounding subjects arrested at their summit enjoyed a vogue in sports magazines. Balls—footballs, tennis balls, golf balls—appeared in France on a wave of Anglomania, and were regularly fetishized in instantaneous photographs of the *My Nanny Dudu* variety (plate 20).[71] An instantaneous photograph of a football champion shows this, as does a "Rugby Match"; in both examples, the ball is a black orb against a white sky, hovering above the anxious players.[72] Poetic contortions of

PLATE 40. "The Gordon Bennett Cup," from *La Vie au grand air*, 7 July 1905. Bibliothèque Forney, Paris

PLATE 41. "A Great Kick of the Football," cover illustration for *La Vie au grand air*, 2 March 1906. Association pour la conservation et la reproduction photographique de la presse, Marne-la-Vallée, France

the human form could also make for striking graphic interest, as seen in a *Vie au grand air* cover from 1906 (plate 41), in which a footballer, caught in mid-kick, casts a dynamic form against a solid white background. The relationship between foot and ball is exploited in another of that magazine's covers, featuring a close-up of the point of contact. Here, word and text form a visual compound—"foot/ball"—throwing, together with the cover's bold typography, the same pared-down, graphic punch.[73]

The abstracting isolation of these bold, dynamic elements offers one key to understanding the fascination with the sensational sports photograph. Reyner's advice—to lower the horizon line in order to increase the sense of height—also harbored a crucial graphic strategy: by isolating the figure against the sky, all the surprising elegance and oddity of its movement were clearly delineated. An article appearing in *Je sais tout*, "Jumping in Sports," is illustrated with photographs of athletes leaping—each of the figures crisply delineated against a blank, white sky.[74] More dramatic were *La Vie au grand air*'s photographs of divers, which the magazine published frequently (such as plate 42). Diving was a particularly appealing subject for instantaneous photographs, as divers concentrated specifically on form. Unlike other athletes, whose goal it was to propel their bodies over or past something, a diver's objective, essentially, was to pose in flight, and to hold it for as long as possible, before gravity and water dictated otherwise. Diving seemed almost made for the instantaneous photograph, as the photograph allowed infinite analysis of what judges only had seconds to view. Indeed, interest in the vividly airborne body evolved in more overtly artistic directions. Amateur societies, such as the Swimming Society of Rome, formed to stage airborne *tableaux vivants*, all for the benefit of the camera, which captured figures in positions both exuberant and idiotic (as in plate 43). Prizes were given to those who struck the most provocative poses—as the Roman god Mercury, as kidnapper and kidnappee, as a "human board" (*la planche*).[75]

This same documentation of agility could be achieved in the reverse by aiming the camera down and photographing an event featuring light figures against a dark background, such as a tennis match. About 1911, when tennis first gained popularity among the elite in France, dark pages began to appear in illustrated magazines as backgrounds to white-clad players. A collage of dynamic tennis players, participants in a tournament at the Côte d'Azur, appeared in *La Vie au grand air* in 1911, and a cover by the satirist Sem (a.k.a. Georges Goursat)

exploited this same effect in 1914.[76] For the successful sports illustration, contrast was every bit as important as dynamism.

As discussed previously, Lartigue's photograph of his nanny (plate 20) is an example of the elemental instantaneous photograph, while portraits of Lartigue leaping from a bench (plate 7) and of Zissou leaping from a boat's hull (plate 21), which were choreographed by his father, are one step higher on the scale of technical and aesthetic challenge. A more elaborate—and less predictable—scenario is glimpsed in Lartigue's photographs of Tupy, Folletête's dog. There are two large series of these: one made in the Bois de Boulogne, where Tupy's reflection appears in pools of placid water (plate 35); the other made at the quarries near Rouzat, where Tupy appears to float high in a clear, white sky. Lartigue himself was an avid jumper, and perhaps this explains why there seem to be as many instances of him photographed leaping as there are of him photographing leapers. In Rouzat, where the family passed each August and September, jumping and photographing figured prominently in the day's activities. Once cameras were loaded, distributed, and positioned, divers leaped accompanied by clacks and whirs, and the action was repeated over and over again. A drawing from Lartigue's diaries shows his father positioned with a Cinématographe in the foreground, Toto (his cousin, Paul Roussel) with camera at poolside, and Jacques descending like Diaghilev from the high dive.[77] A photograph snapped with his camera by his friend Louis Ferrand shows the same.[78] It was clear, too, that the spirit of the Swimming Society of Rome gripped the group on occasion. Jacques decided one summer to jump into the pool in a state of full dress—in old clothes, on his mother's orders—while spectators stood by with cameras, poised to photograph the stunt from below (these pictures seem not to have turned out).[79] Zissou, however, appears in a series taken at Biarritz in 1910 (such as plate 44), floating high above the dunes, the socialite poseur version of his earlier attempts to fly by leaping from a boat's hull back in 1904.

Again, the frozen figure in such pictures only suggested movement. The magazines attempted to rectify this through sequencing. Some sequences were fabricated for didactic purposes, such as a sequence of collaged photographs demonstrating the different stages of a dive, or a series of drawings showing an airplane making a spiral descent, with a single, curling line indicating the craft's perilous course.[80] Also, motion-picture sequences were increasingly reproduced, most famously "A Parachutist's Death Leap," published in *L'Illustration* in 1912,

PLATE 42. "Swedish Divers," frontispiece for *La Vie au grand air*, 26 August 1900. Association pour la conservation et la reproduction photographique de la presse, Marne-la-Vallée, France

PLATE 43. "Mercury," from "An Original Way to Dive," *L'Illustration*, 23 October 1909. Harvard College Library, Harvard University, Cambridge, Mass.

PLATE 44. Jacques Henri Lartigue, *Biarritz*,
1910. Roll-film negative, 3½ x 4⅞ in. (9 x
12 cm). Association des Amis de Jacques-Henri
Lartigue, Paris

which showed a Monsieur Reichelt, an Austrian tailor, plunge to his death from the lower tier of the Eiffel Tower when his parachute failed to open.[81] Another strategy involved chronophotography. Chronophotographs, such as those produced by Marey in the 1880s and 1890s, appeared regularly in *La Vie au grand air*, especially just before the outbreak of World War I. One of that magazine's frontispieces in 1913 shows a gymnast during various stages of a vault exercise.[82] The caption informs readers that the image was taken with Marey's own camera, installed at the athletic training grounds at Joinville, by Georges Demeny, a founder of athletics in France and onetime assistant to Marey.[83]

Lartigue's attempts at sequences reveal an interest in representing movement but also an evolving preference for the sequential image more generally.[84] After acquiring his own motion-picture camera in 1911, much of the time allotted to photographing fell instead to filming.[85] Sports are the subject of a majority of Lartigue's films, but he also made scripted dramas, which the family staged as a way to occupy time during the war. Lartigue screened these films at home on occasion and even sold a reel to Pathé for cinema-house exposure.[86] He also had the habit of printing single frames as pictures or, as was the case later on, printing entire segments, comic-strip style, on single sheets of paper. This he did with numerous sequences of tennis players (as in plate 45), the lush contrasts of which—fluttering white figures on a ground of deep gray—achieved a particularly enchanting effect as a composite image.[87] While the result faithfully replicated effects seen in the magazines, in which movement was reduced to a series of instants laid out for visual analysis, Lartigue's attraction to the expressive potential of sequencing and its relation to narrative—cinematic narrative in particular—cannot be denied. In much the same way that Lartigue's 1912 drawing of airplane spirals (in the form of squiggles trailing a descending craft)[88] demonstrates a clear indebtedness to the model presented by magazine illustration, his serialized rendering of events in his own life owe their form to cinematic narrative (see chapter 3).

It is not surprising that, out of this oscillation between the cinematic sequence and the instantaneous photograph (his efforts in each of these modes faithfully recorded in drawings in his diaries), Lartigue would discover a third way: painting. (He entered the well-known though nonexclusive Académie Julian in 1915.)[89] For in painting, particularly Lartigue's sports paintings of the 1920s, he could achieve the dynamism of the instantaneous photograph without

PLATE 45. Jacques Henri Lartigue, *The Championship of France*, 1914. Motion-picture film stills. Association des Amis de Jacques-Henri Lartigue, Paris

limiting himself to the image's strict temporal specificity. Significantly, the vast majority of Lartigue's paintings are more iconic than referential. They convey duration of time even while ostensibly depicting the instant.[90]

WHILE LARTIGUE'S PHOTOGRAPHS display a keen awareness of photo-reporter's motifs, he remained professionally noncommittal. He did earn a little money for his photographs (which delighted him), but pressure to make a living never drove him seriously toward the profession, as it did others. Besides, Lartigue's parents, whose control over their sons was formidable, would never have approved of such a lowbrow occupation—and, by all indications, they were worried. Lartigue's mother's comment, "You're going to ruin us," may not have been referring to money, but to status, for photojournalism was considered an arriviste occupation at the time. Despite Lafitte's tactical efforts to glamorize the métier, photo-reporters were generally looked upon unfavorably. "The profession of photographer," ceded a writer for *Photo-Revue* in 1910, "is quite discredited today."[91] This lack of prestige, combined with Lartigue's streak of resolute independence (during his brief stint in the military, he learned that he looked good in uniform but did not like following orders),[92] eventually persuaded him to pursue the acceptable occupation of painting, prodded in that direction by a respected family friend, actor Camille Dumény. Ultimately, though, painting would earn Lartigue far less recognition than his efforts as a photographer.

Sport

The belated recognition of Lartigue as an amateur photographer has blinded posterity to the fact that, as a young man, his identity was formed in the image of a different social type, that of "amateur sportsman." He participated in many kinds of sports, including, at one time or another, swimming, tennis, rowing, gymnastics, ice-skating, snow skiing, and sledding. Lartigue also enjoyed the mechanical sports—cycling, automobile racing, aviation, boating—but only sensibly, as spectator sports. He also practiced another sport that today is not normally thought of as a sport, one that received substantial coverage in the sporting magazines alongside archery, wrestling, and the like: photography. The editor of *La Vie au grand air*, in his column on the first page of the debut issue, enumerated the various sports the magazine intended to cover. Photography was included with cycling, hunting, boxing, fencing, football, hockey, gymnastics, and more—in all,

twenty-three sports were listed (confirming one sports historian's perception that "variety is the keynote of French sport").[93] The following year, the magazine announced that it was accepting photographs from readers for a regular feature called "Photographic Curiosities."[94] Thereafter, submissions from both amateur and professional photographers were commonly solicited and published under a distinct photographic rubric.[95] To round things out, technically sophisticated articles on photography began to appear.[96] Even knowing that Lartigue's camera, the Nettel, was advertised as "the sports camera" (the camera that every "sportsman should possess") and that he read not photography journals but sports magazines, it is still startling to realize that the distinction between Henri Lartigue and his teenage son was less a difference between types of photographers than between photographer and sportsman.[97]

"Is photography a sport?" The question was posed by Émile Dacier in an article that appeared in 1908, "Photography and Sports."[98] It was not an easy question to answer. In the nineteenth century, photography had adopted hunting terminology to define its maneuvers. In English, photographers "shoot" pictures, and the word *snapshot*, we are reminded, derives from hunting, too: "a hurried shot, taken without deliberate aim."[99] In French, the terms don't have quite the same origins. A snapshot in French is an *instantané* (an instantaneous photograph) or a *photo d'amateur*, which adds a nuance of incompetence. Yet in French fashion magazines of the time, photographers frequently undertake "the hunt for elegant women." This was described as "a difficult sport practiced at the track, at the Bois, at garden parties," where photographers tried to "catch" their quarry by means of surprise tactics. Indeed, the terminology, as applied here, is pejorative; men who practiced this sort of sport were not generally well-thought-of.[100] By contrast, sports reporters like Simons were revered as heroes worthy of their subjects—scorers of images rather than of points.

Dacier's response to the question, less semantic than analytic, emphasizes the symbiotic nature of sport and photography. Photography memorializes sport: "Sport, considered by professional photographers, has relied upon the darkroom for a record of its results, the conservation and popularization of its types." And sport inspires photography: "Thanks to sport, photography was able to aid science through the invention of new equipment, and to widen the domain of art through the revelation of true movement, unknown until that time." Outside this perfect symbiosis, another relationship is considered, one specifically involving

sportsmen. "Sport," Dacier concludes, "considered by occasional 'sportsmen' to be an easy means of renewing their photographic field of action, never takes a backseat to other occupations in the hearts of true believers; for them, shots brought back from an excursion are only a kind of marker, more or less elegant, but always infinitely precious, useful for recovering memories and resuscitating impressions."[101]

The practical differences are not so great. Photography, adapted to the needs of mass media, offers a record of sporting activity. The key difference here is the distinction between players. Professionals memorialize sport's heroes and activities; serious amateur photographers develop photography's potential for science and art; sportsmen take pictures as souvenirs of their sporting exploits. Here, just like amateur divisions in photography, distinctions between sports photographers are key. Lartigue was not just a sportsman who photographed, but an "amateur sportsman," and this, like "serious amateur," is a load-bearing term.

Sport of all varieties proliferated in France during the 1890s, attracting participants from all ranks of society. In Germany and Great Britain, organized sport had been popular throughout the nineteenth century, but its growth in France was slow. Although members of the aristocracy had taken up riding, hunting, and shooting during the Second Empire, and sporting clubs such as the Club Alpin Français began to appear as early as the 1870s, it wasn't until the 1890s that sport became an activity of mass consumption.[102]

Despite (or because of) its wide appeal, sport was the focus of considerable social friction. As in photography, "amateur" and "professional" soon emerged as polarized terms. This was one effective way to institute class distinctions in athletics. The strongest voice on the side of amateurism was that of Baron Pierre de Coubertin, best known for his revival of the Olympic Games in 1896. A reactionary figure, Coubertin saw sport as a means of maintaining class distinctions by propagating the English prep-school idea of sport, which encouraged competitiveness and loyalty, yet also promoted such attitudes as "fair play" and "what matters is having played the game." Participation was valued over winning, personal improvement over material gain. "Amateurism" thus became a term symbolic of an alternative value system that might counter the values fostered by competing professionally for money. For Coubertin, sport played a role in holding back the wanton avarice and vulgarity of industrial civilization by separating those who played for fun from those who played for profit.[103]

There was, of course, a moral spin placed on the former. Professional athletes, at least as depicted in Lafitte's highbrow publications, were seen as base opportunists, whose participation in sport vitiated the entire purpose of competing in the first place. Working-class cyclists in particular, often sponsored by bicycle and tire manufacturers, were portrayed as greedy and "impure."[104] An article from *La Vie au grand air*—"Professionals or Amateurs?"—offered sympathy for those driven to compete "more for the *galette* than for the glory," but concluded that amateurs were ultimately superior athletes because they played for their own pleasure, and not that of others.[105]

Coubertin's ideas about sport represented the interests of the rentier class, whose members frequented clubs like the Racing Club, where Lartigue was a member.[106] Among rentiers of this period, sport offered something more than social distinction; it offered a rare opportunity for personal exertion, a chance to pursue something—to pursue it passionately, even—without actually getting one's feet wet in, say, politics or business. Though not strictly forbidden from these realms, rentiers were little compelled toward them. As Eugen Weber explains, these privileged young men were the products of a unique educational experiment: "What schools of the bourgeoisie offered at this time was disinterested culture, as remote as possible from practical, utilitarian education, designed rather to differentiate its beneficiaries from the unprivileged masses than to train them for life."[107] A bit like show dogs, bred for appearance and not utility, young men of the rentier class fulfilled the one duty that was placed upon them, to cultivate a superior bearing, and this they accomplished largely in the sporting arena. As playwright Jean Giraudoux remarked, "a sporting life is a heroic life in a vacuum."[108]

Yet fulfilling this duty was a more complex challenge than one might expect. The social world of the young rentier was a complicated, highly regulated realm, ruled by routine and social custom. As one reporter of social life from the period observed, "Without being aware of it, we pass our life turning a little in the same circle, like a circus horse under the whip of Monsieur Loyal."[109] The "whip," of course, was the opinion of fellow socialites, self-appointed arbiters of taste and propriety, but there were also tutors, peers, parents, and the Catholic Church to satisfy. Although social elites enjoyed exceptional privilege, including freedom from work, it did not necessarily grant freedom *to* work, and this was the potential stumbling block for someone like Lartigue, whose interest in photography

brought him into regular contact with low-rung members of the popular press. Particularly past a certain age—seventeen seems to have been a threshold—behavior was an object of public scrutiny.[110]

Amateur sport, as advocated by Coubertin, was essentially another form of art for art's sake.[111] Just like avant-garde artists of the period, amateur sportsmen were (on the surface anyway) more concerned with form than content—that is, the figure one cut on the playing field was more important than winning or even performing well. For one thing, amateur sportsmen were fixated on sporting attire. If they couldn't separate themselves physically from their inferior compatriots, they could at least distinguish themselves modishly, in jerseys and costumes designed by the most expensive couturiers.[112] "I know many of my contemporaries," wrote actor Albert Dieudonné, in 1924, "who take up a particular sport only in order to be able to wear the uniform."[113] Such "uniforms" were not only ostentatious, they were binding and cumbersome, which affirmed to observers that the sportsman in question was not only wealthy but also little inclined toward breaking a sweat. Sem's brilliant portrait of British king Edward VII, "Sportsman," shows a fat man in a top hat, smoking a cigar, bundled into a coat, supported by a cane, eyes swollen shut, exercising his indifference at the horse races.[114]

Amateur sportsmen were obsessed with a related formal element: style. Style included not just fashion but also movement. When engaging in sport, according to experts, one should be "doubly elegant: by means of costume and by gesture." In an article entitled "Elegance in Sports," Henri Duvernois advises women to dress in a practical manner, as nothing encourages inelegant gestures more than impractical costumes.[115] Duvernois also warns them against engaging in "inelegant sports," especially *automobilisme* (driving or riding in a motorcar), which required goggles, trench coat, and other bizarre accouterments for keeping out the dust. "One minute you have a delicious creature, the next you have a monster, to whom one can assign neither sex nor age!"[116] (Indeed, people who were dressed for motoring looked as if they were ready for chemical warfare.)[117] Duvernois is more charitable when he discusses the "elegant sports": hunting, horseback riding, ice-skating, and tennis. Ice-skating, here beautifully illustrated (plate 46), wins the author's full endorsement: "No sport is more gracious than this winter sport, which permits skaters to exhibit furs that suit them marvelously."[118]

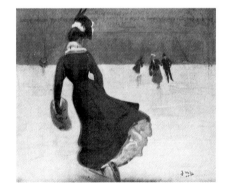

PLATE 46. Jacques Wély, "Ice-Skating," from "Elegance in Sports," *Je sais tout*, 15 June 1905. University of Minnesota Libraries, Minneapolis

A special double issue of *La Vie au grand air*, entitled "Style in All Sports," is devoted entirely to the question of style and contains articles on such subjects as "Useless movements," "What Does Style Consist Of?" and "Style in French Boxing."[119] These articles focus specifically on movement. Photographs and illustrations, such as a chronophotograph of gymnastics on the high bar, break down movement into single, elegant moments. The purpose here is twofold: to increase physical efficiency through careful analysis of gesture, and to create beautiful gestures. More than simply enhancing physical prowess, sports held the potential to promote a new form of beauty, and spectators were encouraged to cultivate an appreciation.

Lartigue's identity as a photographing amateur sportsman emerged out of this convergence of sport and style—of dynamism and fashion igniting on film. Ground zero for this particular subject matter was a phenomenon known as the gymkhana. The word itself is exotic, and suggests the hybrid nature of the activity: "gym" derives from *gymnastics*; "khana" is, oddly enough, Hindustani for *course* or *court*. Developed in India during the early days of British rule, the gymkhana there was a kind of open-air festival featuring horseback riding and competitions. Adopted by French society at the turn of the century, the gymkhana became a "sports cotillion," which was effectively an outdoor society ball with sporting events—it was sack races for the very rich.[120] The "sports" engaged in were farcical and fantastic: "the suitcase race," "the egg race," "the frog race," as well as the obstacle course, tug-of-war, and many more—the definition remained open, and the invention of new games was encouraged. The gymkhana, a diversion both "graceful and healthy," as *Je sais tout* put it, appealed to socialites as an activity that tapped the current vogue for sport while preserving a sense of nobility and exclusivity. "Isn't the gymkhana the last vestige of the ancient tournaments," wrote André de Fouquières for *Je sais tout*, "where knights died for the smile of a woman, for the conquest of a flower, a handkerchief? . . . The games of today, less bloody, are they not inspired by the same gallantry—that's what has made for their immediate success in France."[121]

Just like certain other high-society sports—tennis, for example, or ice-skating—which provided a kind of playing field for matchmaking among people of a certain class, the gymkhana offered a circumscribed environment where young socialites could mingle and be seen in the best possible light.[122] Many of Lartigue's photographs document his friends participating in gymkhanas: Oléo

leaping chairs, James and Rico footracing, the naval battles at Rouzat, Simone and Golo doing gymnastics (plate 47). The world these photographs convey is one of sport, privilege, elegance, and frivolity. Combined, these elements produced a distinctive ornamental dynamism. It was not just sport, nor just fashion, but the summit of athletic gentility that Lartigue captured in photographs, and this defines a central aspect of their appeal.

Amateur sportsmen could not always hide their desire to win behind a facade of disinterested showmanship.[123] Winning the game may have been officially disdained, but winning in the larger sense—winning socially and economically—was what amateur sportsmanship was really all about. In this sense, amateurism, which served as a proof of social superiority, relied on a display of superior sensibilities, and this came through in the parading of a distinctly

refined aesthetic, whether the arena was sport or art. Whenever these members of society's elite were moved to compete (or to write, paint, or perform)—as amateurs increasingly were—they were expected to display a natural, "winning" polish of superiority.

As Albert Flament observed in "The Triumph of Amateurs" in 1907, the elite were spurred more and more to cultivate the parlor arts, which included poetry, music, and painting. Society people, according to Flament, were not only reviving these arts, they were increasingly going public with their talents, turning out plays, paintings, and novels with surprising regularity.[124] Flament attributed the movement to the efflorescence of literary revues, periodicals, and illustrated dailies, which offered a venue for noble talents, but what he does not mention, understandably, is that many aristocrats were facing hard times. The Comtesse de Martel, for example, known by her pen name Gyp, responded to dire poverty by producing a string of children's books and other publications, many of them nationalistic and rabidly anti-Semitic.[125] Marcel Proust, plagued less by poverty than by a moroseness over the waning of his social milieu, is a more sympathetic example of the type.[126]

Lartigue was not entirely of this class, nor of this generation, but there is a bit of the Proustian preservationist impulse behind his efforts as a photographer. Like Proust's writings, Lartigue's photographs are rich in social detail. Yet the young Lartigue (despite his statements to the contrary made later in life) was not motivated by a personal regret over the passage of time. He photographed to be fashionable, to take part in the vogue for social narcissism among people of his class—a class that was becoming increasingly rarefied. "In several years," wrote Flament, "the word *amateur* will have ceased to be, thanks to amateurs themselves, who will have removed all its character."[127] What Flament was observing was a dissolution of categories caused by the gradual permeation of elites into public life. Lartigue's oeuvre, while infused with amateur self-consciousness and circumscription, is also the product of this amateur preservationist moment, which encouraged cultivated people to attempt to represent their world in words or images and to display it to others.

Fashion

Lartigue's pictures owe a great deal to magazine photography, but the young man heeded other, more fashionable models as well. As an amateur sportsman,

PLATE 48. Dandolo, "A. M. Fischof, Winner of the Grand Steeplechase of Paris," frontispiece for *La Vie au grand air*, 9 June 1904. Association pour la conservation et la reproduction photographique de la presse, Marne-la-Vallée, France

PLATE 49. Sem (Georges Goursat), cover illustration for *La Vie au grand air*, 9 June 1904. Association pour la conservation et la reproduction photographique de la presse, Marne-la-Vallée, France

Lartigue was unconcerned with producing photographs that satisfied editors' expectations, and this is the real distinction between Lartigue's body of work and that of photo-reporters. This is especially true of his fashion photographs, which often display a satirical edge that has generally been mistaken for boyish mischief. One source of this attitude lies in contemporaneous cartoons by humorists, whose observation of social behavior was a kind of sport in its own right.

Art illustration and photography, to state the case again, shared a complex relationship in the illustrated press. Although Lafitte fully exploited the photographic aspect of his publications, hand-drawn illustrations often upstaged photographs. Covers for Lafitte's magazines were adorned with splashy, full-color illustrations, while frontispieces comprised full-page black-and-white photographs. Sometimes a cover and frontispiece took the same subject. A pairing from the *La Vie au grand air* shows a horse and jockey admired by a woman. In the photograph (plate 48), the woman is rather matronly, dowdy in her ruffles and layers, and she is greeted with complete indifference by the all-male entourage passing by (the fact that she is obviously incorporated by means of collage rescues her dignity somewhat). In the illustration by Sem (plate 49), the female figure is elegant and birdlike, the top half of her slender figure silhouetted against a dark parasol. Unlike her stolid photographic counterpart, Sem's lady is coy and animated, a perfect counterpoint to the humorless men. The style and wit of the illustration are lacking in the photograph, and this is true of nearly all photographs in Lafitte publications. The question was one of appropriateness. While it may have been flattering to be caricatured by Sem, it could be humiliating to be photographed in a bad light. Photography's specificity as a documentary tool thus precluded its use for expressing social satire—but photography was certainly capable of satire.

Unlike his reporter friends, Lartigue cultivated a Sem-like wit in his photographs of fashionable society. This was possible because of his station in society and his independence as an amateur sportsman photographer. Not feeling the imperative to please editors (or his subjects), he photographed according to the dictates of his own whim, his own sophisticated sense of what was rare and ridiculous. Lartigue's *At the Races, Auteuil,* for example, features a coy beauty similar to the woman in Sem's drawing, only here she is espied by two sly admirers (plate 50). The men's gleeful enthusiasm is shared as a private joke, but

PLATE 50. Jacques Henri Lartigue, *At the Races*, *Auteuil*, 1912. Glass stereo negative, 2⅜ x 5⅛ in. (6 x 13 cm). Association des Amis de Jacques-Henri Lartigue, Paris

Lartigue's observation of them at this critical instant, and his capturing them on film, reverses the power of the gaze. The observers become the observed, insects under the microscope of the social scientist, similar to the female beauties offered up for delectation in the magazines. It is this kind of social observation that has contributed greatly to Lartigue's reputation, and yet the attitude has been little understood. As with the sports pictures, Lartigue's fashion photographs owe much to precedent.

Like the auto rallies and airplane trials, with their techno-dramas and personal rivalries, the rituals engaged in by the social world of Paris were uncommonly flamboyant. The upper echelons of French society, which included such figures as Anna de Noailles, Liane de Pougy, Santos-Dumont, and Boni de Castellane, led very busy, very public lives. Their days were a "frantic rush," remarked one observer in 1914. Charles Rearick describes a good day's work for the rentier this way:

> Affluent women went to their couturier and bootmaker, the candy shop and the flower shop, and then to the golf course, tennis courts, Bois de

PLATE 51. Sem (Georges Goursat) and Auguste Roubille, "All of Paris, Avenue du Bois," from *L'Illustration*, 11 December 1909. Harvard College Library, Harvard University, Cambridge, Mass.

Boulogne, expositions at the Bagatelle, garden parties and open-air balls, teas at the Carlton or Ritz, concerts, opening days at art exhibits, illustrious lectures and sermons, charity sales and charitable societies for teaching and feeding the poor, and plays by Jules Lemaitre, Maurice Donnay, and Jean Richepin. Much time also went into large family dinners and ritual social visits—six to eight in an afternoon. . . . Some of these people were what Paris observers Benjamin and Desachy called "prisoners of pleasure," drudges slaving away at their own pleasure.[128]

The din created by these busy socialites reached its height in the afternoons, when stampedes of elites advanced by foot, carriage, and auto through the Bois de Boulogne. "All of Paris, Avenue du Bois" (plate 51), a diorama created by Sem and fellow designer Auguste Roubille and exhibited at the Galerie Brunner in 1909, featured "everyone" from "all of Paris" in a Lilliputian rendering of the world of letters, the arts, sports, the sciences, society, and the theater.[129] The density of strollers and the format of the diorama are strikingly similar to a series of drawings by Lartigue of the same year (plate 52). As in Sem's work, spatial depth is shallow. Figures—ladies with parasols and men in top hats—parade across the foreground of a broad panorama, while carriages and automobiles pass on the avenue du Bois de Boulogne just behind.[130] Although Lartigue did not meet Sem until 1915, the photographer was in the habit of copying that satirist's drawings, particularly his caricatures of eccentric socialites such as Polaire and Santos-Dumont.[131] Lartigue's rendering of the avenue du Bois, fastidious in its attention

PLATE 52. Jacques Henri Lartigue, *Avenue du Bois*, 1909. Colored pencil drawing, 3½ x 12¼ in. (9 x 31 cm). Association des Amis de Jacques-Henri Lartigue, Paris

to costume and celebrity, is clearly derived from Sem. Both had full access to society events and circles, yet enough distance as artistic dandies to look mischievously on these.

The purpose of promenading was not simply social; it provided a daily fashion spectacle, one that attracted legions of publicity. Understandably, fashion, like sport, had its own set of photo-reporters. These included, besides the Séeberger brothers, the marquis de Givenchy, Tresca, Doyé, Carle de Mazibourg, Chéri-Rousseau, Chusseau-Flaviens, Agélou, Royer, Suzanne Delanoue, and others.[132] Photographs by these "hunters of elegance," many of them fashion plates themselves, showed the latest fashions draped, slung, and stretched across the bodies of women, usually outdoors, most often at the races or in the Bois de Boulogne. The models for these photographs are unfailingly poised. Indeed, they are frequently posing, putting their best foot forward, compliant with the photographer's wish to document their toilette for posterity. These *snobs* and *snobinettes*, as they were called, early objects of paparazzi desire, were astute posers. "This 'world' is vanity of vanities," wrote one observer: "Each seeks not only his immediate personal pleasure—eating well, drinking, dancing, or listening to music; each lives these moments, too, as an occasion to be noticed. The intention is never innocent for those who pass through certain doors with a certain gait. They want to be seen, and to see those who see them. Perpetual exhibition."[133]

Circling photographers had their own job to do: to document elegance. Among this set, the marquis de Givenchy is an exemplary figure. Photography experts of the time might have attributed the consistent elegance of Givenchy's fashion photographs to natural good taste, since the photographer was born into that culture, as his title indicates, and he was comfortable in the milieu he photographed. Like his young acquaintance Jacques Lartigue, whom Givenchy photographed often as a dandy-*flâneur* during the mid-1910s, Givenchy was a fixture among the smart set who frequented the Bois.[134] He knew the fashion code by heart; moreover, he knew who was fashionable, and how the fashionable wished to present themselves. Trust, of course, was an important element contributing to a fashion photographer's success. So long as fashionable people liked the way Givenchy pictured them, both in the photographs appearing in the magazines and in the photographs he sold to individuals through what was effectively an open-air portrait studio, models remained plentiful and compliant. This arrangement extended to the treatment of subjects by magazines. If the unswerving

PLATE 53. Sem (Georges Goursat), an illustration from *Le Vrai et le faux chic*, 1914. Smithsonian Institution Libraries, Washington, D.C.

grace of the women appearing in photographs in *Femina* and *L'Illustration* does not proclaim with crystalline clarity the innate seductiveness of these strolling fashion plates, captions and headlines emphasize the point: "At the Grand Auteuil Steeplechase: A Day of Parisian Elegance," "A Beautiful Day of Elegance and Sport," "The Parisian Woman in 1912."[135] Exhibiting beauty was a collusive business, and flattery a photographer's most effective tool.

Sem, unlike his photo colleagues, earned his living off satire, and for him the fashion milieu was like an orchard in autumn—with plenty of fruit ripe for the picking. In his book *Le Vrai et le faux chic* (True and false chic), published in 1914, Sem assembles a catalogue of lambasted beauties. On exhibit in this "Museum of Errors" are women—old, fat, and stoop-shouldered—swathed in fashions of the day, which consisted of billowing, multilayered skirts; enormous fur wraps, muffs, and collars; and hats sprouting all forms of avian finery. "What dog beds!" Sem writes in his introductory text. Not simply making fun of their physiognomies nor their taste, his attack is directed toward attitude. "Showing off your

PLATE 54. Jacques Henri Lartigue, *Étretat*, 1910. Roll-film negative, 2⅜ x 3½ in. (6 x 9 cm). Association des Amis de Jacques-Henri Lartigue, Paris

good taste is certain proof that you lack it."[136] Sem's critique, offered wryly, places vanity at the pinnacle of fashion sins. Women past their prime, or lacking in beauty, should not succumb to "Modomania." Do so, and one risks making a "grotesque spectacle" of oneself. In this, photographers were implicated as well. One illustration by Sem shows a pair of photographers encouraging a trio of posing women (plate 53). The photographers, loaded with equipment, stooped and kneeling, fawn over the women like drones before their queen. The women, absurdly ornamented, puffed and poised, eat up the attention. This shameless lust for recognition—this is Sem's definition of bad taste.

In the handful of images from Lartigue's oeuvre in which subjects are pictured posing for other photographers, a fundamental attitude is divulged. Always, whether he is photographing family at home or beauties in the Bois de Boulogne, Lartigue maintains an ironic distance. In images such as *Étretat* (plate 54), in which women pose for photographers, a semantic wedge is driven into the objective order of the photograph. Here, in the setup of the double photograph—where the models are not only photographed but photographed being photographed—a ripple is sent across the transparent surface of the image, calling attention to the act of representation itself. The relationship between Lartigue and his subjects is visibly distanced, circumspect, and self-reflective, the "natural" composure of the models suddenly exposed. For Lartigue literally catches them from the side, with their attention focused elsewhere. He peers behind the curtain of their elegance or celebrity and in doing so illuminates the disparity between self and self-presentation. Caught outside the armature of the photographic type (the head-on fashion plate), his subjects are seen as individuals posturing as types; they are unmasked, revealed to be made of flesh and blood, not porcelain and toile. With their humanity thus exposed, Lartigue's subjects are more endearing than Sem's grotesque matrons. For both these artists, however, vanity exposed is the gist of the joke.

For the social satirist, of course, ridicule lies in the details. Hats, for instance, grew to enormous proportions circa 1910. A cartoon by Sem's friend Abel Faivre pictures an elegant, faceless woman, bent by the weight of her enormous hat. She is greeted by a man on hands and knees, who exclaims, "Ah! I've been looking for you for a half hour under all the hats."[137] Hats not only grew big, they grew feathers. Designers in 1911 were inventing more and more elaborate confections using feathers, which were bound like stalks of wheat, sent cascading over wide

PLATE 55. Sem (Georges Goursat), "Hats," from *Le Vrai et le faux chic*, 1914. Smithsonian Institution Libraries, Washington, D.C.

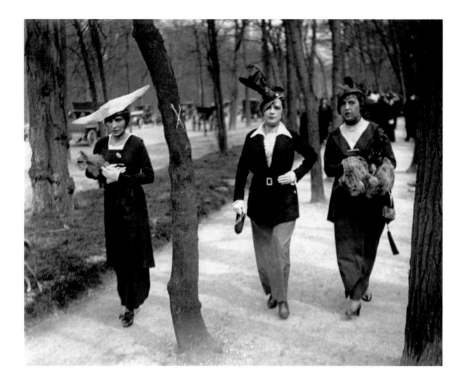

LEFT: PLATE 56. Jacques Henri Lartigue, *Sentier de la Vertu*, 1912. Glass stereo negative, 2⅜ x 5⅛ in. (6 x 13 cm). Association des Amis de Jacques-Henri Lartigue, Paris

brims, or set like spikes on top of the head.[138] Hats grew outdated, too. Another illustration by Faivre shows a young woman trying on a hat—an enormous hat with piles of feathers—and saying, "Here's a hat that is only for July. . . . It's already ridiculous," to which her stout suitor responds, "It's charming to me. . . . I'm very June myself."[139] Sem summed up the millinery situation best in a series of thumbnail sketches (plate 55), which shows a clown tossing "hats"—funnels, saucepans, strainers—at a submissive young woman, while below that is a sampling of models bonneted in what look to be, variously, a bishop's miter, a turban, a gladiator helmet, an Indian headdress, a weather vane, and several more fantastic designs.

By 1910, the year he began photographing women in the Bois, Lartigue was astutely aware of form—photographic, social, and otherwise. The comedy of the hat was certainly not lost on him. A big hat (it almost looks like a hatbox) is spied on the avenue du Bois de Boulogne in 1911.[140] Bizarre hats resembling nun's habits and hot-water bottles are noticed along the sentier de la Vertu in 1912

PLATE 57. Jacques Henri Lartigue, *The Fashion of October*, *1908*. Ink drawing with gouache, 10 x 3½ in. (25.5 x 9 cm). Association des Amis de Jacques-Henri Lartigue, Paris

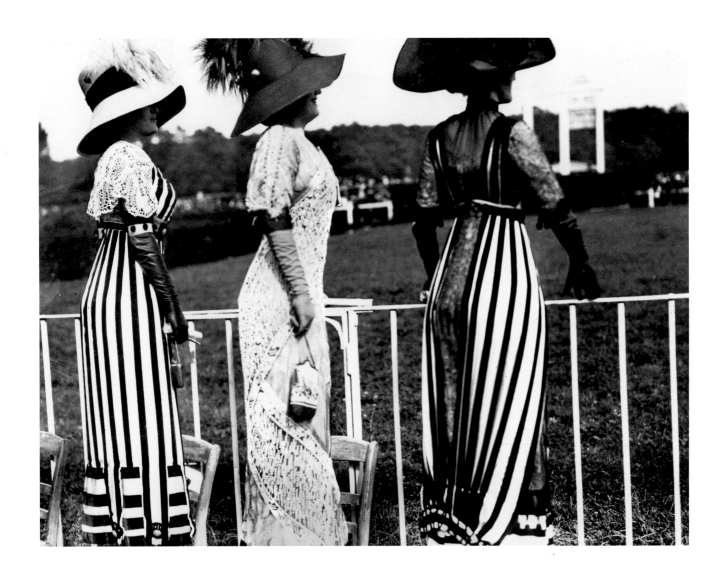

PLATE 58. Jacques Henri Lartigue,
Day of the Drag Races at Auteuil, 1910.
Glass negative, 3½ x 4⅝ in. (9 x 12 cm).
Association des Amis de Jacques-Henri
Lartigue, Paris

Quelques toilettes remarquées. — *Photographies Tresca et Raffaele.*
AU GRAND STEEPLE-CHASE D'AUTEUIL : UNE JOURNÉE D'ÉLÉGANCES PARISIENNES

(plate 56). Feathered hats are spotted at the drag races at Auteuil in 1911, the wearers of these concoctions clucking over the presence of a predatory cameraman.

It is commonly believed that Lartigue's fashion photographs are the expression of innocent wonder at the mysteries of feminine beauty. While there are some outstanding beauties in his photographs, such a naïve attitude on his part is a misperception. Lartigue's project is far more probing, observant, sophisticated, and mocking. In his fashion drawings, the earliest of which date from 1907, many of them direct copies of caricatures by Sem, women are not enchanting creatures so much as they are alien creatures, with their blackened eyes, high-collared gowns, and puff-pastry hats.[141] Does the head of the woman in his drawing entitled *The Fashion of October, 1908* (plate 57) resemble more a caramel apple or an Italian shrub? A woman in his drawing entitled *The Fashion of April, 1908* is actually rather dowdy and wasplike. Lartigue was not out to worship at the altar of beauty so much as to prove his insider knowledge—to show that he knew what was in fashion, that he noticed how people scrutinized one another, that he understood the humor of personal vanity, and that he belonged (if not as a scion then as a meritocrat) to this world. The impetus here lay not in the tribute but in the perception.

Fashion trends came and went quickly, and Lartigue's photographs are rich in fugitive detail. Black-and-white apparel—so eminently photographable—came into vogue during the summer of 1910, and women began turning up in every conceivable version of this color combination. Vertical stripes offered one of the most striking variations of this. Lartigue's famous *Day of the Drag Races*

PLATE 59. "At the Grand Steeplechase, Auteuil," from *L'Illustration*, 25 June 1910. Harvard College Library, Harvard University, Cambridge, Mass.

at Auteuil (plate 58) demonstrates that his finger was right on the pulse.[142] His trio of models, two of them exhibiting this "latest fashion of the season," also caught the attention of photographers for *Femina* and *L'Illustration*. Photographs of the same women appear in the magazines' coverage of the event the following week (plate 59).[143] The formal resonance between the vertical stripes of the dresses and the fence rails has been commonly recognized as the main feature of Lartigue's image; less often registered is the fact that these festooned creatures are standing on chairs. The counter-elegance of this posture, working against the modishness of the black-and-white stripes, reveals the true spirit of the photograph, a play on the theme of social affectation manifested by the juxtaposition of dignified spectators and the absurdity of their perch.[144]

Furs were all the rage during the winter of 1910–11. Ermine was sewn onto hems, collars, and cuffs. Fox fur was used for enormous muffs that were slung over an arm, rendering that limb useless, while piles of fur were heaped onto shoulders, cradling the head while raising (or hiding) the chin.[145] Long stoles wrapped around shoulders were an added note of luxury, and when the wearer walked at a brisk pace, the ends whipped and curled provocatively. An instantaneous photograph featured in *L'Illustration* makes note of this "last word in fur" (plate 60). The text urges a comparison between the effect as it appears in Raffaële's photograph and in an illustration by Sabattier: "Sabattier, far from exaggerating reality, has instead diminished it."[146] Lartigue's camera also captured this effect, most notably in his photograph of Anna la Pradvina, taken in 1911 (plate 61). The movement expressed here—in Mme la Pradvina's thrust foot, in the dogs' curling limbs, in the vehicles moving into and out of the picture frame—is most elegantly conveyed in the trailing stole as it whips and rolls beyond the contours of the woman's magnificent silhouette.

Veils were another trend. Because women were now spending more time outdoors, it was argued that veils were necessary as protection from the sun, dust, and cold.[147] Less practical reasoning held that veils added mystery.[148] Lartigue's photograph *Paris, Avenue des Acacias* (1911), in which two women struggle forward beneath layers of lace and satin, suggests that while veils added a Turkish mystique to the face, they placed a blindman's peril on the feet.

The drollest of fads was the fashion for dogs. Then, as now, trends in breeds ebbed and flowed. Certain large breeds, like greyhounds, borzois, and collies provided "aristocratic companions," while smaller breeds, like fox terriers, bulldogs,

PLATE 60. Raffaële, "Effect of a Fashionable Dress after an Instantaneous Photograph," from *L'Illustration*, 11 June 1910. Harvard College Library, Harvard University, Cambridge, Mass.

PLATE 61. Jacques Henri Lartigue, *Anna la Pradvina, Ave. du Bois de Boulogne*, 1911. Glass negative, 3½ x 4⅝ in. (9 x 12 cm). Association des Amis de Jacques-Henri Lartigue, Paris

PLATE 62. Jacques Henri Lartigue, [Woman and dog], 1913. Ink drawing with gouache, 6⅛ x 3⅓ in. (15.4 x 8.3 cm). Association des Amis de Jacques-Henri Lartigue, Paris

and spaniels served as living accessories—furs on legs.[149] Lartigue, who owned several dogs himself (including a Saint Bernard named Barÿe, an old English sheepdog named Rags, and a French bulldog named Javotte), was observing dog breeds and habits from an early age. This is apparent in a drawing from 1908 that shows dogs in all forms and manner, a tableau as rich in social spectacle and eccentricity as Sem's "All of Paris." Another drawing, which he gave to a sweetheart as a gift in 1915, depicts "the sentimental life of dogs."[150] Indeed, dogs are present in an inordinately large number of Lartigue's photographs: for example, Anna la Pradvina accompanied by her fox terriers, Chichi and Gogo (plate 61); actress Mary Lancret walking a border terrier; Marthe Chenal, Lartigue's first sexual conquest, posing majestically with a greyhound.

The appeal of dogs for humorists and satirists lay in the dogs' artless ability to unmask the pretensions of their masters. A dog could look ridiculous or do ridiculous things, and in the wag of a tail the sophistication of its owner could vanish into thin air. A gouache by Lartigue, for example, shows a young lady's elegance compromised by the naughty, though natural, behavior of her canine companion (plate 62). Often, it is the simple contrast that brings a smile. Madame la Pradvina's dogs are handsome, like her, yet naked and rather tentative next to her haughty, sumptuously fur-swathed figure. As a fashion statement, such contrast was often intentional. As noted in a humor piece, "Beauty and the Beast," ugly dogs, such as the bulldog pictured (plate 63), were the ideal foil for feminine beauty: "You know the old theory of the 'revulsionist,'" goes the text, "according to which beautiful women choose ugly friends! Lacking ugly friends, certain *coquettes* are enlisting *le bull*, the most frightful of dogs as everyone knows, to play the role of revulsionist."[151]

Lartigue's cousin Simone had a pair of French bulldogs; he photographed the three together in 1913. A scruffy terrier sets off a trio of languid beauties in *Avenue des Acacias* (plate 95). For fashionable women whose chief concern was to cover every inch of their person in exquisite finery, the dog offered yet another surface for expressing personal taste. A *Femina* cover by Bernard Boutet de Monvel, which features several clothes hounds with their human admirers, is captioned "Dogs follow fashion, too."[152] Lartigue's photograph of Alice Clairville and Gaby Boissy of 1913 observes a black Pekinese sporting a large white bow and trotting alongside its mistresses; the women are dressed in nearly identical outfits, matching the dog (plate 64).

The *jupe culotte*, or *robe pantalon* as it was sometimes called, was a pant-skirt hybrid that appeared in 1911, amidst considerable controversy. (Lartigue documented his first sighting of this fashion in Monte Carlo in April of that year.) The invention set out to remedy the physical encumbrances of current fashion, particularly the long, straight skirt, so narrow that its stride-span could be measured in inches. An article appearing in *Femina* in 1910, "The Manacled," revealed the ways in which women were restricted by the hems of their skirts: they had trouble climbing stairs, getting in and out of carriages and automobiles, tying their shoes, picking things up off the ground, crossing their legs, stepping over low objects such as turf wires in the park; they even had trouble walking.[153] The pant-skirt, which in truth did not look so different from a traditional skirt, freed the legs yet kept them tastefully covered. Another article, which appeared in *Femina* a year later, showed the ways in which women were liberated by this fashion development: now they could easily climb into an automobile, tie their shoes, cross their legs, step off a curb. Even while the photographs seemed to celebrate these advances (the models are all smiling), the text ridiculed such progress, calling the outfits "neo-oriental," and the young women who "risked" wearing them, "rebels." "Those Parisians conserving some notion of taste," wrote the

PLATE 63. "Beauty and the Beast," from *Femina*, 15 December 1910. University of Illinois Libraries, Urbana

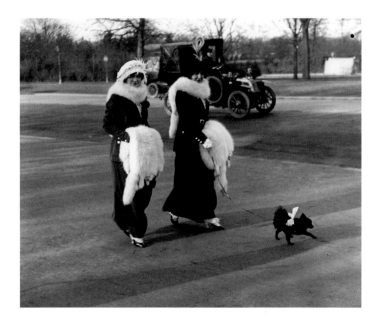

PLATE 64. Jacques Henri Lartigue, *Alice Clairville and Gaby Boissy, Ave. du Bois*, 1913. Glass stereo negative, 2⅜ x 5⅛ in. (6 x 13 cm). Association des Amis de Jacques-Henri Lartigue, Paris

PLATE 65. Auguste Roubille, advertisement for Thisbé perfume, from *Je sais tout*, 15 September 1911. University of Minnesota Libraries, Minneapolis

author, "still like to look upon this as an amusing wager."[154] Fashion's fundamental principle, impracticality, was central to maintaining class distinction, and if women had to be bound hand and foot in order to prove their rank, so be it.[155] Immobility, however, was another matter, and many saw this clearly as a larger struggle for progress and personal freedom. A stunt executed in Germany, reported by *Femina*, in which two women in *jupes culottes* and a man in a kilt paraded gallantly about town, was not so much a battle cry for women's rights as a wry proclamation that fashionable people would do as they pleased.[156]

The rawest nerve struck by the *jupe culotte* was the implication that greater freedom of movement would lead to a degeneration of femininity itself, by inadvertently encouraging ugly, improper movements. Liberated women in the *Femina* article are shown striding like a man, resting a knee on a park bench, kicking a foot out provocatively, and shaking hands like an Englishman, implying that given a little legroom, French women would soon be campaigning like English suffragettes. Just as sportsmen became obsessed at this moment with style in sport and lauded classical sculpture as their beau ideal, tastemakers were educating women in the art of classical gesture.[157] An illustration by Roubille for Thisbé perfume shows a woman straight from an Attic Greek vase painting offering a bottle of perfume to a French beauty, also drawn in classical profile (plate 65).[158]

Women, particularly Parisian women, lived in a state of constant surveillance. They were watched not only by fellow Parisians, but, increasingly, by the world. As a center of fashion, Paris relied on the allure of its women to represent a kind of living allegory of French culture. Madame Carette wrote on the occasion of the 1900 World's Fair: "Since the extraordinary diffusion of information among people thanks to the rapidity of communication, the scepter of fashion has not fallen. It remains in our hands. The day after this extraordinary Exposition, where French taste inspired the admiration of all the world, we conserve intact our privileges: spirit, grace, and taste remain invariably fixed in this intersection of the world, between the rue Drouot, the rue de la Paix, and the avenue des Champs-Élysées."[159] As the envy of the world, Frenchwomen were under social contract to pay scrupulous attention to every detail of their toilette. Scrutiny was comprehensive, and gesture an important part of the formula. Indeed, for some, gesture was even more important, for unlike physical beauty, gesture was illusory, provocative. Madame Carette describes how the "softly

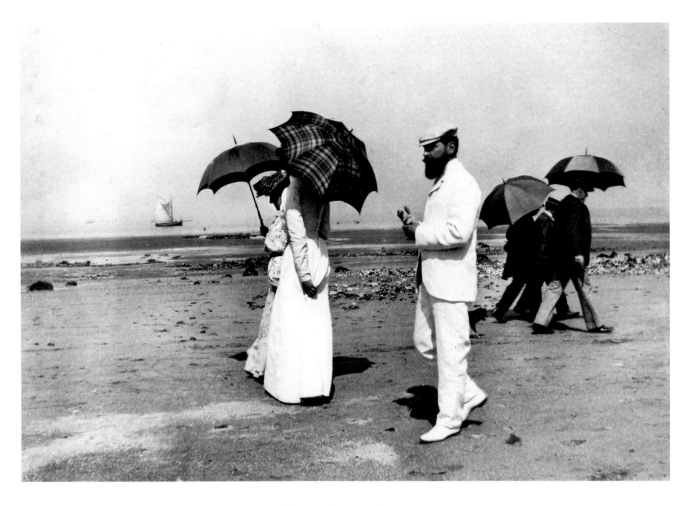

rhythmic gait of certain women," when observed from behind, "will engrave at the base of memory a world of thoughts."[160]

Photographs by Carle de Mazibourg illustrate Madame Carette's point. Narrow waists, trailing skirts, hats like baskets of flowers, parasols angled and cocked—these are some suggestive silhouettes, stirring embodiments of lightness and grace. Lartigue's version (a group of women observed from behind), taken soon after the article appeared, is a similar exposition on figure and poise, only here, variety is key; the view from behind reveals a variety of feminine forms—short, svelte, and round—with mirthful precision.

PLATE 66. Jacques Henri Lartigue, *Villerville, Cousin Caro and M. Plantevigne*, 1906. Roll-film negative, 2⅜ x 3½ in. (6 x 9 cm). Association des Amis de Jacques-Henri Lartigue, Paris

CHEZ ELLE

PLATE 67. Louis Sabattier, "Chez Elle," from *L'Illustration*, 4 December 1909. Harvard College Library, Harvard University, Cambridge, Mass.

Gesture was a practice in transition, especially during the century's first decade. The dissemination of automobiles, bicycles, telephones, and other modern obstacles across the field of daily life posed a challenge for women attempting to maintain their composure as the "eternal feminine."[161] Certain gestures, such as the *retroussé* (the gathering up of one's skirts), were choreographed early on. A *Femina* article offered dos and don'ts for executing this "Parisian gesture."[162] In Lartigue's photograph, *Villerville, Cousin Caro and M. Plantevigne* (plate 66), his cousin gathers her skirts in a manner "practical and correct," grasping the folds just below the derriere, a gesture that is lost on her companion, whose attention is elsewhere. Other movements were choreographed as the challenge arose, such as the proper method for getting in and out of an automobile. Observers claimed that, as with the view from behind, one could glimpse the true character of a woman in her execution of this novel and potentially awkward move.[163] The same was true for handling the telephone, that absurdly phallic device, which had to be held close to the face. If a woman let her attention wander, she ran the risk of letting down her guard and forgetting that, in such a compromising situation, grace was of the essence. Thankfully, magazines provided prototypes for how to present oneself in this novel, modern attitude (plate 67).[164]

For women wishing to express their modernity, the greatest threat to bodily propriety by far came in the form of sport. Tennis, popular among *haute bourgeois* women, produced some of the more disagreeable and curious gestures. "Who among them," worried *L'Illustration* in 1912, "in the conquest of a decisive set, could be concerned with *coquetterie*?"[165] Though clad in pristine white skirts, the women pictured there lunge, swat, and grimace in a most unladylike fashion (plate 68). Lartigue's photographs of Suzanne Lenglen revel in the same unselfconsciousness (plate 69). They are, indeed, the very antithesis of the self-regard exhibited by the socialite who wouldn't be caught dead in a *jupe culotte*.

Ice-skating, potentially more humiliating than tennis, offered at least "trainers," those handsome men who held their client by the waist to keep them from falling. For skaters who dared to take the ice on their own, *Femina* published a series of photographs demonstrating a range of tasteful moves. One photograph proves that even the most dreaded scenario (finding oneself seated on the ice) might be righted with the help of a gracious smile, a delicately offered wrist, and the attentions of a trainer.[166]

Here was what Chaplot described in *La Photographie récréative* as a prime opportunity to "denature" the model.[167] As a tool for capturing moments of bodily impropriety, the camera was an indispensable, if not insidious, ally. And, as Tom Gunning has argued, representing the body casually, in moments of such impropriety, was an increasingly popular photographic pastime. While the instantaneous photograph offered technical amateurs of the 1890s a pseudoscientific glimpse into the previously imperceptible world of movement, it satisfied a more overtly mischievous and voyeuristic impulse for amateurs a decade later. The portrayal of the ungainly, the ungraceful, rather than simply scandalizing nineteenth-century laws of aesthetic beauty, became the means of constructing, circuitously, "a new modern self image, a casual self presentation."[168] Gunning goes on to make the point that this "mischief" was initiated by boys, and he cites Lartigue as a prime exemplar, but also notes a movie, "Bobby's Kodak" (1908),

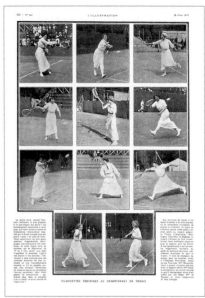

ABOVE: PLATE 68. "Feminine Silhouettes at the Tennis Championship," from *L'Illustration*, 15 June 1912. Harvard College Library, Harvard University, Cambridge, Mass.

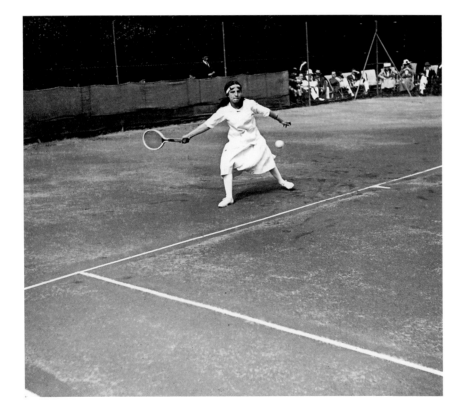

LEFT: PLATE 69. Jacques Henri Lartigue, *Suzanne Lenglen at the Racing Club*, 1914. Glass stereo negative, 2⅜ x 5⅛ in. (6 x 13 cm). Association des Amis de Jacques-Henri Lartigue, Paris

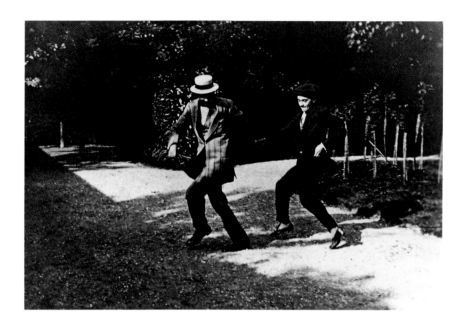

PLATE 70. Jacques Henri Lartigue, *Oléo and Zissou Trying to Dance the Cakewalk*, 1910. Original negative unlocated. Association des Amis de Jacques-Henri Lartigue, Paris

in which a young boy attempts to capture various indiscretions with his camera. The boy was just one of the tropes for representing this spirit of bodily transgression flourishing at the time; other films, which feature the bungling, slapstick humor of, say, Charlie Chaplin and Buster Keaton, suggest that the impulse was hardly confined to the adolescent set. Indeed, the casual body had a specific cultural signification: it announced the self-image of a new generation. For most participants out to denature their subjects, capturing the unconscious movement, the indiscreet gesture, was not so much malicious, boyish, or prurient. It was instead an expression of modernity, an identification with that smart set who associated spontaneity and physical dynamism with progress, contemporaneity, internationalism, and, in Lartigue's case, ultimate urbanity.

Sport was one way to breach physical etiquette—while, it should be added, remaining safely within the walls of bourgeois respectability. Dance was another. Lartigue's photograph of Zissou and Oléo doing *le cake-walk* (plate 70), in its pairing of the chic (clothing) and the ungainly (gesture), is an icon of the kind of fashionable impertinence alive at the time. To dress elegantly was, of course, a primary duty of the fashionable elite. Adding a touch of calculated awkwardness was, for the younger generation especially, a sign of *vrai chic*.

So many of Lartigue's photographs pivot on this incongruity of lavish fashion and bodily impropriety. The picture of Bichonnade leaping down the stairs captures this, as do images of Simone tumbling from a go-cart (plate 71), Marcelle mounting a donkey, Oléo leaping chairs, Simone and Golo doing gymnastics in full dress at Saint-Cloud (plate 47)—the list could go on and on. Guitty caught fleeing the surf at Biarritz (though she flees gracefully, and gathers her skirts correctly) is another example, similar to Bichonnade clinging to a bridge, while a raft, along with her feet, floats vexingly away. Lartigue's later pictures of his first wife, "Bibi," made in the 1920s, preserve this same spirit, though on a much more intimate level: Bibi hanging from an exercise bar; Bibi sitting on the toilet; Bibi careening awkwardly as she negotiates a rock at Cannes. Another set of photographs, also made in the 1920s, show women of diverse character engaging a new

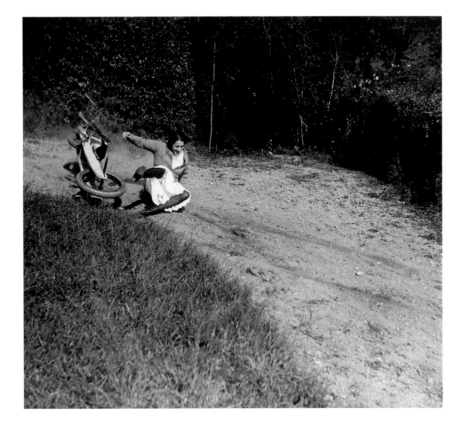

PLATE 71. Jacques Henri Lartigue, *Simone, Rouzat*, 1913. Glass stereo negative, 3½ x 5⅛ in. (6 x 13 cm). Association des Amis de Jacques-Henri Lartigue, Paris

PLATE 72. Jacques Henri Lartigue,
Paris, June, 1911. Glass negative,
3½ x 4⅝ in. (9 x 12 cm). Association des
Amis de Jacques-Henri Lartigue, Paris

pastime open to them: smoking. The naughty excitement of this activity is vividly evident in the eyes of the various smokers.[169]

Such antics were voluntary, performed in semiprivate settings. In the public space of the Bois de Boulogne, however, bodily improprieties were gaffes, not gags, and these were harder to wrest from one's subjects. Lartigue's images of society people caught during indelicate moments are some of his finest: the Countess Tcherkowski descending warily from an automobile; a woman at the drag races intently biting the inside of her cheek (plate 72); a regally dressed "dog bed" moving down the avenue du Bois de Boulogne, her whole being a sort of physical indiscretion, for the face does not match the beauty of her costume.

Getting caught looking at others was another kind of gaffe, and there are many, many pictures of this: the two men espying the coy beauty at Auteuil (plate 50); a libidinous dandy following close behind a pair of rare beauties on the avenue du Bois; a man on the avenue des Acacias shooting a doleful glance at a tall woman in furs; a scowling woman surreptitiously sizing up the toilette of another as she passes by; the three women on the park bench discreetly exchanging a spot of gossip (their dog stares most boldly) (plate 95); a male voyeur admiring Gaby Deslys's performance from the wings, just like a shadowed, predatory figure in a ballet painting by Edgar Degas.[170] Part of this social exchange involved the photographer himself. Many of Lartigue's subjects are looking (or glaring) at him, such as the male component of a couple encountered in *In the Sentier de la Vertu* (plate 73), who offers the photographer a dismissive tip of the hat. Perhaps there exists no better evidence of the social game at the heart of these photographs, and the social presence of the photographer, than this simple, knowing gesture.

THE ORIGINALITY OF Lartigue's photographs from this mature period may be regarded as arising out of a confluence of various factors. Formally, the pictures build upon a vocabulary at once Pictorialist and reportorial. The idiom developed by sports photographers like Simons is taken up in Lartigue's images of similar subject matter, but that idiom is refined in its recombination with compositional strategies passed down from his father and through Lartigue's awareness of pictorial developments in graphic design. Similarly, Lartigue's fashion pictures draw from his status as an informed social insider. Behind the richness of social observation apparent in these images lay a lightly satirical sensibility, not unlike that of Sem, which Lartigue adapted to the photographic medium. This was something

Lartigue's fashion-photographer associates, who answered to the demands of editors and readers, were not at liberty to pursue—assuming, of course, they had the instincts for such ingenuity in the first place.

There is another aspect of Lartigue's photography that deserves particular consideration: his involvement with cinema. Lartigue's interest in cinema embodied a much broader approach to photography, an approach encumbered by neither aesthetic ideology nor fidelity to any one medium. Cinema, which unleashed a tidal wave of images onto the modern world, literally swept the individual instantaneous photograph into a larger realm of photographic meaning. For Lartigue, who had by the mid-1910s amassed an enormous body of individual pictures, the next step was obvious: he would narrate his life—both real and imagined—through photographs.

PLATE 73. Jacques Henri Lartigue, *In the Sentier de la Vertu*, 1911. Glass negative, 3½ x 4⅝ in. (9 x 12 cm). Association des Amis de Jacques-Henri Lartigue, Paris

CINEMA

THROUGHOUT HIS LIFE, Lartigue worked in various media, including (besides photography) drawing, painting, and writing, and his obsessive integration of these diverse modes of expression in the form of the personal album constitutes a complex, highly idiosyncratic autobiographical narrative. Is the form Lartigue's own, or did he have a model? Of the various narrative systems he was exposed to, including those presented by novels, short stories, picture essays, and, most obviously, the family album, one form clearly compelled him more than others: cinema.

A synthetic medium (a *bricolage*, as one film historian puts it)[1] encompassing imagery, movement, narrative, and, eventually, sound, cinema is also a historically specific phenomenon with particular relevance to Lartigue and his photographs. Cinema's birth in France in 1895, following Lartigue's own birth by a year, occurred at the moment when the instantaneous photograph was at the zenith of its popularity, and the technical amateurs who pursued the former—the Lumière brothers, most notably—were, not coincidentally, also the chief enthusiasts of the latter. Furthermore, the aesthetic preoccupations of cinema during the medium's early years, which ranged from the most basic display of cinematic movement to trick effects, multiple angles, filmic narrative, and the propagation of genre, were precisely the preoccupations of Jacques Lartigue. Mere coincidence? Or do the complexities of the kinetic image propose another sphere of influence? The great autobiographical project that consumed Lartigue's life, I argue, has its origins in cinematic structures and motifs.

Cinema and Amateur Photography

The first public cinema screening took place on 28 December 1895, at the Salon *See* PLATE 45

Indien of the Grand Café, 14, boulevard des Capucines, Paris. The screening featured a selection of film clips, none of them more than a few minutes long. It was a venture of the entrepreneurial Lumière brothers, Auguste and Louis, whose success in the manufacture of photographic supplies made them shrewd promoters, not just inventors, of this new technology.[2] The Cinématographe (a combination motion-picture camera and projector) was born out of the same culture that pursued the elusive instantaneous image—the experimental, pseudoscientific culture of the serious amateur photographer[3]—and was originally destined for an amateur market. This was apparent in the camera's design. Unlike comparable motion-picture cameras produced around this time, the Cinématographe was elegant in design, portable (it weighed only twelve pounds), and easy to use.[4] Likening their invention to other hand-held cameras on the market, the Lumière brothers envisioned a consumer base of skilled amateurs, filming holidays and family gatherings with their own Cinématographes, as well as recording these events with various still-photography cameras. Despite the momentous about-face in marketing that occurred in 1895, which reoriented the business away from amateur practitioners and toward mass spectacle, the company did manufacture a commercially available motion-picture camera for serious amateurs. Lartigue obtained his first Cinématographe in 1911; by 1912 he had three more and was filming alongside the professionals.[5] Equally important, he had been going to the movies all his life.

The cinema was not just a source of fascination for technically minded amateurs but courted the attentions of a mass audience. As Charles Rearick argues, cinema very quickly dealt a deathblow to other popular entertainments. If the 1890s was the heyday of bohemian pleasures of the kind widely available in Montmartre, exemplified by the cabaret Chat Noir and the *café-concert*, by the end of the century the entertainment industry had moved to central and western Paris, to the *grands boulevards* and the Champs-Elysées, where the first cinema houses were built.[6] By 1900, the year of the World's Fair, held that year in Paris, there were eighteen projection sites across the city, including the Géant Cinématographe offered by the Lumières.[7] The most ambitious step occurred in 1902, the year the Pathé brothers bought out the Lumières, acquiring patents for the manufacture of their own motion-picture camera, an instrument designed for the single function of shooting film (unlike the Lumières' device). This camera dominated the market among professionals until after the war.[8] (Lartigue acquired a

Pathé Professionel, his second motion-picture camera, for Christmas in 1912.)[9] In addition to monopolizing the manufacture of equipment, the Pathé brothers also commanded a movie-studio empire, with five studios in Paris by 1908.[10] It was at this time that Pathé began to distribute films rather than simply sell cameras and products.[11] Max Linder, an actor whose slapstick comedies made him the world's first internationally recognized film star, was on Pathé's payroll; in 1914, just before his departure for the United States, where the film industry would retreat during the war, he was the highest-paid actor in the world.[12] Lartigue photographed Linder at Chamonix in January 1913, when the comic was at the height of his fame.

Lartigue recalled that his first cinema experience occurred in 1902, the year of the debut of Georges Méliès's *Trip to the Moon*, which he saw with his mother at the Dufayel department store.[13] Henri Lartigue took an early interest in cinema as well, presumably gathering his information from amateur photography periodicals such as *L'Amateur photographe*, which treated cinema as a branch of photography. He even invested some of his own money in the industry, becoming a shareholder in a cinema house called Musicarama.[14] After 1911, when the diaries commence, we see the young Lartigue attending screenings at no less than thirteen different cinema houses, many of them newly opened, all within walking distance of his home on the rue Leroux at the western edge of the city.[15]

What was shown at these cinema houses? The earliest films, by Louis Lumière (Auguste Lumière made only one film, *Weeds*, in 1895),[16] were very short, simple, animated versions of serious amateur themes—babies, the seaside, mechanical locomotion.[17] Unlike the early films of Thomas Edison, made in 1894, which depicted a figure or figures performing a kind of impromptu vaudevillian spectacle within a shallow proscenium, Lumière's films were shot in the open air and showed scenes from everyday bourgeois life. In films such as *Baby's Lunch* (1895) and *Boat Leaving the Harbor* (1896), Lumière's connections to amateur photography culture are made most explicit, just as Edison's affinities toward the scientific imagery of Muybridge and Marey are apparent in his own work.[18] Georges Méliès, the other important figure in early cinema, established a studio and began making films in 1896. Méliès was a conjurer and illusionist employed by the Théâtre Robert-Houdin, in Paris. Although he made outdoor views similar to those by Lumière, Méliès is best known for his so-called trick films, such as *The House of the Devil* (1896) and *Trip to the Moon*, films involving fantastic sets,

elaborate costumes, and spectacular special effects, which included figures vanishing and reappearing, explosions, and the flights of fantastic vehicles through outer space.[19] In addition to all the razzmatazz, Méliès structured his films around simple plots, and for this reason he is often credited—erroneously perhaps—as the father of narrative cinema.[20]

The early part of the century saw the emergence of cinema genres: the "realistic film" established by Ferdinand Zecca, working for Pathé; adaptations of literary classics produced by Film d'Art, a studio founded by the Lafitte brothers (one of whom, Pierre, was the magazine mogul); light comedy, popularized by Max Linder; and episodic crime fiction, such as the *Nick Carter* series and *Fantômas*, products of the Éclair and Gaumont studios, respectively.[21] American films began to be shown increasingly in France, especially during the war. *Les Mystères de New York* (released as *The Exploits of Elaine* in the United States), with Pearl White, was a huge box-office success in 1915; and Charlie Chaplin (whom the French nicknamed Charlot) arrived in France that same year.[22] The *actualité* (newsreel) emerged as another important genre. The Lumières had started this trend, sending cameramen to the far corners of the earth to record exotic places and peoples for showing on-screen back home. Under Pathé, newsreels of sensational events, such as Reichelt's mortal leap from the Eiffel Tower, became increasingly popular, so much so that the company opened a special cinema house, Pathé-Journal, which showed only newsreels at low ticket prices.[23]

Before 1911, it is hard to know for sure what Lartigue was watching. When the diaries do commence, Lartigue lists—with a fastidiousness bordering on the perverse—all the films that he sees, and he rates each film according to his own system: "B." (*bien*), "T.B." (*très bien*), "A.B." (*assez bien*), "assez drôle," "tordant," etc.[24] Judging by the frequency of his cinema-house visits, and by the sheer number of films that he saw, Lartigue seems to have seen just about everything there was to see, and he saw many of the films twice. He certainly saw the most popular and well-known films of his day, including *The Ruses of Nick Winter* (which he rated "B."), and other films in the *Nick Winter* series; episodes of another detective series, *Fantômas* ("T.B."); Max Linder's comic offerings ("D." [*drôle*]); installments in the *Rigadin* series ("T.B." and "T.D." [*très drôle*]); the comic *Onésime* series (which he described as "D.—but disgusting. You see the surgeon remove the heart and lungs [a cow's] from the belly of Onésime and throw them in his face.");[25] Louis Feuillade's powerful series *Les Vampires*

("B."), which was later a favorite of the Surrealists; and the hugely popular American series *The Exploits of Elaine* ("idiot, tordant"), the serialized version of which Lartigue had already read before the movie reached screens in Paris.[26] He saw lesser-known films, too, most of them detective yarns, romances, and comedies, such as *The White Mouse* ("très bien et très drôle"), *A Too Loving Wife* ("T.B."), *Robinet the Unstoppable* ("B."), *One-Hundred Dollars, Dead or Alive* ("T.T.B."), and *The Coquettish Servant* ("B.").[27]

Lartigue's favorites seem to have been the newsreels, many of which were shot in the United States, as these contained the most curious, shocking, and even grisly images available on screen. Lartigue saw footage of a buffalo hunt in America ("T.B."); women's championship swimming ("B."); a storm at Biarritz ("T.B.—already saw it"); the burning of the Equitable building in New York ("T.B."); a boxing match between Carpentier and Klaus ("T.B."); birds and animals of Brazil ("B."); *The Railway of Death* ("an extraordinary film"); and footage of winter sports, in which Lartigue's cousin Simone is filmed skating with ice champion Sabouret ("*T.B.*"). All this exposure to cinema leads one to an easy conclusion: Lartigue was as saturated in cinema imagery as he was in photography.

JONATHAN CRARY, in his book *Techniques of the Observer*, defines a modern observer.[28] This is a historically determined figure, one whose ocular mechanism is shaped, trained, and regimented according to the conditions of capitalist modernization—"forms of artificial lighting, new use of mirrors, glass-and-steel architecture, railroads, museums, gardens, photography, fashion, crowds."[29] Central to Crary's thesis is a demonstration of the ways in which this historical mutation of vision, situated in (though not caused by) certain optical devices such as the stereoscope and the phenakistiscope, produced an observer programmed for the challenges of modern life. Modern vision was an increasingly disjunctive vision, a vision at once fractured by urban life and severed from the physical body; it was, Crary argues, the sensory equivalent of modern capitalism, which propagated a phantasmagoria of uprooted social relations, circulating images, and unceasing waves of commodity desire. "Over the course of the nineteenth century," writes Crary, "an observer increasingly had to function within disjunct and defamiliarized urban spaces, the perceptual and temporal dislocations of railroad travel, telegraphy, industrial production, and flows of typographic and visual information. Con-

currently, the discursive identity of the observer as an object of philosophical reflection and empirical study underwent an equally drastic revolution."[30] Crary's observer is not only a fractured, dislocated being but a passive observer as well, submitting bodily to the displacement of vision occurring within the frame of experience staged by, for example, the stereoscope.[31] He or she suffers the blur between internal perception and external reality and, correspondingly, reenacts the cyclical process of desire and consumption ad infinitum.[32]

Lartigue was certainly formed by the social, aesthetic, and technological conditions of his time, and cinema, one of the most radical of modern innovations, played no small role in this. If we are to accept, as I do, Walter Benjamin's model of cinematic distraction, which claims for cinema a greater, all-pervasive power over spectators than other media such as painting, cinema's efficacy as both exemplar and engineer of modern vision cannot be ignored. Drawn to the cinema in search of distraction, Benjamin argues, audiences experience an inculcation of new forms—social as well as aesthetic—through the process of habit. Just as architectural style and space are appropriated through constant exposure, through oblique perception in an unfocused state, cinema's values are absorbed by observers in a most profound and collective way. As Benjamin notes, "this mode of appropriation . . . in certain circumstances acquires canonical value." Here Benjamin applies a term normally associated with painting; cinema, he proposes, supplants the fine arts as promulgator of values in the age of mechanical reproduction.[33]

Lartigue's inculcation of cinematic values, like his absorption of other media styles and structures, was not merely imitative. In a very important sense, Lartigue escaped the imprint of Benjamin's distracted viewer and Crary's "dominant model" of the passive modern observer. Rather than remaining simply in the receptive role, Lartigue took an active role in his manipulation of media, in his attempts to establish—through his handling of photographs, cinema, and narrative—his own system of meaning. In his reordering of the manifold symbolic systems at his disposal, Lartigue imposed shape upon such abstractions as experience, personal history, and the drama of the self. This was a process that changed over time. As will be demonstrated, what started out as a mission to collect the spectacular, the novel, the precious, gradually evolved toward a form of autobiographical dramatization, with cinema serving as the model for the organization of experience. Still, later in life, the whole thing would turn Proustian. In

his varied efforts to reveal continuity through the arrangement of imagery and personal narrative, Lartigue's disparate glimpses of a spectral epoch hardened into a mass of material memory—sanguine youth corrupted by nostalgia.

As mentioned above, the Cinématographe was born out of the culture of serious amateur photographers. This was a culture both exclusive in its technological proficiency and bourgeois in its tastes and habits. As Gunning has shown, the Lumière brothers were archetypal serious amateurs. Three instantaneous photographs published in *L'Amateur photographe* (two in 1887, by means of engraving, and another in 1888), in which the brothers are shown leaping—from a wall, toward a bystander, over a chair, grinning furiously in the third example—display the peculiar combination of technological prowess and lighthearted humor typical of their group.[34] Not surprisingly, when the Cinématographe made its debut in 1895, it was photography periodicals such as *L'Amateur photographe* that provided the forum for discussion. Moreover, cinema, assimilated as a new application of photography, was described in a language familiar to photographers: the *Bulletin du Photo-Club de Paris* described cinema as "a curious application of instantaneous photography;"[35] *L'Univers illustré* described cinema as a series of "photographic plates;"[36] and, as Stephen Bottomore points out, cinema was often seen as an extension of lantern-slide projections, just as "cinematographic slides" was a common term for films.[37] Technically, photography and cinema did share a similar DNA, for the film stock that was used in the Cinématographe was prepared with the same emulsion used for the still camera's Étiquette Bleue dry plates; all that was different was the support, and the fact that one system was much faster in its output of images.[38]

Given the technological similarities, as well as the considerable overlap of practitioners, it is unsurprising that the formal and thematic choices made by early filmmakers were effectively the same as those of their still-photography counterparts. Most compelling was the common obsession with movement, frozen in the instantaneous photograph and serialized in the filmstrip. The two forms were held in stark juxtaposition during cinema screenings when, as the movie began, the first image was projected as a film still, familiar to observers as a lantern slide. "At this point nothing new," commented one observer. Then, when the operator began to crank the apparatus, "all at once the image . . . stirred itself and came alive."[39] Although the results were dramatically different—the instantaneous photograph being a dissection of movement, the cinema produc-

ing an illusion of it—strategies for capturing fugitive subjects were essentially the same. In the Lumières' early films, for example, not only was the subject matter standard hand-held camera fare, so too was the approach to composition. In 1894, the Lumière brothers published a short guide to composition for the benefit of consumers of their Étiquette Bleue plates. In it they outlined a familiar pictorial approach, one that prescribed oblique perspectives, subtle variations in massing, and pictorial animation produced by the careful placement of figures in a landscape—the standard beaux-arts formula followed by serious amateur photographers.[40]

The same sensibility surfaces in Lumière films. Most of these consist of a single, well-composed shot, with the camera remaining stationary for the duration of the film. In *Baby's First Steps* (1896), the action is contained in a garden view, where a pathway cuts diagonally, and a patch of sky offers depth; the figures, two children and Madame Lumière, add animation to the landscape according to amateur photographic convention. *Child and Dog* (plate 74) observes a similar pattern, with boy and dog judiciously placed before masses of dark foliage and a light walkway, which recedes toward a visible horizon line in the upper-right corner. In *London, Boats on the Lake at St. James Park* (probably 1896), a boat in the foreground balances gracefully with a smaller boat and masses of foliage in the misty distance. The only real difference between these cinema views and photographic compositions was the fact that in cinema, because of the unpredictable movements of people and objects, what started out as a good composition did not always remain that way. Indeed, the action tended to work both with and against the composition, alternating from balance to disequilibrium, or "discomposition," as the film unfolded. The process was essentially instantaneous photography exposed to a wider range of chance.

Chance, as I argued in the first chapter, was a key factor in the development of a formal vocabulary of modernism. The nature of cinema as an expanded medium, one that factored a much greater temporal element into the equation of pictorial representation, increased the opportunity for chance a thousandfold. Still photography was already engaged in a subversive assault, however unorganized, on standard beaux-arts formulas for picture-making via mass enthusiasm for the instantaneous photograph, but early film demonstrated an even greater pictorial chaos. On the one hand, by setting the awkward poses wrought by the instantaneous image into motion, and thus making them appear more

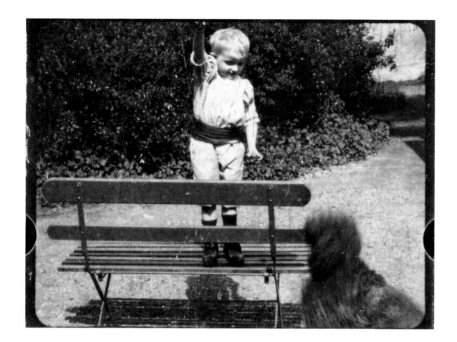

familiar and true to life, the moving image seemed to temper the excesses of amateur photography. On the other hand, the expansive nature of film, involving larger spans of time during which, from the cameraman's point of view, subjects were granted greater freedom and opportunity to perform unpredictable actions, gave it less control over the final product. This applied to inanimate objects as well as to people. In 1895, when Méliès saw the Lumière film *Baby's Lunch* at the first Paris screening, he made specific mention of the rustling of leaves in the background. The comment is striking in its similarity to early observations on photography, in which viewers observed—not without some distaste—unwanted details such as leaves on trees in the backgrounds of photographs.[41] Just as photographers sought to reconcile their photographs with aesthetic conventions established by painting and etching, early filmmakers developed strategies for aligning cinema with the idées fixes governing formal expectations for photography and, to a large extent, theater.

The conceit of the frame, as noted, aligned cinema with standards of photographic composition. While filmmakers strove for control over their final product through a combination of careful composition and staging—both anticipated

PLATE 74. Louis Lumière, film still from *Child and Dog*, 1896. Institut Lumière, Lyon, France

and directed—moments of discomposition were an unavoidable aspect of cinematic representation. This occurred in the balance of figures as they moved across the screen, offering a balanced composition one instant, and a lopsided one the next—a dancer drifts to the edge of an empty stage; fish in a bowl suddenly clump, their individual silhouettes obscured; cavalrymen rush into the frame and out the other side in an A-B-A rhythm of discomposed/composed/discomposed (plate 75). The result amounted to a photograph shifting in and out of composition, as it were. If such imbalances distracted viewers (and there is evidence that they did),[42] the offense was generally righted through the flow of movement, by which occasional resolutions of composition served to relieve the threat of out-and-out chaos.

There were, however, other, more egregious consequences of cinematic action, these more directly the result of unpredictable crowds, bystanders, and changing weather conditions. Techniques were developed in order to avoid problems, but the variables were often too many to manage. One way that cinema and instantaneous photography diverged significantly, for example, was in the cinema's embrace of extremes of pictorial space—the circulation of people and

PLATE 75. Lumière and Co., film still from *Buffalo Bill: Cowboys*, c. 1896. Institut Lumière, Lyon, France

objects from foreground to background and past the frame's edge. Because the Cinématographe was stationary (though small, it sat on a tripod and was hand-cranked), and editing had not yet been developed as a component of cinematic language, movement was limited to width of frame and depth of field.[43] When crowds of people were involved, fragmentation of figures and/or figures occupying the extreme foreground of the picture plane was common. In the famous *Arrival of a Train in the Station* (1896), a boy in the lower-right corner stands close to the camera and stares directly out at us. Frames of *Buffalo Bill: Cowboys* (plate 75) show a man on horseback rushing across the picture plane, his blurred, truncated figure blotting out riders occupying the middle ground of the shot. In *Fire Trucks Returning to the Station* (c. 1897), the fire truck passes so close to the camera, and so quickly, that it appears as little more than an enormous dark hulk.

Such distortions must have been puzzling to early moviegoers, but one would have to have been blind not to see that such effects sometimes revealed a surprising charm. Alan Williams, remarking on the Lumière film *Fountain at the Tuileries* (1896), writes: "There is a luminous moment when a young boy unwittingly stands in front of the camera. From frame left, an umbrella or cane enters the image and pushes him out of the way."[44] Comparison with the photograph from the Lartigue notebook of a boy gazing at a boat (discussed in chapter 1; see plate 12) is unavoidable. This is not to suggest a direct causal relationship between the two, but to emphasize instead that cinematic imagery was substantially altering people's perception of the world. For a perspicacious observer such as Lartigue, visual novelties such as those generated by the cinema may not have been, on a certain level, noticed; and yet, one can be sure that they were perceived.

As a strategy for containing movement, particularly in the case of processions or races, where the action followed a linear path from point A to point B, rather than moving in place (like dancing), the diagonal view was adopted. Note that this was a strategy deployed by photographers in pursuit of the instantaneous photograph—of, for example, a racing automobile. To frame the route diagonally was to augment the period of time that the auto occupied the viewfinder, and this increased one's chances of capturing the shot exponentially. It didn't hurt the composition either, for the oblique view added formal interest as well as advantage in execution. This practice in cinema has been termed *deep staging*.[45] Deep staging enlarged the plane of action, taking the width of the frame determined by the stationary camera and pushing the field of performance

PLATE 76. Lumière and Co., film still from
Team Pulling a Truck, c. 1896. Institut Lumière,
Lyon, France

back toward infinity. In theatrical terms, if one normally thinks of a stage as a wide, shallow space defined by the proscenium, where actors move left to right in front of a flat backdrop, deep staging turned the stage on its end, so that actors moved not only from side to side, but from front to back and vice versa—on a deeper stage, as it were.

A preponderance of this technique is observed in French films made during cinema's first decade (1895–1905), particularly in Lumière films, films by Méliès, and in newsreels. In a still from *The Attack on Master Labori* (1899), Méliès's film about the Dreyfus Affair, two figures appear to conspire in the extreme foreground of the shot, while an unsuspecting pedestrian passes in the distance.[46] The same technique is particularly notable in Lumière's films, *Boat Leaving the Harbor* (1896) being a most elegant example. Here, a group of women and children are stationed as observers on the end of a jetty protruding into the frame at middle distance; a boat enters the frame at bottom right and travels diagonally across the picture plane toward the open sea at top left. The action, which lasts about fifty seconds, comprises one continuous movement, from front to back, and this is contained within a single shot.[47] Many Lumière films, particularly the newsreel footage sent home by cameramen abroad, use deep staging to document processions, such as a religious procession in Évian, a line of workmen in Saigon, and traffic on the Tower Bridge in London. In films such as these, figures often pass close by the camera when entering or exiting the frame; they fall out of focus and disintegrate before passing off-camera, or to the center zone. In *Team Pulling a Truck* (plate 76), horses enter the frame at the extreme left and become identifiable only as they approach the middle ground of the image. In another example, featuring a parade of Hussars in Dublin (c. 1897), riders travel from the distance at left before moving off-camera in the right foreground. Again, the choreography is diagonal; depth is used to maximize movement, to exploit the unique character of the cinematic medium, while remaining within the bounds of standard compositional formulas.

Curiously, a similar effect was sought in stereoscopic photography, which was enjoying a resurgence in popularity during the first decade of the twentieth century. However, in stereographs (the pairs of nearly identical positive images in side-by-side format, printed from stereoscopic negatives), the spatial discrepancies that made for a striking visual experience were also planar—arranged in layers on flat planes—and, of course, immobile.[48] The relationship between

these two different media seems tenuous, perhaps, until one considers that both cinema and stereographs not only celebrated extremes of pictorial space, but also relied on a transformation of the ordinary photograph in their staging of the spectacular. In other words, both trumped the documentary and/or pictorial signification of the photograph with a much more complex cognitive experience, one that involved vision and the projection of vision onto a hypothetical ground, where multiple images are meshed into one.[49] Early cinema viewers watching *Arrival of the Train in the Station* are said to have dodged the screen as the train proceeded toward them, "into the station."[50] Users of the stereoscope described a curious hypnotic absorption, "a dream-like exaltation, in which we seem to leave the body behind us and sail away into one strange scene after another."[51] Still photography, of course, hadn't quite the same phenomenological force, not by 1900.[52] Viewers may have appreciated photography's claims on realism, but it was easy to accept that it was an image on paper.

What we are speaking of here is entertainment, visual novelty, attraction— in the same sense as amusement-park attractions such as the *montagnes russes* (roller coaster), Luna Park, the wax museum. Early cinema and the stereograph, for a time at least, shared a common role as visual entertainments. Just as the instantaneous photograph had enjoyed a unique status among serious amateurs during the 1890s, fulfilling a dual role as an object of science and a visual novelty, the cinema and the stereograph claimed a similar position, but for a wider, less erudite audience, during a period spanning about ten years. Initially, before it became a vehicle of dramatic narrative, cinema was a species of carnival attraction. As Gunning has argued, all early cinema, from Lumière newsreels to Méliès "dramas," participated in an exhibitionist spectacle, providing audiences with "direct stimulation" rather than "diegetic absorption." Early film, like the stereoscope, served no larger purpose than as a "cinema of attractions."[53]

Until 1907, which marked the commencement of the "narrativization" of the cinema (i.e., the rise of feature films that quickly took possession of the market), cinema's power over audiences relied upon little more than a flickering image and, perhaps, marvelous or exotic subject matter. The Lumières' films, such as *Workers Leaving the Lumière Factories*, were captivating not for their plot, roster of stars, or exotic locale, but merely because they moved, plain and simple. Similarly, Méliès's films, which ostensibly engaged viewers on a rudimentary narrative level (*Trip to the Moon* takes viewers to the moon), were, according to

Gunning, more a forum for the display of cinematic tricks. Tricks were performed like a magic show, with actors looking at the camera, directly engaging the audience. The intent is not unrelated to the photographic amusements proposed by Chaplot in *La Photographie récréative*. Although Méliès's connections to the theater are obvious, and this explains much of his exhibitionist sensibility, the filmmaker's connections to amateur photography are also apparent in his exploitation of the capabilities of his medium—the tricks in his films are camera tricks as much as stage tricks. Méliès's films are animated versions of photographic recreations, just as those by the Lumières are fluid renderings of instantaneous photographs.[54] And both are cinema of attractions.

Cinema Structures

An important aspect of Lartigue's photographic output is that much of it is in stereo format. This fact, if acknowledged at all, has been explained in terms of technological causality. Smaller plates, it is reasoned, made stereoscopic film faster, so the stereo camera was selected to serve a premeditated pictorial end; for example, when Lartigue wanted to see his cousin Bichonnade caught in mid-flight, he used a stereo camera for its fast exposure time, then printed the picture as a single image. Contradicting this explanation is the existence of an enormous number of stereographs, which Lartigue had printed for three-dimensional view-

ing just after he exposed the negatives.[55] What's more, Lartigue's Takir-Klapp, with a 9 x 12 cm negative format, was comparable in speed to the 6 x 13 cm Klapp-Nettel stereo camera that he acquired in 1912 (1/1000 versus 1/1200), but the Takir-Klapp, with its larger-format negatives, captured greater detail. Most important, Lartigue interchanged cameras with great regularity. A reconstruction of Lartigue's movements over two days at the Grand Prix of the A.C.F., in 1913, shows that Lartigue used both the Klapp-Nettel stereo and the Takir-Klapp, and that he took twenty photographs with each. (*Grand Prix of the A.C.F.* [plate 38] was taken the second day with the Takir-Klapp.)[56] In the MoMA exhibition of 1963, thirteen of the photographs had been taken in stereo format, seventeen with a 9 x 12–format camera, five in the 6 x 9 roll-film format, three as panoramas (also taken with the stereo camera, adaptable to panorama format), one with the small-format Block-Notes, and three by unknown means (one likely adapted from a Cinématographe film frame).[57] Clearly, Lartigue was interested in capturing a variety of effects; besides instantaneity, he was considering the illusion of depth produced by the stereograph.

If the stereoscopic photographs are compared to other photographs made in single-negative format, are there noticeable differences in the treatment of space?

PLATE 78. Jacques Henri Lartigue, *At the Races, Auteuil*, 1912. Glass stereo negative, 2⅜ x 5⅛ in. (6 x 13 cm). Association des Amis de Jacques-Henri Lartigue, Paris

Among the photographs exhibited at MoMA, a striking number of images are composed around pronounced, diagonally receding lines: the leash connecting Mary Lancret to her dog (MoMA exh. no. 8); the railroad tracks in *Flat Tire in Soumoulou* (MoMA exh. no. 35); the legs of Lartigue's cousin in *Jean, Rouzat* (MoMA exh. no. 29); Marcelle's legs, which splay as she attempts to mount a donkey (MoMA exh. no. 24); the long auto chassis in *Auvergne Auto Rally* (MoMA exh. no. 39; plate 77).[58] Planar complexity is another technique that surfaces in Lartigue's stereographs: the "Zissou 24" is tethered to attendants in foreground and background (MoMA exh. no. 26; plate 33); a cyclist and auto form a perfect parallel in *Avenue des Acacias* (MoMA exh. no. 38); a motorcycle passes in front of a bystander in *Orléans* (MoMA exh. no. 37); a pair of female strollers are framed by dark human fragments in *Sentier de la Vertu, Paris* (MoMA exh. no. 17); the elusive lady in *At the Races, Auteuil* (MoMA exh. no. 12; plate 78) forms a step in a multilayered staircase of gentlemen admirers. Both these techniques were expressly recommended by experts on stereoscopic photography. An example of a good stereograph, one that illustrates both the diagonal and the planar, appeared in *Photo-Revue*, in 1905 (plate 79). The camera's angle on an outdoor banquet captures both perspectival recession in the lines of the table and planar complexity in the stair-stepped configuration of the guests. Another stereograph in the same article, showing a dog smoking a pipe, provides an example of what not to do: do not place a single subject in the center of a spatially unmodulated composition.[59]

PLATE 79. "Stereograph with Complete Range of Intermediate Points," from *Photo-Revue*, 1 October 1905. Société Française de Photographie, Paris

Lartigue's nonstereoscopic images of this period share a common thread in that, like the pipe-smoking dog, they generally comprise a single subject tightly framed within a spatially undramatic landscape. Moreover, they lack perspectival emphasis. This is the case in *Paris, Avenue des Acacias* (MoMA exh. no. 6) and *June, Paris* (MoMA exh. no. 7), both of which depict women scrutinized in close-up. The stripe-wearing women in *Day of the Drag Races at Auteuil* (MoMA exh. no. 13; plate 58) all occupy the same spatial plane, which also contains the fence, yet nothing in the distance offers anything for spatial contrast. Similarly, Jean's original-looking dive in *Rouzat, Jean* (MoMA exh. no. 23) bears little spatial relation to anything in the background; he floats, as does Zissou in his inner tube (MoMA exh. no. 31; plate 32), both, in a sense, defying space as the core of their actions. The instantaneous photographs in the group, such as *Bobsled Race, Louis, Jean* (MoMA exh. no. 34; plate 26), which shows Louis and Jean making a hard turn, and *Dédé, Renée and Jean, Rouzat, September* (MoMA exh. no. 19), another photograph of divers, demonstrate little or no interest in spatial depth. Even severely cropped as they are, these images are hardly worth noting as compositions; the preoccupation here is not space, but simply getting the action in the frame.

There exist, however, a couple of examples in which space is not emphasized by format. Lartigue's close-range photograph of his father driving (MoMA exh. no. 40), in which Henri Lartigue's head fills nearly the entire frame, offers no space for stereographic play. Conversely, *Villerville, Cousin Caro and M. Plantevigne* (MoMA exh. no. 3; plate 66) would have made a great stereo, as would *The Grand Prix of the A.C.F.* (MoMA exh. no. 41; plate 38). Lartigue's approach to photography was never so rigidly systematic as to hold one strategy above all others. Accordingly, this excursus on stereo effects is not meant to reduce analysis of the work to a single technological factor. On the contrary, what it shows is that Lartigue's "method" was guided, though open to possibility. Indeed, for a young man with so many options at his disposal—cameras and accessories, magnificent people and events—photography was a grab bag of possibilities.

It might be argued that Lartigue's stereographs exploit depth in a fashion more like cinematic deep-staging techniques than standard stereoscopic practices, not only in their utilization of the diagonal view but also in their disregard for the distortions caused by objects positioned extremely close to the camera, which registered as blurs and fragments. Stereo practitioners, by the close of the first

decade, were largely serious amateur holdouts, preoccupied with stereoscopic photography precisely because of its technical complication, which prohibited involvement by mass amateurs and preserved the serious amateur's self-image as a technological elite.[60] As such, the enthusiast of stereo photography was a former connoisseur of the instantaneous photograph and subscriber to classic, though by now slightly passé, principles of composition—namely, the crisp mise-en-scène approach so consistently observed in Henri Lartigue's photographs. Blurs and fragments, like those inadvertently disseminated by the cinema (and by the mistakes of mass amateurs, it should be noted), would not have been met with joy by most stereo photographers; indeed, blurs and fragments were what they were specifically instructed to avoid. What this suggests is that Lartigue, weaned on the visual innovations disseminated by the cinema and other forms of nontraditional imagery seeping into the public domain—images appearing in the illustrated press, but also in poster art and advertising—was simulating effects of cinema with a stereo camera.

Above and beyond such technological considerations, Lartigue's early photographs (those taken before 1911) show a common interest in the photograph—both stereo and traditional—as a cinema of attractions. How can this be argued? Analysis of Lartigue's handling of photographs in the diaries and albums, both of which he began about 1911, reveal a shift in his regard for the individual image. Within the narrative contexts of these essentially discursive forms, a revolution is seen to occur: the individual image, formerly regarded as a novelty, prize, or entertainment, begins to assume a role as a component in a larger lexical system. The cinema-of-attractions aspect of Lartigue's images begins to recede under the newer order of personal narrative, a narrative that takes cinematic narrative as a model for the shaping of experience. In other words, the original expressive content of the photographs starts to play into the hands of myth.

In *Mythologies*, Roland Barthes makes a distinction between language and myth by defining myth as a kind of language that appropriates objects into speech. The meaning of photographs, according to Barthes, is established first on a basic linguistic plane. At this level, words are assigned to objects in the photograph. Lartigue's photograph of a boy gazing at a boat, *Pont-de-l'Arche, Louis* (plate 12), for example, is, on the linguistic plane, precisely what the descriptive title implies: a boy, gazing, a boat. Within the context of the notebook, and through Lartigue's retrospective overlay of a rhetoric of naïveté, the literal

meaning of the image ascends to the mythic plane. In semiological terms, the sign (the associative total of signifier and signified) now functions on the plane of myth as a signifier. Regardless of the density and complexity of the image on the linguistic plane, the sign takes on a global significance, one that is engaged by the larger semiological system. In other words, once the larger system of cinema overtakes the individual photograph, ties to all specific references are cut and the picture becomes meaningful only in its relation to the larger series of photographs. What started out as a document of a steamboat becomes, in the context of the notebook, "boy gazing at a boat," an image pregnant with narrative possibility; childhood, nostalgia, a multitude of myths are suggested.[61]

To say that Lartigue's photographs lost their cinema-of-attractions significance en route to participation in the fulfillment of a larger personal narrative is to assert that the original historical circumstances behind the pictures' creation and valuation were forgotten due to the strong-arming of the mythic form presented by cinema. Just as cinema subsumes the meaning of the individual photograph in a shower of rapidly projected images, the specific historical factors described in the preceding chapters of this book were, to a large extent, obliterated by the insertion of the photographs into the albums (and remade albums), the diaries, and Lartigue's published writings, where they serve the larger purpose of illustrating "history"—personal but also public histories, such as histories of the belle époque, histories of photography, histories of a universal childhood, etc.[62] MoMA alone did not efface the historical conditions of Lartigue's photographs; Lartigue himself had already begun that process in 1911.

As I previously noted, an important shift was occurring in cinema during this period of Lartigue's involvement with auto-narrative: from 1907 to about 1913, the true narrativization of cinema occurred. Feature films began to follow the model of the legitimate theater, producing well-known plays starring well-known actors, and this curbed the formal novelties disseminated by the cinema of attractions. As Gunning explains, "The look of the camera becomes taboo and the devices of cinema are transformed from playful 'tricks' . . . to elements of dramatic expression, entries into the psychology of character and the world of fiction."[63] The coincidence of these parallel processes is highly significant, for it emphasizes a pattern in Lartigue's photographic practice already observed: he was a shrewd adapter of popular visual modes. Lartigue's sensitivity to changes in cinema can be detected in several ways. First, Lartigue's handling

of images in the pages of his diaries shows a transition from a compilation of individual images to the construction of cinematic sequences. Second, the writing in the diaries follows a similar pattern, demonstrating a shift from accounts of isolated moments organized around the hours of the day to a more fluid, self-reflective, narrative style. Last, Lartigue was increasingly practicing cinema itself; not only was he filming his own "newsreel" subjects, he was also writing scripts and producing dramas, which he modeled after studio hits such as the *Nick Carter* series. Overall, the progression witnessed in the diaries suggests that cinema became Lartigue's primary model for the representation and shaping of experience.

Lartigue's acquisition of a Cinématographe for Christmas in 1911, when he was seventeen, is really the starting point for a discussion of his oeuvre, for it is at this moment that a change in consciousness can be seen to occur. Although he had been watching movies all his life, acquiring his own movie camera and testing its capabilities seems to have spurred a more intimate awareness of cinematic form. This awareness is reflected in Lartigue's handling of photographs in the pages of his diaries, where he fastidiously documented, as a kind of catalogue of photographs taken, the most interesting images he had produced each day. With the original albums having been dismantled, the diaries are now the primary source for tracing this conceptual shift in Lartigue's oeuvre.[64]

In one sense, the commencement of the diaries themselves is an important step toward cinematic sequencing, for the arrangement of "photographs"—his drawings of his own photographs—on the page prompts in the observer a linear response, a reading of the images as a sequence, from left to right and down the page. An initial example from January 1911, in which this pattern is *not* observed, provides a striking contrast. Perhaps because it was winter, with short days and weak light, Lartigue was experimenting with photographing at night. On 13 January, he photographed the moon and a table lamp. The results are drawn and labeled at the bottom of the page as two separate images, each with its own distinct frame, one a horizontal ("lune"), the other vertical ("lampe"). Significantly, the pictures are positioned at a distance from one another on the page; like pictures arranged on a wall, they each enjoy considerable white space. This arrangement is fairly rare.

Later in the season, as his photographic activity picked up, Lartigue started to arrange his images in bands, storyboard style. Moreover, the images begin to

relate to one another as series documenting coherent events, or "scenes," experienced that day. A trip to Auvergne in August of 1911 resulted in fourteen photographs, carefully redrawn (from the developed prints, not from memory) at the bottom of the page in band format, each image labeled with the same notation system used for cinema—"B." (*beau*), "T.B." (*très beau*), "missed, failed," etc.—in the lower-left corner to indicate the success of the photograph. The photographs taken that day are of mountain landscapes, local villagers, and flocks of sheep. In their sequential arrangement—the first one showing a winding road, the second a mountain lake, the third an Auvergnat village, etc.—the images recount the day's journey; and the text treads the same path in verbal form.[65] Together, text and images comprise what might be regarded as a typical travel diary. However, Lartigue also used the same format to recount the day's activities in and around Paris. One day in February 1911, he passed the morning strolling in the Bois de Boulogne with his brother, where he took four fashion photographs; in the afternoon, the brothers went to Issy-les-Moulineaux, the airfield on the southwestern outskirts of Paris, to watch the airplanes take off and land. These experiences are recorded in two bands (plate 80), the morning images forming a strip across the center of the page, the afternoon images presented in two attached bands just below an explanatory text.

Despite the subtle differences in formatting, what these images have in common is a shared status as *specimens*. They are specimens of individual, technical photographic achievements. Lartigue's notations ("B.," "T.B.," "missed, failed") assess the level of success, and in each instance this refers to a specific technical or aesthetic challenge assailed: photography practiced in low light, photography of a moving object, photography of a picturesque setting. The photographs are specimens in terms of contents, too. The Auvergnat villager is a type of person, as different from the fashionable creatures seen in the Bois de Boulogne as cheese is from chocolate. The airplanes photographed at Issy are each a different model (le Canard, le Zodiac), and flown by a different pilot-hero (Farman, Voisin), and this information is noted next to each image. While these collections of images, based on a common experience, recall cinematic structures in their mimicry of the unfolding of events at a single site (they comprise a "shot," in cinematic terms), it should also be apparent that the sensibility in question here is that of the cinema of attractions. Not only are the images both sequential and spectacular, with narrative competing against individual pictorial effects, they are also cumulative—

PLATE 80. Jacques Henri Lartigue, diary page, 9 February 1911. Association des Amis de Jacques-Henri Lartigue, Paris

that is, the sum of the whole is greater than the parts. Individual photographs contribute to a larger picture of an event or experience, none claiming iconic status here (although there are iconic photographs among them), only fragmentary status, like frames in a strip of film.

Lartigue's interest in the Cinématographe began to alter this relationship. Soon after receiving his second one (the first was apparently just a toy),[66] subtle variations in the formatting of images began to occur in some instances, the sequencing of which displays a more precise cinematic progression. One sequence from 31 March 1912 shows a series of automobiles (the same automobile, actually, depicted in different positions), with the first three images featuring Zissou in a Hispano-Suiza pretending to drive. The sequence simulates depiction of a speeding auto rounding a curve: the vehicle is pictured first in profile, then in three-quarters view, then head-on. Another sequence of photographs from 1912, arranged in Lartigue's albums during the 1970s, shows a similar progression, with an auto approaching the camera at a distance, getting closer in the second, passing nearly in profile in the third, and speeding away in the fourth, all

PLATE 81. Jacques Henri Lartigue,
Grand Prix of the A.C.F., 1912. Album page.
Association des Amis de Jacques-Henri
Lartigue, Paris

arranged on the page in a descending, terraced layout (plate 81). While it is not certain that this type of sequence actually existed in the original albums (although sequencing of this kind in the diaries suggests that it did, in one form or another), the path of Lartigue's thought—the individual photograph in migration toward a temporally elongated expression of speed—is clearly stated.[67]

Lartigue's fourth motion-picture camera, a Pathé Professionel, which he received for Christmas in 1912, must have been simpler to use, for once he started operating this camera, both his activity as a filmmaker and his involvement with cinematic language intensified significantly.[68] After the new year, as the sun grew brighter and there were more outdoor activities, Lartigue began to use his movie camera as often as his still cameras. Lartigue received a lesson in how to use it from a Pathé operator at the Pathé headquarters in the Bois de Vincennes on 30 December and three weeks later he was in St. Moritz, photographing madly as usual, but also trying his hand at motion pictures. As with Lartigue's training in still photography, his father (and, on occasion, Folletête, his father's secretary) took the lead, relying on the teenager to load the movie camera and get it into position, and then assuming the role of operator. By the end of the trip, Lartigue *fils* was taking motion pictures increasingly on his own. One sequence that he shot during the trip shows Folletête photographing a passing sled; another one, presumably by Folletête, shows Lartigue photographing a passing sled from the exact same position. (In the former, Folletête can be seen to pivot as he photographs. Is Lartigue's success in *The Grand Prix of the A.C.F.* [plate 38] indebted to a technical tip from Plitt?)[69]

As the year progressed, Lartigue used the movie camera increasingly on his own—not just for taking newsreel footage, with themes similar to his photographs (e.g., sports and fashion), but also to create short dramatic films, which he thought up and staged with friends. "The Abduction," scripted by Lartigue with Jean Baldoni, an aspiring actor and painter, was filmed in the Bois de Boulogne in April 1913.[70] A drama in four acts was filmed at Rouzat in August of that year, with the participation of actor Camille Dumény, a family friend (Lartigue seems to have acted in this venture more than he filmed).[71] Two dramas were filmed the following year: "The Bandit," presumably a spoof on the *Nick Carter* detective series, with Lartigue's father as "Nick Papi"; and "The Fairy Améliot," a trick film in the Méliès genre, starring Lartigue's aunt Amélie.[72] By the winter holidays of 1914, which he spent with Folletête in Chamonix, his cinema ambitions had

reached a level on a par with his earlier interest in photo-reporting, as is evident from his diary entries that week:

> January 17, Saturday. I prepare the cinema. 10:00 I go with Plitt to meet M. de Lesseps [an inventor]. He arrives with his wind-powered sled. We go set up the cinema and I film it in motion. . . . We go to Praz. I install the cinema and Plitt films. . . . 5:30 Rest. I unload the cinema. I get dressed. I telephone Pathé. 7:30 Dinner. I prepare the packet of films to send to Pathé, and I write to them. . . . Berg, André, etc. advise me on filming bobsleds in motion.

> January 18, Sunday. I set up the cinema. 12:00 The bobsled races begin. I film. I also film the team of Berg, André et al. from close up. . . . 1:45 we go (on skis) to the ice rink. I take along the cinema. We attend the French hockey championship. . . . I film. . . . I send the films to Pathé.

> January 21, Wednesday. 10:00 depart with my cinema, 2 cameramen from Gaumont, a photographer, and 4 sleds. . . . I film and take some color photos of us skiing; we are filmed by Gaumont skiing and skijoring behind the sleds (in black-and-white and in color). 12:30 The sleds return. . . . I write and try to telephone Pathé. . . . 5:30 I telephone Pathé. They tell me they probably won't take the films of hockey, nor the sleds; perhaps the one of the snowmobile of de Lesseps. They tell me to refilm some of the others. I load the cinema.

> January 22, Thursday. I install the cinema in the garden of the hotel and film Berg, André. . . in the winning sled of the President's Cup. 11:00 I go to the ice rink with Didi and Madeleine, with the cinema. We watch a hockey match. . . . I film the teams. . . . 4:00 I return with Madeleine, Didi and Plitt. We see in front of the hotel 2 little 5-year-old boys skijoring behind a little donkey (they were hilarious). I photographed and filmed them (the cameraman from Gaumont filmed them, too).

> January 23, Friday. I send the film to Pathé.

After arriving back in Paris, on 26 January, Lartigue made the rounds at the film studios to offer his spoils:

> January 26, Monday. I go to Pathé where I see M. Gaveau. He intro-
> duces me to the head operator who projects my films of Chamonix. . . .
> He points out the faults. It seems they want to buy the film of Berg
> and his sled, and they might also take the one of hockey (they buy
> them from me for 5 francs per meter for the Pathé-Journal). I go to
> "Rapid" where I see the cameraman who was at Chamonix. He
> shows me the photos he took there. A lot of them are of us. I order
> some from him.[73]

That same day Lartigue visited other film and photography agencies, includ-
ing Gaumont, Éclair, and Rol, but found no other buyers. While visiting these
places, however, he took the occasion to buy films and photographs shot by pro-
fessionals, and to order additional copies of his own films; as a further consola-
tion, Lartigue and Folletête stopped off at Maxim's for a second lunch. A week
later, Lartigue organized a private screening at the residence of family friends,
where he showed his own films and films he had purchased to memorialize the
trip.[74] By 1917 he was still pondering a career in cinema: "Why not get involved
in cinema, that industry that is going to become so formidable?"[75]

Related to this intense cinema activity, significant changes were occurring
in the sketches that he made in the diaries. By the end of 1912, Lartigue was
already beginning to add broader, larger illustrations depicting the day's
events, often along with bands of sketched "photographs," which he drew as
insets in the margins of the larger drawings. Moreover, he began to place him-
self in these larger drawings, where he assumes an active role in the unfolding
drama: the cameraman has come forward, emphasizing the autobiographical
character of the work.[76] By mid-1913, however, the bands depicting photo-
graphs have all but disappeared and a new form of pictorial annotation has
taken over. Gone are the neatly drawn, boxlike frames arranged in strips; in
their place are larger drawings, two or three to a page, separated by a thin,
squiggly line or by no line at all, depicting scenes occurring that day. In one cor-
ner, a number within a sprocketed frame indicates the footage shot with the
movie camera. This sits among numbers within frames of other formats, one a

PLATE 82. Jacques Henri Lartigue, diary page (detail), 26 September 1913. Association des Amis de Jacques-Henri Lartigue, Paris

simple box, another a double-outlined box, denoting the number of black-and-white photographs and autochromes, respectively, taken that day.[77] Because he was working in multiple media, Lartigue needed a shorthand for recording his efforts; the larger drawings are a part of his new shorthand system. Rather than trying to document each individual frame he'd shot, which would have been an exceptionally daunting task (on a par, say, with the achievements of pre-digital Disney), he took a cue from cinema to arrive at a solution of fewer, temporally elaborated images, in which a multitude of moments is summarized in a single, nonspecific image. The result is not unlike Masaccio's painting *The Tribute Money* (c. 1427; Brancacci Chapel, Santa Maria del Carmine, Florence), in which an elongated format and continuous narrative serve the needs of narrative complexity and pictorial integrity in a single, clearly laid image.

A half-page drawing from September 1913 (plate 82) is a mélange of time, place, and personal viewpoint. Here, the seams separating each scene are only vaguely noted, if noted at all. A straight, diagonal line running parallel to an ascending road could be a continuation of the winding road in the illustration below; the transition between an embankment and the go-cart route below is entirely legible as real, traversable space; a squiggle in a scene with ascending vehicles serves as a quick barrier between the roadway and the sky of a neigh-

boring scene. Were it not for the squiggle, and the fact that Lartigue himself appears in each of the three scenes, the composition could be read as a picture of a single time and place. Lartigue has noted at the top of the page that he shot nine photographs and thirty meters of film that day. His illustration, with its circulating, ascending, and descending routes defining a sort of continuous, wandering action, is like an instantaneous photograph—but of an entire day. Lartigue has represented the temporality of cinema, but rendered it as a still.

A similar effect can be observed in Lartigue's writing. By the mid-1910s, instead of recording the day's events as a series of moments organized around the hours of the day (8:30 shave, 9:00 breakfast, 10:00 promenade, etc.), Lartigue began writing lengthier, more reflective passages that summarize events occurring over longer periods of time. Passages written at the end of the month, or at year's end, became increasingly common. In 1916, he expressed his reflections on the labor of keeping a daily journal; outbursts of purple prose on the subject of love began to occur that year, too. (Lartigue was discovering his worth as an eligible suitor, but was not very confident in the management of his affairs.)[78] Entries for 1917 became particularly sketchy as the year progressed. He stopped writing in mid-June, than made a comeback in December with one long entry (thirty-three pages), containing his retrospective thoughts on his endeavor: "Here it is, the end of the year. It's the first time my journal hasn't been kept up to date. Why did I abandon it. . . ? Because, increasingly, I've come to realize that the facts I've been recording are of little importance next to all the feelings, all the impressions, all the wonderful things that fill my days that are impossible for me to retain." Further down the page he describes his journal as "a little novel that I'm going to write; it could be perhaps infinitely charming and interesting if only I had talent, and could relate all the sentiments of youth, of love, of hope that constantly make me see life and its events as one sees nature under the first rays of the spring sun."[79]

Here, the diaries (the word in French, *agendas*, is by definition a detailing of affairs) are becoming memoirs before our very eyes. The momentary observations of Lartigue's youth, when the instantaneous photograph served as model for all that was exciting in life, are subsumed in a larger search for narrative continuity, explanation, meaning. When preference for the instant gives way to the explanatory, all the formal artifice—the art—of self-expression associated with such forms as the novel, autobiography, and cinematic narrative takes over his artistic production. Some might say that Lartigue, at age twenty-three, was ripe

PLATE 83. Jacques Henri Lartigue,
"June Notes," diary page, 1914. Association
des Amis de Jacques-Henri Lartigue, Paris

for such a transformation. That a similar transformation was occurring on a vast cultural scale, in the absorption of the instantaneous photograph by an elaborating mass media and narrativized cinema, is more than a coincidence, in my view. Lartigue's sensitivity to the formal changes occurring in imagery around him made his adaptation of certain techniques to the expressive concerns in his own life a foregone conclusion.

Such temporal elongation is expressed quite literally in the panorama, a format that Lartigue would be using almost exclusively by the 1920s. Like the movement of the Klapp-Nettel stereoscopic camera, which could be adapted from stereo to panorama with the flip of a lever, Lartigue's drawings of photographs break their frames, widen, and decenter. The act is at once expansive and generalizing; instead of instantaneous effect, it offers an overview. Here, the reference of the instantaneous photograph is clearly abandoned for a more calculated pictorial idea. In a series of views drawn on an end page headed "June Notes" (1914), Lartigue uses the full page to summarize events pictorially. Three broad bands (panoramas) describe different aspects of the Grand Prix of the A.C.F., held that year outside Lyons (plate 83). The top drawing, captioned "on the circuit," shows a general view of the route, with a broad, curving roadway laid out as a dais, showing automobiles in the foreground, automobiles in the distance, and spectators along the route (Lartigue carefully notes his and his brother's positions). The second drawing, "General view of the stands," shows the route flanked by grandstands from a distance. The bottom view, the most complex, shows a curving segment of the route, with Lartigue in position in the foreground, stationed with his motion-picture camera on a hillside overlooking the action. Below, outside the picture frame (although no line separates the space), three racecars are depicted in specimen form. As these images show, the model for Lartigue's thinking has shifted from the documentation of the specific detail to a larger project of overview. Recollection and idealization have been inserted between the instant and its preservation.

And yet, a significant detail has invaded the picture. One of the most peculiar features of the third drawing is a circular vignette, which offers a telescopic view of the start of the race, added by Lartigue to the left of his overview; it is the only specific moment of the rally that is illustrated. This technique, too, has cinematic origins. The telescopic inset, inspired by early cinema screenings, which often included (and sometimes overlapped) lantern-slide projections, was

common to early cinematic language. In G. A. Smith's movie *Santa Claus* (1898), for example, the earliest recorded instance of the technique, the object of a child's dreams is projected in circular close-up on the wall above the bed. The technique was used in other films to emphasize various acts of looking—a child looking at objects under a magnifying glass, a detective spying on a wayward husband.[80] It was, of course, a cinema of attractions if ever there was one, and Lartigue's use of the pictorial convention is no less attention-getting. The inset, highlighting one of the most dramatic moments of the event, yet offering data within a context of pictorial narration, is an apt representation of the fate of the instantaneous photograph after narrative cinema—the spectral engulfed by the sequential.[81]

THE HISTORICAL DISPLACEMENT of instantaneity by the moving image marked a critical technological passage with broad cultural consequences. The instantaneous photograph, once admired as a scientific novelty, went underground at the moment cinema harnessed its power to replicate movement. Its fascination as a visual curiosity was lost to the later spectacle offered by cinema. Cinema itself suffered a similar fate. The cinema of attractions, a visual amusement with no greater purpose than direct stimulation, slid into oblivion with the introduction of narrative. Visual sensation lost its authority and became subservient to narrative absorption. In both instances, the more complex entity is the dominant one; the weaker becomes a component of the larger system, like a sign absorbed into mythic speech.

Lartigue's photographs track this very same process, emerging from the technological conditions supportive of the instantaneous photograph, following the sportsman's pride over a great shot, finally succumbing to abandonment of the instant for illusion, narrative, autobiography. If Lartigue's photographs continued to express a vague wonder at the potential of technology and man's exuberance over this, it is because they were indeed created in a spirit of genuine awe over photography's ability to show what previously had never been seen: a strange world, in which people appeared with their feet off the ground. Lartigue's efforts to draw these images into a larger personal narrative, establishing at first a simple chronology of a life, later embellishing this narrative as an idealized belle époque childhood, effectively effaced this original impulse. Photography's ability to capture the instant was relatively new in 1910; coinci-

dentally, so was sport. If one wanted to exploit the capabilities of the former, it was logical to aim the camera at the latter—hence the early utility of the instantaneous photograph in sports magazines. Trouble arises in the misreading of Lartigue's photographs as an expression of an exceptionally happy childhood, or, more generally, of widespread period optimism. This is not to claim that Lartigue's childhood wasn't happy, or that people weren't excited about new technologies, but rather that capturing the instant was a fashion, and fashions can look very different in retrospect.

The change of context that occurred in 1911—when Lartigue's photographs made the shift from a collection of unique, sensational instantaneous photographs to a series of illustrations constituting a visual autobiography, based on the narrativizing example set by cinema—substantially alters the original meaning of the photographs. Here, a break occurs between the image and its origins as a technological novelty. It loses its signification as a photographic specimen, an amusement, as a historically determined, technological wonder known as the instantaneous photograph, and becomes instead an illustration, a memory trace, an index of unadulterated joy. Lartigue's youthful passion was poised to become a cultural benchmark.

TRANSFORMATION

LARTIGUE AS ARTIST, 1963–1979

CHAPTER FOUR

LARTIGUE AT MOMA

MORE THAN ANY other qualities, Lartigue's name is associated with spontaneity, authenticity, invention. Usually this is "recognized" as play.[1] Since the summer of 1963, when he made his auspicious debut as a photographer at the Museum of Modern Art, New York, the irrepressible, abiding, and—I hasten to add—false assumption has been that Lartigue's photographs were produced haphazardly, unwittingly, by a wildly imaginative child, one unencumbered by the laws and conventions governing adult creativity. Only a "true primitive," wrote John Szarkowski, who was MoMA's new curator of photography, "could have produced work as confidently radical as this."[2] It did seem radical, not only in its formal dynamism, candor, and vivacity, but also for having been made during the first decades of the twentieth century, before the advent of the Leica, the Ermanox, and other technically advanced hand-held cameras.[3] For Szarkowski, Lartigue's photographs looked like an infantile version of the stylish reportage popularized by Henri Cartier-Bresson during the 1930s; better yet, they seemed to prophesy the recklessly incisive and controversial street photographs of Garry Winogrand, originator of the so-called "snapshot aesthetic."[4] Almost overnight, Lartigue's photographs became known to a large, critical audience. Although most of this audience responded with unbridled admiration, it was an audience nonetheless working with its own set of questions concerning the nature of photography and its distinct artistic bloodlines, an audience eager to discover its own values within the modest borders of Lartigue's "innocent" body of work.

Can it be merely a coincidence, the fact that spontaneity—the grown-up term for play—was a primary aesthetic goal among artists and critics of the postwar period in America? In his book *The Culture of Spontaneity*, Daniel Belgrad defines

Detail of PLATE 94

a "coherent aesthetic of spontaneity" arising in American culture during the 1950s. Spontaneous gesture, Belgrad argues, was a sign of the times, signifying among avant-garde artists and the public alike both a rejection of European culture and dissent against the dominant American ideology of consumerism and technological progress. Spontaneity offered "a third alternative, opposed to both the mass culture and the established high culture of the postwar period."[5] For Abstract Expressionist painters, spontaneity suggested an approach to art-making that was at once formally innovative, establishing an "American style" once and for all, and an art object imbued with authentic, psychological content, something not often visible amidst the vast materialist landscape of American life.

American art photography occupied a special place in relation to this phenomenon. Without a substantial or continuous tradition of its own, left to languish within the pages of the picture press for much of the twentieth century, photography did not achieve official or critical academic legitimacy until the 1960s and 1970s. The task of defining a position for art photography that was consistent with MoMA's previous efforts to legitimize photography,[6] while distancing art photography from contemporary commercial work disseminated by picture magazines, as well as from a rising tide of amateur work and developments in other media, became a particularly complex imperative. The spontaneity exemplified by Lartigue presented one solution, just as the classical stasis of Eugène Atget revealed another. Together, these two aesthetic sensibilities established boundaries for photographic practice. You were either spontaneous or studied in your approach—a "window" or a "mirror," as Szarkowski framed the choices in 1978[7]—and either way, you were true to the limitations of your medium, for this had been the indisputable given of modern photography since the end of Pictorialism.

Szarkowski's mission to alter the course of art photography during the 1960s found in Lartigue a vivid accomplice—and also a pliant one. Lartigue, still living, contributed greatly to his own mythification; and Szarkowski, by ignoring, misinterpreting, or simply not questioning the evidence at hand, "authored" Lartigue to suit his own theoretical precepts. To illustrate his narrative of the birth of photographic modernism, Szarkowski stressed form over content, intuition over know-how, experience over art. This view of Lartigue was as distorted as it was potently influential. Indeed, the episode is emblematic of the nature of historical transference in general. When Nietzsche wrote in *The Use and Abuse of History*, "Forgetfulness is a property of all action," he was arguing that a little fictionali-

zation of history helps to make it more compelling and "useful" for mobilizing change in the present.[8] Lartigue's foray through the sacrosanct halls of MoMA reveals more than the deformities that occur when one historical moment searches for inspiration in another; it also dramatizes the resulting consequences—in this case, a radical retheorization of photography, a revision of its history, and the birth of a new "master."

Prelude to the Exhibition

Lartigue's discovery by the American art establishment in 1963 marked a positive turn in his life. During the period between the two world wars, Lartigue had gained and lost the spoils of an entire career as a painter. He had started in the late 1910s with large light-filled, Bonnard-style canvases of gardens and portraits of his new wife, Bibi; but by the time his work entered the salons during the 1920s, he had moved on to what the press termed "l'art sportif."[9] Although critics often noted talent in Lartigue's paintings of tennis players, boxers, and automobiles, the genre as a whole was panned. "These works do not excel beyond the level of a good snapshot," declared one perceptive critic.[10]

Lartigue soon turned to other subjects, including flowers, portraits of famous acquaintances, fashion illustration, and interior decoration.[11] While his work was not universally celebrated, Lartigue was certainly prolific, and his paintings were widely shown. He was a regular participant in numerous seasonal exhibitions, including the Salon d'Automne, the Salon des Indépendants, the Salon de l'École Française, and the annual exhibition sponsored by the Société Nationale des Beaux-Arts, most of these held at the Grand Palais, Paris.[12] He was also represented by the Galerie Georges Petit, Paris, the gallery that represented Monet late in his career.[13] By 1931 *Le Figaro* offered the fair estimation that Lartigue was certainly "the most brilliant and bold of decorative floral painters."[14] Two years later, he exhibited with Picasso, Kees van Dongen, and Jean-Gabriel Domergue in an exhibition called *Mon Paris*.[15] The onset of World War II, however, altered whatever course Lartigue's career had been on. He continued painting after the war, exhibiting his work at the Galerie Alex Cazelles, Paris, but by the mid-1950s his career as a painter was essentially over.[16]

Lartigue had reason to strive for success as a painter. His father's vast fortune, which was substantially diminished by the stock market crash of 1929, declined even further during World War II. Although the family still owned

properties, their liquid assets were apparently quite limited. Social connections insured a certain standard of living, with invitations to Maxim's and to houses in the south of France providing a buffer from the unsavory aspects of poverty. According to Florette Lartigue, what little income she and her husband shared came through the sale of paintings.[17]

In 1950, Lartigue began selling photographs to the popular press, especially to religious publications. *Fêtes et Saisons* and *La Vie Catholique illustrée*, French Catholic versions of *Life* magazine, published numerous photo-essays by Lartigue on religious life. His photographs of convents, the hardships of rural life, and religious ceremonies appeared throughout the 1950s.[18] Other opportunities arose through Picasso and Cocteau, whom Lartigue had met through the gallery circuit. In 1955, Lartigue photographed Picasso undergoing acupuncture treatment in Cannes, where Lartigue also vacationed; these photographs appeared in *L'Aurore*, *Point de Vue*, and in other publications around the world.[19] At the age of sixty-five, a career in photography began to resurface as a lucrative possibility.

A year earlier, Lartigue had become involved in organizing L'Association des "Gens d'Images" (Association of "picture people"). Although Lartigue was still little known as a photographer, his friend Albert Plécy, a founding editor of *Point de Vue*, *Images du Monde* and a private admirer of Lartigue's photographs, asked him to serve on the board of the new organization; Lartigue became a co–vice-president, sharing the title with Raymond Grosset, who soon became Lartigue's photography agent.[20] Lartigue also served on the jury of the Prix Nièpce, an annual award presented by Gens d'Images to a photographer whose work demonstrated significant artistic merit.[21] The organization also sought to establish a permanent exhibition space for photography. "The Museum of Modern Art, New York, and the Art Institute of Chicago alone organize regular exhibitions of photography," Plécy noted in the organization's press release, a manifesto of sorts declaring the group's ambition to raise public awareness of photography as a contemporary art form. The Galerie d'Orsay, located at 73 bis, quai d'Orsay, was selected as the site for this veritable "Académie de l'Image." The first exhibition, a show of color photography, was held in 1955.[22] Other shows that year included *Nu*, *Photos Choc*, and an exhibition of color photographs of flowers by Lartigue and others held at the Salle Guimet, place d'Iéna.[23]

Although there were certainly photo visionaries in France during the 1950s, photography did not have an institution like MoMA, or a publication like *Aperture*,

to promote the idea of artistic photography.[24] The photography agency Magnum was founded in Paris in 1947, and the style of photography propounded by Robert Capa, Cartier-Bresson, David "Chim" Seymour, and other members certainly had its aesthetic merits; but this was reportage, photography produced for the printed page and not intended—at least not at first—for art exhibitions.[25] As a publisher of photography books, Robert Delpire emerged during the 1950s as a one-man photography institution. His innovations in photographic book design, which allowed images to dominate text, provided a context for work by Cartier-Bresson, Robert Doisneau, Brassaï, Inge Morath, Werner Bischof, Robert Frank, and others.[26] This was a context not unlike MoMA's, in which form was given dominance over text; even so, it was photography for the printed page.

As for institutions, the Bibliothèque Nationale had long been the depository of photographs, but here photography tended to be regarded for its content value alone. Significantly, classification was determined according to subject matter rather than photographer. It was reported in 1953, for example, that, "M. Prinet, of the Cabinet des Estampes at the Bibliothèque Nationale, and charged specifically with the photographic section, has said how difficult it is for him to find photographs of everyday life—of interiors and customs of our time—to match the innumerable engravings on these same themes from other periods further back in time."[27] This was published in *Point de Vue*, in an article illustrated with photographs by Lartigue. Indeed, Plécy and the members of Gens d'Images, despite their higher goals for photography, thought of the medium primarily as a purveyor of content. Documentation of life's quieter moments seemed to be their highest aspiration. The author of the article continues: "Besides history's great moments, which have generally been illustrated by the professionals, a whole world exists to be fixed on film which, with time, will gain in value like good wine. That's why amateurs should organize their photographic albums with special care, and protect their negatives, for 'a treasure is hidden within.'"[28]

Plécy was really at the head of the wrong publication for launching a photographic avant-garde. *Point de Vue* was a picture magazine; like *Life* magazine, it catered to a popular audience, and a discussion of photographic form would not have been—to put it simply—popular. Plécy had a bit of a "wooden eye" as well. It is almost embarrassing to note the number of issues in which he published the same insipid photographs by Lartigue and others (flowers, vases of

flowers, flowery landscapes), lending new meaning to the heading "Permanent Salon of Photography."[29] When Plécy decided to publish a selection of Lartigue's early work, which he did in the fall of 1954 (plate 84), he arranged the images like documents submitted for historical consideration, accompanied by extensive, descriptive captions—in other words, they were handled just like the "photographs of everyday life" labeled and catalogued in the Bibliothèque Nationale.[30] "J.-H. Lartigue had found in his own family," according to the text from a second, similar article, published the following year, "the subjects and the elements for the constitution of a veritable photographic archive."[31]

The story of Lartigue as the boy photographer, including the well-known "trap of images" anecdote (*piège à oeil*, or eye trap, as this memory trick was described in *Point de Vue*), actually preceded the publication of his early photographs in *Point de Vue*. "Image Man: J.-H. Lartigue," an article published in July 1954 and illustrated with recent photographs by Lartigue, lays the groundwork for later variations on the theme. The article tells of his extraordinary visual memory which, from the age of six, he cultivated with the aid of his "eye trap": he would look intently at a person, an object, a flower, or an animal that he loved, and then, placing his hands over his eyes, he would preserve the vision in memory. As he grew older, however, the trick faltered. One day, the story continues, his older brother found him in tears and offered him a Kodak. After that, Lartigue photographed all that he found astonishing, striking, or interesting throughout a half-century rich in extraordinary events.[32]

Plécy was careful to position this history in relation to Lartigue's success as an artist working in a legitimate (i.e., traditional) medium; he used the eye-trap story to illustrate an extraordinary, instinctive visual sensitivity, one that formed a prehistory for Lartigue's adult work as a painter. This is consistent with attitudes about the artistic merits of photography at the time. Many artists known today primarily for their photographic work, including Man Ray, Brassaï, László Moholy-Nagy, and even Cartier-Bresson, regularly downplayed their interest in photography, insisting on painting or other media as the focus of their true art.[33] (When offered the Legion of Honor, Lartigue, like Brassaï, asked to be honored as a painter, not as a photographer.)[34] Plécy, clearly ambivalent, bows to this attitude but then goes on to make a truly prophetic (if offhand) statement: "No one questions Lartigue's value as a painter, but who knows; he may one day be more famous as an artist-photographer, he who took photos for personal amusement alone."[35]

The first public exposure of Lartigue's so-called boyhood photographs followed a thematic program. "In the Heroic Days of the Automobile," a selection of approximately fifty photographs of early autos, appeared in *Point de Vue* in September 1954 (plate 84). "All of Aviation History in the Life of a Single Man" was published in *Point de Vue* in Febuary 1955, along with another feature on airplanes, "What Will the Airplanes Lartigue Photographed Look Like in 45 Years, In the Year 2000?" And a selection of his fashion pictures, "Promenades of Yesteryear . . . ," was published in June 1955.[36] With that, Lartigue's debut had run its full course—at least in the pages of *Point de Vue*. Other European magazines noticed Lartigue and ran features with his photographs soon after. For the German-speaking populace, there was "In the Heyday of Automobiles," pub-

PLATE 84. "In the Heroic Days of the Automobile," *Point de Vue*, 30 September 1954. Association des Amis de Jacques-Henri Lartigue, Paris

lished in the *Schweizer Illustrierte Zeitung*, in March 1955.[37] In England, "50 Years on Wheels" appeared in *Lilliput* in April 1955. "The photographs are the life-work of a Frenchman, M. Jacques Lartigue, who realised, when still in rompers, that something would come of the automobile."[38] In both cases, the treatment was like that of *Point de Vue*—archival and brief. Lartigue's debut had occurred, but there it sat. All this would change in New York in 1963.

The Lartigues conceived of their trip to the United States as a kind of second honeymoon. At an exhibition in Cannes, in 1961, they met an American couple, Frank and Flo Wolf, who invited them to their home in Los Angeles. The Lartigues, having little money, not having traveled much outside France, and celebrating the twentieth anniversary of their "amour," accepted.[39] They departed by cargo steamer from Marseille on 6 February 1962 and arrived in Los Angeles, at the Wolfs' Bel Air home, on March 6. Except for a disagreeable trip to Disneyland, their stay was pleasant and amusing.[40]

Exactly what happened next is not entirely clear. By Lartigue's later account, it was a mix-up at the shipping company that sent the couple cross-country via Greyhound bus, bound for New York, instead of departing Los Angeles by cargo ship as planned. Once in New York, with no special purpose, Lartigue looked up Charles Rado, a photography agent at the Rapho-Guillumette Agency and a colleague of Raymond Grosset. During the conversation (Rado spoke French), Rado expressed polite interest in Lartigue's photographs. Lartigue and his wife returned to Rado's office the next day with a quantity of prints, which the photographer happened to have with him as something to do during the voyage—for "spot-toning"—according to Florette Lartigue.[41]

The events that followed are now legendary: Rado, thunderstruck, rushed the prints over to MoMA. Two hours later, Rado phoned the couple at their hotel to announce that *Life* magazine had signed on for a portfolio, *Car and Driver* wanted one, too, and the Museum of Modern Art was proposing an exhibition. That night, the Lartigues accompanied Rado to a cocktail party, where they met the former art director for *Harper's Bazaar*, Alexey Brodovitch, who is said to have proclaimed to Lartigue, "All of New York is talking about you."[42] On May 15, the Lartigues departed for Paris, leaving the photographs at MoMA with Szarkowski (under orders to forward them to *Life*), and Rado in charge of affairs.[43]

Accounts differ on what Lartigue showed Rado that day. Lartigue said he offered a single "miniscule album" of old prints.[44] Florette Lartigue says about

twenty small prints were shown to Rado.[45] Szarkowski says that the "oeuvre" he first saw that day consisted of two large "scrapbooks" containing a variety of prints from different eras, and a "sheaf" of fifty-two loose prints, all modern.[46] Grosset gives the broad figure of forty to one hundred prints.[47] Pierre Gassmann, Lartigue's printer during the 1950s and early 1960s, believes that he made the modern prints that were shown to Rado et al. that day but has no specific recollection of the number.[48] To complicate matters further, the ingenuousness of Lartigue's purpose is not entirely certain. In what appears to be an early draft of an account describing his meeting with Rado, Lartigue tells a slightly different version of the story: "Among the 'list of things to do' . . . go show some photos . . . to Rapho's representative in New York, Charles Rado, recommended by Ray Grosset. Ray asked me to go see him 'if I had nothing else to do,' without any hope of interesting him—who, like so many, had been indifferent to my old photos for so many years."[49] According to Grosset, the question of how to earn some money with photography was a common topic of conversation between the Lartigues during this period.[50] If Lartigue had harbored hopes of interesting American editors in his photographs, a detour to New York would have been inevitable, as New York is where the publishing industry was (and is) based in America. Moreover, the question arises: why take precious photographs on a trip to another continent, if not for the purpose of trying to generate interest in them? (Throughout his life, particularly during World War II, Lartigue was extremely anxious about the safety of his collection.)[51] The good fortune that day in New York may have been more strategic than providential.

From the beginning, *Life* and MoMA were at cross-purposes. *Life*, represented by associate editor David Scherman, demanded exclusive first-publication rights, which delayed MoMA's exhibition and catalogue (the latter produced as an issue of the museum bulletin devoted entirely to Lartigue) by months.[52] *Life* also placed restrictions on MoMA's use of certain images for publicity. And whereas *Life* competed freely as a for-profit institution, one that paid agents and photographers for their efforts,[53] MoMA offered only prestige—but what prestige.

Although *Life* and MoMA used the pictures very differently, they did agree on one thing: both demanded higher-quality prints. Orders were sent to Lartigue, via Rado and Grosset, for reprints of images selected for publication and exhibition. According to Grosset, Lartigue made decisions about cropping, which he noted on contact prints; Grosset then carried the negatives over to

Gassmann for printing.[54] Lartigue was liberal in his cropping, often eliminating as much as two-thirds of the original image. As Grosset remarks (and this is consistent with my analysis of early printing practices), it was standard for photographers using older cameras to crop down images from big negatives.[55] Even so, both *Life* and MoMA took further liberties with framing, adapting the pictures to their particular needs. *Life*'s alterations were far more severe. Like *Point de Vue*, *Life* was interested in content, not composition. Pictures were cropped close to the bone, with the center of interest placed large in the frame (plate 85). Frames, moreover, were adapted to fit the layout (see *Simone, Rouzat*, plate 71), which *Life* intended, after all, as just a showcase for historic oddities.[56] Whatever *Life* readers might have thought of this, Szarkowski was scathing:

> By means of poor picture selection, childish captions, and witless cropping, *Life* made Lartigue's pictures look much like those produced every week by its regular staff, except that Lartigue's subjects wore funny clothes. Of the eighteen Lartigue pictures included in the *Life* story, five were also reproduced in the Museum *Bulletin*; in *Life* each of the five was cropped differently than Lartigue's print; in four of these cases the change was radical. The story as a whole stands as a wonderfully clear demonstration of the point of view of the editors and art directors of the leading picture magazines of the time. They regarded a photographer's work as the raw material out of which they might create something interesting.[57]

Szarkowski's intention to emphasize the "lineaments of the pictures themselves" allowed, nonetheless, for some judicious editing.[58] *Bobsled Race, Louis, Jean* (MoMA exh. no. 34; plate 26), the negative for which comprised mostly foreground, had another inch masked out at bottom and right by MoMA. *At the Races, Auteuil* (MoMA exh. no. 12; plate 50) lost an inch at the bottom. Compared with measures taken at *Life*, however, such alterations were minor. And at any rate, Lartigue seems not to have objected in either case.

While MoMA for the most part respected Lartigue's judgment on cropping, Szarkowski did order another set of prints that were larger, cleaner, and untoned. Gassmann's prints, which Szarkowski compliments in a letter to Lartigue, were essentially stock-photography prints, the kind required by magazines for repro-

The family's best jumper was Raymond Van Weers, brother of the girl leaping downstairs on page 67. Jacques kept him jumping so he could photograph the rapid motion, and Raymond happily hurdled chairs, tables, even a goat. Very proper, he kept his hat on.

A donkey pulls two Lartigue-built racing carts up the hill to the chateau, with Maurice in the lead cart. The slow loop-mile trip to the top took half an hour, and the carts shot down the hill at such speed that they frequently flipped over before reaching bottom

No indignity escaped Jacques's camera. When Simone Roussel tumbled off a Lartigue-made scooter while rounding a curve, she found that Jacques had anticipated the spill and was waiting with shutter cocked. She was very good natured, recalls Jacques.

Petticoats fly when Jacques's cousin Marcelle Huguet (whose cousin Robert is securely atop the donkey in the picture above) tries to pull herself up for a ride in the chateau. She made the downhill trip in a cart, which had been harder to stay aboard than the donkey.

duction, but toned to suggest their period of origin.[59] Szarkowski's decision to have the prints enlarged, printed in high-contrast gelatin silver, matted, and placed in thin metal frames endowed the photographs with the status of modern art. A clear distinction was made: larger prints and cool tonality versus smaller prints and warm tonality, art photography versus mass media and turn-of-the-century nostalgia. It was a subliminal makeover; Lartigue's relation to contemporary art photography was visible in the print as well as the image.[60]

One trouble that did arise during the printing phase was a question of authorship: who had actually exposed the negative? Grosset recounts the day that Lartigue, presented with the list of photographs *Life* wanted to reproduce, suddenly responded, "No, not that one . . . no, not that one."[61] At MoMA, the

PLATE 85. "The World Leaps into an Age of Innovation," *Life*, 29 November 1963. Harvard College Library, Harvard University, Cambridge, Mass.

first letter came from Rado on 10 December 1962: "I have just received word from our office in Paris that twelve of the Lartigue photographs were actually *not* taken by him, but belong to his personal collection. I am very sorry that we haven't alerted you sooner."[62] The following week another letter arrived: "Our office in Paris has just alerted us that five more photographs from the Lartigue selection you have made belong to his collection but are not actually photographs of his own."[63] On 11 January 1963, the last of the letters arrived: "I just received word from Paris that the three photographs as enclosed photostats were not taken by Lartigue himself."[64] This news wreaked a slight havoc on operations at MoMA. Szarkowski explains that five of the "Collection Lartigue" pictures had been destined for the *Bulletin*, and seven were to be installed as part of the exhibition but had to be taken off the list once this news arrived.[65]

Where did the "Collection Lartigue" photographs come from? The answer came sometime later, during a visit Szarkowski paid the Lartigues in Paris. When Szarkowski raised the question (Grosset's American wife, Barbara, translated between the two parties), Lartigue answered that the "Collection Lartigue" photographs were, for the most part, from the Société des Bains de Mer, Monaco, which had disposed of its photographic collection after World War II. Nostalgic for the era and lifestyle that the photographs represented, Lartigue incorporated them into his collection.[66] The explanation is supported by the fact that the majority of MoMA's "Collection Lartigue" photographs were taken in Monaco. Szarkowski seems not to have understood this explanation; in "The Debut of Jacques Henri Lartigue" (1992), he wrote: "We have not yet solved the mystery of who made the photographs of the 'Collection Lartigue.' I asked Lartigue when we met, but we did not really have a language in common. His answers were much too rapid for me, but it was clear that he regarded the confusion as unimportant, now that it had been set straight."[67] From the very start, miscommunication played an important role in the shaping of Lartigue's image as a photographer.[68]

Szarkowski and Photographic Modernism
The Museum of Modern Art had been chartered essentially as an educational institution, with the twofold task of alerting the public to revolutionary developments in modern art and establishing modern art's historical roots by showing its relation to the more familiar art of the past.[69] These goals varied in their

urgency over time and across departmental divides.[70] MoMA curator John Elderfield has warned against making the mistake of presuming a "monolithic institutional ideology," and this point seems particularly relevant to an investigation into the Department of Photography.[71] From its founding in 1940, the photography department was confronted with the unique challenge of identifying a tradition of photography in addition to bringing new work to the public's attention. Photographer Paul Strand complained in 1923, "Photographers have no access to their tradition, to the experimental work of the past. For whereas the painter may acquaint himself with the development of the medium, such is not the case for the student-worker in photography."[72] With the possible exception of Edward Steichen's curatorship, the photography department's mission may be characterized as an institutional response to Strand's complaint.

Beaumont Newhall had laid the groundwork by exhibiting a technical history of the medium, from which he extrapolated a set of aesthetic implications. This treatment included a short list of photographic masters crowning an account of the more practical aspects of the medium.[73] Due to a complex set of political and financial circumstances, however, Newhall's greater program was waylaid, and the rather populist approach to photography adopted by Steichen, Newhall's eventual successor, dominated the department throughout the 1940s and 1950s.[74] The changing of the guard from Steichen to Szarkowski has thus been characterized as a return to the art-historical perspective outlined by Newhall.[75] This is an important point to emphasize, as Szarkowski's almost mythic change in curatorial direction seems by and large a conscious response to his predecessors, especially Steichen.[76]

Szarkowski proceeded by shifting attention from the heroic themes of the Steichen years to a critical investigation of the medium itself. Like Newhall, Szarkowski brought an art-historical perspective to his treatment of photography, and resumed a "great masters" course for his explication of the history of the medium. More important—and here he diverged from Newhall—Szarkowski began a theoretical interrogation of photographs themselves, employing a form of Greenbergian formalism as his primary mode of operation.[77] Formalism offered a vocabulary for defining a pictorial syntax unique to photography, which in turn became useful as a criterion for determining the art status of any given photograph across the broad spectrum of diverse photographic practices. This adoption of formalism thus allowed Szarkowski the theo-

retical flexibility in which to manage the problem of inducting the vernacular into the canon of photography as art, a move that Szarkowski deemed necessary as, in his view, the vernacular roots of the medium defined a vital aspect of its growth and achievement as an art form.[78]

There were, however, continuities of approach that Szarkowski shared with Steichen. First, entirely consonant with the museum's general mission to educate the public, both Steichen and Szarkowski assumed a didactic posture in their curatorial roles. Steichen's execution of this function came through his treatment of photography as a medium of communication, and this he directed toward large social and political issues in much the same way *Life* magazine spoke out with blunt purpose through photography.[79] Szarkowski's message was concerned less with the content of photographs and more with their formal properties as expressive objects. Through exhibitions and publications such as *The Photographer's Eye* (1964; catalogue, 1966), *From the Picture Press* (1973), *Looking at Photographs* (1973), and *Mirrors and Windows* (1978), Szarkowski educated his audience in viewing habits commensurate with his formal theorization of the medium.

A second similarity concerns the treatment of individual photographers in service of these larger didactic programs. Just as Steichen subordinated the unique vision of individual photographers to the communication of larger social and political themes, Szarkowski tended to diminish idiosyncrasies of individual photographers to fit a larger schema. He conceived of photography in a quite Hegelian fashion, as a total organism discovering its own formal nature through the cumulative contribution of a pliant, largely interchangeable photographic collective. Szarkowski's oft-quoted statement that the greatest photographer of all is called "Anon." is an apt illustration of this point.[80]

A criticism that was leveled at MoMA from the very beginning concerned the apparent contradiction in terms posed by the juxtaposition of "modern" and "museum" in the institution's name, an issue made famous by Gertrude Stein in a line to Alfred Barr: "A museum can either be a museum or it can be modern, but it cannot be both."[81] At stake here was the problem of institutionalization, through which process the museum would inevitably enervate its own lifeblood, the avant-garde. This was the price to be paid for obtaining the power to validate and canonize a new list of modern masters, a power MoMA wielded to such effect that the resentments only continue to reverberate as studies in modernism proliferate.[82]

The dynamic central to MoMA's efficacy as a canonizing authority centered precisely on this uneasy play between a continually evolving avant-garde tradition and an inchoate contemporary art scene. For Szarkowski, whose inheritance from Steichen amounted to a popular image of photography as a mass-media organ, the urgency of developing both a body of undisputed contemporary artist-photographers and a supporting tradition of modernist antecedents found its resolution in this defined structure.[83] To put a finer point on it, Szarkowski did what other MoMA curators had done: he refashioned a past to validate the present.

The classic example of this strategy at work is Alfred Barr's watershed 1936 exhibition *Cubism and Abstract Art*, an exhibition that established abstraction as the main goal of modern art, and Cubism as the main movement. To effect this, Barr used established art-historical methodologies, conceiving of art history as an insular process of stylistic development, detached from outside influences, such as social and political conditions. With the aid of his now-famous chart of modern art, Barr presented Cubism as a historically completed style with clear antecedents and descendants. At the same time, he removed Cubism from its own historical, social, and political context. Today such a treatment is widely recognized as arbitrary and limited.[84]

PLATE 86. Garry Winogrand, *Opening, Frank Stella Exhibition, MoMA, New York* [Szarkowski smoking], 1970. Gelatin silver print, 8¾ x 13⅛ in. (22.2 x 33.2 cm). Center for Creative Photography, University of Arizona, Tucson

PLATE 87. Garry Winogrand, *New York*, 1965. Gelatin silver print, 13 ⅛ x 8 ¾ in. (33.2 x 22.2 cm). Center for Creative Photography, University of Arizona, Tucson

Szarkowski never provided a chart such as Barr's, yet the patterns of history, to use Szarkowski's own favorite metaphor, are easy enough to delineate.[85] Where Barr delivered abstraction embodied by Cubism as the salient organizing principle of early-twentieth-century modernism, Szarkowski conceived of the "snapshot aesthetic" embodied by the work of Garry Winogrand for photography in the 1960s (plates 86, 87). And just as Cubism and abstraction represented the fruition of "main traditions" arising out of avant-garde obscurity to take their rightful place in the museum, Winogrand and the snapshot aesthetic signaled the surfacing of the latent vernacular to reinvigorate art photography.[86]

Szarkowski discovered Winogrand just in time for the first exhibition he organized at MoMA, *Five Unrelated Photographers*, which ran from late May to mid-July 1963 (and overlapped the Lartigue exhibition by almost a month).[87] Winogrand, deemed by Szarkowski the central photographer of his generation, seems at times to function as raw material in the hands of Szarkowski, whose distinct gallery hangings and forceful verbal rhetoric so dramatically control the context for determining meaning in the work. This "curator as artist" scenario is a key to understanding Szarkowski's role in the making of artists at MoMA, for it is important to recognize that the artist's promotion is, in a larger sense, tangential to Szarkowski's larger purpose of disseminating a message of photographic modernism. Likening Winogrand to a muse for Szarkowski, Richard Woodward has written: "Winogrand and Szarkowski are as closely linked as Frank Stella and William Rubin, each artist representing for his curator a heroic figure who has carried forward the modernist agenda."[88]

In *Mirrors and Windows*, Szarkowski's assessment of photography of the 1960s and 1970s, Szarkowski characterizes Winogrand as an explorer, a man in search of the "uniquely prejudicial (intrinsic) qualities of photographic description." Szarkowski goes on to define the exact nature of Winogrand's talent: "The self-imposed limitation of Winogrand's art is symmetrical with its greatest strength: absolute fidelity to a photographic concept that is powerful, subtle, profound, and narrow, and dedicated solely to the exploration of stripped, essential camera vision."[89] Szarkowski is suggesting that this lean photographic aesthetic is not Winogrand's own invention, nor is it the product of an individual sensibility; it is instead the essence of the medium itself. Winogrand functions as an artist/cipher in this highly romantic definition of the artist as an explorer of photographic truth. Expressing compliance with this attitude, Winogrand states in the

press release for *Five Unrelated Photographers*: "The man who would be a photographer must proceed from the firm base of respect and love for what his camera and film do best."[90] Szarkowski's conviction that formal resolution was of greater importance than personal vision is most clearly stated in this line from *Mirrors and Windows*: "The ways in which photography can translate the exterior world into pictures is essentially not a personal but a formal issue."[91] In other words, the ideals of art—specifically, photography's destiny as an independent art form—transcend and encompass individual agency. Winogrand is ultimately insignificant alongside the higher purposes of the medium—the higher purposes that Szarkowski skillfully espoused, that is.[92]

Szarkowski, it must be acknowledged, was navigating adverse ideological waters, and perhaps this is why his formalism can seem so extreme. Szarkowski's efforts to win independent art status for photography, a goal that had been neglected since before Steichen's ascension to the "judgment seat," had to win according to the terms set by the art establishment itself.[93] If Szarkowski's formalism is like that of Clement Greenberg, this is partly because Greenberg's ideas held the art establishment enthralled.[94] To talk about photography in the same vocabulary that one used for talking about painting was to harness the power of a popular critical mode.[95] Furthermore, this manner of speaking served to distance MoMA from two closely linked, lower-order positions on photography: the domineering, journalistic approach manifested by *Life*, and the opinion of growing numbers of weekend amateurs, who were increasingly demanding notice in the public discourse over photography.[96]

It was not surprising that, during the 1960s, *Life* and amateurs shared a similar perspective in their disdain for art photography, as determined by MoMA and other museums. Amateur opinion, expressed through magazines such as *Popular Photography* and *Modern Photography*, held that photojournalism still offered the most "dynamic climate" for photographers with talent. Photography, proclaimed Bruce Downes, founding editor of *Popular Photography*, "doesn't need the pretentious label of 'Fine Art' or the support of museums to sustain it."[97] Amateurs, of course, were fans of these magazines, including *Life*, which occasionally honored its readership with contests and special issues devoted to amateur work.[98] Yet amateurs clamored for a kind of recognition that *Life* could not quite provide; indeed, the magazine's attitude toward them was ultimately patronizing.[99]

MoMA's position was less ambiguous, if less encouraging. When Szarkowski first entered the museum in 1962, the mood among amateurs was—naïvely perhaps—hopeful. Jacob Deschin, who wrote a column for *Popular Photography*, expressed hopes that the new curator would honor a more "catholic" view of photography; that he would "advance the cause of photography by demonstrating its achievements in every category where excellence can be found"; that he would provide a "showplace for outstanding work by all who use the camera"; and that he would include in exhibitions at MoMA "amateur hobby efforts."[100]

Szarkowski's taste, of course, was catholic in a way. Lartigue's work might have seemed to some like "amateur hobby efforts" at the time. But this was something altogether different from the photographs of babes and babies taken by *Popular Photography* subscribers. As in 1900, when amateur ranks were swelling rapidly, defining distinctions among amateurs became an absolute necessity. Even before his appointment at MoMA, Szarkowski had set his boundaries, in an article on photography and architecture that appeared in *Art in America* in 1959: "A high degree of competence is within the reach of any genuinely serious amateur. This amateur is in no sense a dilettante. He is free of the necessity of earning his living by photography, but not of the obligations of responsible statement and effective craft."[101] If mass amateurs thought their interests were going to be represented at MoMA—if they thought they might ascend to the tower on the shoulders of fellow amateurs like Lartigue—they had to think again.[102] Szarkowski's formalism worked like a litmus test: although practitioners of all kinds of photography could put their work to the test, very little of it induced the definitive hue that led to being exhibited at MoMA. Form—that mysterious union of "responsible statement and effective craft"—was Szarkowski's gold standard for differentiating between the artistic and the everyday.[103]

Lartigue as Precursor

Szarkowski's conceptualization of photography as a self-contained, self-guiding medium served a practical purpose. It imposed order on a chaotic world of images and photographers. By confining his analysis to the picture within the frame, Szarkowski limited value judgments to style alone. And this criterion encompassed the broad spectrum of photography, embracing the amateur snapshot as easily as the fine-art print.[104] A consequence of this was that one needn't worry excessively about the details of artists' genealogies or the forces of influence.

Szarkowski's conception of photography as an organism comprising an amorphous image-universe conveniently ignored the channels through which visual ideas were supposedly communicated through living, working photographers.

Western culture, however, maintains an ideology of authorship, and this persists as a primary organizing principle, especially within the art museum, where stylistic and economic validity is so dependent on the stability of an artistic persona. Szarkowski's reestablishment of an art-historical approach to photographic discourse demanded at the very least a nod to traditional modes of handling artists. What it came down to was this: artists had to be produced for canonization. And despite Szarkowski's second agenda to demonstrate photography's autonomy from other media, the legitimizing benefits of treating photography like art—and photographers like artists—could not be ignored.[105]

Szarkowski's construction of a photographic genealogy for Winogrand was in keeping with curatorial practices in other departments during the 1960s. A most common practice is what John Elderfield has called the "precursor exhibition." Precursor exhibitions, as Elderfield defines them, were shows devoted to "other periods of art history in which the modern spirit happened to be foreshadowed or by which modern artists have been influenced."[106] The precursor phenomenon had been a significant MoMA strategy all along, especially during the early years, but in the 1960s it enjoyed a resurgence.[107] Elderfield attributes this to the radical changes that occurred in art during this period, and to the subsequent desire to explain this art in terms of a known quantity—art of the past. The precursor exhibition was thus effective not only for validating contemporary work and making it more easily comprehensible, but also for activating and enriching a tradition of modern art with new expressive potential and relevance for the present.

According to Elderfield, the precursor exhibition served two interrelated functions: "first, to contemporize the historical and, second, to historicize the contemporary."[108] Szarkowski "contemporized" Lartigue both conceptually and spatially. Through a series of direct links to hand-held camera work of the 1930s and 1940s, Szarkowski repeatedly cast Lartigue forward in time. "Before he was ten years old," Szarkowski wrote in the MoMA *Bulletin* devoted to the exhibition, "Lartigue was making pictures which today seem an astonishing anticipation of the best small-camera work done a generation later."[109] Here the connection is conceptual; Lartigue is lifted out of his own historical period and grouped with photographers of a later time. In another example—the press release for the exhi-

 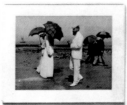 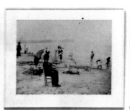

bition—Szarkowski first draws formal parallels between Lartigue and Cartier-Bresson, and then introduces Atget as a point of contrast: Lartigue's pictures, which are "concerned with movement and the continually changing image it creates, suggest the work done a quarter century later by Cartier-Bresson, yet they were done during the same years in which Eugene Atget documented Paris with the techniques and photographic approach of the nineteenth century."[110]

How far forward in time did the comparison with Cartier-Bresson bring Lartigue? The link is indeterminate, as Cartier-Bresson was at once celebrated for his visual innovations of the 1930s and still widely influential in 1963. The completion of Lartigue's contemporization was not fully realized until it was stated spatially—in the context of the exhibition (plates 88–92). The hanging of Lartigue prints in the MoMA galleries (synchronous with *Five Unrelated Photographers*, as I mentioned earlier) achieved a recontextualization that was quite literal and, I would argue, even more compelling than the verbal rhetoric of the curator. Showing the photographs in sleek modern frames, mounted on white walls, subdued the historical aspect of Lartigue's photographs.[111] Szarkowski's belief in the hegemony of the visual was emphasized through a distancing of Lartigue's work from its original intent as personal documentation.[112] Excerpted from their original context of the album and divided from their textual counterpart—Lartigue's diaries—the prints floated in the void of the contemporary gallery, where their formal acuity was brought to the fore.[113] By exhibiting the photographs this way, Szarkowski unveiled an approach to photography from

PLATE 88. First wall of the exhibition, *The Photographs of Jacques Henri Lartigue*, Museum of Modern Art, New York, 1963

earlier eras that would become a hallmark of his career as a curator: projecting the critical concerns of contemporary photography onto images of the past that were never intended as art.[114]

Szarkowski's ahistoricism is most evident in the careful sequencing of Lartigue's images. On the face of it, the organizational system seems thematic, with groupings of fashionable women, airplanes and kites, swimmers, bicycles and automobiles (see the installation views [plates 88–92], and the Appendix containing MoMA's exhibition checklist). Note, however, that the images on the third wall (plate 90) comprise a curious mixture of kites, airplanes, and swimmers, an arrangement lacking thematic unity. The wall becomes comprehensible only when it is perceived as presenting images of an activity rather than of a subject—that is, when the unifying principle is recognized as a verb and not a noun. Thus, the theme is quickly understood to be the activity of flying, or better, floating, which encompasses MoMA exh. no. 31, a picture of Lartigue's brother serenely poised in an inner-tube float (plate 32). Following this logic, the other wall groupings can be interpreted as sunning, strolling, floating, and riding. This organization is based not on historically specific subjects or themes—various forms of French leisure circa 1910, for instance—but on a notion of universality: common human activities across the ages. The approach is not so different from Steichen's organization of *The Family of Man*, which traversed themes of birth, work, and death across vastly different cultural landscapes, but Szarkowski is also specially attentive to another potentially unifying aspect of the exhibition: its formal arrangement.

Each of the walls is dominated by the repetition of a particular formal element. The first wall, the "sunning" wall (plate 88), is regulated by the domes of the parasols in the central images (MoMA exh. nos. 3 and 4), which are echoed

PLATE 89. Second wall of the exhibition, *The Photographs of Jacques Henri Lartigue*, Museum of Modern Art, New York, 1963

in the fanned dress of the girl (MoMA exh. no. 2), and in the elaborate hats of the women (MoMA exh. no. 5). Just as a balance of darks and lights governs each individual image—white dress and black dog, white clothes and black clothes, etc.—the wall as a whole is ordered by a balance of dark and light figures against opposing grounds. (Note, too, that the first image—of young Lartigue with his camera—is removed from the main group and isolated at the left, above the wall text. This photograph, which is key for establishing the myth of the boy photographer, functions in an informational rather than a formal mode and is thus separated from the other photographs and grouped with the other purely informative element, the wall text.)

The dominant formal element regulating the second wall, the "strolling" wall (plate 89), is the strong vertical. This is most clearly articulated in the image at the bottom center (MoMA exh. no. 13), in which the vertical stripes of the women's skirts are repeated in the bars of the iron railing (plate 58). This pattern is carried out through the rest of the "wall composition" in the erect postures of the svelte figures passing by. The third wall, the "floating" wall (plate 90), is formally the most "playful." It is dominated by the diagonal, which is glimpsed in the skewed wings of the careening airplanes and kites, their tether lines, and the flailing limbs of the human forms. The portrait of Lartigue's brother, Zissou, afloat in his inner tube (MoMA exh. no. 31; plate 32), serves as a droll anchor for this lively sequence. The fourth wall, the "riding" wall (plate 91), is based on the circle, prominently displayed and repeated in the wheels of the various contraptions. Two notable exceptions (MoMA exh. nos. 39 and 40, at the far right) cohere with the group through the steering wheel and prominent goggles, while a bent circle in MoMA number 36 adds a moment of formal whimsy. Finally, the fifth wall (plate 92) is conceived as a summary wall, with all the dominant formal elements combined in

PLATE 90. Third wall of the exhibition, *The Photographs of Jacques Henri Lartigue*, Museum of Modern Art, New York, 1963

PLATE 91. Fourth wall of the exhibition,
The Photographs of Jacques Henri Lartigue,
Museum of Modern Art, New York, 1963

three images to produce a polymorphous grand finale. The oval parasols and strong vertical of number 42, the diagonals of both numbers 41 and 43, and the circles of number 41 achieve a crescendo as a trio of images. Here, Szarkowski has summarized his four main points about Lartigue.

Acutely aware that the subjects of Lartigue's photographs held a seductive appeal for viewers, Szarkowski cautioned against falling into a nostalgic stupor and overlooking the more important formal achievement of the work. In the catalogue essay, he deftly escorts viewers away from content toward the more profound appreciation of form: "Time works in favor of the honest photograph, and will in fifty years often turn a banal record into a moving souvenir, sweet with the slight poetry of nostalgia. But the photography of Jacques Henri Lartigue is a different case: here the persuasive charm of a vanished world may hide the work's deeper beauty. For these pictures are the observations of genius: fresh perceptions, poetically sensed and graphically fixed."[115] This passage, in its disdain of nostalgia, reveals Szarkowski at his most ahistorical. The "genius" of Lartigue's photographs, he insists, the real measure of their success, derives not from their "charm" as personal effects, culturally patterned, but from their unspoken relation to the formal values of work by photographers such as Cartier-Bresson and Winogrand. If Lartigue's photography was resonant with modern sensibilities in 1963, it was only because the work of contemporary photographers active during the 1960s had proposed a dialogue on a shared formal plane. This was the common ground Szarkowski fought to emphasize at the expense of other elements in Lartigue's photographs.

The precursor exhibition also historicizes the contemporary, a dynamic that, in light of Szarkowski's theorization of a closed photographic field, takes on a

particular relevance. With Lartigue's arrival on the contemporary art scene in 1963, his legitimizing function as a precursor to Winogrand fulfilled a vital genealogical role. By characterizing Lartigue as a naïve genius, Szarkowski was able to initiate discussion of a vernacular history of the medium. In a partial borrowing from George Kubler's ideas concerning the evolution of form and its manifestation in all areas of material culture, Szarkowski postulated that vernacular photographs contained evidence of the medium's innate properties, and that credit was due to the untrained amateur practitioner for the discovery of these properties.[116]

Szarkowski spelled out his argument and advanced another candidate for the role of naïve genius in his third exhibition at MoMA, *The Photographer and the American Landscape*, which opened in September of 1963 and ran alongside Lartigue for more than a month. In the exhibition catalogue, Szarkowski refers to the vernacular as "photography's central tradition" and names Timothy O'Sullivan a key practitioner.[117] Like Lartigue, who fortunately had "neither tradition nor training," O'Sullivan photographed "with no photographic authority looking over his shoulder" and without concern for "artistic fashions."[118] Szarkowski characterizes this "indigenous tradition" as a common project of photography that unites photographers—particularly those practicing in isolation as Lartigue, O'Sullivan, and Atget did—across time and space in the service of a higher cause of photographic development. Furthermore, only photographers can instruct other photographers in the true capabilities of their medium. Vernacular precursors such as Lartigue and O'Sullivan were thus essential, according to Szarkowski, in constructing a sense of continuity in the medium and served the vital function of demonstrating the existence of a prove-

PLATE 92. Final wall of the exhibition, *The Photographs of Jacques Henri Lartigue*, Museum of Modern Art, New York, 1963

PLATE 93. Eugène Atget, *At the Tambour, 63, quai de la Tournelle*, 1908. Albumen print, 8¼ x 6⅝ in. (21.1 x 16.8 cm). Bibliothèque Nationale de France, Paris

nance for the formal innovations emerging during the 1960s—Lartigue made Winogrand's recklessness intelligible.

The weak link in Szarkowski's theory, of course, is the point of contact between a vernacular tradition and art photography. If vernacular unknowns such as Lartigue and O'Sullivan had really enjoyed the benefits of pursuing photography in aesthetic isolation—which, of course, they did not[119]—where and when, aside from MoMA's exhibitions, did their pioneering discoveries regarding the nature of the medium find their way to a legitimate body of photographic descendants? Before 1963, who did Lartigue ever directly influence?

Szarkowski often discusses the issue of influence, especially as it relates to an artist's importance. In his *Mirrors and Windows* essay of 1978, Szarkowski assesses contemporary photographers along a continuum of photographic precedents and descendants. Winogrand, influenced by Frank, wears the "mantle of leadership" as the most influential—the "dominant figure"—of his generation; Lee Friedlander, in his "playful homage to his peers of the past," is exemplary only as a revisionist; and Diane Arbus, for whom Szarkowski cites predecessors including Brassaï, Bill Brandt, and Weegee, is widely copied but "has not provided a useful model for most of those who have attempted to emulate [her]."[120]

In a 1985 interview, Szarkowski attempted to make a case for the influence of another naïf problem case, Atget (plate 93).[121] Early in the interview, Szarkowski proclaimed Atget to be "*the* central modern photographer." When pressed to explain this assertion in terms of influence—"Atget worked in relative solitude . . . he had virtually no influence on his contemporaries," the interviewer asserts—Szarkowski responds with a "key people" explanation, describing Atget's transformative power over the work of Berenice Abbott, Walker Evans, Ansel Adams, and Cartier-Bresson. The explanation, couched in the vaguest of terms, relies not on a record of specific contact between Atget and these photographers, but on stylistic similarities: "Cartier-Bresson did not write about [Atget] but saw him very early on and made plain flat-out Atgets in the beginning."[122] Szarkowski's explanation may have some validity, yet the implication (and clearly the interviewer thinks this) is that Szarkowski is reaching for facts in order to justify a judgment that is entirely subjective.[123]

Assessing Lartigue's importance in terms of influence is even trickier than with Atget, for Lartigue's photographs had very limited exposure before the

1960s. Szarkowski's rhetorical grouping of Lartigue with Cartier-Bresson and his institutional juxtaposition of Lartigue and Winogrand suggest influence without actually naming it in such terms. The implication is that Lartigue represents more than a paternity for these photographers; metaphorically, Lartigue personifies the childhood of photography itself. More than a "photographer-as-explorer" like O'Sullivan, or an eccentric "pointer" like Atget, Lartigue is treated as an embodiment of camera vision itself. Szarkowski describes Lartigue as "the child [who] loved the physical act of seeing," and as one who saw the modern world around him "as though for the first time."[124] The Lartigue-as-camera metaphor is most fully realized in Lartigue's description of his play activity as a "trap of images" (discussed earlier in this chapter), a story that Szarkowski quotes extensively: "By opening and shutting my eyes in a 'certain fashion' I had found the way of capturing all the images that pleased me! . . . It was a superhuman invention! I caught it all!"[125] The metaphor escalates to mythic proportions at just the point where Szarkowski stops short of offering an explanation for Lartigue's formal precociousness. Szarkowski instead reshrouds the phenomenon in a mythology of primitivism: "It is impossible to believe that the visual character of the child's work—with its remarkable directness and economy—could be the product of a conscious concern with formal values. It is more likely that work as confidently radical as this could have been achieved only by a true primitive: one working without a sense of obligation either to tradition, or to the known characteristics of his medium."[126] The source of Lartigue's inspiration remains hidden, and one is left to speculate that it must be the voice of Photography itself speaking through the child.[127] It is the closest thing the history of photography has to a creationist myth: Photography rising from the mists, looking on itself with awe and wonder.

This narrative could only be sustained as long as Lartigue remained in the nether regions of childhood, that unknown category of desires, abilities, and intentions, and Szarkowski devotes a considerable amount of attention to keeping him there. Szarkowski selected photographs exclusively from Lartigue's "early period" (the most recent photographs in the exhibition are dated 1922, taken when Lartigue was twenty-eight), and dismissed the later work as lacking the "prophetic freshness" of the earlier period.[128] By focusing on this limited portion of the oeuvre, Szarkowski presented only images that seemed to signify youth and spontaneity through formal design.[129]

PLATE 94. Henri Lartigue, *Paris, in the Bois de Boulogne, Grandmother, Mother, Zissou, and Me with My Jumelle, Photo by Papa*, 1903. Glass negative, 3½ x 4⅝ in. (9 x 12 cm). Association des Amis de Jacques-Henri Lartigue, Paris

Szarkowski deployed other strategies as well. Although Lartigue's age when he made the photographs in the exhibition ranged from eleven to twenty-eight (with his average age being seventeen), Szarkowski oriented his discussion toward the juvenile author of a handful of works. When referring to Lartigue's age, he keeps the numbers low: "Before he was ten years old, Lartigue was making pictures which today seem an astonishing anticipation of the best small-camera work done a generation later;" and, "he discovered modern photography at the age of five." Moreover, Lartigue is commonly referred to as "the child Lartigue," "child," and "boy."[130] One has the distinct impression that these are photographs by a pre-adolescent—a ten-year-old, perhaps, or younger.[131] This notion was supported by a portrait of Lartigue, chaperoned by his mother and grandmother, placed at the start of the exhibition (plate 94). A diminutive nine-year-old in the photograph, Lartigue holds a large camera, a hand-held Jumelle. The construction of this myth is easily revealed by asking two simple questions: How many photographs in the exhibition were made at age nine or younger? One. How many photographs were made with the large Jumelle? None. Even knowing this, the image of Lartigue as boy photographer is not easily shaken. Indeed, almost every single exhibition and publication on Lartigue since MoMA has used this portrait to establish the photographer's unique identity as a precocious artist.

Lartigue's role as a personification of photography's childhood dovetails neatly with Szarkowski's idea of a vernacular tradition. Such a tradition, though vital to Szarkowski's explanation of 1960s art photography, remained sketchy and historically ill-defined. Pinpointing the relevance of a mass of nameless amateurs to art photography was, to say the least, a cumbersome task. In order to develop his point, Szarkowski chose to dramatize the issue through metaphor rather than dissecting a tedious history. Consequently, in Szarkowski's genealogy, Lartigue functions not as an actual photographer subject to historical and social contingencies; he is instead a symbol of an anonymous vernacular tradition. "Lartigue" signifies not Jacques, son of Henri Lartigue, but a massive body of anonymous amateur photographs dating from the dawn of the twentieth century. Lartigue lent an identity to the category of vernacular photographer— which, it should be emphasized, never existed as a coherent entity in the first place—and supplied a body of work to prove the value of such a category. For the sake of history, Lartigue acceded to the role of author.

Michel Foucault's well-known concept of the author-function provides a model for examining this issue, and I want to invoke his theory here briefly for the clarity of its exposition. According to Foucault, authorship serves a vital function by circling a body of work and by signaling a particular artistic intent. More specifically, the author-function operates according to a set of constants. The author is: defined as a constant level of value; used to designate a field of conceptual and theoretical coherence; conceived as a stylistic unity; and appreciated as a historical figure at the crossroads of certain presumably important events. The author is the principle of unity, according to which all irregularities must be resolved.[132]

The key terms here are constant value, stylistic coherence, and historical importance; these are the concepts that the author-function clarifies. Now consider this passage by Szarkowski, in which he extrapolates a larger significance from the evident "graphic quality of Lartigue's work": "These visual characteristics of Lartigue's work are not his invention, and are only partly his discovery. They are basic to the discipline of the camera, and are visible with increasing frequency during the nineteenth century. But what had been a random tendency of the camera becomes in Lartigue's work a coherent mode of seeing—a new kind of clarity."[133] One is witness here not only to the flowering of an individual photographer, but to a key moment in the development of the medium as a whole. Lartigue functions as an actor in Szarkowski's mise-en-scène of the birth of modernist photography. The emergence of a "coherent mode of seeing" is embodied in the persona of the ingenuous Lartigue, whose fortuitous presence at this precise historical moment enables a historical condensation to occur. Szarkowski, in his role as revisionist, endorses the value of this moment and, ultimately, the worth of Lartigue as a newly minted artist.

AROUND THE TIME of the MoMA exhibition, Lartigue carried a set of prints over to the Bibliothèque Nationale, in Paris. There, he met with Jean Adhémar, head of the Cabinet des Estampes, who, after looking at the prints, is said to have responded, "Yes, yes, we have lots of pictures from circa 1910. Thanks, goodbye." Lartigue left in a rage. Eventually, Adhémar, having observed Lartigue's success in the United States, came to realize his mistake.[134] Although Lartigue's debut in America was auspicious, his fame grew slowly. A string of exhibitions, publications, and commissions during the 1960s and 1970s increased Lartigue's

recognition as a photographer, but not always on a level with that projected by MoMA. As Szarkowski settled into his role as curator, his theorization of photography evolved, and Lartigue's work continued to play a role in his larger explication of the medium. But MoMA was one isolated instance in which Lartigue's name held some form of high-culture recognition. Other groups celebrated Lartigue for various aspects of his persona—as an amateur, as amanuensis of the belle époque, as a fashion-world dandy—but MoMA alone established for Lartigue a significance as an important art-world figure. Szarkowski, quoted in nearly every publication on Lartigue to this day, demonstrated forcefully, if illogically, Lartigue's relevance to a larger cultural history. Not until the 1970s— when the market for art photography lifted off, photography became part of the art-school curriculum, and France manifested an institutional response to the threat of losing its own photographic patrimony—did Lartigue gain a level of cultural recognition commensurate with his elevated status as an artist first proposed by MoMA.

CHAPTER FIVE

LARTIGUE AFTER MOMA

LARTIGUE'S CELEBRITY IN America took root in two very different contexts. These can be seen represented in the seminal events of 1963—Lartigue's exhibition at MoMA and the publication of his photographs in *Life* magazine. MoMA had catalyzed an art world interest in Lartigue, presenting his work as a signboard for concepts germane to photographic modernism. *Life*, by contrast, treated Lartigue as a messenger from a beautiful lost world, a treatment indicative of a general nostalgia for the belle époque during the 1960s. Despite their mutual antagonism, it was the combination of these two perspectives, buoyed by growing international interest in photography, that secured Lartigue's lasting fame.

Popularization

Perhaps the best measure of MoMA's influence can be seen in the legacy of projects focusing on Lartigue inspired by the exhibition. After New York, *The Photographs of Jacques Henri Lartigue* traveled to seventeen other venues throughout the United States and Canada, including Harvard University, U.C.L.A., the Milwaukee Art Center, and the National Gallery of Canada; the exhibition toured for more than three years.[1] In 1966, Lartigue's work appeared in the fashion section of the Photokina photography fair, Cologne, and in 1972 he had shows at Witkin Gallery and Neikrug Gallery in New York.[2] A reviewer of a 1974 Lartigue exhibition, held at the Alliance Française, New York, summed up the cultural worth of Lartigue by declaring that "Lartigue's boyhood photographs represent one of the most precious commodities in the photography market today—the innocent eye."[3] During a visit to New York in 1974, to oversee the production of a commercial portfolio by Time-Life, Lartigue attended a cocktail

Detail of PLATE 96

party at collector Sam Wagstaff's Greenwich Village apartment, where the photography curator of the Metropolitan Museum of Art, Weston Naef, offered to buy his entire collection of albums on the spot.[4]

Lartigue's photographs also continued to appear in exhibitions at MoMA. Both *The Photographer's Eye* (exh. 1964; cat. 1966), Szarkowski's first large and coherent theoretical statement on photography, and *Looking at Photographs* (1973), a primer for comprehending photographic form, deepened the image of Lartigue as a child prodigy. At the same time, they elaborated the idea of photography as a closed formal universe, where vernacular and art photographs shared an equal footing.[5] "When [Lartigue's] work came to light," Szarkowski explained in the text accompanying Lartigue's *Anna la Pradvina* (plate 61), "it seemed to confirm the inevitability of what had happened in photography much later, when more mature and sophisticated photographers came to understand what the child had found by intuition."[6] The Lartigue who made that photograph was actually seventeen years old, socially astute, and keyed in to the technical and aesthetic practices of his medium—evidently not the photographer Szarkowski had in mind.[7]

Szarkowski's ideas had an enormous impact on photographic thought. Two points in particular captivated the photographic community. One was the modernist notion of photography as a discrete artistic medium, with its own distinct aesthetic qualities, as outlined in *The Photographer's Eye*. On the broad acceptance of this approach, critic Gene Thornton wrote, "Szarkowski's new aesthetic found growing acceptance in art photography circles. It encouraged the growth of a new breed of art photographer who looked not to contemporary painting for artistic models but to photography itself, and it gave rise to a new school of photography critics and historians who concentrated on the peculiarities of the photographic medium."[8]

The other idea, a less aristocratic one, held that vernacular photographs—those not consciously produced as art—could be considered works of art retrospectively according to aesthetic standards set forth in *The Photographer's Eye*. This idea was in many ways more problematic than the first. In a survey of the field written in 1976, Janet Malcolm examined the effect registered by "Szarkowski's pioneer work" in relation to other trends. Whereas Szarkowski insisted on a pluralistic approach to the medium, inviting consideration of "the family snapshot as well as the Weston pepper," other members of the photo-

graphic establishment did not see matters so clearly. Dealers in particular still held a vested interest in maintaining distinctions between vernacular photographs and those produced by knowing craftsmen working within a self-conscious fine-arts tradition. Malcolm wrote:

> If every family album and historical society and old copy of *Life* is a source of art photography . . . , then what is all the trade in, study of, fuss over, writing on, pains taken with photography about? Few members of the photographic community have cared to look at this question (photography has, after all, only just pushed its way into the art market, so why instantly rock the boat?), and most have simply . . . carried on as though nothing had happened—upholding the heavy-breathing traditions of Stieglitz, Steichen, Weston, et al., promoting the equal right of photographs to hang in museums with paintings, cherishing the fine print, distinguishing between good and bad work in terms of the pictorial aesthetic thrown up by a small body of acknowledged masterpieces, and making these masterpieces available to students and lovers of photography, in the way that the classical repertory is kept before concertgoers.[9]

Amidst all the adjudication and adulation, the fabled "vernacular forefathers"—i.e., the "artless" generators of imagery for a later generation of cognizant, art-photography practitioners—fell into a state of photographic purgatory, caught between a market most at ease with the provenanced art photographer and the random, uninformed products of the casual amateur, discussion of which was always more hypothetical than concrete. If sufficient evidence was not available to secure Lartigue in the first category, he would have to be consigned to some subcategory of the second—although clearly he did not belong there either. Hence Szarkowski's term *primitive*, synonymous with *untrained*, though nuanced toward a specific and beloved modernist category laden with romantic and periodizing connotations. Lartigue was an amateur because he was unprovenanced; he was a primitive because his work radiated genius, and because he preceded other photographers of similar stature.

While the vernacular alternative threatened to sully the good name of Photography, it also spawned (thus taking Szarkowski's ideas to their natural conclusion) a legitimate art-photography movement of its own, one that sought to

negate the values of the Stieglitz/Weston set by embracing formlessness, accident, imbalance, even ugliness—the very definition, in a nutshell, of the "snapshot aesthetic." These values, so radiant in the work of Garry Winogrand, Lee Friedlander, and William Eggleston, were not really the values of the movement's so-called forebears, the Lartigues, Atgets, and O'Sullivans, whose photographs demonstrate (as I and others have shown) a conscious quest for form, order, and clarity. Rather, they were the by-products of true vernacular efforts, the slop-and-pail work of mass amateurs, who photographed in happy ignorance of discussions of photography held at MoMA, at art schools, or even in the pages of *Popular Photography*. True vernacular photographs, it should be underlined, rarely made it into collections such as MoMA's.[10]

An anthology edited by Jonathan Green, *The Snapshot*, published as a single-theme issue of *Aperture* in 1974, demonstrates the theoretical incoherence of this particular aesthetic movement. The book, which contains "imitation snapshots" (Malcolm's term) by Winogrand, Emmet Gowin, Nancy Rexroth, Robert Frank, and others is introduced with an essay by Lisette Model, whose definition of the snapshot centers on a unique yet hard-to-define quality, "innocence": "The picture isn't straight. It isn't done well. It isn't composed. It isn't thought out. And out of this imbalance, and out of this not knowing, and out of this real innocence toward the medium comes an enormous vitality and expression of life. . . . We are all so overwhelmed by culture and by imitation culture that it is a relief to see something which is done directly, without any intention of being good or bad, done only because one wants to do it."[11] The sensibility certainly descends from Lartigue (who else at the time exemplified "real innocence toward the medium"?), but it is based on a false notion of his approach, a misinterpretation of his talent. Lartigue's photographs, as accomplished as those of any serious amateur, as calculated as those of any photo-reporter, were, contrary to what partisans of the snapshot aesthetic believed, composed, thought out, knowing, intended, and "straight." These are the same qualities, moreover, that are apparent in all the other contributors' photographs in *The Snapshot*—except that their work strives for the reverse. Indeed, Lartigue's photographs are as intentionally "done well" as works by these faux snapshooters are intentionally "not done well." The phenomenon underlines a gross misunderstanding: historical instantaneity mistaken for spontaneity, social perspicacity for optical innocence.[12] It was an error that did not pass unnoticed by Lartigue. After a seminar led by Cornell Capa at the newly founded International

Center of Photography, New York, in 1974, Lartigue confided in his diary: "Same photos and same questions, most of which reveal a complete lack of imagination in these brains that think they understand, yet understand nothing."[13]

Lartigue's fame developed to a large degree through the publication of two immensely successful volumes. Within a decade of his debut at MoMA, two new books of his photographs appeared: *Boyhood Photographs of J.-H. Lartigue*, a facsimile family album published by A. Guichard in 1966, and *Diary of a Century: Jacques-Henri Lartigue*, a project edited by Richard Avedon and Bea Feitler, published in 1970.[14] While the books' texts were conspicuously biographical (and thus, unlike Szarkowski's writings, encouraged readers to wax nostalgic over the belle époque), they reinforced and extended Szarkowski's characterization of Lartigue as a photographing naïf and, just as important, disseminated a much larger selection of his work. Critic A. D. Coleman described *Boyhood Photographs* as "a combination Bible and touchstone to a generation of photographers who . . . were frequently in teaching positions."[15] Coleman's assessment of Lartigue as "one of the major influences of contemporary photography" attests to the influence of Szarkowski's ideas by the mid-1970s. More obvious, it recognizes Lartigue as a legitimate presence in photographic thought, a genuine forefather eliciting study and response. Whereas Szarkowski had written Lartigue into a schematic history, Coleman was testifying to (and abetting) Lartigue's contribution to history in the making.

The photographic establishment was growing and diversifying by the late 1960s. University art programs in particular were striving to accommodate a widespread fascination with photography. Before World War II, few programs in photography had existed in the United States. Most prominent was the one established in Chicago by László Moholy-Nagy in 1937 at his New Bauhaus School of Design (later renamed the Institute of Design), where many important photographer-educators of the next generation received their training.[16] After 1944, largely because of opportunities created by the Servicemen's Readjustment Act (the G.I. Bill), photography programs expanded and proliferated, most notably the California School of Fine Arts in San Francisco, headed by Ansel Adams and Minor White, and the Rochester Institute of Technology, which offered courses by Minor White and Ralph Hattersley and a history course taught by Beaumont Newhall.[17] During the 1960s, a second expansion of photography education occurred. This was closely related to progressive education

reforms enacted on a primary-school level, where photography was enlisted in the campaign for "visual literacy."[18]

Such ideas found fruition in two already-existing university departments: journalism and art. Although journalism programs attracted many more participants, art schools demonstrated greater transformations overall.[19] The Maryland Institute College of Art, in Baltimore, reported a forty-percent increase in enrollment of photography students in 1968 and announced plans to offer an M.F.A. in photography the following year; Moore College of Art, in Philadelphia, reported that "the popular acceptance of photography as a college course . . . has led to the development of that subject as a major."[20] Increased interest in photography encouraged expansion of several important programs. Harry Callahan, formerly a teacher at the Institute of Design in Chicago, arrived at the Rhode Island School of Design in 1962 to transform its photography program; Minor White began reshaping the program at the Massachusetts Institute of Technology in 1965. Meanwhile, Robert Heinecken, at U.C.L.A., was encouraging experimental approaches to the medium; and in 1969, the State University of New York at Buffalo announced an affiliation with the Visual Studies Workshop, directed by Nathan Lyons, formerly of George Eastman House.[21] By the early 1970s, study of the history of photography was solidified as well. Van Deren Coke developed the program at the University of New Mexico, where he was replaced in 1971 by Beaumont Newhall; Thomas Barrow was added to the faculty soon after. In 1972, Peter Bunnell was appointed to the McAlpin Professorship of the History of Photography and Modern Art at Princeton University, the first academic post of its kind.[22]

All this academic activity was part of a larger interest in photography, most clearly demonstrated by the increasing number of photography exhibitions by the late 1960s. A writer for the *Photography Annual 1970* found it remarkable that in 1969 there had been twenty-four exhibitions of photography on view at one time in New York City.[23] MoMA alone was mounting between five and eight photography exhibitions per year during the 1960s, peaking at ten shows in 1970.[24] The Metropolitan Museum of Art, the Boston Museum of Fine Arts, the Smithsonian Institution, the San Francisco Museum of Modern Art, and many others were adding or enlarging photography programs. Furthermore, media coverage of photography promoted interest on a national level. Major publications—including *Life*, *Newsweek*, the *New York Times*, *Art News*, and *Art in America*—devoted

special issues to photography during the 1960s and 1970s.[25] Coinciding with this, commercial galleries were becoming increasingly viable. Lee Witkin, who exhibited Lartigue in 1972, opened his gallery in 1963. Castelli Graphics began representing photographers in 1971, and Rinhart Gallery and Light Gallery both opened that same year.[26] Predictably, the auction houses followed suit. Sotheby Parke Bernet held the first big sale of photography in New York in 1970; by 1975, the auction house was holding regular, semiannual sales. Christie's began regular photography auctions in 1978.[27] The sales included not just older photographs, but the work of living photographers as well. Ansel Adams, who had stopped making prints on demand in 1975, saw the prices of his photographs skyrocket.[28] With the sharp upsurge in the market value of photography occurring during the early 1970s, photography's legitimacy, claimed by the trinity of art museum, academy, and market, was complete.

Lartigue's debut had been remarkably well timed. In the decades before, particularly in France, photographers had had to rely on picture magazines and government archives as venues for their work. By the early 1970s, however, a vital art-photography discourse was pulsing through a network of museums, galleries, and universities in America. A system was suddenly in place for accessioning, interpreting, and appreciating photography as a modern art form. The misguided comment of a *Village Voice* writer who, in 1975, smugly declared that "Lartigue was a child prodigy, and we knew it first," harbored a rather fanciful distortion of circumstances.[29] It wasn't that the French lacked the judgment to publicize the talents of their countryman; they simply hadn't the same critical apparatus—not yet, at least—for promoting his achievement.

One of the great ironies of Lartigue's entrance into the history of photography as a precursor is that the photographers he was positioned to validate were already fully developed, if not firmly established, by the time he came along. Lartigue had no real influence on Winogrand; it was the younger photographers, those making their way through art school and embarking on careers circa 1970, who were actually affected by Lartigue's work. Mark Cohen, Duane Michals, Ralph Gibson, Emmet Gowin, Jerry Uelsmann—these photographers and many more were in a position, historically speaking, to absorb, process, and advance certain aspects of Lartigue's work, to take him into the fold of photographic tradition.[30] And yet Lartigue's photographs bear little resemblance to these photographers' work. Here, Lartigue's legacy was not so much a formal ideal as an

attitude toward photography. As photographers proceeded to slough off Szarkowski's binding modernist theories during the 1970s, particularly the mandate for photographic purity, they embraced one aspect of the Szarkowskian Lartigue unequivocally: Lartigue had recorded his own life. For Szarkowski, this obvious fact mattered only to the extent that Lartigue's life was gilded, that its gleam drew him out into the world and down a path toward pure camera vision. For others, especially young photographers determined to discover for themselves the potential of their medium, Lartigue had done something personal and expressive. Their Lartigue had asserted his subjectivity through the camera; Szarkowski's had subordinated his will to it.[31]

Exposed to Lartigue's photographs via professors, publications, new exhibitions in New York and Rochester, and through direct contact with the photographer himself—who traveled to the United States in 1974 to participate in workshops— young photographers devoured Lartigue's work.[32] Mark Cohen, a young photographer at the time, recalls attending a presentation by Lartigue in New York: "The room was packed to the rafters . . . hundreds, more maybe . . . young photographers in surplus army jackets, [with] Leicas . . . Nikons."[33] Pilgrimages to see Lartigue in the flesh were also common. Ralph Gibson and Erica Lennard traveled to Paris in 1972, reporting to Lartigue: "All the students in American photography schools talk of nothing but you."[34] Others made the trip as well: Duane Michals paid a visit in February 1973; a troupe of English photography students passed through in March of that year; some Canadian students turned up in May; another, who was writing a thesis on Lartigue, appeared in June.[35] Despite some bemusement over the uninformed questions posed, Lartigue could only conclude: "This is decidedly the great dessert era of my life."[36]

Stylistic diversity characterizes photography of the 1970s, but a search for the personal, the subjective, the authentic was a common goal among photographers striving to define themselves during this period. As photographers proceeded to experiment with their medium, swept along in the current of cultural rebellion and innovation taking place in art schools, the photographic image began to take many forms. This is observed in the products of various "movements," including the theatrical fictions of Michals and Arthur Tress, the neo-surrealism of Uelsmann and Gibson, and the mixed-media experiments of Heinecken.[37] Common to all was an impulse to reinvent photography, which was seen as part of a larger project to reinvent society itself.[38]

Lartigue, on the face of it so culturally and historically remote, seems an unlikely messiah. Yet the language that photographers used in talking about him (as most of them did) reveals an attraction based more on approach than form. "Innocence," "authenticity," "experimentation," "emotion"—all modish topics among creative-photography students during the early 1970s—found precedence in the example of Lartigue. Cohen "loved the way [Lartigue] experimented and did camera tricks."[39] For Uelsmann, Lartigue's work was "emotionally based . . . authentic and embedded with social insights. . . . There are so few examples of photography that celebrate life with enthusiasm and a sense of humor."[40] A shift in the way photographers regarded themselves was also occurring at this time, and this can be seen in how photographers expressed their admiration for Lartigue's creative spirit. "Ralph Gibson, with his pale blue eyes," Lartigue recounted in his diaries in 1973, "finds it wonderful that I still have the 'muse' in me."[41] Now that photographers had an established place in art school and were no longer dependent on the paradigm of the picture magazines (*Life* folded in 1972), they were able to reassert an expressive sensibility.[42] It was a quiet defiance of Szarkowski. Less and less beholden to a single critical perspective, photographers were encouraged to advance their own subjectivity through an exploration of, among other things, formal experimentation, an emotional approach to subject matter, and an imaginative reinterpretation of photographic tradition.

While for some photographers Lartigue's name was synonymous with invention, imagination, and authenticity, regardless of what form these took photographically, for others—"true amateurs," readers of *Popular Photography* and the like—his effect was much more literal. Photographer Charles Harbutt wrote a series for *Modern Photography* during the mid-1970s called the Harbutt Workshop, which featured Lartigue as an exemplar of photography's basic principles. One installment, "The Shutter," had amateur photographers restaging Lartigue's fabled discovery of the "eye trap" for the benefit of experiencing, on some primal level, the fundamental operations of the camera. Harbutt wrote: "The action of the shutter can best be understood with a little experiment. Close your eyes and move your head from side to side and up and down. Then, click: open and close your eyes very quickly. Zap! That's what it looks like inside a camera when the shutter goes off."[43] The semantic imitation of Lartigue ("Zap!") is intended to set the mood for playful discovery. Moreover, photographs by Lartigue serve as illus-

trations throughout the article. Here, however, the lesson is only partly formal. Instead of emphasizing composition, Harbutt catalogues the moods that may be produced by engaging the "various kinds of time photography."[44] He talks of— to go down the list—capturing emotion, communicating the time of day or season, conveying the feeling of an era, picturing important historic events, showing emotional interactions, noting private events, creating sequences to communicate the passage of time, and recording things that remind one of one's memories.[45] What was ostensibly an elaboration of Szarkowski's category "time" is here diluted with references to sentiment and nostalgia. Like serious students of photography, amateur photographers emulated what they took to be Lartigue's innocent approach. While photography students adopted this attitude and applied it to the development of new subject areas and techniques, amateurs stuck with the classic iconography of their genre—photography as a personal record of one's life—which Lartigue's body of work so perfectly exemplified.

The interest Lartigue mustered outside the photographic establishment— mainly in the fashion world, but also among a general audience defined by the readership of *Life*—tended to focus not on the idea of Lartigue as photographer but on Lartigue as emissary of the belle époque. During the postwar period, the belle époque loomed large in the American imagination. Popular films such as *Gigi* (1958) and *My Fair Lady* (1964); memoirs recounting idyllic belle époque childhoods, such as Vladimir Nabokov's *Speak Memory* (1951) and Michel Leiris's *Manhood* (1963); fashion collections evoking a belle époque élan—all were symptomatic of a broad cultural preoccupation with pre–World War I nostalgia.[46] *Life*'s series "The Last Years of Splendor," a glittering exposé on the decline of elegance and royalty (which included photographs by Lartigue in Part II), presented the belle époque as a lost golden age, obliterated by the war. "In the catastrophe of 1914," wrote Edward Kern, author of the article, "the old order was swept away, a new way of life took hold and the world of today was born."[47] The series celebrated the innovations and transformations leading to the development of the modern world (Lartigue performed his part with optimistic aplomb), but it also lamented the loss of what was perceived to have been a simpler, brighter era, the pinnacle of all history that had gone before. Tacitly expressed, too, of course, is an attitude toward 1963. Kern's intimation of an "uneasiness" that "had begun to creep over the age" is easily read as a description of cold-war America as well: "Beneath its surface moved new ideas and

PLATE 95. Jacques Henri Lartigue, *Avenue des Acacias*, 1912. Glass stereo negative, 2⅜ x 5⅛ in. (6 x 13 cm). Association des Amis de Jacques-Henri Lartigue, Paris

forces that seemed radical and dangerous, but were destined to shape the future."[48] Just as Lartigue's debut in *Life* was eclipsed by John F. Kennedy's assassination, the magazine's fiftieth anniversary series on World War I was shadowed by escalating U.S. military intervention in Vietnam.[49] An era plagued by fears of Communism, nuclear holocaust, and civil unrest, the 1960s found in the belle époque a kind of psychic retreat from contemporary conflict.[50]

Lartigue was packaged for a nostalgic American consumer, but he consciously played to this image as well. MoMA and *Life* both solicited from Lartigue personal accounts of his childhood, to which Lartigue responded volubly, in a prose style exuding infantile exuberance. Much of this material was apparently invented, while some of it was based loosely on his diaries, which

Lartigue had not begun writing until he was seventeen. (MoMA rejected much of this new material for their publication.)[51] More firsthand commentary was generated for the 1966 publication *Boyhood Photographs of J.-H. Lartigue*, a facsimile belle époque album with an embossed oxblood cover, sage-green pages, and tipped-in photographs. This "family album of a gilded age" (the book's subtitle) transported readers back to that earlier period through weight and texture as well as image and anecdote. Even more of Lartigue's personal commentary was elicited for *Diary of a Century*, Avedon's book of 1970. By 1975, Lartigue was publishing his memoirs (in French), an elaborately embroidered account of his privileged childhood meant to be taken for the unmediated, original diary, ostensibly begun before he could read or write.[52]

No group embraced Lartigue more ardently than the international fashion community. Already, during the mid-1960s, European editors were making fashion then-and-now comparisons, juxtaposing Lartigue's old photographs with recently commissioned works. A series published by *L'Illustré* (Lausanne), in 1966, paired belle époque fashion with that of the 1960s—women strolling with dogs, emerging from cars, topped in fanciful headgear—and found that nothing much had changed in fifty years (plates 95, 96).[53] A decade later, Lartigue was accepting commissions from *Vogue* and other fashion magazines to photograph their fall collections.[54] Meanwhile, in New York, Cecil Beaton was designing costumes for *My Fair Lady* after Lartigue photographs (plate 97), and Fifth Avenue department stores were filling *vitrines* with belle époque nostalgia wear; "Lartigue Summer" was emblazoned across the glass of one storefront.[55] Also during the 1960s, Lartigue made the acquaintance of fashion photographers Hiro (Yasuhiro Wakabayashi) and Avedon, who mimicked Lartigue's dynamic approach in their own fashion work.[56] Although the styles of the clothes in these fashion shoots were most unlike those of the belle époque (psychedelic as opposed to elegant), the attitudes of the models—who were photographed jumping—paid direct homage to Lartigue. Also published were pictures of Lartigue and Hiro photographing each other—another form of homage.[57]

What all of this ultimately conveyed was a message of seamless progress within tradition. The optimism inherent in Lartigue's work—the dynamism, the experimentation—could also be seen, in the broad sense, as a venerable belle époque tradition. For most viewers, Lartigue's vision of the belle époque was also the embodiment of a current, familiar sensibility; his photographs depicted

PLATE 97. Cecil Beaton,
Audrey Hepburn in *My Fair Lady*
(film version), photographed
in 1963. Sotheby's Picture Library,
London

aestheticized change, the excitement of progress tempered by nostalgia. Like the transformation of Eliza Doolittle from cockney flower girl to courtly noble-woman in *My Fair Lady*, it was a safe vision of change, one achieved on the stage set of the belle époque.

Repatriation

All the attention Lartigue was receiving in the United States was, by turns, baffling, gratifying, and alarming to the French. For some, the boy genius with a camera seemed to suggest the emperor's new clothes. *Charlie Hebdo*, the caustic Parisian weekly, responded with a satirical cartoon about a boy "who at the age of eight began photographing everything that interested a boy of eight: kites, dirigibles, cars; at nine, everything that interested a boy of nine: his family, cars, kites; and at 10, etc. etc."[58] For others, especially in the beginning, the phenomenon was looked upon as an instance of cultural benefaction, of French culture colonizing foreign lands. The headline that *Paris-Match* ran in 1964, to accompany their *Life*-style photo-essay on the photographer, read, "A Frenchman Tells America about the Belle Époque."[59] And while Lartigue continued to gain exposure in the press by way of various events, including the publication of *Boyhood Photographs* and *Instants de ma vie* (the French version of Avedon's book, published in 1973), there remained a certain bewilderment, as if the public did not quite know how to think of Lartigue—or what to think about the hype in America, anyway. In 1972, a journalist asked Lartigue, "Why are the Americans still so obsessed with you?" Lartigue responded in typically elliptical, though illuminating, fashion:

> It's really simple: ten years ago, after having shown my photos to lots of people in France . . . and having received only words of indifference or discouragement, I showed my little album, completely by accident, to Charles Rado, representative for the Rapho Agency in New York. He looked at it quickly and seemed bored at first, then suddenly he seemed to wake up. . . . Two hours later, I was having lunch with the directors of 'Life' and the Museum of Modern Art. . . . It's since that moment that I'm known in the U.S.A. . . . and, as a result, in France.[60]

It wasn't that there was a bias against photography in France, but a bias against photography as an art form. By 1972, aware of photographic activity

(including market activity) in other countries, French critics had begun seriously discussing photography as art. For in France, as elsewhere in Europe, regard for the photographic image had long been dominated by the attitudes of the press, which had treated photography as a media tool since the turn of the century. Although the Bibliothèque Nationale and the Société Française de Photographie maintained enormous photographic holdings, gallery exhibitions of photographs, particularly contemporary photographs, were still uncommon. However, as the perception grew that France was being left behind in the artistic exploration of the medium (which, discussants were quick to point out, had been invented in France) and, particularly alarming, that American collectors were making off with France's photographic patrimony, institutions began to respond.

Lartigue subscribed to a press service, and in the articles from the 1970s in which his name appears one can read the entire history of France's institutional shift in attitude toward photography.[61] In 1971, the Cabinet des Estampes at the Bibliothèque Nationale opened its first gallery for exhibiting photographs. Even though the print department had been collecting photography since the nineteenth century, and the holdings now comprised some two million works (classed by subject, not photographer), these were rarely exhibited, and certainly not as works of art. Jean-Claude Lemagny, assigned to curate the first exhibition, settled on a neutral and expansive theme: *Récents enrichissements des collections photographiques du Cabinet des estampes* (Recent additions to the photography collection of the Cabinet des Estampes); works by Lartigue hung alongside those by Cartier-Bresson, Edouard Boubat, Willy Ronis, and others.[62]

One year later, the photography scene in France had expanded only slightly. A few businesses had installed photography galleries in some of their stores, namely Nikon and FNAC, and the idea of a photography market was gaining some press, but critics were still asking when "a photographer of the renown and genius of Lartigue" was going to gain the recognition—in the form of an exhibition at the Bibliothèque Nationale, for example—that he ultimately deserved.[63] That same year, Lartigue attended the Rencontres Arles (Rencontres photographiques du Festival d'Arles), an annual gathering of photography enthusiasts, established in 1970, and dedicated to the promotion of photography among the general public. The presence of Lartigue and fellow photographers Lucien Clergue and Jeanloup Sieff raised the profile of the cause considerably.[64]

A new idea of photography was endorsed in 1974, when France's president, Valéry Giscard d'Estaing, chose Lartigue to make his official portrait, an honor that normally fell to a well-known studio portraitist or photojournalist. Informal rather than imperious, spontaneous rather than studied, the choice affirmed the president to be both cultured and accessible. The press, making much of the fact that Lartigue was an artist photographer, said that Lartigue was "above all else an eye" and that his vision counted much more than his technique—a rule of thumb for those wondering what separated art photography from the ordinary kind.[65]

In 1975, Lartigue's first major exhibition in France, *Lartigue: 8 x 80*, opened, significantly, at the Musée des Arts Décoratifs, Paris.[66] The exhibition, sponsored by the Centre Georges Pompidou and Kodak-Pathé, was curated by photography-book publisher Robert Delpire. Delpire's approach—to blow the images up, poster-size—had the effect of both lending the work a grandiosity associated with exhibitions of painting and trumping the ordinariness of the photographic print with a spectacular optical display that emphasized quality of vision.[67]

Only in 1975 did a viable commercial gallery specializing in photography, Agathe Gaillard, appear in Paris. The market was still sluggish, as it remained the following year, when the Hôtel Drouot, the Paris auction house, held its first sale of photographs—"a demi-fiasco," as everyone agreed. Despite this, Lartigue's photographs were selling at a level commensurate with the highest prices for living photographers, along with works by Cartier-Bresson and Doisneau (all of their prices, according to Gaillard, were driven up by the American market).[68] In 1977, the Bibliothèque Nationale opened another gallery devoted to photography, the Galerie Louvois. The inaugural exhibition, *Portraits peu connus de personnages connus* (Little-known portraits of well-known people), featured work by Lartigue, as well as by Cartier-Bresson, Doisneau, Brassaï, Gisèle Freund, and others.[69] That same year, Delpire announced his series of books on the history of photography, later known as Photo Poche. Lartigue's pocket monograph was third in the series, after Nadar and Cartier-Bresson.[70]

At the time of the Hôtel Drouot sale, in 1976, fear was expressed among curators and government officials that France's photographic patrimony was in danger of being plundered. Michel Nuridsany reported in *Le Figaro*: "In a month, certain wealthy American collectors will arrive in France with an overt goal, for a well-defined task: to search France with a fine-toothed comb and buy

all the old photographs they can find. . . . If we don't watch out . . . a large part of our cultural patrimony will disappear."[71] Almost from the start, Lartigue's countrymen looked upon him as the object of a cultural theft. Yet, more than blame, critics responded with self-chastisement: this had happened, and was happening, because France had no institutional network of support for art photography. The temptation to compare the situation in France to that of other countries was irresistible. "And what about our great artists of photography?" asked a writer for *Le Figaro* in 1973. "Besides the specialists, who in France knows the work of Jacques-Henri Lartigue, familiar to the Americans, the Japanese, the English, and the Italians? An entire museum is being devoted to him. But in Hamburg."[72]

By the time plans were announced to establish an art-photography collection at the future Musée d'Orsay, in 1980, Lartigue's name had become synonymous with the photographic patrimony.[73] The year before, in June 1979, Lartigue had donated his entire collection of albums, prints, and negatives to the state, a donation evaluated at one million francs.[74] When asked by an interviewer what the donation, the first of its kind in France, meant to him, Lartigue responded: "It's a unique collection, in the sense that nothing is missing: all my albums are included and they comprise a multitude of photos of the era. In this sense it represents a kind of *patrimoine* for France."[75]

Not only was there official French institutional support for photography in 1980, there was also a visible audience.[76] This was measured in the turnout for Paris's first Mois de la Photographie (Month of Photography), held in November 1980, a citywide photography event designed to sensitize the French public to the medium. Organized by Jean-Luc Monterosso, the first successful Mois proclaimed both a widespread critical acceptance of photography and a commitment to the preservation and exhibition of photography as a vital part of France's cultural patrimony.[77]

"For photography, the hour of glory has arrived," wrote Nuridsany, in 1980.[78] It was Lartigue's hour of glory as well. *Bonjour Monsieur Lartigue*, the most widely attended Lartigue exhibition to date (attracting 35,000 visitors during the first month), opened in 1980, in the magisterial halls of the Grand Palais—"The Grand Palais!" remarked a rare skeptic, "What a symbol!"—and then traveled around the world.[79] Embracing Lartigue as a symbol of national identity, France brandished his achievement and the medium of his obsession

with a patriotic fervor. Having been taken up and celebrated in the unique photographic climate of 1960s America, Lartigue finally had the audience and the institutional support in France necessary for his legitimate repatriation. After twenty years of foreign exile, Lartigue's personal obsession with photography now had an official home in Paris, and in the collective consciousness of the nation.

CONCLUSION

ONE QUESTION REMAINS: What explains the current interest in Lartigue? The answer is in part economic. With the death of Florette Lartigue in May 2000, and the recent surfacing of the collection of Renée Perle, Lartigue's companion and model during the early 1930s, a significant number of vintage prints have appeared on the market. Vintage prints by Lartigue have been rarely seen outside the archive in Paris, where they rest, mixed among prints of other eras, in the albums Lartigue donated to the state in 1979. Several recent exhibitions of Lartigue's vintage prints—held at Christie's, London; Edwynn Houk Gallery, New York; and at the Pompidou[1]—have provided an occasion for trying to understand Lartigue in a new way. While the nascent market for photography during the 1970s contributed significantly to Lartigue's success, Lartigue himself benefited not through the sale of vintage prints but through payment schemes and deals established by the illustrated press—commissions for photo assignments, book royalties, Time-Life's publication of prints in "limited editions" of 5,000 (about as exclusive as *Life*'s readership). The vintage print, valued by the historian for its sedimentary deposit of historical detail and by the collector for its rarity and aura of genuineness, offers a glimpse into a more "authentic" Lartigue. This is the Lartigue sought in this book, a Lartigue formed by the constellation of cultural and technological conditions that defined photographic practice in France one hundred years ago. Vintage prints, unique in terms of size, paper, chemistry, inscriptions, and a multitude of harder-to-classify distinctions, deepen our understanding of photographs as historically produced objects. While the historian is little concerned with supporting or encouraging the market value of photographs, it must be acknowledged that higher prices generally rely on greater

Detail of PLATE 16

scholarly authentication; conversely, commercial activity often results in greater availability of prints for study. A study such as mine could not have been done ten years ago—or, at least, not done in the same way.

The second reason for today's interest in Lartigue has to do with the intellectual conundrum he poses, and the centrality of this to certain historiographic questions germane to photography that artists, historians, curators, collectors, and dealers are grappling with today. Since its inception, the history of photography has passed through various critical phases. During the last thirty years, photography has both achieved widespread recognition as an academic discipline, one generally approached as a subfield within art history, and has also been the object of vehement protest by critics of photography's canonization as an art form.[2] Lartigue, of course, represents an early battle in the campaign to "academicize" photography. He was, however, a rather dubious photographer to begin with, a "child artist," an amateur whose official canonization remains, in some ways, unfinished business. Even so, the process of his attempted canonization predicts many of the rhetorical strategies deployed during the years to come. My treatment of Lartigue as both a product of "visual culture"—a culture of "low" arts, such as amateur photography, the illustrated press, and cinema—and a consecrated art photographer of the 1960s is intended as a historiographic critique of the history of photography and an examination of art history's relation to the broader sphere of visual culture. In a certain sense, Lartigue has served as a case study for addressing these larger problems of the field. Biography has been—to play on Barbara Tuchman's well-known phrase—a prism of historiography.[3]

A final explanation might have something to do with distance—cultural, historical, and psychological. As we approach the one-hundred-year mark for the creation of Lartigue's early work, his photographs conjure a complex and conflicting storm of emotions: pleasure, puzzlement, immediacy, nostalgia, detachment, remembrance, and perhaps even indifference. Conceptually speaking, Lartigue's photographs can be seen to rest on a historical divide. They occupy a borderland between the not-so-distant and the far-distant past, between the last days of the present time zone—call it modern, industrial, confident—and a zone beyond recognition. If today this body of images seems poised at the edge of a historical precipice (which may be a peculiarly American perception, amnesiac as we are), perhaps it is this vague sense of fatality that compels us to confront a suppressed, occasionally surfacing idea: what is familiar today may not be

so tomorrow. Lartigue's long involvement with photography—specifically, the attempt to preserve a life in photography—made him aware of this, and we must face the same. Photography's magnificent inadequacy as a preservative of memory opens to question the pitiful human need to believe in such a possibility in the first place. For packing history into photographs is a desperate act and can only lead to disappointment. It is not merely that names and faces will be lost, but that the lives recorded in photographs may be reinvented by those who come after.

APPENDIX A

KEY TO NAMES OF LARTIGUE'S FAMILY, FRIENDS, AND PETS

AMÉLIE—*His aunt*

AUBERT—*Marius Aubert, his math and science tutor*

BIBI—*Madeleine Messager, his first wife*

BICHONNADE (or BICHE)—*Madeleine Van Weers, his older cousin*

BICLO—*Jean Haguet, his cousin*

BOBINO (or BOB)—*Robert Ferrand, his friend from childhood*

BOUBOUTTE—*Marthe Van Weers, his cousin and darkroom assistant*

CARO—*Caroline Roussel, his older cousin*

CÉCÉL—*Marcel Lartigue, his uncle*

COCO—*Nickname for Jacques himself (as a teenager)*

DÉDÉ—*André Haguet, his young cousin*

DIDI—*Didi de Rauch, his friend*

DUDU—*Julie Giquel, his nanny*

DUMÉNY—*Camille Du_meny, actor and family friend*

GOLO—*Simone's acrobatic friend*

GUITTY—*Marguerite Bourcart, cousin of Plitt*

KÄTCHEN—*A domestic*

LOULOU—*Louis Ferrand, his friend from childhood*

MADELEINE—*Madeleine Bourgeois, his friend and love interest*

MAMI—*Marie Lartigue (née Haguet), his mother*

MARCELLE—*Marcelle Haguet, his cousin*

OLÉO—*Raymond Van Weers, his cousin*

PAPI—*Henri Lartigue, his father*

PIC—*Nickname for Jacques himself (as a teenager)*

PLITT—*Monsieur Folletête, his father's private secretary*

RENÉE—*Renée Haguet, his young cousin*

RICO—*Henry Broadwater, his American friend*

SIMONE (or SIM)—*Simone Roussel, his cousin*

TOTO—*Paul Roussel, his cousin*

TUPY—*Plitt's dog, a terrier*

UBU—*Robert Haguet, his cousin*

YÉYÉ—*Geneviève Haguet, his aunt*

ZISSOU (or ZYX)—*Maurice Lartigue, his older brother*

ZIZI—*His cat*

1963 MOMA EXHIBITION CHECKLIST

The Photographs of Jacques Henri Lartigue, The Museum of Modern Art, New York, 1 July–3 November 1963

NOTE: Numbers preceding the titles are MoMA-designated exhibition numbers, and the titles and dates given first are the ones used for the exhibition. Since then, information on certain photographs has been updated, by Lartigue, the Association des Amis de Jacques-Henri Lartigue, and other researchers, including myself. Updated information, along with French titles by Lartigue and negative formats, is given in brackets after each entry. The titles used throughout this book are my translations of the titles that appear in brackets below.

1. *J. H. Lartigue with his mother and grandmother, Bois de Boulogne, Paris*, 1905. [Paris, au Bois de Boulogne, Grand-mère, Maman, Zissou, et moi avec ma jumelle, Photo Papa, 1903; 6 x 13 cm glass-plate stereo.]

2. *Simone Roussel on the Beach at Villerville*, 1906. [Villerville, Simone, 1906; 6 x 9 cm roll film.]

3. *The Beach at Villerville*, 1908. [Villerville, la Cousine Caro et M. Plantevigne, 1906; 6 x 9 cm roll film.]

4. *The Beach at Trouville*, 1905. [Plage de Trouville, 1906; 6 x 9 cm roll film.]

5. *The Beach at Pourville*, 1908. [Septembre, Étretat, les amies de ma mère, 1910; 6 x 9 cm roll film.]

6. *Avenue des Acacias, Paris*, 1911. [Paris, Avenue des Acacias, 1911; 9 x 12 cm glass plate.]

7. *Race Course, Nice*, 1912. [Juin, Paris, 1912; 9 x 12 cm glass plate.]

8. *Mary Lancret, Avenue des Acacias, Paris*, 1912. [12 juin, Paris, 1912; 6 x 13 cm glass-plate stereo.]

9. *Avenue du Bois de Boulogne, Paris*, 1910. [Mai, Paris, Avenue du Bois, 1911; 9 x 12 cm glass plate.]

10. *Maurice and Henri Lartigue, Auvergne*, 1914. [Mon père et mon frère en promenade en Auvergne, 1914; negative unidentified; possibly a motion-picture film still.]

11. *Avenue des Acacias, Paris*, 1911. [Arlette Prévost dite Anna la Pradvina avec Chichi et Gogo, Ave. du Bois de Boulogne, 1911; 9 x 12 cm glass plate.]

12. *At the Races, Auteuil, Paris*, 1910. [Aux courses à Auteuil, 1912; 6 x 13 cm glass-plate stereo.]

13. *The Race Course at Auteuil, Paris*, 1910. [Le jour des Drags, aux courses à Auteuil, 1910; 9 x 12 cm glass plate.]

14. *Bois de Boulogne, Paris*, 1911. [Avril, Paris, Au Sentier de la Vertu, 1911; 9 x 12 cm glass plate.]

15. *Avenue du Bois de Boulogne, Paris*, 1911. [Avenue du Bois de Boulogne, Max de Cazavent suivant ses amours, 1911; 9 x 12 cm glass plate.]

16. *At the Races, Nice*, 1910. [negative unidentified; collection of the Société des Bains de Mer, Monaco?]

17. *Bois de Boulogne, Paris*, 1911. [Sentier de la Vertu, Paris, Mai, 1912; 6 x 13 cm glass-plate stereo.]

18. *At the Races, Auteuil, Paris*, 1911. [26 juin, Paris, Élégances aux drags, 1912; 9 x 12 cm glass plate.]

19. *Andre, Renee and Jean Haguet, Chateau de Rouzat*, 1910. [Dédé, Renée et Jean, Rouzat, Septembre, 1911; 9 x 12 cm glass plate.]

20. *The Beach at Biarritz*, 1907. [Biarritz, Cerf Volant, 1905; 4.5 x 6 cm glass plate.]

21. *Combegrasse, Puy de Dome*, 1922. [Concours de planeurs à Combegrasse, 1922; 6 x 13 cm glass-plate panorama.]

22. *Glider constructed by Maurice Lartigue, Chateau de Rouzat*, 1912. [Rouzat, Louis s'envole sur le "ZYX 24," 1912; 6 x 13 cm glass-plate stereo.]

23. *Jean Haguet, Chateau de Rouzat*, 1910. [Rouzat, Jean, 1911; 9 x 12 cm glass plate.]

24. *Marcelle Haguet, Chateau de Rouzat*, 1912. [Rouzat, Marcelle, 1912; 6 x 13 cm glass-plate stereo.]

25. *Avenue des Acacias, Paris*, 1911. [21 juin, Paris, Avenue des Acacias, 1912; 6 x 13 cm glass-plate stereo.]

26. *Glider constructed by Maurice Lartigue, Chateau de Rouzat*, 1909. [Le Zissou 24, Rouzat, 1910; 9 x 12 cm glass plate.]

27. *Combegrasse, Puy de Dome*, 1922. [Concours de planeurs à Combegrasse, 1922; 6 x 13 cm glass-plate panorama.]

28. *Professor Aubert of the Sorbonne, Chateau de Rouzat*, 1911. [Rouzat, Mon savant professeur de mathématiques M. Aubert, 1911; 9 x 12 cm glass plate.]

29. *Jean Haguet, Chateau de Rouzat*, 1912. [Jean, Rouzat, Août, 1911; 6 x 13 cm glass-plate stereo.]

30. *M. Laroze and Louis Ferrand, kite built by Henri Lartigue, Chateau de Rouzat*, 1911. [Rouzat, Louis et M. Hubert Laroze, 1911; 9 x 12 cm glass plate.]

31. *Maurice Lartigue, Chateau de Rouzat*, 1911. [Zissou, Rouzat, 1911; 9 x 12 cm glass plate.]

32. *Issy-les-Moulineaux*, 1911. [Issy-les-Moulineaux, 1911; 9 x 12 cm glass plate.]

33. *Monaco*, 1912. [negative unidentified; collection of the Société des Bains de Mer, Monaco?]

34. *Bobsleigh on wheels invented by Lartigue*, 1911. [Course de bobs, Louis, Jean, 1911; 9 x 12 cm glass plate.]

35. *Peugeot Touring Car*, 1912. [Pneu crevé à Soumoulou, 1912; 6 x 13 cm glass-plate stereo.]

36. *Maurice Lartigue on his "bobsleigh," Chateau de Rouzat*, 1909. [Le Bobsleigh à roues de Zissou, après le virage de la grille, 1909; 4.5 x 6 cm glass plate.]

37. *Motorcycle*, 1912. [Orléans, Passage d'un concurrent pendant la course de motos, Paris-Tours, 1912; 6 x 13 cm glass-plate stereo.]

38. *Avenue des Acacias, Paris*, 1912. [Avenue des Acacias, Une Singer de course, 1912; 6 x 13 cm glass-plate stereo.]

39. *Gordon Bennett Cup Race*, 1905. [Circuit d'Auvergne, 1905; 4.5 x 10.5 cm glass plate.]

40. *Henri Lartigue driving*, 1914. [Mars, Voyage en auto, Papa à 80 km à l'heure, 1913; 6 x 13 cm glass-plate stereo.]

41. *Grand Prix of the Automobile Club of France, Dieppe*, 1912. [Grand Prix de l'A.C.F., 1913; 9 x 12 cm glass plate.]

42. *Mme. Roussel and her friends at Villerville*, 1906. [Étretat, juillet, 1907; 6 x 9 cm roll film.]

43. *Meeting of glider enthusiasts in the Puy de Dome*, 1922. [Combegrasse, Edmund Allen, 1922; 6 x 13 glass-plate panorama.]

CHRONOLOGY

13 JUNE 1894 Jacques Henri Lartigue is born in Courbevoie, just outside Paris.

1902 Lartigue receives his first camera from his father and begins photographing with his father's help.

1905 Meets and photographs one of the Simons brothers, photographers for *La Vie au grand air*.

JANUARY 1911 Attends lectures at the Sorbonne given by Marius Aubert, assistant to Gabriel Lippmann, inventor of an early color-photography process.

MARCH 1911 Shoots his first film footage with the Cinématographe.

OCTOBER 1911 First mention in his diaries of Givenchy, a society and fashion photographer active in the Bois de Boulogne.

JANUARY 1912 Sells his first photograph, a picture of an airplane, to *La Vie au grand air*.

JANUARY 1914 Films winter sports in Chamonix and sells footage to Pathé News.

AUGUST 1914 Exempted from military service for health reasons and spends the war in the south of France.

FEBRUARY 1915 Enrolls in the Académie Julian, Paris, where he studies painting under Jean Paul Laurens.

AUGUST 1915 Meets satirical illustrator Sem (Georges Goursat) in the south of France.

DECEMBER 1919 Marries Madeleine Messager ("Bibi"), daughter of composer, opera-company director, and conductor André Messager.

AUGUST 1920 Lartigue's only son, Dani, is born.

1922 Exhibits paintings for the first time, at the Galerie Georges Petit, Paris, and forms friendships with painter Kees van Dongen, singer Maurice Chevalier, film director Abel Gance, and actors Sacha Guitry and Yvonne Printemps of the Théâtre-Français.

JANUARY 1923 Daughter Véronique is born, but the infant dies three months later.

1930 Meets Renée Perle, a Romanian model and painter, who becomes his model and companion for the next two years.

1931 Divorces Madeleine Messager.

1932 Works with film director Alexis Granowsky on *Les Aventures du roi Pausole* on location in the French Riviera.

MARCH 1934 Marries Marcelle Paolucci ("Coco").

1935 Exhibits his paintings of van Dongen, Sacha Guitry, Marlene Dietrich, Joan Crawford, and other personalities at the Galerie Jouvène, Marseille.

1940 An exhibition of Lartigue's paintings opens in Paris at the Galerie Charpentier.

1942 Meets Florette Orméa, who later becomes his third wife, in Monte Carlo.

AUGUST 1944 Photographs the liberation of Paris.

1945 Marries Florette Orméa in Paris.

1950 Begins selling photographs to the popular press.

1954 L'Association des "Gens d'Images" is formed, with Lartigue serving as co–vice-president.

1954 First time a group of Lartigue's early photographs is published in *Point de Vue, Images du Monde*.

1955 Lartigue's photographs of Pablo Picasso and Jean Cocteau appear in numerous magazines. Takes part in a series of photography exhibitions at the Galerie d'Orsay organized by Gens d'Images.

1957 Exhibits paintings in Havana, Cuba, at the Centro Arte Cubano.

FEBRUARY 1962 Travels to California.

MAY 1962 Travels to New York, where he meets with Rapho-Guillumette agent Charles Rado, who shows Lartigue's work to editors at *Life* and *Car & Driver*, and to John Szarkowski, curator of photography at the Museum of Modern Art.

JULY 1963 *The Photographs of Jacques Henri Lartigue* opens at the Museum of Modern Art, New York.

NOVEMBER 1963 Lartigue's photographs appear in *Life* along with coverage of John F. Kennedy's assassination.

1966 *Boyhood Photographs of J.-H. Lartigue* is published. Meets photographers Hiro and Richard Avedon in New York. Exhibits at Photokina, Cologne.

1970 Avedon publishes *Diary of a Century: Jacques-Henri Lartigue*.

1972 Begins reconstructing albums of photographs.

1974 Takes the official presidential portrait of Valéry Giscard d'Éstaing.

1975 *Lartigue 8 x 80*, the first French retrospective of Lartigue's photographs, opens at the Musée des Arts Décoratifs, Paris.

JUNE 1979 Donates entire photographic oeuvre to the French state.

1980 *Bonjour Monsieur Lartigue* opens at the Grand Palais, Paris, and travels to venues around the world.

12 SEPTEMBER 1986 Dies in Nice.

16 SEPTEMBER 1986 Is awarded the Officer's Cross of the Legion of Honor by the French government at his memorial service.

1991 and 1993 Florette Lartigue donates her husband's paintings to the Ville de L'Isle Adam, where the Centre d'Art Jacques-Henri Lartigue is established.

FEBRUARY 2000 Florette Lartigue dies in Paris.

NOTES

INTRODUCTION

1. Colette, *Chéri* and *The Last of Chéri*, trans. Roger Senhouse (London: Penguin Books, 1954), 103.
2. John Szarkowski, *The Photographs of Jacques Henri Lartigue* (New York: Museum of Modern Art, 1963).
3. Alan Riding, "Lartigue's Albums: The Well-Lensed Life," *New York Times*, 6 July 2003, sec. 2, p. 27.
4. The Association des Amis de Jacques-Henri Lartigue (AAJHL) was established shortly after Lartigue's donation in 1979. Objects in the care of the AAJHL include: 280,000 photographs (and their negatives), 120 albums, 50,000 pages of diary text ("Agendas"), scrapbooks with press clippings spanning Lartigue's entire career, drafts for the published memoirs, and a calendar recording Lartigue's every perambulation, plus letters, postcards, and drawings. Additional materials have since surfaced, much of this vintage material in the possession of the late Florette Lartigue.
5. Jacques Henri Lartigue, *Mémoires sans mémoire* (Paris: Éditions Robert Laffont, 1975), 93.
6. Lartigue writes in his diary that day: "*Très très beau*, cold, a little windy, very dry and lots of wind in the evening (cold). 10:30, ave. du Bois with Anna. 11 o'clock, lesson. 12 o'clock, I take 2 photos of my plane [drawings of 2 model airplanes]. 12:30, depart with Grandma and Mami. I walk with Maman in the Bois, ave. des Accacias. I take 3 photos [drawings of 3 fashion photographs]. 4:15, I go with Maman to the rue Leroux. 5:30, lesson. 7:15, dinner with Papa et Maman." Lartigue, diary entry for 30 Jan. 1911. (Note: All citations of Lartigue's diary entries refer to his unpublished "Agendas" in the archive of the Association des Amis de Jacques-Henri Lartigue.)
7. Other passages in the memoirs are dramatizations based on the photographs themselves, descriptions written from memory inspired by certain images. Lartigue's photograph of Wilbur Wright (1909), *Day of the Drag Races at Auteuil* (1910), and *Grand Prix of the A.C.F.* (1913) all have fictionalized, exclamation-point–riddled counterparts in the memoirs. Perversely, such descriptions have been used in turn to explicate the photographs. This has proven treacherous in some cases, as with the well-known Grand Prix photograph. In his memoirs, Lartigue misdates the photograph, which has remained misdated until recently; the diaries substantiate the investigations of David Junker, who argues that the photograph was taken in 1913, and not 1912. See David E. Junker, "Jacques-Henri Lartigue: A Correction," *History of Photography* 19 (summer 1995): 179–80.
8. Traces of paper around the edges of certain prints show that many prints previously occupied older albums, which Lartigue presumably dismantled in order to make the present albums. Independent conservator Sabrina Esmeraldo examinined the albums with me, and offered her professional opinion on the dating of prints.
9. Lartigue refers to his albums as his "nouveaux 'vieux albums'" in his diary entry for 24 Apr. 1972.
10. *Point de Vue* began publishing Lartigue's photographs during the mid-1950s. See, for example, "Aux temps héroïques de l'automobile, par le peintre J.-H. Lartigue," *Point de Vue*, 30 Sept. 1954, 7–11, and chap. 4 of this book.

CHAPTER ONE—*Amateur Photography*

1. Jacques-Henri Lartigue, *Mémoires sans mémoire* (Paris: Éditions Robert Laffont, 1975), 34. Unless otherwise indicated, all translations are by the author.
2. Ibid.
3. Ibid.
4. A report by colleagues details Henri Lartigue's role in restoring the Compagnie Franco-Algérienne to a state of fiscal responsibility. MM Armand Linol et O. Jacob, *Compagnie Franco-Algérienne, Société-Anonyme au Capital de 30.000.000 Fr.: Du Chemin de fer d'Arzew à Saida et prolongements concessionnaire du droit exclusif d'exploiter l'Alfa sur*

300.000 hectaires en Algérie. Examen de la situation du concordat de 1890 à l'exercice de 1896 (Paris: Imprimerie Noizette, 1897). Henri Lartigue's position with the Société Française de Constructions Mécaniques is mentioned in an article appearing in *Le Figaro*, "Nouvelles Diverses: Un fou meurtrier," *Le Figaro*, 2 Feb. 1914, p. 4.

5. Florette Lartigue reports this in her book *Jacques-Henri Lartigue: La traversée du siècle* (Paris: Bordas, 1990), 16.

6. The passage in full: "The aggressor is a man half-crazed; he asked Papa for a business paper that doesn't exist, and as Papa didn't give it to him, he just shot him in the back!!!" Lartigue, diary entry for 1 Feb. 1914. *Le Figaro*'s coverage of the event reports that the gunman, a Monsieur Chevallier-Kurt, emphasized to the police that he was not mentally insane and claimed to have been ruined by Henri Lartigue. "Nouvelles Diverses: Un fou meurtrier," 4. Other press coverage of the event: "A Travers Paris," *Le Figaro*, 3 Feb. 1914, p. 1; "Nouvelles Diverses: Le drame de la place de l'Etoile," *Le Figaro*, 3 Feb. 1914, p. 5.

7. Lartigue's tutors included Marius Aubert (math and science), Monsieur Blum (German/English), and Monsieur Lecordier (French). Lartigue's brother was tutored by the young playwright Jean Giraudoux.

8. These photographs exist in the album entitled "Prologue," in the Association des Amis de Jacques-Henri Lartigue (AAJHL), Paris.

9. After the stock market crash of 1929, which greatly diminished Henri Lartigue's fortune, his sons found themselves in the awkward position of having to earn a living. Because of their pampered upbringing, both proved to be rather inept at business and were forced to rely on social connections to carry them through much of their adult lives. See Florette Lartigue's account of financial struggles, *Jacques-Henri Lartigue: La traversée du siècle*, chap. 7, 125–39.

10. The Third Republic lasted from 1871–1940 (dissolved at Vichy), making it the longest period of political stability since the Revolution of 1792. As Charles Rearick notes, however, despite the general contentment granted by political stability, the belle époque proper (which he dates 1890–1914) also saw "bitter labor and political conflicts, anarchist attacks, threats to the parliamentary Republic, poverty and economic crisis, and fierce battles over the Church." For the well-to-do, of course, these problems were easy enough to ignore. Charles Rearick, *Pleasures of the Belle Epoque: Entertainment and Festivity in Turn-of-the-Century France* (New Haven, Conn.: Yale University Press, 1985), xi.

11. Political historian André Siegfried has defined more specific social categories within the larger category of the bourgeoisie. The terms he used are discussed in Gordon Wright, *France in Modern Times*, 5th edition (New York: W.W. Norton and Co., 1995), 268–69.

12. Wright discusses two definitions of "the bourgeois": Siegfried describes him as "a man who has something in reserve"; a similar definition is offered by historian Pierre Sorlin, who writes that "the bourgeois is one who has more money than he needs for bare subsistence, and who considers the excess indispensable to maintain a certain social position." See ibid., 268–70.

13. David Landes, quoted in ibid., 265.

14. This is recounted by Lartigue in a 1975 interview with Philippe Bernet, "Le Secret du photographe de Giscard," *L'Aurore*, 25 Aug. 1975, page unknown (in Lartigue's scrapbooks of press clippings, "Revues de Presse," AAJHL, Paris).

15. Henri Lartigue's father, Charles Lartigue (1834–1907), was an engineer. He began his career as a professor of mathematics, then later became an astronomer at the Paris Observatory. In 1856, he began working for the railroad in Spain and Algeria. Eventually he would propose a system for an elevated monorail train, precursor to the Métro. See Charles Lartigue, Ingénieur, *Monorail ou Chemin de fer à rail unique surélevé* (Paris: Charles Bayle, 1888), and Charles Lartigue et al., *Projet de voies aériennes dans Paris* (Paris: n.p., 1887). Henri's uncle, Henry Lartigue, worked for the Administration des Chemins de Fer du Nord, where he was in charge of the telegraphic services, and later worked as director of the Société des Téléphones. His inventions include an electro-semaphore, an automatic electric whistle, and a switch control system. Henri Lartigue's grandfather, Joseph Lartigue, was a hydro-engineer, and wrote several treatises on wind, air currents, and atmospheric regions during the 1840s, 1850s, and 1860s. See *La Grande Encyclopédie, inventaire raisonné des sciences, des lettres et des arts* (Paris: Librairie Larousse, 1886–1902).

16. See the Vicomte d'Avenel's extensive compilation of innovations and business statistics from the period. Vicomte Georges d'Avenel, *Les Mécanismes de la vie moderne* (Paris: A. Colin, 1900–1905).

17. Eugen Weber, *France: Fin de Siècle* (Cambridge, Mass.: Harvard University Press, 1986), 207.

18. See, for example, Allan Sekula, "The Instrumental Image: Steichen at War," *Artforum*, Dec. 1975, 26–35.

19. Marta Braun describes Tissandier as "one of those universal amateurs that the nineteenth century specialized in." Marta Braun, *Picturing Time: The Work of Etienne-Jules Marey (1830–1904)* (Chicago: University of Chicago Press, 1992), 35–37.

20. Among the plethora of photographic advertisers, one notes Lumière *et fils*, Krauss-Zeiss, Gaumont, and Vérascope

Richard, manufacturers of cameras and equipment consumed by the Lartigues.

21. "Papa told me that he will give me a 6 x 13 camera (like I'd really like to have) if I agree to having my teeth fixed (I'm half happy, half worried)." And: "Papi wrote me a little note saying that he will give me right away and under no conditions the 6 x 13 (I'm *very very very* happy)." Lartigue, diary entries for 11 and 14 Feb. 1912.

22. Earlier evidence of Henri Lartigue's photographic interests derives from pictorial documentation, and from retrospective accounts by his son.

23. Lartigue, *Mémoires san mémoire*.

24. The annuals referred to here include: *L'Annuaire général de la photographie, France, Belgique, Suisse* (Paris: Plon, 1892–93), *L'Union nationale des sociétés photographiques de France, annuaire* (Paris: Gauthier-Villars, 1900–1902), *L'Annuaire général des sociétés françaises militaires, patriotiques et sportives* (Paris: F. de Solières, 1907), and *L'Annuaire des amateurs de photographie des sociétés photographiques et des hôtels ayant chambre-noire* (Paris: Charles Mendel, 1903).

25. This information is from the *Annuaire général de la photographie, France, Belgique, Suisse.*

26. Mendel, Introduction, *Annuaire des amateurs de photographie, 1903*, 5.

27. Monsieur Folletête, the family secretary, used a Vérascope Richard. Article-style advertisements for the Vérascope appear in the *Annuaire général* for 1896 and 1897. See, for example, "La photographie simplifiée avec le Vérascope ou l'Homéoscope," *Annuaire général et international de la photographie, 1897* (Paris: Plon, 1897), unpaginated.

28. These prices were offered by Astre, a distributor of photographic products, in the "Catalogue Astre" for 1913; see pages 25–26 of this commercial catalogue.

29. Charles Izouard, "Opinions: Qu'est-ce qu'un amateur sérieux?" *Photo-Revue*, 24 Apr. 1910, 135–36.

30. A cartoon from 1907 shows a man in bed, his room filled with phantoms holding cameras, crying out in his sleep: "My nights were nothing but a long nightmare in which all the inventors gawked at me through their cameras. . . ." Reproduced in the *Annuaire général et international de la photographie, 1907*, 23.

31. Besides photographic evidence, such as extant negatives, prints, and equipment housed in the AAHJL, Paris, one finds textual confirmation of Henri Lartigue's activities throughout his son's diaries of the early 1910s. In addition to mentions of cameras, magnesium flash, and autochrome plates (already cited in the text earlier in this chapter), see also 11 Aug. 1911, 11 Sept. 1911, and 4 Jan. 1913 for the construction and repair of photographic equipment. See 7 Aug.

1911, 24 Jan. 1913, and 20 Apr. 1914 for instances of Henri's developing and printing.

32. See Lartigue's diary entries for Aug. 1911.

33. Lippmann's interference method won him the Nobel prize in 1908. See Sylvain Roumette and Michel Frizot, *Early Color Photography*, exh. cat. (New York: Pantheon Books; Paris: Centre National de la Photographie, 1986), unpaginated.

34. Lartigue, diary entry for 28 Jan. 1911.

35. A roster of examples from Lartigue's diary entries for 1911 alone: Henri, Laroze, and Jacques go to photography dealers Krauss and Poulenc to examine telephoto lenses on 2 June 1911; they develop photographs in the darkroom together at Rouzat on 9 Aug. 1911; Laroze and Jacques discuss the latter's photographs on 27 Sept. 1911.

36. Folletête's first name was probably Victor (Marie Charles Joseph Victor Folletête), one of two brothers who left his native Switzerland to live and work in France. Victor Folletête (1869–1945) lived in Paris in the 16th arrondissement at the time of his death; his brother, Casimir Folletête (1873–1946), died in Sète, France. This information was provided by François Noirjean of the Office du Patrimoine Historique, Canton du Jura, in Porrentruy, Switzerland, the town of Folletête's birth.

37. Lartigue, *Mémoires sans mémoire*, 128–29.

38. Folletête's involvement with Lartigue seems to have fallen off just after the war, by which time Lartigue had made the safe transition from sporting, sociable teen to adult socialite.

39. Mendel, *Annuaire des amateurs de photographie, 1903*, 5.

40. In addition to photographs by Henri Lartigue, one finds in the archive many photographs by Lartigue's uncles, his mother, the house staff, and Lartigue's friends, and numerous photographs by unknown photographers.

41. While one is accustomed to histories of individual groups such as those noted here, studies that treat the full spectrum of amateur activity are rare. In the anglophone literature, there are three historical treatments of the popular photography movement: Brian Coe and Paul Gates, *The Snapshot Photograph: The Rise of Popular Photography, 1888–1939* (London: Ash and Grant, 1977); Colin Ford, ed., *The Story of Popular Photography* (Bradford: National Museum of Photography, Film and Television, 1989); and Douglas Collins, *The Story of Kodak* (New York: Abrams, 1990). For coverage of the popular movement in Austria and Germany, see Timm Starl, *Knipser: Die Bildgeschichte der privaten Fotografie in Deutschland und Österreich von 1880 bis 1980*, exh. cat. (Munich: Münchner Stadtmuseum, 1995). Aside from their confinement to certain countries, these studies tend to treat the amateur phenomenon as the Kodak phenomenon. Kodak was present in France circa 1900, of course, but in

France, as in other places, the company and its products played only a part in amateur photography as a whole. Significant studies of serious amateurs in France include the Bibliothèque Nationale's *La Révolution de la photographie instantanée, 1880–1900*, exh. cat. (Paris: Bibliothèque Nationale de France/Société Française de Photographie, 1996), and Denis Bernard and André Gunthert's *L'Instant rêvé: Albert Londe* (Nîmes: Éditions Jacqueline Chambon, 1993). On Pictorialism in France, see Michel Poivert, *Le Pictorialisme en France*, exh. cat. (Paris: Éditions Hoëbeke and the Bibliothèque Nationale de France), 1992. For anglophone literature on serious amateurs, see Paul Spencer Sternberger, *Between Amateur and Aesthete: The Legitimization of Photography as Art in America, 1880–1900* (Albuquerque: University of New Mexico Press, 2001) and Sarah Greenough, "'Of Charming Glens, Graceful Glades, and Frowning Cliffs': The Economic Incentives, Social Inducements, and Aesthetic Issues of American Pictorial Photography, 1880–1902," in *Photography in Nineteenth-Century America*, ed. Martha Sandweiss (New York: Abrams, 1991). And on American Pictorialism proper, see Peter Bunnell, ed., *A Photographic Vision: Pictorial Photography, 1889–1923* (Salt Lake City: Peregrine Smith, 1980).

42. The dry-plate process was invented by Richard Leach Maddox in 1871. At first the process was slower than the wet collodion process. By 1879, however, improvements proposed by Désiré Van Monckhoven made the process not only easier but also faster. In France, the Lumière brothers were the largest manufacturers of dry plates. See André Gunthert, "Introduction à la photographie instantanée," in *La Révolution de la photographie instantanée*, 2–9. By 1889, the year of the Congrès international de photographie, held at the World's Fair, Paris, standards were established for the widespread manufacture of photographic materials. Frédéric Dillaye discusses the significance of this conference in his book *L'Art en photographie, avec le procédé au gélatino-bromure d'argent* (Paris: Librairie Illustrée, 1896), 11.

43. Albert Londe, "La Crise photographique," *Le Chasseur Français*, 1 Mar. 1908, 25.

44. Cédric de Veigy, "La Main-d'oeuvre de la photographie: Petite histoire de la saisie de la photographie par des amateurs non avertis munis d'appareils à main" (master's thesis, Université de Paris I, Panthéon Sorbonne, 1999), 59.

45. In the first issue of 1887, *L'Amateur photographe* acknowledged a significant female readership, and offered articles expressly addressing the interests of women. However, just a few years later, the journal had narrowed its focus considerably and was treating photography exclusively, presumably in response to the explosion of photographic equipment, techniques, and practitioners—articles on ladies' pastimes were apparently pushed off the page. Anonymous, "Plusieurs avis," *L'Amateur photographe*, 1 Jan. 1887, 3.

46. It should be noted that Muybridge used the wet collodion process, although his photographs were soon associated with the instantaneous images sought by users of the dry plate. For a discussion of the technical relation between the dry plate and instantaneous photography, see Gunthert, "Introduction," in *Révolution de la photographie instantanée, 1880–1900*, 6–9.

47. Albert Londe, *La Photographie moderne, pratique et applications* (Paris: G. Masson, 1888), 2.

48. "Les snobs de l'art" is the subtitle of a series on art photography by Robert Demachy called "Les maîtres de la photographie," which appeared in *Photo-Magazine*, 23 Apr. 1911, 129–36. Pictorialism, less of a revolutionary cause by this date, perhaps due to the dissolution of the serious amateur movement (now replaced by the nonthreatening Kodak-style snapshooter), could afford a lighter, wittier touch in the world of amateur publications.

49. Michel Poivert has shown that the Photo-Club de Paris, born out of the editorial staff of *L'Amateur photographe*, originally pursued the same goals as the Excursionists before assuming its elevated role as a proponent of French Pictorialism. Michel Poivert, "La Photographie pictorialiste en France (1892–1914)" (master's thesis, Université de Paris I, 1992), vol. 1, 35–41.

50. J. B., "La première exposition d'art photographique," reproduced in the *Annuaire général et international de la photographie, 1894*, 11.

51. Paul Chaux offers a defense of the hand-held camera in the introduction to his book *La Photographie instantanée par les appareils à main* (Paris: E. Bardin, 1894), 2–3. Examples abound of complaints against the amateur photographer as a kind of "game hunter" in the streets: "The photographer shouldn't be like a hunter, shooting all game that passes [in front of] the end of his barrel." H. Emery, *La Photographie artistique, comment l'amateur devient un artiste* (Paris: Charles Mendel, 1900), 7. Cartoons frequently illustrate this problem, too. An obese woman in a swimsuit is caught wading at the seaside by a horde of photographers; comparing photography to other annoying faddish pastimes, she exclaims: "Decidedly . . . I like bicyclists better," in the *Annuaire général et international de la photographie, 1905*, 37.

52. De Veigy divines this "iconography of the serious amateur" from the advertising imagery found in amateur periodicals. "La Main-d'oeuvre de la photographie," 56. Dillaye, quoted in de Veigy, dismissed this body of work as "topographical documents, portraits of actresses or instantaneous photographs of speed." Ibid., 66.

53. Ernest Boivin, "La Photographie d'art: Composition d'un tableau photographique," *L'Amateur photographe*, 1 Feb. 1888, 60.

54. "Vieilles Lunes, Vieux Galons, Vieux Clichés," by "X.," *Annuaire général et international de la photographie, 1897*, 231–42.

55. Pierre Bourdieu judges the photographic activity of the middle and lower classes ("the majority") to be the norm, from which other practices, like those of Pictorialists, are seen to deviate: "Individuals who take it upon themselves to treat photography as an artistic activity can only be a minority of 'deviants,' defined socially by their greater independence from the conditions that determine the practice of the majority . . . and by a particular relationship to scholarly culture linked to their position in the social structure." Pierre Bourdieu, *Photography: A Middle-Brow Art* (1965), trans. Shaun Whiteside (Cambridge: Polity Press, 1990), 72.

56. Bourdieu's history of photography places great emphasis on class as a determining factor in photographic production. He argues that "the relationship which photographers—and particularly the most demanding and the most ambitious among them—have to photography is never independent of their relationship to their group." While Bourdieu claims rather monolithically that taking photographs was equated simply with "playing at being the gentleman," the point is in some sense well-founded, especially if one considers that photography was such a high-visibility activity, and would have been an obvious focal point for determining the social self-perceptions—and aspirations—of one's fellow practitioners. Ibid., 46–50.

57. An anonymous author, writing in *Annuaire général et international* in 1899, lamented that "most photographers—an immense majority of amateurs—still rebel against pictorial instruction," and attributes this to "a vague fear of expense, ill-defined worry about encountering considerable difficulties, and the inconvenience of several unhappy attempts." Mostly, the author concludes, these photographers simply lacked the education, taste, intellect, and culture. Anonymous, "Variétés," *Annuaire général et international de la photographie, 1899*, 188.

58. For a short summary of cameras offered in France, see Jean-Claude Gautrand, *Publicités Kodak, 1910–1939*, trans. Solange Schnall, exh. cat. (Paris: Contrejour, 1983), unpaginated. Eastman established his four company guidelines in the late 1880s, yet the full fruition of these guidelines did not occur until around 1900 with the production and marketing of the Brownie. Eastman's guidelines: "1. Production in large quantities by machinery. 2. Low prices to increase the usefulness of products. 3. Foreign as well as domestic distribution. 4. Extensive advertising as well as selling by demonstration." Collins, *The Story of Kodak*, 48. For a step-by-step history of Eastman's road to success, see Collins, chap. 2, "You Push the Button, We Do the Rest."

59. Eastman, quoted in ibid., 59–60.

60. Alfred Stieglitz, "Twelve Random Don'ts," originally published *Photographic Topics* 7 (January 1909), reproduced in *Stieglitz on Photography: His Selected Essays and Notes*, ed. Richard Whelan (New York: Aperture, 2000), 209–11.

61. Mass amateurs, like serious amateurs, were interested in taking aesthetically proficient photographs, too. To educate the Kodak consumer, Eastman offered various publications, starting with *Kodak News* (1895–97), *Kodakery* (1913–32), and the first edition of a 160-page manual entitled *How to Make Good Pictures* (1913). These publications are discussed in Coe and Gates, *The Snapshot Photograph*, 20, and in Collins, *The Story of Kodak*, 125.

62. For example, the *Annuaire général* of 1899 includes articles identifying papers and print processes, and calls the use of *persulfate d'amoniaque* "the event of the year"; see *Annuaire général et international de la photographie, 1899*, passim. An article in *Photo-Revue* offers instructions on constructing your own viewfinder: J.-E. Adnams, "Construction d'un viseur très commode," *Photo-Revue*, 23 Apr. 1905, 129–30. One mathematical-equation-filled article on photographing movement is particularly intimidating: "Photographies de sujets en mouvement," *Photo-Revue*, 24 Sept. 1905, 99–102. Among the many articles on stereoscopic photography is Théodore Brown, "La Photographie Stéréoscopique: du choix du sujet," *Photo-Revue*, 1 Oct. 1905, 108–10. On composition, see L. Gastine, "Sur la composition," *Photo-Revue*, 29 Jan. 1905, 35–37, and Max Lütry, "Quelques règles de l'art de la composition," *Photo-Revue*, 6 Mar. 1910, 75–77.

63. A discussion of photography practiced under forest cover appears in the chapter entitled "Les Effets" in Frédéric Dillaye's book *L'Art en photographie*, 125. See also "La Photographie des sous-bois," *Photo-Revue*, 19 Nov. 1905, 163–65.

64. See Bernard and Gunthert for a discussion of the formation, method, and purpose of the Excursionists. Bernard and Gunthert, *L'Instant rêvé: Albert Londe*, 227–29.

65. For example, an article subtitled "Pratique des excursions" urged photographers to press themselves to move beyond predictable "interesting documentary shots" to "artistic shots." *L'Amateur photographe*, 15 Nov. 1888, 493.

66. Some examples are: "À l'amateur photograph," an anonymous article (more an extended advertisement for the Vérascope), which features photographs of the Norman countryside, village churches, and boaters on the Marne, in *Annuaire général de la photographie, 1896*, 3–10; L. Joux,

"Épreuves d'Amateurs," showing images made with the Stéréo Jumelle, featuring strollers, architecture, and exotic street scenes, in *Annuaire général et international de la photographie, 1897*; and Léon Vidal's *Manuel du touriste photographe* (Paris: Gauthier-Villars et Fils, 1889), aimed at the "knowing excursionist and scientific missionaries," offering the basics for those wishing to photograph both on trips and at home (the first edition sold out quickly, according to the Introduction).

67. E. Giard, *Lettres sur la photographie: spécialement écrites pour la jeunesse des écoles et les gens du monde* (Paris: Charles Mendel, 1896), 189.

68. See the chapter entitled "Portraits d'enfants" in Josef Maria Eder, *La photographie instantanée, son application aux arts et aux sciences*, trans. from German to French by O. Campo (Paris: Gauthier-Villars, 1888), 54–55. De Veigy discusses photography of children in his master's thesis, "La Main-d'oeuvre de la photographie," 50–55.

69. On portraiture, see Elizabeth Anne McCauley, *Likenesses: Portrait Photography in Europe, 1850–1870* (Albuquerque: University of New Mexico, 1980); Richard Brilliant, *Portraiture* (Cambridge, Mass.: Harvard University Press, 1991); and Graham Clarke, ed., *The Portrait in Photography* (London: Reaktion Books, 1992).

70. Children as a subject of photography and the growing appreciation for greater expression in portraiture are just two of de Veigy's themes, part of his larger project to uncover the roots of an amateur iconography—an iconography increasingly judged and appreciated by measure of "sincerity"—associated with the hand-held camera. See his discussion of "the natural" in "La Main-d'oeuvre de la photographie," 46–50.

71. Eder, *La photographie instantanée*, 54–55.

72. Besides Bourdieu, *Photography: A Middle-Brow Art*, see Marianne Hirsch, *Family Frames: Photography, Narrative and Postmemory* (Cambridge, Mass.: Harvard University Press, 1997). On the album format specifically, see Ellen Maas, *Die Goldenen Jahre der Photoalbum* (Cologne: n.p., 1977); and Janice Hart, "The Family Treasure: Productive and Interpretative Aspects of the Mid to Late Victorian Photograph Album," *The Photographic Collector* 5 (1984), 164–80.

73. Albert Londe, *La Photographie moderne, pratique et applications*, 269.

74. Anonymous, "De l'Instantané," *Annuaire général et international de la photographie, 1896*, 113.

75. Léon Vidal, *Manuel du touriste photographe*, 163.

76. Indeed, publishing amateur work, especially instantaneous photographs, was an important selling point for amateur publications. *L'Amateur photographe* pledged to its readers in 1888, just on the eve of important breakthroughs in photolithographic processes: "Finally, desiring to raise our journal to the height of American publications, so sought after for the beautiful prints offered to subscribers, we intend to create an analogous deluxe edition, each monthly issue of which will include a photograph." By the mid-1890s, prints proliferated in amateur publications at a rate greatly exceeding one per month. Anonymous, "À nos lecteurs," *L'Amateur photographe*, 1 Jan. 1888, 3. Another important arena for viewing instantaneous photographs was the lantern slide show, which was often conducted outdoors. See Louis Malatier, "Plein air et expositions," *Annuaire général et international de la photographie, 1898*, 214.

77. Quoted in de Veigy, "La Main-d'oeuvre de la photographie," 67.

78. Quoted in ibid., 67–68.

79. Giard, *Lettres sur la photographie*, 182.

80. See David Summers, "Contrapposto: Style and Meaning in Renaissance Art," *The Art Bulletin* 59, no. 3 (Sept. 1977), 336–61.

81. As both Gunthert and de Veigy note, a strain of instantaneous imagery runs through the arts at the end of the century, particularly in book and magazine illustration, but it took time for a recognized iconography of instantaneity to gain legitimacy. See Gunthert, "Introduction," in *La Révolution de la photographie instantanée*, 6–7.

82. Dillaye, *L'Art en photographie*, 144.

83. J. B., "La Première Exposition d'Art Photographique," *Annuaire général et international de la photographie, 1894*, 161.

84. Chaux, *La Photographie instantanée*, 2–3.

85. G. G., "La Photographie du Cheval," *Photo-Magazine*, 18 Dec. 1910, 194; Jules Carteron, "L'Art dans la photographie instantanée," *Photo-Revue*, 16 Jan. 1910, 24.

86. Like other writers on the subject, Chaux recommended that beginners start by mastering landscape composition before proceeding to instantaneous photographs. See chap. 10, "La Pratique Instantanéité," in *La Photographie instantanée*.

87. Londe, *La Photographie moderne*, 269.

88. Dillaye, *L'Art en photographie*, 144.

89. De Veigy, "La Main-d'oeuvre de la photographie," 51.

90. Gunthert, *La Révolution de la photographie instantanée*, 6.

91. Ibid., 9.

92. De Veigy, "La Main-d'oeuvre de la photographie," 74–77.

93. Rossignol and Fleury-Hermagis, "Traité des Excursions photographiques," *L'Amateur photographe*, 1 Sept. 1888, 395–96.

94. Anonymous, "De la composition," *Photo-Magazine*, July–Dec. 1905, 202.

95. Ibid., 203.

96. In addition to "De la composition" (n. 94, above), see also Dillaye, *L'Art en photographie*, especially chap. 2, "Le Beau et ses Attributs"; H. Emery, *La Photographie artistique*, which offers sections addressing composition, unity, strong and weak points in the composition, choice and limitation of the subject, selecting a point of view, figures in the landscape, and other aesthetic issues; Gastine, "Sur la composition"; and Lütry, "Quelques règles de l'art de la composition."

97. Particularly with his training as an engineer, Henri Lartigue would have been thoroughly instructed in drawing and composition. By the 1850s, as Anne Wagner has argued, drawing had become a fundamental pedagogical tool for engineers and artisans as well as artists in training. On the role of drawing in education during the nineteenth century, see chap. 2, "Workers and Artists," in Anne Middleton Wagner, *Jean-Baptiste Carpeaux: Sculptor of the Second Empire* (New Haven, Conn.: Yale University Press, 1986), 29–62. On the training of engineers specifically, see Antoine Picon, *L'Invention de l'ingénieur moderne: l'École des ponts et chaussées, 1747–1851* (Paris: Presses de l'École nationale des ponts et chaussées, 1992). Gustave Eiffel, the nineteenth century's most famous engineer, did not show much promise as a student, we are told, for the simple reason that he was not very good at drawing; see Bernard Marrey, *Gustave Eiffel, une entreprise exemplaire* (Paris: Institute, 1989).

98. His surviving photographs, dispersed throughout the archive of the AAJHL, have not been officially inventoried. A cursory count of the negatives of photographs he shot before 1910 (not including any of his prints contained in his son's albums) turned up seventy-three.

99. E. Giard's concept of the *point mort*, or "dead point," is similar to Henri Cartier-Bresson's "decisive moment," a term popularized in the 1950s. Giard's definition from 1896: "There exists a *dead point* for everything that walks, runs, leaps, flys, swims, oscillates or breathes: it is the train as it makes a turn, the boat at the summit of a wave, the sudden reflex [*coup d'élan*] of a skate or a blade, the culminating degree of a jump just before the descent, the repose of the beating of a wing—in short, it's that mysterious second when movement is suspended, as if for catching a breath, that the lens must seize, as much by experience as by divination." Giard, *Lettres sur la photographie*, 208. Etienne-Jules Marey had defined the idea two years earlier in his book *Le Mouvement* (Paris: G. Masson, 1894).

100. As this document shows, Lartigue took his first photographs at the age of eight, not—as reported by MoMA in 1963, according to early information—five.

101. The notebook was sold to a private collector in 1998. A color photocopy of the notebook is in the archive of the AAJHL, Paris.

102. This inscription is found in volume 2 of Lartigue's albums, in the AAJHL, Paris.

103. Annotated by Lartigue in the AAJHL's catalogue of "photographs printed, published, or exhibited."

104. "Papa's 18 x 24 cm glass-plate camera. Prepared by him, the lens cap lifted and replaced by me, plate developed by him." Inscription by Lartigue, ibid.

105. These are in volume 2 of Lartigue's albums.

106. Lartigue, *Mémoires sans mémoire*, 35.

107. See "De obsessie van een 80 jarige," *Nieuwe Rev*, 30 Sept. 1977, 30–33.

108. The steamboat was invented in the 1780s. By the middle of the nineteenth century, steamships as a form of commercial transport dominated the economy, but by 1870 it had been overtaken by the railroad. Henri Lartigue's appreciation for a steamship in 1902 is thus perhaps colored by nostalgia.

109. By 1902, the year Georges Méliès's *Trip to the Moon* debuted in Paris, Henri had developed a strong interest in this form of photographic expression. See Lartigue, *Mémoires sans mémoire*, 43.

110. According to Gunning, Lumière films, for example, included movement "from foreground to background and past the frame's threshold." Tom Gunning, "New Thresholds of Vision: Instantaneous Photography, and the Early Cinema of Lumière," in *Impossible Presence: Surface and Screen in the Photogenic Era*, ed. Terry Smith (Sydney: Power Publications, 2001), 78. See also Jacques Rittaud-Hutinet, *Auguste et Louis Lumière: Les 1000 premiers films* (Paris: Philippe Sers Éditeur, 1990), especially plates 37, 39, and 79.

111. Lartigue seems to have stumbled innocently across a concept undergoing popularization at the time by philosopher Henri Bergson: duration (*la durée*). Bergson first presented his ideas on time and space in *Time and Free Will* (1890), and later in *Matter and Memory* (1896). His lectures at the Collège de France (1900–1921) were extremely popular, particularly among artists and intellectuals. Despite the tendency to associate Lartigue with Bergson (this is common with Lartigue and Proust as well), there is no evidence that Lartigue had any specific awareness of Bergson's ideas.

112. As Gunning notes, "the image of the small boy armed with a camera capturing moments of indiscretion became a staple of the comic narrative revolving around 'bad boys' in this period." Gunning cites the films *Bobby's Kodak* (1908) and *The Gardener* (*L'Arroseur arrosé*; 1896) as his examples. Gunning, "New Thresholds of Vision," 92.

113. Ibid., 15.

114. Chaplot was also editor of "games and entertainments" for numerous popular magazines, such as *Le Petit Journal* and *L'Illustration*, and published several books on games and other "intellectual pastimes," such as *La Théorie et la pratique des jeux d'esprit* (Paris: Charles Mendel, 1895), and *Mots croisés, jeux d'esprit et jeux de combinaisons* (Paris: Busson, 1925).

115. Tom Tit was the author of numerous books on popular science, such as *La science amusante: 100 nouvelles experiences* (Paris: Larousse, 1889, 1892, 1906) and *Magical Experiments, or science in play*, translated from the French (New York: Worthington, 1892, 1894). These books, which were issued in numerous editions and translations, were enormously popular.

116. C. Chaplot, *La Photographie récréative et fantaisiste, recueil de divertissements, trucs, passe-temps photographiques* (Paris: Charles Mendel, 1904), v.

117. Another indication that this work was intended for the serious amateur lies in the considerable space alloted to trick prints. Pictorialists, of course, were dedicated to print manipulation, but the kind of effects produced here would have been seen as "unaesthetic," if not sophomoric. Mass amateurs, however amused they might have been by such effects, did not engage in darkroom work.

118. Chaplot was not alone in the photographic-amusement genre. Bergeret and Drouin, authors for the popular *Science en Famille* series, published the first edition of *Les Récréations photographiques* (Paris: Charles Mendel) in 1891; a second edition, with contributions by readers, appeared soon after. Walter Woodbury, editor of *The Photographic Times* (New York), covered the anglophone market with his *Photographic Amusements* (New York: Scovill and Adams), first published in 1896, and new editions came out in 1897 and 1898. Although the texts of these various publications and editions vary slightly, almost all reproduce the same handful of illustrations. *La Nature* published various photographic amusements, including an article on spirit photography by H. Fourtier: "Photographies spirites," *La Nature*, 13 Jan. 1894, 99–103.

119. Chaplot, *La Photographie récréative et fantaisiste*, 181.

120. Florette Lartigue writes of this image, "Several years later, thanks to the [automatic] shutter release, Lartigue could appear in his photographs without running the risk of looking like a phantom," expressing the commonly mistaken assumption that here, as in other so-called spirit photographs by Lartigue, the boy had prepared the camera, run into the picture frame, and returned to the camera to close the shutter. Florette Lartigue, *Jacques-Henri Lartigue: La traversée du siècle*, 25. However, the image of his figure here, as one can plainly see, is opaque and clear, ruling out this explanation.

121. Another common method for composing spirit photographs was to photograph the phantom separately, alone in front of a dark, blank backdrop. The figure of the spirit was related to figure(s) in a second exposure according to placement within the frame. This is not the case here, as the fabric trailing from Zissou's garment relates specifically to the stairs of the porch. Woodbury explains the various methods most thoroughly in *Photographic Amusements*, 21–28.

122. The first two chapters cited here are from Bergeret and Drouin, the second two from Chaplot.

123. Chaplot, *La Photographie récréative et fantaisiste*, v.

124. From the very beginning, clarity of detail became the objective of scientific imagery. See *Beauty of Another Order: Photography in Science*, ed. Ann Thomas, exh. cat. (Ottawa: National Gallery of Canada, 1997), passim.

125. "A bicycle is suspended with the aid of a hook attached to the base of the seat, which is in turn attached by a cord affixed to the wall or to the ceiling. One can incline the machine in such a way that one creates the illusion of a cyclist taking a curve at full speed; one can further the illusion of movement on a curve by inclining the camera. If the cord shows, one can retouch the negative." Chaplot, *La Photographie récréative*, 91–92.

126. See additional examples published on pages 34–35 of the recent Centre Pompidou exhibition catalogue, Martine d'Astier et al., *Lartigue: Album of a Century* (Paris: Centre Georges Pompidou; New York: Abrams, 2003).

127. See chap. 3 in Chaplot, *La Photographie récréative*.

128. Chaplot suggests decorative print presentations in his chapters 4 and 5, and animals photographing themselves (one of the more bizarre photographic amusements) in "Les Animaux photographiés par eux-mêmes," 48–49; see page 70 for "Photographie de sources lumineuses, feux d'artifice, lueurs, étincelles, etc.," in ibid. Lartigue's attempt to have animals photograph themselves appears in the diary entry for 3 June 1911.

129. *An Intrepid Ascent*, illustrated in Chaplot, *La Photographie récréative*, 193–94.

130. In a publication from the 1970s, *J. H. Lartigue et les autos et autres engins roulants* (Paris: Editions du Chêne, 1974), Lartigue stated that he received this camera in 1902. Moreover, Lartigue's so-called first photograph, the group portrait taken at Pont-de-l'Arche, is confirmed to have been made in 1902. In his published memoirs of 1975, however, Lartigue recalled the year of both the camera and the portrait as 1901. Lartigue, *Mémoires sans mémoire*, 34–35.

131. Ibid.

132. With its bellows open, the Folding Brownie No. 2 measured $3\frac{1}{2}$ in. in height, $6\frac{3}{4}$ in. across its face, and 5 in. in depth.

The Block-Notes, by contrast, was 2½ in. high, 5 in. wide, and 3¾ in. deep. These measurements were provided by Sean Corcoran of George Eastman House, Rochester.

133. These details are noted in Lartigue's albums, Paris.

134. In the midst of reconstructing his albums in 1972, Lartigue expressed his frustration with the inconsistency of the early works: "only these bad photos from 1905 . . . still, they've become irreplaceable." Lartigue, diary entry for 2 Mar. 1972.

135. There are about 500 negatives in the 4.5 x 6 cm format in the AAJHL. Figures for other formats used exclusively during this early period are much lower: 24 x 36 cm, about 50; 18 x 24 cm, about 50; 13 x 18 cm, about 50. Some formats, such as 6 x 13 cm, cannot be accurately gauged, as Lartigue used this format both before and after 1910.

136. The Brownie photographs include most of the beach pictures: *Villerville, Simone* (1906), *Villerville, Cousin Caro and M. Plantevigne* (1906), *Beach at Trouville* (1906), and *September, Étretat* (1910). *Auvergne Circuit* (1905), a photograph of an auto rally that Lartigue apparently attended with Plitt, was taken with the Vérascope.

137. All the images listed here have been published or exhibited.

138. This is especially visible in the fairly recent, elephantine publication on Lartigue produced by Robert Delpire, with text by Vicki Goldberg, *Jacques Henri Lartigue: Photographer* (Boston: Little, Brown and Co., 1998), in which prints are reproduced in large format with little retouching.

139. An advertisement for "Le Nettel" published in *La Vie au grand air* proclaims the Nettel to be "The Sports-Photography Camera." *La Vie au grand air*, 11 July 1914, vii.

140. Besides camera advertisements appearing in photographic annuals and periodicals of the period, commercial catalogues from the early twentieth century have been useful in gaining an understanding of Lartigue's camera history: namely a Gaumont catalogue disseminated at the World Fair of 1900, *Le Comptoir Général de Photographie*, which provides operating instructions, descriptions of cameras, accessories, chemicals, and their prices; and a *Catalogue Astre* from 1913, which provides information on Kodaks, albums, and other photographic items. These were shown to me by Michel Frizot. Also useful in this respect was Michel Auer, *The Illustrated History of the Camera, from 1839 to Present*, trans. D. B. Tubbs (Boston: New York Graphic Society, 1975).

141. Lartigue, the first page of the diaries for 1912.

142. *Webster's Dictionary of the English Language* (New York: New Lexicon, 1987).

143. All these activities, except for the Racing Club, are mentioned in Lartigue's 1911 diaries. Lartigue's name, along with those of his friends, is listed in the *Racing Club de France Annuaire, 1921* (Paris: Racing Club de France, 1921).

The sentier de la Vertu ("Path of Virtue") was a fashionable pedestrian path in the Bois de Boulogne.

144. The drawings discussed are from the collection of the late Florette Lartigue.

145. Coburn exhibited his series "New York from Its Pinnacles" at the Goupil Galleries, London, in 1913. See Keith Davis, *An American Century of Photography: From Dry-Plate to Digital* (Kansas City, Mo.: Hallmark Cards Inc., 1995), 45.

146. The Leica became available in Europe during the late 1920s.

147. Auer, in his *Illustrated History of the Camera*, refers to this kind of viewfinder as a "sports finder." The Kodak Brownie had a small lens and a tiny ground-glass viewer, the challenge here being one of avoiding eyestrain while striving for accuracy.

148. The term "en dansant," so apt a description for the approach of Cartier-Bresson, comes from a conversation that I had with Michel Frizot, 1998.

149. Lartigue, diary entry for 18 Oct. 1914.

150. Chaux, *La Photographie instantanée*, 119–20.

151. Gastine, "Sur la Composition," *Photo-Revue*, 36.

152. Severe cropping was also necessary in order to eliminate lens distortions appearing near the edges of the images; this was especially a problem with stereoscopic photography. See L. Stockhammer et al., *Essais de stéréoscopie rationelle* (Paris: Charles Mendel, 1907).

153. A recent exhibition of Cartier-Bresson's work, held at the Maison Européenne de la Photographie, Paris, exhibited large gelatin-silver prints printed and matted full-frame, with the negative sprockets visible at the edge of every print, in order to stress the perfection of the image at the moment of its inception.

154. Particularly after the separation of church and state, enacted in December 1905, which prohibited "all congregational instruction," religious organizations were forced to seek other means to monitor the behaviour of their flock. See *L'Enseignement catholique en France aux XIXe et XXe siècles*, eds. Gérard Cholvy and Nadine-Josette Chaline (Paris: Éditions du Cerf, 1995), 207 and passim.

155. The only extant album from the period, besides the notebook, is a small album in the collection of the George Eastman House, Rochester, dated 1910. Unlike Lartigue's other albums, this is an aperture-format album organized around a single theme: aviation. During World War I, Lartigue began taking his negatives to Chaucherat, a commercial printer located in the rue St. Denis.

156. Lartigue's knowledge of darkroom practices and chemicals is not surprising considering the nature of his paternal tutelage. The diaries are full of mentions of specific chemicals (fixing agents, new developers, etc.); for a concise summary of these, see Lartigue, *Mémoires sans mémoire*, 89.

157. See the diary entry for 9 Feb. 1915.

158. Lartigue, diary entries for Dec. 1912. The albums them-selves were purchased from various sources, including the Bon Marché department store. Lartigue mentions this in *Mémoires sans mémoire*, 71; from his diaries, it is clear that he shopped there frequently.

159. Apparently, several waves of reprints and enlargements occurred. See the diary entries for Oct. and Nov. 1911, and Feb. 1915, for two particularly ambitious episodes. Madame Lartigue's remarks are recounted by her son in *Mémoires sans mémoire*, 71.

160. Prints in the MoMA exhibition that underwent significant cropping during the reprinting process include exh. nos. 6, 7, 19, 31, and 34. Szarkowski made further alterations to nos. 12 (*At the Races, Auteuil*, 1912) and 34 (*Bobsled Race, Louis, Jean*, 1911), masking off nearly two inches at the bottom of each.

CHAPTER TWO—*Sport and Fashion*

1. The first illustrated periodicals appeared in France at the end of the eighteenth century. Publications such as *Le Cabinet des modes* (1785–92) and *Le Journal des dames et des modes* (1797–1839) included one or two tricolor copperplate en-gravings in each issue. During the 1830s, copperplate en-graving was supplanted by stone lithography, which resulted in a spate of new illustrated periodicals, including, most prominently, *L'Illustration* (1843–1944). Zincography, in-vented in 1850, triggered another wave of periodicals, result-ing in the "illustrated supplement" offered by major newspapers, such as *Le Petit Journal*, *Le Petit Parisien*, and *Le Figaro*, among others; this trend declined soon after the turn of the twentieth century. Halftone, invented in 1880, was the definitive development in printing technologies, enabling the direct, mechanized reproduction of photographs into print. *Le Monde Illustré* published the first photomechanical repro-duction in halftone, in 1877, yet the first photographically illustrated magazines, *La Vie Illustré* and *Lecture pour tous*, did not appear until 1898. While the halftone process was im-plemented almost immediately in the United States, it was slow to be adopted in France because the equipment was expensive, the paper used for periodical publications was too thin, and because a series of press laws (controlling both what could be printed and what could be photographed), remained in force until the end of the century. For a concise technical history, see Pierre Albert and Gilles Feyel, "Pho-tography and the Media: Changes in the Illustrated Press," in *A New History of Photography*, ed. Michel Frizot (Cologne:

Könemann, 1998), 359–69. On press laws, see Donald Eng-lish, "Political Uses of Photography in the Third French Republic, 1871–1914" (Ph.D. diss., University of Washing-ton, 1984). See also Estelle Jussim, *Visual Communication and the Graphic Arts: Photographic Technologies of the Nineteenth Century* (New York: R. R. Bowker, 1974).

2. In his album for 1910, Lartigue identifies his "first photo-graph published" in *La Vie au grand air* (a picture of an air-plane), but does not include the date of publication. Florette Lartigue claims that her husband's first photograph was pub-lished in that magazine in February 1911; Florette Lartigue, *Jacques-Henri Lartigue: La traversée du siècle* (Paris: Bordas, 1990), 184. I could not locate this image in 1910 or February 1911 issues of that magazine. Lartigue's first published *image* seems to have been a drawing—a fashion drawing, second-prize winner in the "Ideal Male Outfit Competition," which appeared in *Je sais tout* in June 1911. "Concours du Costume Idéal Masculin: Résultats," *Je sais tout*, 15 June 1911, 587.

3. Lartigue also had numerous photographs published in *Tennis et Golf* between 1912 and 1916, along with a series of photo-graphs of actor and family friend Camille Dumény; the pho-tographs of Dumény appeared as winners of a photography competition sponsored by *Comoedia Illustré* (5 Sept. 1913).

4. Lafitte also published numerous series titles, such as *Sports-Bibliothèque* and *Lilliput Bibliothèque*, portfolios of art, and collections of literature, many of which Lartigue perused. An advertisement demonstrating the scale of Lafitte's ambi-tions appeared in *La Vie au grand air*, 30 Aug. 1913, iii.

5. For this and other biographical information about Lafitte, see Nath Imbert, ed., *Dictionnaire Nationale des Contempo-rains*, vol. 1 (Paris: Éditions Lajeunesse, 1939), 315.

6. Pierre Lafitte, "Notre programme," *L'Excelsior*, 16 Nov. 1910, 2.

7. An announcement describing the new editorial quarters of the magazine appeared some months before the opening. Pierre Lafitte, "Notes des Editeurs," *Je sais tout*, 15 Dec. 1906, 540.

8. Coverage of the opening appeared in an article by Max Rivière, "La Maison des Magazines," *Femina*, 13 Apr. 1907, 173–76.

9. After the folding of his belle époque publications, Lafitte went on to edit *Paris-Midi* and *Paris-Soir*, and became co-director of *Le Figaro* and president of *L'Intransigeant*. He also founded a book publishing house, which produced books on various subjects at low cost. Imbert, ed., *Diction-naire Nationale des Contemporains*, 315.

10. In one editorial, Lafitte describes his list of "collaborators" as "the list with almost all of the most famous and esteemed writers today." "Notre programme," *L'Excelsior*, 2.

11. "La Création et le Lancement d'un Magazine," by "X.," *Je sais tout*, 15 May 1905, 494. "Le Papier couché, miroir des belles gravures," *Je sais tout*, 15 Nov. 1906, 421–26.

12. "Les Innovations de la 'Vie au Grand Air,'" *La Vie au grand air*, 31 July 1903, 512.

13. What Lafitte was separating himself from was the yellow-journalism tradition of the *fait divers*, a term first appearing in *Le Petit Journal* in 1863. Defined as "news considered curious, singular, or extraordinary," *faits divers* appealed especially to low-class readers. On the *faits divers*, see the articles by various authors in "Fait Divers," *Feuilles* 3 (winter 1982–83), and the catalogue for an exhibition produced by the Musée National des Arts et Traditions Populaires, *Le Fait divers* (Paris: Réunion des Musées Nationaux, 1982). For a more theoretical approach, see Roland Barthes, "La Structure du fait divers," in *Essais critiques* (Paris: Éditions du Seuil, 1964).

14. Patricia Eckert Boyer notes an "original print" phenomenon occurring during the 1890s, in which publications offered special-edition prints to readers, which fostered a flourishing of the graphic arts at this time. Boyer, "The Artist as Illustrator in Fin-de-Siècle Paris," in *The Graphic Arts and French Society, 1871–1914*, exh. cat., ed. Phillip Dennis Cate (New Brunswick, N.J.: Rutgers University Press, 1988), 115.

15. In his diaries and his memoirs, Lartigue noted numerous painters, illustrators, and designers, including: Sem, Letellier, Barbier, Georges Lepape, Paul Poiret, Constantini, Maurice Bompard, Charles Samuel (sculptor), Brisgand, Drian, Groult, Jean-Gabriel Domergue, Félix Fournery, Henry Reuré, Louis Bausil, Louis-Henri Foureau, Jean Baldoni, Roger Chastel, and others. For a recent history of this eclectic period, see Robert Rosenblum, *1900: Art at the Crossroads*, exh. cat. (New York: Guggenheim Museum, 2000).

16. The frame was used to outline cinematic sequences or series, as seen in the work of Rivière and Dumont; it provided a barrier, which was sometimes transgressed by figures, as noted in the work of Adolphe Willette; or the frame was employed to hold figures in a tense composition, as in Bonnard's covers for *La Revue blanche* (Cézanne commented that Bonnard's covers were "designed within the form"). See Jack Spector's essay, "Between Nature and Symbol: French Prints and Illustrations at the Turn of the Century," in *The Graphic Arts and French Society*, 85–86.

17. Boyer, "Artist as Illustrator," 127.

18. "La Création et le Lancement d'un Magazine," 494.

19. The example of Albert, marquis de Dion (1851–1946), illustrates this point. Risking scorn by members of his class, Dion indulged his passions for mechanical progress, all the while maintaining caustically conservative political views.

Dion founded the Automobile Club de France in 1895, an institution that aptly embodies the period's general ambivalence toward technological progress. The Automobile Club, "with its fine palace on the place de la Concorde and its membership of wealthy, titled, and reactionary *automobilistes*," was closed down briefly in 1899, targeted as a "den of conspirators against the Republic." Eugen Weber, *France: Fin de Siècle* (Cambridge, Mass.: Harvard University Press, 1986), 207.

20. A cartoon published in Giard's *Lettres sur la photographie* (1896) shows photographers on the Pont d'Iéna photographing the Eiffel Tower. The caption reads: "The bridge of asses of instantaneous photographs!" E. Giard, *Lettres sur la photographie, spécialement écrites pour la jeunesse des écoles et les gens du monde* (Paris: Charles Mendel, 1896), 345.

21. Albert Reyner, *Manuel Pratique du reporter photographe et de l'amateur d'instantanés* (Paris: Charles Mendel, 1903), v–vii.

22. The agency system quickly developed to serve the needs of a burgeoning illustrated press. Rol, Meurisse, Séeberger, and Branger were the largest agencies in France up until the 1920s; Rol and Meurisse combined in 1909, merging again in 1945 to become SAFARA (Service des Agences françaises d'actualités et de reportages associés), one of France's largest press agencies. This information is from a series of lectures given by Michel Frizot at the École du Louvre, autumn 1998. Additional information on these agencies is from the Inventaire des Photographes du 19e Siècle, in the Département des Estampes et de la Photographie, La Bibliothèque Nationale, Paris.

23. Cédric de Veigy, in a conversation with the author, 2 Nov. 1999, compared the disruptive "clack" of hand-held cameras of the period to cellular telephones of today.

24. "La Création et le Lancement d'un Magazine," 494.

25. See "Format de l'appareil," in Reyner, *Manuel pratique du reporter photographe*, 92–100.

26. These accounts are suggested in "La Création et le Lancement d'un Magazine," 494.

27. Anonymous, "Les Soldats de l'Instantané," *Je sais tout*, 15 Dec. 1906, 587–94.

28. Herbert Juin, *La France 1900 vue par les frères Séeberger* (Paris: Pierre Belfond, 1979).

29. This is an advertisement that appeared, significantly, in the *Bottin mondain*, the society annual, a telephone book for the rich, which, at the back, included listings of businesses catering to this clientele. *Bottin mondain* (Paris: Annuaire Didot-Bottin, 1913), 79.

30. Also in the article, we read about one of the Simons brothers being thrown from a capsized dingy while photographing a speedboat rally in Monaco, resurfacing after several nerve-

racking minutes, camera in hand. "What bad luck I couldn't have been photographed," he purportedly cried. "That would have been an amusing shot!" "Les Soldats de l'Instantané," 592.

31. See also coverage of Le Prix Lemonnier, a long-distance marathon, in which a Simons brother is stationed atop an automobile in order to photograph the runners as they jog by. "Le Prix Lemonnier," *La Vie au grand air*, 19 Jan. 1907. A Simons is also pictured at an auto rally with a gendarme who is trying to arrest him for venturing into a forbidden zone: "Les À-Côté de la Course," *La Vie au grand air*, 6 July 1907.

32. Lartigue, *Mémoires sans mémoire* (Paris: Éditions Robert Laffont, 1975), 71. Also, in his diaries for 1912, Lartigue records using a press pass arranged by Simons to gain entrance to the pigeon shoot in Monte Carlo. Lartigue, diary entry for 7 Apr. 1912.

33. Advertisement, *La Vie au grand air*, 11 July 1914, vii.

34. See Lartigue's diary entries for Feb. and Mar. 1912.

35. Lartigue's parents were expressly against their son entering the Service Photographique Militaire. The photo-reconnaissance unit was one of the most dangerous assignments in the military; low-flying airplanes were easily shot down. Furthermore, aviation itself, still in its infancy, was a dangerous and unpredictable activity. On aviation, see Anonymous, "L'Aviation: Est-elle dangereuse?" *Je sais tout*, 15 Apr. 1911, 309–18. On Lartigue's interest in the Service Photographique Militaire, see his diary entries for Feb. and Mar. 1916.

36. Jacques Mortane was a writer and editor for *La Vie au grand air*.

37. Lartigue, diary entries for Jan. and Feb. 1911.

38. The images in question here are not all photographic. Seaside activities in particular were lampooned by cartoonists; see, for example, Ernest Gaubert, "Les Plages Comiques," *Je sais tout*, 15 Aug. 1911, 95–102. Or the seaside might be sentimentalized, as in Franc-Nohain, "En Vacances, En Vacances," *Femina*, 15 Aug. 1913, 437–44, where the idyllic, childhood holiday experience is promoted.

39. Major Sauvage, "Le Saut comparé de l'homme et du cheval," *La Vie au grand air*, 23 Mar. 1906, 242.

40. The breakthrough in portraiture around the turn of the century was that it moved from the studio to the outdoors. Photographing fashionable women was already something of a sport by 1899, when *La Vie au grand air* published an article by Maurice Ravidat, "L'Allée des Acacias" (*La Vie au grand air*, 21 May 1899, 424–26), which featured photographs of women making the circuit on foot, on bicycle, and in carriage. *Femina*, too, published a series of articles on the Bois, by Carette, with photographs by Carle de Mazibourg, "Vers le Bois," *Femina*, 15 July 1901, 242–43. Also of interest: Franc-

Nohain, "Les 'Matins' de l'Avenue du Bois," *Femina*, 15 May 1905, 226–28; Albert Flament, "La Psychologie du Bois," *Femina*, 15 May 1907, 218–19; and Roger Boutet de Monvel, "Le Sentier de la Vertu," *Femina*, 1 July 1914, 395–98.

41. Sports began to compete with excursionism around 1900, but this prompted certain anxieties among the rich (i.e., which of the new sports were suitable for ladies, what should one wear, etc.). Articles appeared on this theme to set readers' minds at ease, such as Maurice Ravidat, "Les Sports au Château," *La Vie au grand air*, 15 Oct. 1898, 160–62. Auto rallies, which started in the first decade, were often staged in breathtaking, mountainous landscapes, such as those found in the Auvergne. See F.-A. Wheel, "Le Circuit Européen," *La Vie au grand air*, 13 Apr. 1906, 306–7; and a special issue of *La Vie au grand air*, 29 June 1907, devoted to the 1907 Grand Prix of the A.C.F.

42. "Curiosités," *Je sais tout*, 15 Dec. 1905, 767.

43. "A Travers la Globe," *Je sais tout*, 15 Aug. 1909, 43. A similar contraption appeared in *La Vie au grand air*, "le marcheur sur l'eau" (the water walker), in "La Mode Sportive," *La Vie au grand air*, 15 June 1898, 74. The pool was installed at Rouzat in 1908.

44. *La Vie au grand air* ran a series of articles on the Wright brothers, who had arrived in France in 1908 to promote the sale of patents in France. See, for example, Victor Breyer and Robert Coquelle, "La Vie et les Inventions des Frères Wright," *La Vie au grand air*, 22 May 1909, 339–40. On the aerodrome, see "L'Inauguration du Premier Aérodrome," *La Vie au grand air*, 29 May 1909. On the Salon de l'Aéronautique, see Marcel Viollette, "Le 1er Salon de l'Aéronautique," *La Vie au grand air*, 2 Jan. 1909, 14. For *L'Illustration*'s coverage of these events, see *L'Epopée de l'aviation* (Paris: L'Illustration, 1987).

45. F.-A. Wheel, "Comment Volerons-Nous l'An qui Vient?" *La Vie au grand air*, 9 Jan. 1909, 26–27.

46. H. Petit, "Comment on Construit un Aéroplane," *La Vie au grand air*, 20 Nov. 1909, 366.

47. *La Nature* also published articles on airplane construction. Moreover, kits for building kites and gliders, just like the ones Lartigue and his brother were assembling, were heavily advertised in the back of magazines starting around 1908. See, for example, an advertisement for Aéromnia, "Aéroplanes-jouets volant comme les grands," *La Nature*, 3 Dec. 1910, 18.

48. A full-page article on the breakdown, which instructed motorists how to respond to this modern inconvenience in a gracious manner, appeared in *La Vie au grand air* in 1909. One photograph, captioned "The Furious Chauffeur," advised against flailing one's arms and shouting at the "unconscious machine"; the second photograph, "He Who

Meets Trouble with a Smile," demonstrated that taking it in stride was much more attractive to ladies. H. Petit, "Variations sur un thème connu: La Panne," *La Vie au grand air*, 15 May 1909, 310.

49. See, for example, *Zissou, Yves the chauffeur and Maman in the 22 HP Peugeot*, 1910, exhibited in *Lartigue: 8 x 80*, exh. cat. (Paris: Delpire Éditeur, 1975).

50. For example, "Les Animaux en Automobile," *La Vie au grand air*, 26 Nov. 1903, 874.

51. The credentials of an apologist for "looping the loop," a M. Carlo Bourlet, whose article explaining the diverse forces at work making the spectacle possible, were cited as "A learned professor, who is also a pioneering cyclist, and member of the Touring Club Technical Committee." Carlo Bourlet, "Looping the Loop," *La Vie au grand air*, 21 Mar. 1903, 178–79. A similar stunt was staged in a concert hall two years later; this time the performance involved an automobile driven by a Mlle Randall. "Le Tourbillon de la Mort," *La Vie au grand air*, 30 Mar. 1905, 353.

52. Lartigue, diary entry for 23 Sept. 1911.

53. Reyner, *Manuel pratique du reporter photographe*, 33–34.

54. Ibid., 37.

55. Lartigue, diary entry for 24 Mar. 1912.

56. Reyner, *Manuel pratique du reporter photographe*, 43–45.

57. The distinct pivoting motion, which is behind much of the dynamism in this picture, is also a technique discussed by Reyner. Ibid., 64.

58. A photograph of Lartigue at the Grand Prix of the A.C.F., 1914, in which he stands positioned with his Cinématographe at a choice overlook, shows the kind of latitude he was granted.

59. Illustrated graphs are common in *La Vie au grand air*; some examples: "Ce qui se Fait en une Heure" (How fast they go per hour), *La Vie au grand air*, 19 Jan. 1902, 37–38; "En combien de temps peut-on faire le tour de Paris?" (How fast can one travel around Paris?), *La Vie au grand air*, 24 Jan. 1903, 56–57. Once airplanes arrived on the scene, a height graph was needed; the Eiffel Tower served as a ruler in "Les Records de la Hauture," *La Vie au grand air*, 27 Nov. 1909.

60. "Les Moyennes à l'Heure des Recordmen du Monde," *La Vie au grand air*, 2 Jan. 1909.

61. The phenomenon elicited didactic elucidation from some, such as C. Faroux, who offered his readers a geometry formula for calculating the speed of passing cars in photographs. C. Faroux, "Déformations photographiques, Illusions cinématographiques," *La Vie au grand air*, 16 Nov. 1907, 352.

62. Jacques Mortane, "Impressions de Vitesse," *La Vie au grand air*, 4 July 1908, 14–15. A similar article: Georges Boillot, "Les Joies de la Vitesse" (The joys of speed), *La Vie au grand air*, 7 Dec. 1912, 937–39.

63. Elliptical wheels and truncation also appear in images of cycling, another cortege sport. An earlier cover of *La Vie au grand air* features photographs of three—actually, two and a half—cyclists collaged onto a simple background. See "Le Grand Prix Cycliste," *La Vie au grand air*, 19 June 1903.

64. *La Vie au grand air*, 15 Oct. 1919, vi.

65. Reyner concedes that a certain amount of dust at the end of the ensemble could contribute by giving the ensemble "an appearance of movement." Reyner, *Manuel pratique du reporter photographe*, 51.

66. This technique is seen in a pair of photographs in an article on a Belgian auto rally: "La Semaine d'Ostende," *La Vie au grand air*, 21 July 1905, 605.

67. Lartigue, diary entry for 1 May 1911.

68. "Une Course de Motocyclettes sur route," *La Vie au grand air*, 12 May 1905.

69. *La Vie au grand air*, 29 June 1912.

70. Until recently, this photograph was thought to have been taken at the 1912 Grand Prix. David Junker, however, has shown that the picture was made at the 1913 Grand Prix, held in Picardie that year. David E. Junker, "Jacques-Henri Lartigue: A Correction," *History of Photography* 19 (summer 1995), 179–80. As evidence, Junker points to T.A.S.O. Mathieson, *Grand Prix Racing, 1906–1914: A History of the Grand Prix de l'Automobile Club de France* (Stockholm: Connaisseur Automobile A. B., 1965), where rosters of competitors are reproduced. The car in Lartigue's photograph, it turns out, was a Schneider, which competed in 1913, and not a Delage.

71. On Anglomania and sport in France, see Weber's chapter on sport in *France: Fin de Siècle*, and his essay "Pierre de Coubertin and the Introduction of Organized Sport," in *My France: Politics, Culture, Myth* (Cambridge, Mass.: Harvard University Press, 1991). Also see Richard Holt, *Sport and Society in Modern France* (London: Macmillan Press, 1981), especially chap. 4.

72. "Un champion de football" appeared in the article "Le Sport pour tous" (Sport for all), *La Vie au grand air*, 15 Oct. 1907, 241; "Le Match de Rugby Lyon-Racing-Club, Victoire des Lyonnais" was the frontispiece of *La Vie au grand air*, 16 Jan. 1909.

73. *La Vie au grand air*, 25 Feb. 1904.

74. Frantz Reichel, "Le Saut dans les Sports," *Je sais tout*, 15 Mar. 1908, 155–62.

75. These are droll, high-spirited photographs. I found two examples of this activity, one in *Je sais tout*, 15 July 1910, 792, the other in *L'Illustration*, 23 Oct. 1909, 299.

76. "Le Tennis sur la Côte d'Azur," *La Vie au grand air*, 25 Mar. 1911, 185; and Sem, cover illustration for *La Vie au grand air*, 30 May 1914.

77. Lartigue, diary entry for 16 Sept. 1913.

78. Entries in the diaries for these summers spent in Rouzat indicate that it was a three-ring circus of stunts and photographing, and that Lartigue often played the role of choreographer and technician. See the diary entries for August and September during the years 1911–14.

79. Lartigue, diary entry for 10 Sept. 1912.

80. The illustration, which shows a diver in seven stages of a dive from a cliff, is captioned "Movements that the eye cannot see." "Les Différents stades d'un plongeon," *La Vie au grand air*, 16 Oct. 1909, 285.

81. The film strips—there are two, one taken from the platform, one taken from the ground—both made by Pathé, show Reichelt with his parachute on the platform, Reichelt stepping off, and Reichelt from below, falling to earth among the evergreen cones on the Champ de Mars. "Un Saut mortel en parachute," *L'Illustration*, 10 Feb. 1912, 106.

82. "La Chronophotographie du mouvement," *La Vie au grand air*, 22 Mar. 1913, frontispiece.

83. Numerous articles analyzing athletic movement with the help of chronophotography appeared in *La Vie au grand air* in the early 1910s. See, for example, Georges le Roy, "L'Effort athlétique analysé par l'image," *La Vie au grand air*, 9 Aug. 1913, 652–53. Marta Braun discusses Demeny and athletics extensively in her book *Picturing Time: The Work of Etienne-Jules Marey (1830–1904)* (Chicago: University of Chicago Press, 1992), passim.

84. Chronophotography, it should be noted, required a special camera not commercially available. Unlike the Cinématographe, which was conceived as a mass-market movie camera, the chronophotography camera was highly specialized and continued to serve the interests of a handful of scientific specialists. See Braun, *Picturing Time*, passim.

85. His father already owned a Cinématographe before 1911, and Lartigue used it on occasion until he obtained his own.

86. See Lartigue's diary entry on 26 Jan. 1914.

87. It was Richard Avedon who printed the tennis sequences, circa 1970, now in the albums at the AAJHL. While some might consider the printing of single frames from these sequences as instantaneous photographs to be a form of cheating (followers of "the decisive moment" would no doubt see this as a radically stacked deck), there is little to suggest that any of Lartigue's iconic works were achieved this way. One exception: a print from the MoMA exhibition (exh. no. 10) depicts actors in a Lartigue family drama, filmed in 1914; no negative exists for this image in the AAJHL. Several problems probably discouraged Lartigue from printing individual Cinématographe frames. The flexible film was small in size, positive, and slow; printed stills would have been comparatively grainy and blurry. Lartigue's taste in instantaneous photographs at this time would not have abided this.

88. It should be noted that the notations "Photo" and "X," written in blue ballpoint pen (the rest of the diaries are in black ink, or in pencil), were added to this drawing much later, apparently during the 1970s, when Lartigue was honing his mythology as a photographic child prodigy. A similar motif is found in the diaries on 15 May 1911, and also on the cover of a sheaf of drawings Lartigue made in 1908 entitled "Dessins d'Aéroplanes," formerly in the collection of Florette Lartigue.

89. Lartigue's art training at the Académie Julian, which was directed by Jean Paul Lauren, followed the pattern of his basic education—it was neither strict nor rigorous—and he frequently skipped lessons.

90. Most of Lartigue's sports genre paintings, which depict high jumpers, swimmers, boxers, etc., date from 1921 and 1922. These works, exhibited in 1922, received a fair amount of press coverage. A French reviewer declared the arrival of a new genre, "l'art sportif," *Petit Bleu*, 3 Nov. 1922, page unknown; *The Times* (London) reported a good showing of seven paintings by "M. Lartingue" (*sic*), author and title unknown, *The Times*, 17 Apr. 1922. (Both articles are in Lartigue's scrapbooks of press clippings, "Revues de Presse," AAJHL.)

91. Anonymous, "La photographie professionnelle: le débutant 'professionel,'" *Photo-Revue*, 19 June 1910, 198–200.

92. When his conscription became unavoidable, a post as hospital driver was arranged for Lartigue. During the war, he drove upper-level military personnel around Paris until his delinquency earned him a dismissal after only six months of service. Lartigue writes on November 16, the day of his dismissal: "Honestly, I'm not really cut out for a little *rococo* job such as this." See the diaries entries for Apr.–Nov. 1916.

93. Pierre Lafitte, "La Vie au grand air," *La Vie au grand air*, 8 Apr. 1898, 4; and Holt, *Sport and Society in Modern France*, 3.

94. "Curiosités Photographiques," *La Vie au grand air*, 17 Dec. 1899, 159.

95. Response must have been great, for the magazine regularly published the terms of publication and payment, along with information on its "Service Photographique," through which readers could order copies of photographs appearing in the magazine. "Entre Nous: Aux Photographes, Amateurs et Professionnels," *La Vie au grand air*, 14 Jan. 1904, 24.

96. See, for example, Raoul Cheron, "Photographies d'amateurs," *La Vie au grand air*, 1 June 1898, 59; P. Doyé, "Le Soleil, agent de M. Lépine," *La Vie au grand air*, 14 Oct.

1900, 728; and "La Photographie avec la lumière noire," *La Vie au grand air*, 28 Oct. 1900, 755–56.

97. Advertisement for "Le Nettel," "The sports-photography camera," in *La Vie au grand air*, 11 July 1914, vii.

98. Émile Dacier, "La Photographie et les sports," *Annuaire général et international de la photographie, 1908* (Paris: Plon, 1908), 401–26.

99. This definition is widely repeated, but John Kouwenhoven pins its origins to a diary entry of 1808, in which an English sportsman, Hawker, notes that almost every bird he got was by "snapshot." John Kouwenhoven, "Living in a Snapshot World," in *Half a Truth Is Better than None* (Chicago: University of Chicago Press, 1982), 161.

100. "La chasses aux élégances," *Femina*, 15 Aug. 1911, 441.

101. Dacier, "La Photographie et les sports," 401.

102. Historians cite numerous contributing factors, including economic changes; the rise of literacy and the growth of the popular press; changing attitudes toward adolescence and a new sense of individualism; changes in the amount of leisure time; a rising awareness of the health benefits associated with fitness; the increasing identification of sport with social prestige and fashion; and, the unofficial impetus, a simple pursuit of amusement. See chaps. 1 through 3 in Holt, *Sport and Society in Modern France*. All these factors can be seen converging in a broad array of clubs established during the 1890s, such as the Automobile Club de France and the Aéro Club de France, both founded by the Comte de Dion; in the variety of events sponsored by clubs and manufacturers; and in the breathless coverage of these events disseminated by a range of new sporting publications. Henri Desgranges's *revanchiste* daily *L'Auto*, for example, sponsored the first Tour de France in 1903, a publicity stunt that boosted sales of the paper enormously and set workmen to dreaming about owning their own bicycles. See Geoffrey Nicholson, *Le Tour: The Rise and Rise of the Tour de France* (London: Hodder and Stoughton, 1991).

103. On Coubertin, see Weber, "Pierre de Coubertin and Organized Sport," 207–25.

104. An illustration from *La Vie au grand air* shows a cyclist basking in a shower of equipment and money, while a sponsor (a Jewish type, regrettably noted) gestures in a mephistophelean manner from the sidelines. This illustration is part of an article denouncing the "new amateur," a participant in amateur competitions who, poor by birth, enjoyed financial support from bicycle manufacturers. The author laments that the new amateur, because he is paid, "cannot participate in sport for his own pleasure." Robert Dieudonné, "L'Amateur Professionnel," *La Vie au grand air*, 28 Sept. 1907, 224–25.

105. L. de Fleurac, "Professionnels ou amateurs?" *La Vie au grand air*, 9 Feb. 1907, 94.

106. Lartigue joined the Racing Club in 1913, the same year that Pierre Lafitte joined. Lartigue's brother, cousins, and numerous friends were also members, as were acquaintances such as tennis player Suzanne Lenglen and ice-skater Henri Sabouret. *Racing Club de France, Annuaire 1921* (Paris: Racing Club de France, 1921).

107. Weber, "Pierre de Coubertin and Organized Sport," 222.

108. Quoted in Ibid.

109. Richard O'Monroy, *Coups d'épingle* (Paris: E. Dentu, 1886), quoted in Charles Rearick, *Pleasures of the Belle Epoque: Entertainment and Festivity in Turn-of-the-Century France* (New Haven, Conn.: Yale University Press, 1985), 160.

110. It is not coincidental, I believe, that Lartigue began keeping his diaries in 1911, at the age of seventeen. This was a critical age for a young man, the moment of his social debut, and Lartigue's parents were very concerned about the numerous choices facing their son—namely, his choice of occupation and his choice of a wife. Their presence is felt in the diaries, opining often on these matters. See Gérard Cholvy and Nadine-Josette Chaline, eds., *L'Enseignement catholique en France aux XIXe et XXe siècles* (Paris: Éditions du Cerf, 1995), 207 and passim.

111. Weber, "Pierre de Coubertin and Organized Sport," 221.

112. One of the most conspicuous manufacturers of high-end sporting clothes and equipment was Belle Jardinière, which regularly placed full-page advertisements with modern illustrations in *La Vie au grand air*. A common example was the company's advertisement for driving attire, which featured a stylish chauffeur in cap, goggles, and fur collar. *La Vie au grand air*, 8 Dec. 1905, unpaginated.

113. Quoted in Holt, *Sport and Society in Modern France*, 181.

114. Sem, cover illustration, *La Vie au grand air*, 2 May 1903.

115. Henri Duvernois, "L'Elégance dans les Sports," *Je sais tout*, 15 June 1905, 607–8.

116. Ibid., 608.

117. One funny example, a contestant in the *Femina*-sponsored competition for the "ideal feminine costume for the automobile," sports a travesty of a getup (hood, goggles); she is described by the magazine as wearing "a costume of rare elegance." "Notes d'un Visiteur au Salon de l'Automobile," *La Vie au grand air*, 22 Dec. 1904, 1045.

118. Duvernois, "L'Élégance dans les Sports," 610. Also see Albert Flament, "La Journée d'une élégante à St. Moritz," *Je sais tout*, 15 Nov. 1910, 447–58.

119. *La Vie au grand air*, 15 Nov. 1913.

120. Gymkhana appears in both French and English dictionaries, where it is defined variously as a "rally," a "motorcycle

scramble," and an "impromptu competition over a twisting course." The definition I provide here derives from explanations of the activity in French publications of the period. My English dictionary gives the etymological origins of the word: *Webster's Dictionary of the English Language* (New York: Lexicon Publications, 1987).

121. André de Fouquières, "Qu'est-ce qu'un Gymkhana?" *Je sais tout*, 15 Aug. 1905, 100–101.

122. On ice-skating, see "Gymkhana sur Glace," *Femina*, 1 Feb. 1906, 57–58.

123. De Fleurac, for example, is obsessed with proving the superiority of amateurs. See his article "Professionnels ou amateurs?"

124. Albert Flament, "Le Balcon de Femina: Le Triomphe des Amateurs," *Femina*, 15 Oct. 1907, 462.

125. On this fascinating, dreadful figure, see Willa Silverman's biography, *The Notorious Life of Gyp: Right-Wing Anarchist in Fin-de-Siècle France* (New York: Oxford University Press, 1995).

126. Jean-Yves Tadié's biography of Proust (trans. Euan Cameron) is the definitive work, *Marcel Proust: A Life* (New York: Viking, 2000), but I prefer Edmund White's more colorful and concise volume, *Marcel Proust* (New York: Viking, 1999).

127. Flament, "Le Triomphe des Amateurs," 462.

128. Rearick, *Pleasures of the Belle Epoque*, 159–60. Rearick's references: E. Benjamin and P. Desachy, *Le Boulevard, croquis parisiens* (Paris: Marpon et Flammarion, 1893); and Gustave Coquiot, *Paris, voici Paris!* (Paris: Ollendorff, 1914).

129. Galerie Brunner was located at 11, rue Royale, Paris. Coverage of the exhibition, which was apparently very popular, appears in the "Curiosités" column of *Je sais tout*, 15 Feb. 1910, 119, and also in *L'Illustration*, 11 Dec. 1909, 446–47.

130. Other prime meeting places were the racetrack at Longchamps, the Palais de Glace, and the music hall Olympia, all of which operated according to their own, unwritten schedules. On elite places, see chap. 4, "The Music Halls," in Rearick, *Pleasures of the Belle Epoque*.

131. Lartigue's drawings from circa 1908–11 are mostly copies of other artists' caricatures, as is the case with Lartigue's rendering of the cartoon character Little Tich. Later, by around 1914, Lartigue's caricatures, such as those based on family members and actress Eve Lavalière, are drawn from life.

132. My list results from perusal of magazines such as *Femina* and *L'Illustration*. For a more schematic history of fashion photography, see Nancy Hall-Duncan, *Histoire de la photographie de mode* (Paris: Éditions du Chêne, 1978).

133. Madeleine Bonnelle and Marie-José Meneret, *Sem* (Périgueux: Pierre Fanlac, 1979), 67–68. Snobism, both the term and, apparently, the attitude, came from England. See "Le Snobisme: Exaspération de l'Elégance," *Je sais tout*, 15 Mar. 1908, 261–66.

134. Lartigue mentions Givenchy in his diaries as early as 1911. As the unofficial photographer of the Bois de Boulogne, Givenchy often crossed paths with Lartigue. As with Simons, Lartigue benefited from the relationship, soliciting technical information and editorial connections. On 30 December 1912, for example, Givenchy gave Lartigue several potential contacts for publishing Lartigue's fashion photographs (none of these seems to have been published). Lartigue apparently followed the photographer around from time to time, too. A series of photographs by Givenchy, published in *L'Illustration*, in 1912, show a young girl dressing a pony. Lartigue's photograph of the same, *In front of the Pavillon Dauphine, at the Club de l'Etrier, Paris*, shows the trainer as well as the young rider; Lartigue apparently was standing right next to Givenchy during the shoot. For Givenchy's photographs of this event, see "Une Enfant qui Dresse un Cheval," *L'Illustration*, 13 Apr. 1912, 301. By 1915, Lartigue and his friends were photographed often by Givenchy. Lartigue bought prints of these photos as souvenirs of a budding social life.

135. "Une Belle Journée d'Elégance et de Sport," *L'Illustration*, 29 June 1912, 565; "Au Grand Steeple-Chase d'Auteuil: une Journée d'Elégances Parisiennes," *L'Illustration*, 25 June 1910, 567; "La Parisienne en 1912," *L'Illustration*, 6 July 1912, 7.

136. Sem, *Le Vrai et le faux chic* (Paris: Succès, 1914), unpaginated.

137. Another image, a staged photograph used as a frontispiece for *Femina* (artist unknown), captioned "Petite Robe: Grand Chapeau," shows a woman with a delivery boy, the two of them struggling to carry several enormous hatboxes. *Femina*, 1 Sept. 1910.

138. See, for example, an article appearing in *Femina*, "Plumes sur Plumes," *Femina*, 15 Sept. 1911, 486.

139. "La Comédie Féminine," *Femina*, 1 Oct. 1911, 515.

140. This photograph was misdated 1910 in the MoMA exhibition and catalogue (MoMA exh. no. 9).

141. As I have noted above, Lartigue copied caricatures by popular illustrators, such as the cartoon character Little Tich (Lartigue's early self-portraits resemble this character) and the socialite Polaire, whom Sem often drew. Lartigue was also experimenting with his own artistic persona, signing his drawings "Pic," a nickname given to him by his cousin "Oléo" (Raymond Van Weers); "Pic-Oléo," like "piccolo," was a comment on both the teenagers' individualism and allegiance. The lettering of his signature is derived, perhaps, from a Panhard and Levassor advertisement, with its

distinctively widened "P." The idea for such a moniker certainly comes from Sem's famous "pen name."

142. This photograph has been misdated 1911. Lartigue did attend the Auteuil races that year, but the appearance of his models in the magazines the previous year confirms that these were in fact the drag races of 1910 (one can be sure that the same dresses were not worn two years in a row).

143. *Femina*'s coverage is a collage of wearers of black and white; one of Lartigue's striped ladies appears in a photograph in the upper-right corner of the layout. "Noir et Blanc, Blanc et Noir," *Femina*, 15 July 1910, 386–87. By 1912, the trend had evolved into a mannerist phase, with verticals pitted against horizontals, and the entire ensemble trimmed in black-and-white embroidered velvet; this combination is chastised in an article, "Les Illogismes de la Mode," *Femina*, 1 Aug. 1912, 440.

144. This is a fundamentally social observation, one made often by photo-reporters. See, for example, women (and men) standing on chairs in coverage of the Edward VII race at Longchamps in 1903. "La Réunion d'Edouard VII," *Femina*, 1 June 1903, 555. Yet it is an observation lost at MoMA. In the MoMA print of Lartigue's photograph, the chairs are all but cropped out, concentrating the focus on the bold vertical patterning of the skirts and railing.

145. See Sabatier's cover illustration for *L'Illustration*, 29 Oct. 1910. See also the debut of fur coats the following year, "Les Manteaux de Fourrure," *Femina*, 15 Oct. 1911, 563.

146. "Un Effet de la Mode Actuelle," *L'Illustration*, 11 June 1910, 538.

147. Flossie, "Sous le fin réseau des voilettes," *Femina*, 15 Feb. 1912, 8.

148. One *Illustration* article compared fashionable French women to veiled women in Turkey. "Elégances Jeunes-Turques," *L'Illustration*, 24 Feb. 1912, 146–47.

149. See, for example, Robert Dieudonné, "Chiens de dames," *Femina*, 1 June 1906, 245–46.

150. The drawing, which Lartigue gave to Lilian Mure, is a comic strip showing two male dogs competing for a female's affections—a thinly disguised treatment of events in Lartigue's personal life at the time. Florette Lartigue reproduces it in her book. Florette Lartigue, *Jacques-Henri Lartigue: La traversée du siècle*, 60.

151. Aside from content, this image is interesting as a mélange of photography and illustration; the faces are photographs while all other detail is hand drawn. "La Belle et la Bête," *Femina*, 15 Dec. 1910, 671.

152. "Les Chiens Suivent aussi la Mode," *Femina*, 1 May 1914.

153. "Les Entravées," *Femina*, 15 May 1910, 259–60.

154. H. A., "La Robe Pantalon," *Femina*, 15 Feb. 1911, 100–101.

155. See Weber, *France: Fin de Siècle*, 96–97.

156. "Un Spectacle pittoresque dans les rues de Berlin," *Femina*, 1 May 1911, 240.

157. As organized sporting activity began to increase in France just before World War I, a pedagogy of form based on classical models began to appear in sporting magazines. *La Vie au grand air* first noted the reciprocal relation between sport and art in 1910, claiming that, thanks to sport, modern art was undergoing a kind of renaissance in its representation of muscle and athletic gesture. Georges Rozet, "L'Athlétisme et le sport dans l'art moderne," *La Vie au grand air*, 26 Feb. 1910, 141. In March 1913, the magazine published a special double issue on physical education, in which athletes are shown, sometimes nude, demonstrating classical technique. See in particular Dr. Thooris, "Les Bases de l'éducation physique," *La Vie au grand air*, 22 Mar. 1913, 209. The most striking comparison between the classical athlete and the modern athlete appears in an article in 1917, in which the classical serves as a model for turning French children into real men: "Élevons nos Enfants pour en faire des Hommes," *La Vie au grand air*, 15 Mar. 1917, 34–35.

158. "Contemporary women's fashion," writes Pierre Corrard in *Modes et manières d'aujourd'hui* (1912), "is essentially traditionalist, and is inspired by antique classicism, with which it shares a taste for line." Georges Lepape and Pierre Corrard, *Modes et manières d'aujourd'hui* (Paris: Maquet, 1912), unpaginated.

159. Madame Carette, "La Parisienne vue de dos," *Femina*, 15 Feb. 1901, 2–3.

160. Ibid., 2.

161. This was a term used with some regularity. Artist Jules Cayron, for example, exhibited a body of work in 1906 called "Movements of Women," in which he attempted to discover the "eternal feminine" in the everyday activities of contemporary women—women playing with their children, serving tea, applying makeup. For a review of the exhibition, see Maurice Donnay, "Mouvements de femmes," *Femina*, 15 May 1906, 234.

162. Maurice Ravidat, "Un Geste de la parisienne," *Femina*, 1 Nov. 1903, 719.

163. Milady, "Nos Parisiennes en voiture," *Femina*, 1 Oct. 1901, 322.

164. *L'Illustration* ran a fashion series in 1909, in which models are pictured in relation to all kinds of modern technologies: "en auto," "chez elle," at the airfield, etc. See "Les Beaux Soirs de 1909," with illustrations by L. Sabattier, *L'Illustration*, 4 Dec. 1909, unpaginated.

165. "Silhouettes Féminines au Championnat de Tennis," *L'Illustration*, 15 June 1912, 522.

166. J. Fuschen, "La Leçon de Patinage," *Femina*, 15 Jan. 1903, 417–18.

167. See the chapter entitled "La Photographie caricature" in C. Chaplot, *La Photographie récréative et fantaisiste: Recueil de divertissements, trucs, passe-temps photographiques* (Paris: Charles Mendel, 1904).

168. Tom Gunning, "New Thresholds of Vision: Instantaneous Photography, and the Early Cinema of Lumière," in *Impossible Presence: Surface and Screen in the Photogenic Era*, ed. Terry Smith (Sydney: Power Publications, 2001), 90.

169. See *Les Femmes aux Cigarettes*, exh. cat. (New York: Viking Press, 1980); and "Playing with Smoke: Photographs by Jacques-Henri Lartigue," *Esquire*, Dec. 1979, 109–12.

170. I am referring here, of course, to Robert Herbert's exposition on this motif and the social and economic relations he sees represented there. See the section on prostitution in the theater, "Backstage with Halévy and Degas," in Robert Herbert, *Impressionism: Art, Leisure, and Parisian Society* (New Haven, Conn.: Yale University Press, 1988), 107–14.

CHAPTER THREE—*Cinema*

1. *Bricolage* because cinema is "the bringing together of bits and pieces of already known techniques to produce a new capability." Alan Williams, *Republic of Images: A History of French Filmmaking* (Cambridge, Mass.: Harvard University Press, 1992), 9.

2. It was Thomas Alva Edison who announced in 1894 the first moving picture system, which consisted of a camera (Kinetograph) and a viewer (Kinetoscope). For a discussion of Edison, see ibid., 19–23. Edison failed to secure a patent for the invention in Europe, thus providing European entrepreneurs, such as the Lumière brothers, with the opportunity to develop and exploit the technology. The Lumière brothers were particularly successful in their manufacture of dry plates—the Étiquette Bleue rapide—which secured their fortune in the 1880s, while they were still in their twenties, and dominated the market for sixty years. Jacques Rittaud-Hutinet provides a good history of the Lumière brothers in *Auguste et Louis Lumière: Les 1000 premiers films* (Paris: Philippe Sers Éditeur, 1990).

3. Denis Bernard and André Gunthert emphasize this in their book on Londe, *L'Instant rêvé: Albert Londe* (Nîmes: Éditions Jacqueline Chambon, 1993), 212–14. Tom Gunning explicates this idea more thoroughly in "New Thresholds of Vision: Instantaneous Photography and the Early Cinema of Lumière," in *Impossible Presence: Surface and Screen in the Photogenic Era*, ed. Terry Smith (Sydney: Power Publications, 2001).

4. Gunning, "New Thresholds of Vision," 4.

5. As he had with photo-reporters, Lartigue became acquainted with cameramen working for various film-production companies, namely Pathé, Gaumont, and Kinecolor; see, for example, the diary entries for 27 Oct. 1912. Moreover, the acquisition of motion-picture cameras and equipment elicited technical support, often in the form of house calls made by technical professionals; ibid., 9 Jan. 1912 and 8 May 1912.

6. See chap. 3, "Bohemian Gaiety and the New Show Business," in Charles Rearick, *Pleasures of the Belle Epoque* (New Haven, Conn.: Yale University Press, 1985).

7. *Peinture, Cinéma, Peinture*, exh. cat. (Paris: Éditions Hazan et la Direction des Musées de Marseille, 1989), unpaginated.

8. Roy Armes estimates that, in the period up until 1918, 60 percent of all films were shot with a Pathé camera. Roy Armes, *French Cinema* (London: Secker and Warburg, 1985), 13.

9. Lartigue, diary entry for 25 Dec. 1912.

10. On Pathé's hegemony before the war, see chap. 2, "The Era of Dominance, 1906–13," in Armes, *French Cinema*.

11. Richard Abel, *French Cinema: The First Wave, 1915–1929* (Princeton, N.J.: Princeton University Press, 1984), 8.

12. The war severely truncated Linder's career. After relocating to the United States, he produced several more films, but eventually killed himself after he had been eclipsed by Charlie Chaplin and Buster Keaton. Armes, *French Cinema*, 21–24.

13. Lartigue's earliest mention of the Cinématographe appears in a passage from his memoirs covering 1902. The passage centers around two films vital to early film history, Méliès's *Trip to the Moon* and the Lumière brothers' *The Gardener*. Lartigue is at his most untrustworthy in instances such as this, when historical events provide inspiration for fanciful personal reflection. Lartigue, *Mémoires sans mémoire* (Paris: Éditions Robert Laffont, 1975), 43.

14. Lartigue, diary entry for 7 Nov. 1912.

15. Lartigue's notations for the cinema houses he visited and the films that he saw are remarkably detailed. Between 1911 and 1917, he attended screenings at Cinérama, l'Électric Palace, the Hippodrome, the Palace cinema, Cinéma Pathé on the boulevard des Italiens (which showed *actualités* [newsreel footage]), Cinéma Gab-ka, Cinéo (opened in 1912 on the avenue Victor Hugo), Pathé-Journal (which showed only newsreels), Musicarama, Gaumont Palace, Cinéma Select, Cinéma Demours, and Cinéma Mirabeau. Lartigue, diary entries for 1911–17, passim.

16. Williams delves a bit into the working relationship of the brothers. Louis, apparently, was the nervous and creative one, Auguste the boisterous businessman. Williams, *Republic of Images*, 21–26.

17. The understanding of Louis Lumière's films as plotless, random, "primitive" works has been challenged by Marshall Deutelbaum; his article, "Structural Patterning in the Lumière Films," *Wide Angle* 3 (1979): 28–37, generated scholarly reconsideration of Lumière's films and the motivations and intentions of early cinema more generally.

18. For a discussion of interactions between Edison and the Lumière brothers, see Williams, *Republic of Images*, 19–23. Gunning speculates that Edison's aesthetic derives from the scientific photography of Muybridge and Marey, whose work inspired the invention of the Kinetoscope. Gunning, "New Thresholds of Vision," 79.

19. On Méliès, see Williams, *Republic of Images*, 32–40. See also Armes, *French Cinema*, 10–13.

20. Dissenters cite Lumière's film *The Gardener* (1895), unique among Lumière films for its slapstick narrative. Conversely, historians such as Gunning argue that Méliès's films are more visual than they are narrative, that they are "enframed rather than emplotted," and that the search for the historical origins of cinematic narrative has misattributed Méliès's artistic intentions. Tom Gunning, "'Primitive' Cinema: A Frame-Up? Or the Trick's on Us," in Thomas Elsaesser and Adam Barker, eds., *Early Cinema: Space, Frame, Narrative* (London: British Film Institute, 1990), 101–2.

21. Armes provides the best summary of ciné-genres. See chap. 2, "The Era of Dominance," in *French Cinema*, 19–33.

22. Richard Abel notes that by 1917, "American films comprised over 50 percent of the cinema programs in Paris." Abel, *French Cinema: The First Wave*, 11.

23. Lartigue reports this in his diary entry for 26 Oct. 1912.

24. "Good," "very good," "quite good," "quite funny," "hilarious."

25. Lartigue, diary entry for 24 Dec. 1912.

26. For determining whether films were popular and well known, I consulted Abel's *French Cinema: The First Wave*, which offers the most complete index of early cinema titles.

27. The original titles in French are: *La Souris blanche*; *Une femme trop amante*; *Robinet, voleur insaisissable*; *Cent dollars, mort ou vif*; and *La Servante Coquette*.

28. Crary deals specifically with the nineteenth century, though his study bears relevance to the modern period as a whole. Jonathan Crary, *Techniques of the Observer: On Vision and Modernity in the Nineteenth Century* (Cambridge, Mass.: MIT Press, 1995).

29. Crary is referring here to Walter Benjamin's observations made earlier in the century, in *Paris, Capital of the Nineteenth Century*. Ibid., 20.

30. Ibid., 10–11.

31. Crary does occasionally grant agency to the modern observer ("I want to delineate an observing subject who was both a product of and at the same time constitutive of modernity in the nineteenth century") although the question of the observer as a "product of" modernity clearly interests him more. Ibid., 9.

32. Citing Gianni Vattimo, Crary reminds us that "the continual production of the new is what allows things to stay the same." Ibid., 10.

33. Walter Benjamin, "The Work of Art in the Age of Mechanical Reproduction" (1936), in *Illuminations: Essays and Reflections*, ed. Hannah Arendt (New York: Schocken Books, 1968), 239–41.

34. Gunning discusses these photographs in "New Thresholds of Vision," 84–87.

35. Quoted in ibid., 3.

36. This example cited in Rittaud-Hutinet, *Auguste et Louis Lumière*, 26.

37. Stephen Bottomore, "Shots in the Dark: The Real Origins of Film Editing," in Elsaesser and Barker, *Early Cinema*, 104–5.

38. On technical questions related to the Lumières' enterprise, see Vincent Pinel, *Louis Lumière, inventeur et cinéaste* (Paris: Nathan, 1994), 50.

39. Quoted in Gunning, "New Thresholds of Vision," 95.

40. Gunning discusses this guide in ibid., 78.

41. Lady Elizabeth Eastlake noted that foliage in photographs was greatly distorted, and that landscapes appeared "as if strewn with shining bits of tin, or studded with patches of snow." Lady Elizabeth Eastlake, "Photography," *Quarterly Review* (London) 101 (Apr. 1857): 466.

42. Gunning discusses viewers distracted by "moving *puncti*," such as leaves, in "New Thresholds of Vision," 79.

43. See Ben Brewster, "Deep Staging in French Films, 1900–1914," in Elsaesser and Barker, *Early Cinema*, 45–55. On editing, see Bottomore, "Shots in the Dark," in ibid., 104–13.

44. Williams, *Republic of Images*, 30.

45. The term is used by Brewster in "Deep Staging in French Films," passim.

46. Brewster discusses specifically two films from Méliès's Dreyfus series, *L'Attentat contre Maître Labori* (The attack against Master Labori) and *Bagarre entre journalistes* (Brawl among journalists) (both 1899), and shows the development of the technique in later films by Film d'Art (the Lafitte brothers' film company), namely *La Mort du duc de Guise* (The death of the duc de Guise; 1908) among others. Ibid., 45–55.

47. Dai Vaughan sees a prophetic power in the actions of this simple film: "Light shimmers on the water, though the sky seems leaden. The swell is not heavy; but as the boat passes beyond the jetty, leaving the protection of the harbour mouth, it is slewed around and caught broadside-on by

the waves. The men are in difficulties; and one woman turns her attention from the children to look at them. There it ends. Yet every time I have seen this film I have been overwhelmed by a sense of the potentiality of the medium: as if it had just been invented and lay waiting still to be explored." Dai Vaughan, "Let there be Lumière," in Elsaesser and Barker, *Early Cinema*, 64.

48. For a discussion of stereographs and spectacle, see Crary's discussion of the stereoscope in *Techniques of the Observer*, 116–34.

49. Crary's comments on the stereograph apply equally to cinema: "there never really is a stereoscopic image . . . it is a conjuration, an effect of the observer's experience of the differential between two other images." Ibid., 122. Crary, it should be added, stresses that the stereoscope was an invention "thoroughly independent of photography," predating photography's invention by twenty-odd years. In the context that I am discussing the stereoscope here, however, the relationship between the two technologies is assumed; in 1900, stereo images were photographic images.

50. The story is a standard of cinema lore. Vaughan's article attempts to reveal the subtext of this anecdote. Vaughan, "Let there be Lumière," 63.

51. Oliver Wendell Holmes, quoted in Rosalind Krauss, "Photography's Discursive Spaces: Landscape/View," *Art Journal* 42 (winter 1982): 314.

52. The early history of photography is, of course, full of stories of wonder over the purported "realism" of the image. I am speaking here of a more pronounced, "fabricated," occular experience, like that defined by Crary in *Techniques of the Observer*.

53. Gunning explains his term: "The cinema of attractions directly solicits spectator attention, inciting visual curiosity, and supplying pleasure through an exciting spectacle—a unique event, whether fictional or documentary, that is of interest in itself. The attraction to be displayed may also be of a cinematic nature, such as . . . early close-ups . . . or trick films in which a cinematic manipulation . . . provides the film's novelty. . . . Theatrical display dominates over narrative absorption, emphasizing the direct stimulation of shock or surprise at the expense of unfolding story or creating a diegetic universe." Tom Gunning, "The Cinema of Attractions: Early Film, Its Spectator and the Avant-Garde," in Elsaesser and Barker, *Early Cinema*, 58–59.

54. It would be interesting to examine Méliès's connections to amateur photography culture during the 1890s. Unfortunately, because of access restrictions imposed by the family, Méliès has been understudied.

55. In the Association des Amis de Jacques-Henri Lartigue (AAJHL), Paris, there are approximately one thousand stereoscopic positives on glass and numerous vintage stereo views mounted on paper.

56. This reconstruction is based on information found in the inventory of negatives (Inventaire Jacques-Henri Lartigue), the AAJHL, Paris.

57. See MoMA exh. no. 10.

58. The titles are my translations of Lartigue's titles as given in his albums and in other documents at the AAJHL rather than the translations used in the 1963 MoMA exhibition; for those, see Appendix B.

59. These examples appear in a lengthy article by Théodore Brown, "La Photographie stéréoscopique: Du choix du sujet," *Photo-Revue*, 1 Oct. 1905, 108–10.

60. Two statements by writers on photography who addressed the issue of stereoscopic photography, noting renewed interest in the form, are strongly indicative of the particular social demographics involved. H. Emery wondered in 1900 if more photographers wouldn't practice stereophotography if the price of the equipment was not so high, or if photographers weren't better prepared to appreciate the results. L. Stockhammer in 1913 attributed the perfection of equipment to the awakening interest by the general public in stereographs; what Stockhammer does not specify, however, is that it was the common folk who consumed stereographs, while serious amateurs (and professionals) actually made them. H. Emery, *La Photographie artistique, comment l'amateur devient un artiste* (Paris: Charles Mendel, 1900), 71; L. Stockhammer, *La Stéréoscopie rationnelle* (Paris: Charles Mendel, 1913), 6.

61. Roland Barthes, *Mythologies* (1957), trans. Annette Lavers (New York: Hill and Wang, 1972), 110. Also consider Roland Barthes, "Rhetoric of the Image" (1971), in *Image, Music, Text*, trans. Stephen Heath (New York: Hill and Wang, 1977), 32–52.

62. Hayden White emphasizes the fictive aspect of history and the plurality of its uses. See the Introduction to his *Metahistory: The Historical Imagination in Nineteenth-Century Europe* (Baltimore: Johns Hopkins University Press, 1973), and chaps. 1 and 2 in his *Tropics of Discourse: Essays in Cultural Criticism* (Baltimore: Johns Hopkins University Press, 1978).

63. Gunning, "The Cinema of Attractions," 60.

64. Two exceptions among Lartigue's albums—the early notebook and the Rochester album—both predate the cinematic organization that the later albums presumably followed.

65. Lartigue, diary entry for 18 Aug. 1911.

66. Lartigue, apparently, was not all that excited about his first Cinématographe, which he began using in March 1911. His second Cinématographe, received at Christmas, he describes as "a movie camera for full-size films." Lartigue, diary entry for 25 Dec. 1911.

67. André Gaudreault has elucidated narrative in cinema at a basic level. Gaudreault argues that even a film comprising only one shot is a narrative, for the procession of images constitutes a "chronicity": "The strict 'chronicity' of a narrative is what characterizes it as such." André Gaudreault, "Film, Narrative, Narration: The Cinema of the Lumière Brothers," in Elsaesser and Barker, *Early Cinema*, 70–71.

68. Lartigue names this gift last on his list detailing his Christmas gifts, and follows the notation with three exclamation points. Lartigue, diary entry for 25 Dec. 1912. According to Armes, the Pathé camera, which quickly became the top choice of newsreel photographers across the globe and dominated the market until 1918, was indeed easier to handle. Armes, *French Cinema*, 13.

69. The diary for 1913 has been lost; there are, fortunately, photographs of pages from the missing volume, which were made for the publication of the memoirs in 1975. These are located in the archives of the AAJHL. See the diary entries for Jan. and Feb. 1913.

70. An illustration for this scenario from Lartigue's diaries appears in the published memoirs. Lartigue, *Mémoires sans mémoire*, 148.

71. See Lartigue, diary entry for 18 Aug. 1913.

72. Apparently, these films no longer exist. Prints made from individual frames, along with segments preserved in negative sleeves, appear in the albums at the AAJHL.

73. Lartigue, diary entries for Jan. 1914.

74. Lartigue, diary entries for Jan. and Feb. 1914.

75. Lartigue, diary entries for Dec. 1917.

76. A day trip from Rouzat, for example, resulted in a large illustration of a château and a band of small illustrations representing photographs taken during the day. Lartigue, diary entry for 28 Sept. 1912.

77. Lartigue began making autochromes (early color photographs) in October 1911, when the process became commercially available through the Lumière company. Somewhat restricted by the cost of the plates, and not altogether impressed by the results (the emulsion was slow, making instantaneous photographs impossible), Lartigue used the process sparingly, though regularly, during the 1910s and 1920s; the most famous examples date from the 1920s. See Georges Herscher, *The Autochromes of J. H. Lartigue, 1912–1927*, exh. cat. (New York: Viking Press, 1981).

78. In 1916, Lartigue began an affair with stage actress Marthe Chenal, who undertook his *dépucelage* (sexual initiation). Lartigue's descriptions of their affair, like the reconstructed albums, are a palimpsest of old and new; only the handwriting and, in some cases, tone of voice, belie Lartigue's later commentary on this highly mythologized event. See the diary entries for spring 1916, and the "Notes" section at the beginning of the 1917 diary.

79. Lartigue, diary entries for Dec. 1917.

80. Barry Salt discusses this technique in "Film Form, 1890–1906," in *Early Cinema*, 36–39.

81. Laura Mulvey, in her essay "Visual Pleasure and Narrative Cinema," elaborates this point, emphasizing the fundamentally productive aspect of the dialectic between spectacle and narrative in early cinema. Laura Mulvey, *Visual and Other Pleasures* (London: Macmillan, 1989).

CHAPTER FOUR—*Lartigue at MoMA*

1. As recently as 1993, Pierre Apraxine wrote, "From the start, the process of making pictures held for Lartigue an essential element of play." Maria Morris Hambourg et al., *The Waking Dream: Photography's First Century: Selections from the Gilman Paper Company Collection*, exh. cat. (New York: Metropolitan Museum of Art, 1993), 344.

2. John Szarkowski, *The Photographs of Jacques Henri Lartigue*, exh. cat. (New York: Museum of Modern Art, 1963), unpaginated.

3. Hand-held cameras, such as numerous models produced by Gaumont, were widely available by the 1890s. Lartigue and his father owned numerous sophisticated cameras.

4. This term gained favor during the late 1960s. See, for example, Jonathan Green, ed., *The Snapshot* (single-themed issue), *Aperture* 19 (1974).

5. Daniel Belgrad, *The Culture of Spontaneity: Improvisation and the Arts in Postwar America* (Chicago: University of Chicago Press, 1998), 1.

6. MoMA, of course, was photography's main champion in the United States before the 1960s. Beaumont Newhall's groundbreaking exhibition of 1937, which led to the establishment of a photography department there in 1940, marked the start of the art-photography collection as we know it. See John Szarkowski, "Photography," in *The Museum of Modern Art, New York: The History and the Collection* (New York: Harry N. Abrams and the Museum of Modern Art, 1984; repr. 1997), 462–66.

7. John Szarkowski, *Mirrors and Windows: American Photography since 1960*, exh. cat. (New York: Museum of Modern Art, 1978).

8. Friedrich Nietzsche, *The Use and Abuse of History* (1874), trans. Adrian Collins (Indianapolis: Bobbs-Merrill Educational Publishing, 1957), 6.

9. Lartigue married Bibi—the nickname of Madeleine Messager, daughter of opera-company director and composer André Messager—in 1919. The couple divorced in 1931.

10. The quote is from "L'Art Athlètique," probably published in 1922, source and author unknown (an article in Lartigue's scrapbook of press clippings, "Revues de Presse"), in the archive of the Association des Amis de Jacques-Henri Lartigue (AAJHL), Paris.

11. Renée Perle, Lartigue's companion in 1930–33, was often a model for Lartigue's fashion paintings and photographs of this period.

12. Exhibition announcements for these events are in Lartigue's "Revues de Presse" scrapbook at the AAJHL.

13. Starting in 1939, Lartigue's main gallery would be the Galerie Charpentier, Paris.

14. From a review of Lartigue's paintings of flowers held at the Galerie Georges Petit, in *Le Figaro*, 5 June 1931, author, title, and page unknown (in Lartigue's "Revues de Presse" scrapbook, AAJHL).

15. This is noted in an article in *Paris Soir*, 23 Oct. 1933 (in Lartigue's "Revues de Presse" scrapbook, AAJHL).

16. Lartigue's recognition as a photographer in 1963 generated renewed interest in his paintings, some of which were shown in 1964 at Knoedler Gallery, New York, an exhibition arranged discreetly by MoMA in order to keep his photographs and paintings separate. In 1991 and 1993, Florette Lartigue donated her late husband's paintings to the city of L'Isle-Adam; in 1998, the Centre d'Art Jacques-Henri Lartigue was established in the Hôtel Bergeret, L'Isle-Adam, where Lartigue's paintings remain on permanent display. For a brief history of Lartigue's career as a painter, see Frédéric Chappey's essay in *L'Alchimiste du bonheur: Jacques-Henri Lartigue, artiste peintre*, exh. cat. (L'Isle-Adam: Musée d'Art et d'Histoire Louis Senlecq, 1994). Also see Florette Lartigue, *Jacques-Henri Lartigue: La traversée du siècle* (Paris: Bordas, 1990), 75–89.

17. Jean Rogers was Lartigue's dealer during the war, according to Florette Lartigue, *Jacques-Henri Lartigue: La traversée du siècle*, 115. Others, such as Raymond Grosset, Lartigue's photography agent during the 1950s and 1960s, confirm this financial situation; Raymond Grosset, in conversation with the author, 3 June 1999, Paris.

18. Lartigue did two extensive photo-essays for *Fêtes et Saisons*, "La Vie du Christ" and "Saint Dominique Savio," each of which consisted of about fifty photographs. These appeared in December 1956 and January 1957, respectively, and are in Lartigue's "Revues de Presse" scrapbook, AAJHL.

19. The arrangements for the treatment led to the arrangements for the photographs. A friend of Florette Lartigue, Jeanne Creff, a Parisian acupuncturist, was recommended to treat Picasso for sciatica. True to form, Lartigue made an event of it. "Picasso Inconnu, par Jacques Lartigue," *Point de Vue*, 3 Sept. 1955, 10–11. Photographs of Picasso and Cocteau also appeared in *L'Espoir* (Nice) and *Le Provençal* (Marseilles). These articles are in Lartigue's "Revues de Presse" scrapbook, AAJHL.

20. Grosset, conversation with the author, 3 June 1999, Paris.

21. Jean Dieuzaide was chosen as the first Prix Nièpce winner in 1955. Gens d'Images also offered the Prix Nadar, a prize for the best photography book of the year; Robert Delpire's publication of photographs by the late Werner Bischof, *Le Japon*, won the first award. "Une date dans l'histoire de la photographie: première attribution de Prix Nadar . . . et du Prix Nièpce," *Point de Vue*, 10 Mar. 1955, 19.

22. A review of this exhibition and a report on the goals of Gens d'Images appear in Serge Montigny, "À peine constituée, 73 bis, quai d'Orsay, 'L'académie française de l'Image' dresse un bilan de la photo en couleur," 18 Feb. 1955, source unknown (in Lartigue's "Revues de Presse" scrapbook, AAJHL).

23. In one of these exhibitions, according to Florette Lartigue, works by Brassaï, Doisneau, Man Ray, and Lartigue were shown. Florette Lartigue, *Jacques-Henri Lartigue: La traversée du siècle*, 186. This and the other exhibition announcements from the year are in Lartigue's "Revues de Presse" scrapbook, AAJHL.

24. *Aperture*, founded in 1952, was the photographic forum founded by Minor White, Beaumont Newhall, Nancy Newhall, and Ansel Adams among others.

25. See Fred Ritchin's brief history of Magnum in *A New History of Photography*, ed. Michel Frizot (Cologne: Könemann, 1998), 598.

26. Delpire published a remarkable collection of photography books during the 1950s, including Doisneau's *Les Parisiens tels qu'ils sont* (1954); Cartier-Bresson's *Danses à Bali* (1954), *D'une Chine à l'autre* (1954), and *Moscou* (1955); Brassaï's *Séville en Fête* (1954); Inge Morath's *Guerre à la tristesse* (1958); Bischof's *Japon* (1954) and *Carnet de route* (1957); and, of course, Robert Frank's *Les Américains* (1958). Delpire would become the main champion of Lartigue in France, producing the first major retrospective of his work at the Musée des Arts Décoratifs, Paris, in 1975.

27. Probably by Plécy, "De valeur d'évocation de la photographie," *Point de Vue*, 14 May 1953, 24.

28. Ibid.

29. Even in 1960, Lartigue's flower photographs were still appearing. An article from that year declared: "It's almost a tradition now. Each year we open our pages to this Salon de la Photo to show the marvelous bouquets of Jacques Lartigue." "Le Salon Permanent de la Photo," *Point de Vue*, 26 Aug. 1960, 18–19.

30. The first of Lartigue's early photographs to be published were pictures of automobiles. "Aux temps héroïques de l'automobile, par le peintre J.-H. Lartigue," *Point de Vue*, 30 Sept. 1954, 7–11.

31. Probably Plécy, "Toute l'aviation dans une vie d'homme," *Point de Vue*, 10 Feb. 1955, 15.

32. Albert Plécy, "Homme d'Image: J.-H. Lartigue," *Point de Vue*, 15 July 1954, page unknown (in Lartigue's "Revues de Presse" scrapbook, AAJHL).

33. Reflecting on artists' attitudes toward photography during the 1950s and 1960s, Raymond Grosset said, "French artists were always attracted to photography for its modernism, but the instant they appeared to be professionals, they distanced themselves from it." Grosset, conversation with the author, 3 June 1999, Paris.

34. Grosset reminded me of the significance of this, in ibid. Although Lartigue was not actually awarded the medal until two days after his death, in 1986, discussions of the honor seem to have begun during the mid-1970s.

35. Plécy, "Homme d'Image."

36. "Aux temps héroïques de l'automobile," 7–11. "Toute l'aviation dans une vie d'homme," *Point de Vue*, 10 Feb. 1955, 15–18. Guy Michelet, "Quel sera l'aspect des avions que Lartigue photographiera dans 45 ans, en l'an 2000?" *Point de Vue*, 10 Feb. 1955, 19–20. "Courses d'hier . . . ," *Point de Vue*, 11 June 1955, 22. All these articles are in Lartigue's "Revues de Presse" scrapbook, AAJHL.

37. "Aus der Heldenzeit des Autos: Ein Veteran des Volants öffnete uns zum Genfer Jubiläums-Salon sein Archiv," *Schweizer Illustrierte Zeitung*, Mar. 1955, 10–11.

38. "50 Years on Wheels," *Lilliput*, Apr. 1955, 13–16.

39. Lartigue, diary entries for Jan. 1962.

40. Florette Lartigue describes her husband's bad humor during a day spent at Disneyland, and quotes from his diaries a scheme to remain in California and make a living off portraits commissioned by the rich. Florette Lartigue, *Jacques-Henri Lartigue: La traversée du siècle*, 139–42.

41. This is the official story, written by Lartigue in the guise of a diary entry and published in *L'Oeil de la mémoire, 1932–1985* (Paris: Éditions 13, 1986), 282–87.

42. Lartigue, diary entries for May 1962.

43. Szarkowski's recollections, based on surviving correspondence on file at MoMA, explain the considerable intrigue involving Rado and *Life*. Szarkowski, "The Debut of Jacques Henri Lartigue," published in French in Richard Avedon et al., *Jacques-Henri Lartigue: Le choix du bonheur* (Paris: Association des Amis de Jacques-Henri Lartigue, 1992), 4. I consulted the unpublished English draft version.

44. Lartigue's account appears in a typescript version of the diaries, in the entries for May 1962, apparently a stage of a draft for the published version appearing in *L'Oeil de la mémoire, 1932–1985*.

45. Florette Lartigue writes about the encounter in *Jacques-Henri Lartigue: La traversée du siècle*, 142–43. I also spoke with her on 17 Mar. 1999, in Paris.

46. Szarkowski writes about his discovery of Lartigue in "The Debut of Jacques Henri Lartigue," passim.

47. Grosset, conversation with the author, 3 June 1999, Paris.

48. Pierre Gassmann, conversation with the author, 11 May 1999, Paris.

49. Grosset claims he had to remind Lartigue to give Rado proper credit for his role in Lartigue's "discovery." Differing versions of the story, written in the guise of journal entries made at the time, suggest that the anecdote was shaped and refined over time. Handwritten text found among typed manuscript pages of the diaries, folder marked 1962, AAJHL.

50. Grosset, conversation with the author, 3 June 1999, Paris.

51. Florette Lartigue describes her husband's fear for the safety of his photographs, left in storage in Paris during World War II, in her book, *Jacques-Henri Lartigue: La traversée du siècle*, 110. Lartigue was anxious, too, when Richard Avedon and Bea Feitler took a selection of photographs and albums with them back to New York to begin production of *Diary of a Century*. Lartigue, diary entry for 23 May 1968.

52. As Szarkowski explains, although the exhibition opened in July 1963, the catalogue had to be delayed until November of that year, the month that *Life* ran its story on Lartigue. Szarkowski, "The Debut of Jacques Henri Lartigue," 3–6.

53. Ibid., passim. Grosset notes that *Life* paid for photographic prints, whereas MoMA required that each photograph be given to the museum as a gift in order to be exhibited. Grosset, conversation with the author, 3 June 1999, Paris.

54. As the head of Pictorial Service, or "Picto," a commercial printer serving some of the best photographers of the era, including most Magnum photographers, Gassmann prided himself on his intuitive understanding of the vision of each individual photographer. His service, as he conceived of it, was to interpret that vision in the final print. Gassmann suggests that he made decisions about the cropping of Lartigue's prints (in addition to decisions about contrast, etc.), but Grosset, who acted as intermediary, transporting negatives and cropping instructions from one to the other, insists that Lartigue had more control. Gassmann, conversation with the author, 11 May 1999, Paris.

55. The Cartier-Bresson school of thought, outlined in *The Decisive Moment* (1952), held that the picture should be perfectly

composed at the moment the negative was exposed; Grosset and other media professionals found this position extreme. Grosset, conversation with the author, 3 June 1999, Paris.

56. "The World Leaps Into an Age of Innovation: Boy's camera records decade's dash and daring," *Life*, 29 Nov. 1963, 65–72.

57. At the time, Szarkowski was outspoken in his views against media machines such as *Life* and their treatment of photography. He stated flatly in 1967 that "many of today's best photographers are fundamentally bored with the mass media, and do not view it as a creative opportunity." John Szarkowski, "Photography and the Mass Media," *Aperture* 13 (1967), unpaginated. The passage quoted here is from Szarkowski, "The Debut of Jacques Henri Lartigue," 6.

58. Ibid., 11.

59. "Please extend our compliments to Mr. Gassman [*sic*] for the splendid job he did with your prints." Letter from Szarkowski to Lartigue, 19 Nov. 1962.

60. Gassmann says that an American woman in New York was hired to redo the prints; Gassmann, conversation with the author 11 May 1999, Paris. The Department of Photography at MoMA, which does not allow access to correspondence regarding the exhibition, cannot verify this. In either case, two sets of prints are clearly distinguishable in the MoMA collection. Gassmann's prints, stamped "Photo: J.-H. Lartigue, Mention Obligatoire, Droits Reproduction," following press-photography convention, reside in MoMA's Study Collection; the larger "exhibition" prints are in the Permanent Collection. As for other prints, Grosset recalls that after Rado's death in 1970 (see Rado's obituary, "Charles Rado, 71, of Photo Agency," *New York Times*, 5 Oct. 1970, 46), approximately two hundred stock photography prints (8 x 10 in.) were returned to Grosset in Paris, "for the *patrimoine*"; Grosset, ibid. Many of these prints, made by Gassmann for Lartigue's promotional campaign in America, were incorporated by Lartigue into albums just after Rado's death, and are now preserved in that format at the AAJHL.

61. Grosset relates that Lartigue was suddenly struck by a guilty conscience and subsequently sought counsel from Père Fleuret, a Catholic father who also happened to be a photography editor for Éditions du Cerf ("He was a very modern monk," notes Grosset). Père Fleuret advised Lartigue not to say anything; Lartigue, of course, did not follow this advice. Grosset, ibid.

62. Szarkowski, "The Debut of Jacques Henri Lartigue," 7.

63. Ibid.

64. Ibid.

65. Szarkowski is not entirely clear on this point. Considering that the news arrived in January and the exhibition did not go up until June, the implication would be that either seven more photographs were reattributed to the "Collection Lartigue" soon after the exhibition opened, or the staff forgot the reattributions announced earlier in the year, hung the pictures, then realized their error. Ibid.

66. Grosset believes that Lartigue knew an administrator at the Société des Bains de Mer. Grosset, conversation with the author, 3 June 1999, Paris.

67. Szarkowski, "The Debut of Jacques Henri Lartigue," 7.

68. Two photographs that were actually hung in the exhibition, I suspect, also came from the disbanded collection of the Société des Bains de Mer, Monaco: MoMA exh. nos. 16, *At the Races, Nice* (1910) and 33, *Monaco* (1912). Both of these photographs were taken in the south of France and neither is supported by a negative in the collection of the AAJHL.

69. The classic general history of MoMA is Russell Lynes's 1973 book, *Good Old Modern: An Intimate Portrait of The Museum of Modern Art* (New York: Atheneum, 1973). Numerous recent studies examine specific critical issues in MoMA's history: Susan Noyes Platt, "Modernism, Formalism, and Politics: The 'Cubism and Abstract Art' Exhibition of 1936 at The Museum of Modern Art," *Art Journal* 47 (winter 1988): 284–95; John O'Brian, "MoMA's Public Relations, Alfred Barr's Public, and Matisse's American Canonization," *RACAR* (*Revue d'art canadienne*) 18 (1991), 18–30. On the Department of Photography specifically, see Douglas Crimp, "The Museum's Old/The Library's New Subject" (1981), and Christopher Phillips, "The Judgment Seat of Photography" (1982), both in *The Contest of Meaning: Critical Histories of Photography*, ed. Richard Bolton (Cambridge, Mass.: MIT Press, 1989). See also MoMA's 1984 compendium, *The Museum of Modern Art, New York*.

70. See the chapter "Eruptive Interlude" in Lynes's *Good Old Modern*, especially pages 167–68, where he discusses the disparity between MoMA's educational intentions and the public's perception of the museum as glamorous and controversial.

71. See Elderfield's preface in *The Museum of Modern Art at Mid-Century: At Home and Abroad*, Studies in Modern Art 4, ed. John Elderfield (New York: Museum of Modern Art, 1994), 9.

72. Paul Strand, "The Art Motive in Photography," *British Journal of Photography* 70 (1923), 612–15.

73. I am referring here, of course, to Newhall's 1937 exhibition, *Photography: 1839–1937*. For an account of the exhibition's inception and the subsequent founding of the Department of Photography, see Lynes, *Good Old Modern*, 154–59. For a more critical analysis of Newhall's project, see Phillips, "The Judgment Seat of Photography," 17–21.

74. Steichen, it must be acknowledged, dramatically expanded the audience for photography at MoMA, assembling an audience for Szarkowski's critical interrogation of the medium. The best analysis of this transition is by Phillips, "The Judgment Seat of Photography," 23–24. Steichen's view that art should be apolitical (which was directly contradicted by the sensibility expressed in his exhibitions, particularly *The Family of Man*) is stated emphatically in his autobiography, *Edward Steichen: A Life in Photography* (New York: Museum of Modern Art/Doubleday, 1963).

75. Galassi makes this point, clearly declaring his allegiances by stating that, "As we move further away from them, the Steichen years will stand out as an aberration." Quoted in Richard B. Woodward, "Picture Prefect," *Artnews*, Mar. 1988, 171.

76. Szarkowski has remained steadfastly diplomatic on the subject of Steichen and his own career choices in the wake of Steichen's tenure at MoMA. See, for example, Douglas Nickel, "John Szarkowski: An Interview," *History of Photography* 19 (summer 1995): 138–40.

77. Joel Eisinger admits the difficulty in pinpointing Szarkowski's relation to formalist theory: "Formalism was such a dominant theory in the sixties that specific influences would be hard to pin down. The formalist attitude was everywhere in American art, embodied in what Irving Sandler has described as the sensibility of antianthropocentrism, a concern with objects above human emotion and human experience. No doubt Szarkowski responded to the New Criticism in literature and to Clement Greenberg." Joel Eisinger, *Trace and Transformation: American Criticism of Photography in the Modernist Period* (Albuquerque: University of New Mexico Press, 1995), 212.

78. Discussions of Szarkowski's theoretical principles are to be found in Eisinger, *Trace and Transformation*, and Phillips, "The Judgment Seat of Photography." On the vernacular, Szarkowski consulted the work of John Kouwenhoven, whose book *The Arts in Modern Civilization* (New York: Norton, 1948) theorized the essential relationship between America's indigenous technological culture and inherited European cultural aesthetics.

79. Szarkowski describes Steichen's approach relative to his own: "I think one could say that the central thrust of Steichen's work at the museum depended on the suspension of analytical or critical thinking about the photograph as a construct, as something that was made. The success of his work depended on encouraging people to think that photography represented the truth and that it was completely transparent, and that it could stand as an ombudsman, as a substitute, as a representative of life. Maybe that's the basic difference between us." In Nickel, "John Szarkowski: An Interview," 140.

80. "Anon." (anonymous) also refers to the vernacular tradition that Szarkowski defended. Szarkowski's statement first appeared in Mark Haworth-Booth, "John Szarkowski: An Interview," *History of Photography* 15 (winter 1991): 303.

81. Quoted in O'Brian, "MoMA's Public Relations," 18.

82. Critiques of MoMA, particularly those of the mid-1980s, have been widely influential. See, for example, Rosalind Krauss, *The Originality of the Avant-Garde and Other Modernist Myths* (Cambridge, Mass.: MIT Press, 1985).

83. Phillips develops this idea much more fully than I am able to do here. See Phillips, "The Judgment Seat of Photography," 34–41.

84. Susan Noyes Platt notes that this approach is based predominantly on an art-historical model developed by Alois Riegl. She discusses Barr's art history training and influences in "Modernism, Formalism, and Politics," 285–87. Also see Patricia Leighton, "Cubist Anachronisms: Ahistoricity, Cryptoformalism, and Business-as-Usual in New York," *The Oxford Art Journal* 17, no. 2 (1994): 91–102.

85. Szarkowski uses the pattern metaphor to lend an organic, natural understanding to the acts of collecting and of writing history. A collection is a group of admirable objects forming a pattern, he writes, and "the pattern suggests the sketch for a history"; Szarkowski, "Photography," 465. The origin of this concept apparently lies in John Kouwenhoven's work, in which the patterns formed by everyday material culture prophetically reveal "the clearest expression of the vital impulses upon which the future of modern civilization depends"; Kouwenhoven, *The Arts in Modern Civilization*, 12.

86. Much has been written on Winogrand. See, for example, Ben Lifson, "Garry Winogrand's American Comedy," *Aperture* 86 (1982): 32–39; Carl Chiarenza, "Standing on the Corner . . . Reflections upon Winogrand's Photographic Gaze: Mirror or Self or World?" Parts I and II, *Image* 34/35 (fall/winter, spring/summer 1991–92): 16–51, 24–45; Helen Gary Bishop, "Looking for Mr. Winogrand," *Aperture* 112 (fall 1988): 36–59. Interest in the snapshot aesthetic was expressed in a considerable range of publications that appeared during the 1960s and 1970s. See, for example, Jonathan Green, ed., *The Snapshot* (single-themed issue), *Aperture* 19 (1974); John Kouwenhoven, "Living in a Snapshot World" (1972), in John Kouwenhoven, *Half a Truth Is Better than None* (Chicago: University of Chicago Press, 1982); and Brian Coe and Paul Gates, *The Snapshot Photograph: The Rise of Popular Photography, 1888–1939* (London: Ash and Grant, 1977).

87. Szarkowski had only encountered Winogrand a few months earlier, and liked his work so much that he included it in this group exhibition, alongside the work of Ken Heyman, George

Krause, Jerome Liebling, and Minor White. Szarkowski recounts his first encounter with Winogrand's work in Haworth-Booth, "John Szarkowski: An Interview," 304.

88. Woodward, "Picture Prefect," 171.

89. Szarkowski, *Mirrors and Windows*, 23–24.

90. Press release, "Five Unrelated Photographers: Heyman, Krause, Liebling, White and Winogrand," 28 May 1963, Study Center, Department of Photography, MoMA.

91. Szarkowski, *Mirrors and Windows*, 21.

92. Winogrand apparently voiced no resentment about this kind of treatment, although others certainly did. Speaking out against Szarkowski's formalist encasement of his own work, Chauncey Hare wrote that Szarkowski "seemed to be looking for the meaningful in the immediate while searching for the superficial in the obscure. When I saw my photographs at the MoMA exhibit . . . it was clear the pictures were not being presented so that they could be understood. The photographs were hung so as to highlight the formal or intellectual 'art' elements of the pictures and to downplay the more meaningful subject content. The dehumanizing process, denial of heart values in favor of the hard, intellectual and unsentimental, is familiar to me . . . as characteristic of my experience while a Standard Oil engineer." Hare quoted in Eisinger, *Trace and Transformation*, 233–34. A similar objection was raised by Kandinsky regarding his use by Barr in the *Cubism and Abstract Art* show. Platt summarizes Kandinsky's position, which I feel compelled to quote here: "He objected to being considered as part of a deterministic march to abstraction, since, in fact, he painted realistic and abstract paintings at the same time. Kandinsky hit on crucial issues here. First, he questioned the validity of the idea of a common impulse towards abstraction. Second, he criticized the principle of an anonymous, purely formal, determination of art's development. By omitting any consideration of religious context, Barr radically misunderstood Kandinsky, as art historians now know." Platt, "Modernism, Formalism, and Politics," 292.

93. This, of course, is the critical term that Phillips uses in his essay, "The Judgment Seat of Photography," to refer to the position of the director of photography at MoMA.

94. Szarkowski has said that he agreed with Greenberg's judgment "without paying a good deal of attention to his thought." Interview with John Szarkowski, 20 May 1998, New York.

95. The origins of Szarkowski's formalist thought, I believe, are to be found in Szarkowski's early texts, those not specifically focused on photography, especially *The Idea of Louis Sullivan* (1956). Here Szarkowski emphasizes Sullivan's idea of the inseparability of form and function, a position considerably broader than the formalism espoused during his early years at MoMA. On his approach to photographing Sullivan's Prudential Building in Buffalo, Szarkowski writes: "I found myself concerned not only with the building's artfacts but with its life-facts. (Louis Sullivan had claimed they were the same.) This concern began to show in the photographs, and the idea grew." Szarkowski, *The Idea of Louis Sullivan* (Minneapolis: University of Minnesota Press, 1956). In his later writings, such as *Photography until Now* (New York: Museum of Modern Art, 1989), Szarkowski's position softens considerably. Szarkowski's reputation as a formalist has been deepened, it should be emphasized, by the rhetorical opposition of scholars such as Abigail Solomon-Godeau. See, for example, Philip Gefter's double interview with Szarkowski and Solomon-Godeau, "Whose History of Photography Is it Anyway?" *Photo Metro* (San Francisco) 8, no. 78 (Apr. 1990): 3–20.

96. An indicator of the resurgence of amateurs is noted in an article by Whit Hillyer, "The Country's Full of Camera Clubs," *Popular Photography*, Mar. 1960, 60–61, 116.

97. Bruce Downes, "Photography: A Definition," *Infinity*, Jan. 1962, 15.

98. *Life*'s year-end double issue for 1966 was devoted to amateur work. Jacob Deschin reviewed the issue, praising the editors for showing a "representative [cross-section] of American snapshooting." Deschin, "Camera at Work Today," *New York Times*, 1 Jan. 1967, sec. 2, p. 21.

99. As an indicator of divisions, the following anecdote appears in a tribute to Bruce Downes, written on the occasion of his death, in 1964: "About 10 years ago in Hollywood, a young *Life* researcher showed me the photographs he had taken of his wife, his infant son and his dog in a rather shoddy backyard. But the magic of light (mostly backlighting) transformed everything into a poetic fairy tale. The photographs were extraordinary, and I asked: 'John, why don't you try to have them published?' He answered: 'Where? No news-value for *Life*, no interest for a museum, no peeling paint, nor blurred motion, nor other trick—who will publish them?' I knew that the only possibility was to show these pictures to Bruce. He published them in Popular Photography." Philippe Halsman, "Bruce Downes 1964," *Infinity*, Sept. 1964, 24.

100. Jacob Deschin, "Goals for a Photography Center," *Popular Photography*, May 1962, 10. Deschin wrote a piece for the *New York Times* expressing similar views: "Director at Modern: Successor to Steichen Discusses His Plans," *New York Times*, 15 July 1962, sec. 2, p. 10. Similar hopes were expressed by writers for *Infinity* and *U.S. Camera*: Nat Herz, "Steichen's Successor: John Szarkowski," *Infinity*, Sept.

100. 1962, 5–11, 25; Arthur Rothstein, "On Creativity: An Interview with John Szarkowski," *U.S. Camera*, May 1963, 8–9.

101. Szarkowski's article appears in the magazine under the heading "Photography as Art." John Szarkowski, "Photographing Architecture," *Art in America*, summer 1959, 89.

102. Predictably, the popular photography contingent fixated on the idea of Lartigue as a fellow amateur. See "And What Were You Doing at Seven?" *Modern Photography*, Oct. 1966, 66–69; George Hughes, "Lartigue on Being an Amateur," *Amateur Photographer*, 30 June 1971, 8–13; and "The Harbutt Workshop," appearing in *Modern Photography*, Feb. 1976, 94–99, which used Lartigue's photographs to demonstrate photographic essentials, such as "The Shutter." On *Life* and the belle époque, Szarkowski has written: "The published reviews of the show were universally cordial, but not often cogent. In general they reviewed not the pictures but the belle époque, which in the early sixties enjoyed considerable favor in my country." Szarkowski, "The Debut of Jacques Henri Lartigue," 11.

103. If Szarkowski's elitism was distasteful to some, he was at least forthright in his judgment of inferior amateur work and clear in his definition of terms. Photographers who felt slighted by MoMA, such as those devoted to reportage, eventually formed their own organizations. Cornell Capa, for example, founded the Concerned Photographer, and then the International Center of Photography, in 1974, to represent photographic interests outside Szarkowski's purview.

104. Max Kozloff has criticized this approach, stating, "It's an aristocratic pose. It's a modernist attitude that the photograph is a luminous but inexplicable presence that doesn't depend on any social context." Kozloff quoted in Woodward, "Picture Prefect," 171.

105. See Virginia Dell, "John Szarkowski's Guide," *Afterimage* 12 (Oct. 1984), 8–11.

106. Elderfield, "The Precursor," in *The Museum of Modern Art at Mid-Century: At Home and Abroad*, 65.

107. The precursor exhibition category is a relatively broad term and encompasses non-Western as well as Western sources. Elderfield cites a dozen or so important exhibitions devoted to precursors. Precursor shows from MoMA's early years include *Corot, Daumier* (1930), *Persian Fresco Painting* (1932), *American Sources of Modern Art* (1933), *African Negro Art* (1935), and *Pre-historic Rock Pictures in Europe and Africa* (1937); significant shows from the 1950s and 1960s include *Masters of British Painting, 1800–1950* (1956), *Claude Monet: Seasons and Moments* (1960), and—the focus of Elderfield's article—*Turner: Imagination and Reality* (1966). Elderfield, "The Precursor," 88.

108. Ibid., 65.

109. Szarkowski, *The Photographs of Jacques Henri Lartigue*, unpaginated.

110. Szarkowski, press release, MoMA.

111. As a general rule, MoMA's permanent collection galleries were left "undesigned," meaning that walls were painted white and galleries were not complicated by excessive signage; special exhibitions often diverged from this standard, incorporating color and spatial modulation for full dramatic effect. The Department of Photography's permanent-collection galleries, located on the upper level of the building, had white walls, while the auditorium gallery, located on the basement level just outside the theater, was often more colorful. The walls for Steichen's 1952 exhibition of works by Aaron Siskind, for example, installed in the auditorium gallery, were black. On installation history at MoMA, see Mary Anne Staniszewski, *The Power of Display: A History of Exhibition Installations at the Museum of Modern Art* (Cambridge, Mass.: MIT Press, 1998). On framing at MoMA, see Reesa Greenberg, "MoMA and Modernism: The Frame Game," *Parachute* (Montreal) 42 (Mar.–May 1986): 21–31, and Matthew Armstrong, "On Public Hanging," *Art Press* 201 (Apr. 1995): 41–45.

112. Eisinger discusses this general strategy in *Trace and Transformation*, 215–16.

113. Given that Lartigue's total oeuvre consists of approximately 280,000 photographs in more than 120 albums and 50,000 pages of diary text, the forty-three prints selected for exhibition were bound to misrepresent the intentions of their author.

114. The same can be seen in Szarkowski's treatment of E. J. Bellocq, Atget, Timothy O'Sullivan, and multitudes of anonymous news photographers exhibited in the exhibition *From the Picture Press* (1973); this also applies to the work of documentary photographers such as Dorothea Lange, whose photographs were originally made for news magazines and government archives, to serve as witness to economic crisis.

115. Szarkowski, *The Photographs of Jacques Henri Lartigue*, unpaginated.

116. See Eisinger, *Trace and Transformation*, 220.

117. John Szarkowski, *The Photographer and the American Landscape*, exh. cat. (New York: Museum of Modern Art, 1963), 4.

118. Ibid., 3.

119. Just as Lartigue photographed according to the pictorial guidelines established by serious amateurs, magazine illustration, and cinema, O'Sullivan operated within the visual culture of the Geographic Survey, in the aesthetic structures of maps, landscape sketches, and other forms of topographical documentation. Robin Kelsey explores this in his study, "Photography in the Field: Timothy O'Sullivan and the

Wheeler Survey, 1871–1874" (Ph.D. diss., Harvard University, 2000).

120. Szarkowski, *Mirrors and Windows*, 23–24.

121. Rob Powell, "John Szarkowski," *The British Journal of Photography* 132 (20 Dec. 1985): 1423–24. Atget, like Lartigue, captivated Szarkowski as an embodiment of naïve genius, and his handling of the two photographers is very similar. Note especially Szarkowski's highly problematic application of the term "primitive." MoMA's extensive "authoring" of Atget, in the four-volume publication *The Work of Atget*—by Szarkowski, with Maria Morris Hambourg (New York: Museum of Modern Art, 1981–85)—sparked much critical response. See Molly Nesbit, *Atget's Seven Albums* (New Haven, Conn.: Yale University Press, 1992), and "The Use of History," *Art in America*, Feb. 1986, 72–83; Abigail Solomon-Godeau, "Canon Fodder: Authoring Eugène Atget," *The Print Collector's Newsletter* 16 (Jan.–Feb. 1986), 221–27.

122. Powell, "John Szarkowski," 1424.

123. Perhaps Szarkowski was responding in part to an attack on him by A. D. Coleman, who wrote a scathing review of the *Atget's Trees* exhibition in 1972. Coleman's criticism focused specifically on Szarkowski's enclosed formal universe, which, Coleman argued, completely dismissed all issues outside the photograph, including influence. Coleman's article, "Not Seeing Atget for the Trees," is cited in Eisinger, *Trace and Transformation*, 233.

124. Szarkowski, *The Photographs of Jacques Henri Lartigue*, unpaginated.

125. Quoted in Szarkowski, ibid. The exclamation points heighten the sense of childlike wonder.

126. Ibid.

127. Later in the text, Szarkowski uncharacteristically proposes possible sources outside the parameters of photography to explain Lartigue's aesthetic: "If the graphic quality of Lartigue's work suggests the pictures of Degas, Toulouse-Lautrec, and others, it is perhaps because these artists were sensitive to the new camera image—surely not because the ten-year-old had learned from the painters—or from Japanese prints." Szarkowski's confidence in Lartigue's ignorance is in this instance particularly exasperating. As Howard Gardner notes in his book, *Artful Scribbles: The Significance of Children's Drawings* (New York: Basic Books, 1980), even young children are influenced by the visual stimuli surrounding them.

128. Szarkowski, *The Photographs of Jacques Henri Lartigue*, unpaginated. We know that Szarkowski, in making his selection for the exhibition, considered later works by Lartigue because of this comment: "After the early 'twenties his photographs seem less intense in observation." Ibid.

129. As I discuss in chapter 3, by the 1920s Lartigue's interest in the instantaneous photograph as such had become subsumed in a larger project of autobiographical narrative, which borrowed cinematic structures for its form. In keeping with photographic interests of the 1920s and 1930s, Lartigue's pictures from this period are more studied and elegantly composed—which is evidently the quality Szarkowski objected to. As in Lartigue's earlier photographs (i.e., those from the period 1902–14), the photographer remains a keen observer of social habit, and is particularly attuned to the comedy of denatured elegance. His series of photographs of women smoking, taken during the 1920s, are a wry play on the Hollywood film still; they were not published until the late 1970s. See "Playing with Smoke: Photographs by Jacques Henri Lartigue," *Esquire*, Dec. 1979, 109–12; and *Les Femmes aux cigarettes*, exh. cat. (New York: Viking Press, 1980).

130. Szarkowski, *The Photographs of Jacques Henri Lartigue*, unpaginated. The age issue is further confounded by an apparent oversight. In both the catalogue and the press release for the exhibition, Lartigue's birth year is cited as 1896, misleading viewers into believing that Lartigue was two years younger than he actually was. This oversight was corrected by 1966, the year of publication of Jean Fondin's *Boyhood Photographs of J.-H. Lartigue: The Family Album of a Gilded Age* (Paris: Ami Guichard, 1996), reviews of which refer to 1894 as the proper birth year.

131. Journalists covering the story were certainly under this impression, or were all too eager to traffic in the myth of the boy genius as well. See, for example, Roger Jellinek, "Shutterbug at Seven," review of *Boyhood Photographs of J.-H. Lartigue*, *New York Times Book Review*, 7 Aug. 1966, 6–7.

132. Michel Foucault, "What Is an Author?" (1969), in *Art in Theory, 1900–1990: An Anthology of Changing Ideas*, ed. Charles Harrison and Paul Wood (Oxford: Blackwell Publishers, 1992), 923–28.

133. Szarkowski, *The Photographs of Jacques Henri Lartigue*, unpaginated.

134. Recounted by Grosset, conversation with the author, 3 June 1999, Paris.

CHAPTER FIVE—*Lartigue after MoMA*

1. Other venues included: Dulin Gallery of Art, Knoxville, Tenn. (9–30 June 1964); Wisconsin Union, University of Wisconsin, Madison (15 July–12 Aug. 1964); University of Oklahoma, Museum of Art, Norman (1–22 Oct. 1964); University of Bridgeport, Bridgeport, Conn. (23 Nov.–14 Dec.

1964); Harvard University, Cambridge, Mass. (1–22 Feb. 1965); Milwaukee Art Center, Milwaukee (1–22 Apr. 1965); University of California Art Gallery, Los Angeles (26 Sept.–24 Oct. 1965); University of Minnesota, Minneapolis (29 Nov.–19 Dec. 1965); Mount Holyoke College, Mount Holyoke, Mass. (3–24 Jan. 1966); Elmira College, Elmira, N.Y. (7–28 Feb. 1966); Art Center, South Bend, Ind. (1–22 May 1966); Mendel Art Gallery, Saskatoon, Saskatchewan (11 Aug.–4 Sept. 1966); National Gallery of Canada, Ottawa (16 Sept.–12 Oct. 1966); St. Catharine's and District Arts Council, Rodman Hall Centre, St. Catharine's, Ontario (20 Oct.–6 Nov. 1966); Sir George Williams University, Montreal (16 Nov.–4 Dec. 1966); University of Manitoba, Winnipeg (14–31 Dec. 1966).

2. Lartigue attended the opening in New York, where he saw Richard Avedon and Hiro (Yasuhiro Wakabayashi), both of whom he had met in New York in 1966. Lartigue, diary entry for 10 Oct. 1972.

3. Nancy Stevens, "The Child's Eye Opens Wider," *The Village Voice*, 1 Dec. 1975, 108. There was apparently a consensus during this period that the snapshot aesthetic, arising from vernacular traditions, was a uniquely American phenomenon. This opinion endured not only because the United States had the technological culture from which the vernacular could emerge and proliferate unhampered by European cultural aesthetics, but also because the snapshot aesthetic was first appreciated and institutionalized in the United States by curators such as Szarkowski and historians such as Szarkowski's friend, John Kouwenhoven, whose book, *The Arts in Modern Civilization* (1948), identified the mass-produced object as America's real contribution to a European arts tradition.

4. Lartigue recounts this event in his diary entry for 13 May 1974. Weston Naef acknowledges having made the offer, but was unaware at the time of the enormity of the collection. Naef, letter to the author, 26 Nov. 2003.

5. John Szarkowski, *The Photographer's Eye* (New York: Museum of Modern Art, exh. 1964; cat. 1966); John Szarkowski, *Looking at Photographs* (New York: Museum of Modern Art, 1973).

6. Szarkowski, *Looking at Photographs*, 66.

7. Szarkowski also got Lartigue's age wrong, describing him as "a child" of "fifteen," when in fact he was seventeen: "In 1911 Jacques Henri Lartigue was not merely as unprejudiced as a child; he *was* a child. The picture reproduced here was made when Lartigue was fifteen, but it was not one of his early works; by the time he was ten he was making photographs that anticipate the best small-camera work of a generation later." Ibid.

8. Thornton names names in a footnote: Mark Cohen, William Eggleston, Lee Friedlander, Stephen Shore, and Garry Winogrand. Gene Thornton, "The Place of Photography in the Western Pictorial Tradition: Heinrich Schwarz, Peter Galassi and John Szarkowski," *History of Photography* 10 (Apr.–June 1986): 89. Thornton, who was the *New York Times* photography critic in the 1970s, was also one of Szarkowski's harshest critics. Eisinger discusses Thornton's criticisms of Szarkowski in detail: Joel Eisinger, *Trace and Transformation: American Criticism of Photography in the Modernist Period* (Albuquerque: University of New Mexico Press, 1995), 237–44.

9. Janet Malcolm, "Photography: Diana and Nikon," *New Yorker*, 26 Apr. 1976, 134.

10. Serious collectors have recently shown some interest in anonymous photographs. See, for example, the Metropolitan Museum of Art's catalogue to a recent exhibition there on the subject: Mia Fineman, *Other Pictures: Anonymous Photographs from the Thomas Walther Collection* (Santa Fe: Twin Palms Publishers, 2000).

11. Lisette Model, in *The Snapshot*, ed. Jonathan Green, *Aperture* 19 (1974): 7.

12. Malcolm flatly dismisses the notion that innocence is evident in Lartigue's oeuvre: "Photography has neither a primitive style nor a commercial style nor a reportorial style nor a child's style. There is nothing in Jacques Henri Lartigue's photography to betray that he was only ten years old when he took some of his most distinguished pictures." Malcolm, "Diana and Nikon," 133.

13. Lartigue, diary entry for 1 Nov. 1974.

14. Jean Fondin, *Boyhood Photographs of J.-H. Lartigue: The Family Album of a Gilded Age* (Paris: Ami Guichard, 1966); Richard Avedon, ed., *Diary of a Century: Jacques-Henri Lartigue* (New York: Viking Press, 1970).

15. Coleman refers to *Diary of a Century* as a work "which has supplemented 'The Boyhood,' but not supplanted it in the hearts of the faithful." A. D. Coleman, "His Book Became a Bible," *New York Times*, 22 Oct. 1972, sec. 2, p. 39.

16. Prewar schools that taught photography included the Clarence White School, New York, which closed in 1942; the Art Center School of Design, Los Angeles, founded in 1931, run by Will Connell et al.; Ohio University; Indiana University, with a photography program headed by Henry Holmes Smith; and Brooklyn College, where Walter Rosenblum taught. See the section on "The Education Boom" in Keith F. Davis, *An American Century: From Dry-Plate to Digital: The Hallmark Photographic Collection* (Kansas City, Mo.: Hallmark Cards Inc., 1995), 200–202.

17. Ibid., 201.

18. John Durniak campaigned for visual literacy in "Can Johnny Take Pictures?" in *Popular Photography*, Nov. 1961, 49. In the editor's introduction to this issue, Bruce Downes wrote, "It is about time our universities invite outstanding photographers to lecture, if not to take professorships thus giving long overdue academic sanction to the world's only universal language." Bruce Downes, *Popular Photography*, Nov. 1961, 46. The same argument, calling more pointedly for the foundation of a media-studies approach to photography in the universities, was argued by Paul Byers in "Photography in the University," *Infinity*, Jan. 1963, 12–14.

19. Statistics gathered by C. William Horrell in 1964 show that journalism departments offering courses on photography outnumbered art departments two to one: 99 schools offered photography as part of the journalism program and 47 schools offered photography as an art course. Four years later, with the commencement of *Exposure*, "a magazine published for the teaching profession," which served a readership largely comprising the Society for Photographic Education, photographic activity in art schools had risen dramatically. Dr. C. William Horrell, "Photography Instruction in Higher Education, *Infinity*, July 1964, 13–36. See also Horrell's survey of teachers of photography, which profiles the educational backgrounds of photography teachers: C. William Horrell, "Teachers of Photography in Colleges and Universities," *Infinity*, Nov. 1964, 25–28.

20. *Exposure* 2 (Oct. 1968), passim.

21. See Davis, *An American Century*, 294–95.

22. A. D. Coleman discussed the significance of this appointment in 1975: "To have 'legitimacy' thus instantly conferred is at best a mixed blessing. For anyone who takes photography seriously, it is of course gratifying on one level to witness an increased attention to the medium from art critics, galleries, museums, collectors, and institutions of higher learning. On another level, however, acquiescence to the elevation of photography from the ranks of the 'low' arts tacitly affirms the validity of a hierarchy among the arts." Behind Coleman's critique (here and in his other writings) lay a deep mistrust of institutional authority in general. His proclamation, in the same article, that "academies tend to be the mausoleums of tradition, as museums tend to be the graveyards of art," denounces the two most powerful institutions opining on photography at the time: Princeton (the academy) and MoMA (the museum). A. D. Coleman, "My Camera in the Olive Grove: Prolegomena to the Legitimization of Photography by the Academy" (1975), in *Light Readings: A Photography Critic's Writings, 1968–1978* (Oxford: Oxford University Press, 1979), 195–202.

23. John Durniak, "The Double Exhibition Explosion," *Photography Annual 1970* (New York: Ziff-Davis, 1971), 7–8.

24. Reported by Candida Finkel, "Photography as Modern Art: The Influence of Nathan Lyons and John Szarkowski on the Public's Acceptance of Photography as Fine Art," *Exposure* 18 (1982): 22.

25. See Jonathan Green, *American Photography: A Critical History, 1945 to the Present* (New York: Harry N. Abrams, 1984), 144–46.

26. Furthermore, according to Keith F. Davis, "Between 1970 and 1974, the number of photographic galleries in New York City alone grew from four to fifteen." Davis, *An American Century*, 294.

27. Ibid.

28. "The value of [Adams's] classic *Moonrise, Hernandez* (1941)," Davis observed, "went from approximately $150 to $10,000 per print in the 1970s, an increase that was widely remarked upon at the time." Ibid.

29. Stevens, "The Child's Eye Opens Wider," 108.

30. Lartigue had direct contact with these photographers, each of whom he mentions in his diaries. When I asked these photographers what role Lartigue had played in their development during the 1970s, they responded variously, but all acknowledged the centrality of Lartigue in classroom discussions of photography at the time.

31. Jonathan Green considers Szarkowski and Winogrand a team, arguing that they promoted a similar, ideologically excessive idea of photography, one that recognized the realities of the photograph to the exclusion of the world. Green, *American Photography*, 102–3.

32. Lartigue was interviewed in front of a student audience at the Visual Studies Workshop, Rochester, on 22 October 1974; the next evening, Lartigue attended the opening of an exhibition of his work at George Eastman House, an event "full of students." Cornell Capa conducted a public interview in New York a week later, on 1 November 1974, which was attended by hundreds of young photography students. Lartigue, diary entries for 22–23 Oct. 1974 and 1 Nov. 1974.

33. Cohen, like others interviewed, recalls buying *Boyhood Photographs* when it came out in 1966. Cohen, letter to the author, 27 June 2001.

34. Lartigue reports this in his diary entry for 2 Aug. 1972.

35. See Lartigue's diary entries for 15 Feb. 1973 (Michals); 2 Mar. 1973 (English students); 12 May 1973 (Canadian students); and 18 June 1973 (thesis student).

36. Lartigue, diary entry for 7 Nov. 1973.

37. See the section "A New Pluralism" in Davis, *An American Century*, 297–98.

38. Daniel Belgrad argues that spontaneity in the arts—gesture, improvisation—provided, by the 1960s, "a template for expressions of social dissent." Daniel Belgrad, *The Culture of Spontaneity: Improvisation and the Arts in Postwar America* (Chicago: University of Chicago Press, 1998), 247.

39. Cohen, letter to the author, 27 June 2001.

40. Uelsmann, letter to the author, 11 June 2001.

41. Lartigue, diary entry for 27 Oct. 1973.

42. *Life* and *Look* both folded during the early 1970s. Green argues that this "liberated photographic standards." Green, *American Photography*, 146.

43. Charles Harbutt, "The Harbutt Workshop: Part Two, The Shutter," *Modern Photography*, Feb. 1976, 94.

44. Ibid., 95.

45. Ibid., passim.

46. Vladimir Nabokov, *Speak Memory* (London: Gollancz, 1951); Michel Leiris, *Manhood*, trans. Richard Howard (New York: Grossman, 1963).

47. Edward Kern, "The Last Years of Splendor," *Life*, 22 Nov. 1963, 71.

48. Ibid.

49. A photograph by Lartigue had been slated for the cover of the magazine but, in the wake of events in Dallas, a portrait of Kennedy appeared there instead. Coverage of the assassination and Lartigue shared the pages of this issue of *Life*. *Life*, 29 Nov. 1963.

50. See Todd Gitlin, *The Sixties: Years of Hope, Days of Rage* (New York: Bantam Books, 1989).

51. Lartigue went on at some length, for example, about his early obsession with drawing palm trees, his love of sunshine, his affinity for the beach; letter from Lartigue to Szarkowski, 15 Feb. 1963. Szarkowski was apparently a bit squeamish about Lartigue's mock-adolescent affectations; Szarkowski, conversation with the author, 20 May 1998, New York.

52. In his Introduction to his memoirs, Lartigue states that the earliest entries were dictated to aunts; none of these scraps survive. Lartigue, *Mémoires sans mémoire* (Paris: Laffont, 1975).

53. "La Parisienne à travers les miroirs du temps," *L'Illustré* (Lausanne), 15 Sept. 1966, 44–48. Similarly, a fashion article from 1968 shows new frocks inspired by old, with models posed in front of some of Lartigue's photographs of tennis players. "Style Tennis," *Marie France*, Feb. 1968, 61–66.

54. "Le New York de la mode," *Vogue* (Paris), Dec. 1977, 232–37.

55. Lartigue was rather appalled by this display. He wrote in his diary: "A new clothing store. . . . Such enthusiasm for my old photos from my books that they've reconstituted them in the windows (clothes, mannequins, kites; one can even

recognize Simone, Zissou, Dédé, and myself). Enormous title on the glass: 'Lartigue;' do they have the right? Do they owe me nothing? (They made me a gift of a nice sweater.)" Lartigue, diary entry for 18 Oct. 1973.

56. See n. 2 in this chap.

57. An article on Lartigue and Hiro appeared in *Photo* in 1969: "Le Match de Deux Virtuoses," *Photo* (Paris), Apr. 1969, 36–42.

58. Quoted in Stevens, "The Child's Eye Opens Wider," 108.

59. "Un Français raconte la belle époque à l'amérique," *Paris-Match*, 30 May 1964, 162. Another headline read: "L'Amérique découvre un français génial . . . que les français ne connaissaient pas," *Le Nouveau Candide*, 2–9 Jan. 1964, page unknown. Both are in Lartigue's "Revues de Presse" scrapbooks, AAJHL.

60. "'La Belle Epoque' en cent photos," *Le Soir* (Marseille), 20 Sept. 1972, author and page unknown (in Lartigue's "Revues de Presse" scrapbooks, AAJHL).

61. These press service articles are in Lartigue's "Revues de Presse" scrapbooks at the AAJHL.

62. Jean A. Keim, "Un Climat neuf," *Nouvelles Littéraires*, 28 May 1971, page unknown (in Lartigue's "Revues de Presse" scrapbook, AAJHL).

63. Michel Nuridsany, "La Photographie rivalise enfin avec la peinture," *Le Figaro*, 10 June 1972, 22.

64. There was much coverage of this event. See, for example, Danièle Haymann, "Photo, objectif musée," *L'Express*, 16 July–10 Aug. 1972, page unknown; and Jean Boissieu, "Arles: au colloque 'La photographie et le musée,' conservateurs et photographes s'aperçoivent qu'ils ont fait chacun la moitié du chemin," *Le Provençal*, 1972, exact date and page unknown. Both are in Lartigue's "Revues de Presse" scrapbooks, AAJHL.

65. *L'Aurore* pointed out that de Gaulle had chosen a military portraitist to do his portrait, and that Pompidou had chosen a journalist. Alain Riou, "Pour Giscard la Photo du Poète," *L'Aurore*, 28 Aug. 1974, p. 12a.

66. Michel Frizot, *Lartigue 8 x 80*, exh. cat. (Paris: Delpire Éditeur, 1975).

67. Additionally, reviewers in France tended to bolster the artist image of Lartigue by emphasizing that the photographer was also a painter as well as a writer. See Michel Nuridsany, "Lartigue: photographe, peintre et écrivain," *Le Figaro*, 18 Aug. 1975, page unknown; this article is in Lartigue's "Revues de Presse" scrapbooks, AAJHL.

68. On the photography market, see Michel Nuridsany, "La Photographie sur le marché de l'art," *Le Figaro*, 4 May 1977, p. 32, and Pierre Cabanne, "Le Grand Triomphe des Photographes," *Elle*, 22 Oct. 1979, 110–21, in Lartigue's

"Revues de Presse" scrapbooks, AAJHL. Hervé Guibert's interview with Agathe Gaillard appeared in *Le Monde*, "Spéculations sur la photographie," 27 Dec. 1979, p. 14.

69. Lucien Curzi, "Les As de la photo: La 'B.N.' ouvre la galerie Louvois," *L'Humanité*, 15 Nov. 1977, page unknown (in Lartigue's "Revues de Presse" scrapbooks, AAJHL).

70. Jacques Damade, *Jacques-Henri Lartigue*, exh. cat. (Paris: Centre National de la Photographie, 1983). For press coverage of the series, see Michel Nuridsany, "Contribution à une histoire de la photographie," *Le Figaro*, 25 July 1977, p. 18.

71. Michel Nuridsany, "Notre patrimoine photo en danger," *Le Figaro*, 29 June 1976, pp. 1, 17.

72. Michel Droit, "La Photographie dans la chambre noire," *Le Figaro*, 30 Oct. 1973, page unknown (in Lartigue's "Revues de Presse" scrapbooks, AAJHL).

73. A report on the state of photography in France in 1980 discusses not only the Musée d'Orsay's plans to collect and exhibit photography, but also Lartigue's donation to the state in 1979 and the upcoming exhibition of his photographs, *Bonjour Monsieur Lartigue*, at the Grand Palais. Pierre Daix, "La Photographie," *Quotidien de Paris*, 1 Dec. 1980, 16–17.

74. "Le Photographe J.-H. Lartigue fait don de son oeuvre à l'état," *Le Monde*, 28 June 1979, author and page unknown (in Lartigue's "Revues de Presse" scrapbooks, AAJHL).

75. "Des Images et des mots," *Culture et communication* (Paris), June 1980, 17–21, interviewer unknown (in Lartigue's "Revues de Presse" scrapbooks, AAJHL).

76. In an article in 1980, Nuridsany cites gallery owner Agathe Gaillard, who observes a "profound change" in the public's attitude toward photography. Michel Nuridsany, "Situation de la photographie," *Art Press* (Sept. 1980): 16.

77. See J.-F. H., "Dans les greniers de l'Histoire," *L'Express*, 3–9 May 1980, 159, 161. For a longer account of institutional response to art photography in France, read Stuart Alexander, "Photographic Institutions and Practices," in *A New History of Photography*, ed. Michel Frizot (Cologne: Könemann, 1998), 695–707.

78. Nuridsany, "Situation de la photographie," 16.

79. The author mischievously notes the proximity of the Grand Palais to the offices of the president, Valéry Giscard d'Estaing, Lartigue's personal friend. Alain Dister, "Les Clichés du patrimoine," *Le Nouvel Observateur*, 15 Sept. 1980, 11. *Bonjour Monsieur Lartigue*, exh. cat. (Paris: Association des Amis de Jacques-Henri Lartigue, 1980) was curated by Isabelle Jammes and Martine d'Astier; the exhibition traveled from 1981 to 2000. Florette Lartigue cites attendance information in her book *Jacques-Henri Lartigue: La traversée du siècle* (Paris: Bordas, 1990), 187.

CONCLUSION

1. Several sales of Lartigue's vintage prints have occurred over the last few years. Christie's, London, sold a small number of them in an auction of "Fine and Rare Photographs," 8 May 1998. Edwynn Houk Gallery, in New York, recently offered vintage prints from the collection of the late Florette Lartigue; see their catalogue, *Jacques-Henri Lartigue: Imprints of Joy: Vintage Photographs from the Collection of Mme. Lartigue* (New York: Edwynn Houk Gallery, 2000). Étude Tajan, Paris, auctioned the Renée Perle collection in two sales, on 21 Dec. 2000 and 4 May 2001. Also, some vintage prints appeared in the recent exhibition produced by the Centre Pompidou; see Martine d'Astier, et al., *Lartigue: Album of a Century*, exh. cat. (Paris: Centre Georges Pompidou; New York: Abrams, 2003).

2. See Douglas R. Nickel, "History of Photography: The State of Research," *The Art Bulletin* 83 (Sept. 2001), 548.

3. Barbara Tuchman, "Biography as a Prism of History," in *Telling Lives: The Biographer's Art*, ed. Marc Pachter (Washington, D.C.: New Republic Books, 1979).

ACKNOWLEDGMENTS

I would like to thank my adviser at Princeton University, Peter Bunnell, for his advice and friendship during my time at Princeton and after. Thanks are due also to the numerous readers who made comments on the manuscript at different stages: Carol Armstrong, Marta Braun, Hal Foster, André Gunthert, Deborah Martin Kao, Nancy Keeler, Sandra Phillips, Shelley Rice, Joel Smith, Mary Vidal, and Henri Zerner. I traveled to France several times on funding provided by a variety of sources: the Association of Princeton Graduate Alumni; the Center for Excellence in French Studies, Princeton University; the Institut Français de Washington; and the Fulbright Commission. In France, I benefited from the support and encouragement of many people and institutions: Martine d'Astier and Charles-Antoine Revol of the Association des Amis de Jacques-Henri Lartigue; Michaël Houlette of the Mission du Patrimoine Photographique; Michel Frizot of the École du Louvre and the École des Hautes Études en Sciences Sociales; Cédric de Veigy, author of a *maîtrise* on French amateur photography; Sabrina Esmeraldo, an independent photo-conservator; Clément Chéroux and Thierry Gervais of the Société Française de Photographie; Frédéric Chappey, director of the Centre d'Art Jacques-Henri Lartigue; Françoise Heilbrun of the Musée d'Orsay; Quentin Bajac of the Centre Georges Pompidou; Sam Stourdzé, an independent photo curator; Thierry Frémaux and Jean-Marc Lamotte of the Institut Lumière; and fellow discursive graduate students Lara Belkind, Elena Filipovic, and Stephen Pinson. I am grateful for the opportunities I was granted to conduct interviews with Lartigue's former agent Raymond Grosset, Lartigue's former printer Pierre Gassmann, and the late Florette Lartigue. In America, I enjoyed similar support. I would like to thank Maria Morris Hambourg, Malcolm Daniel, and the rest of the staff at the Metropolitan Museum of Art, New York, where I had a Chester Dale fellowship; the Whiting Foundation; Sean Corcoran of the George Eastman House; Darcy Alexander, formerly of the Museum of Modern Art; John Szarkowski, who agreed to a lengthy, illuminating interview; Tom Gunning of the University of Chicago; Mark Cohen, Stephen Shore, and Jerry Uelsmann, who discussed the 1970s with me; Weston Naef of the J. Paul Getty Museum; and Édouard Kopp, Michelle Lamuniere, Laura Muir, Kimberly Orcutt, Theodore E. Stebbins, Anna Tahinci, and the rest of the staff of the Fogg Art Museum, Harvard University. I am also grateful to Nancy Grubb, my editor at Princeton University Press, and to the rest of the editorial staff: Sarah Henry, Carmel Lyons, Devra K. Nelson, Ken Wong, and Kate Zanzucchi. Thanks as well to Stephen Sylvester of Harvard University for help with photography; Stephen Robert Frankel for editing; June Cuffner for proofreading; Kathleen Friello for indexing; and Carolyn Eckert for the book's design. Finally, thank you Jason Siebenmorgen, for being there from start to finish.

BIBLIOGRAPHY

Primary Sources by Lartigue

Lartigue, Jacques-Henri. "Calendrier." Chronology, 1894–1986. Association des Amis de Jacques-Henri Lartigue, Paris.

———. "Agendas." Unpublished diaries, 1911–86. Association des Amis de Jacques-Henri Lartigue, Paris.

———. "Revues de Presse." Scrapbooks of collected press clippings, 1911–86. Association des Amis de Jacques-Henri Lartigue, Paris.

———. *Mémoires sans mémoire.* Paris: Éditions Robert Laffont, 1975.

———. *L'Émerveillé: Écrit à mesure, 1923–1931.* Paris: Éditions Stock, 1981.

———. *L'Oeil de la mémoire, 1932–1985.* Paris: Éditions 13, 1986.

Sources on Lartigue

"50 Years on Wheels." *Lilliput*, Apr. 1955, 13–16.

"1901–1968 dans l'album candide de Jacques-Henri Lartigue: notre siècle." *Photo*, July–Aug. 1968, 25–49.

"Aerei, automobili e belle signore: la belle epoque secondo Lartigue." *Arte*, Aug. 2000, 26.

"L'Album de Famille de la Belle Époque." *Le Nouveau Candide*, 2–8 Jan. 1967, 27–33.

Amodeo, Fabio. "Maestri del Novecento: Jacques-Henri Lartigue: Quando Proust entra in camera obscura." *Arte*, Dec. 2000, 102–15.

Artner, Alan G. "The Visions of a Child. . . ." *Chicago Tribune*, 28 Apr. 1974, sec. 6, p. 8.

D'Astier, Martine, et al. *Lartigue: Album of a Century.* Exh. cat. Paris: Centre Georges Pompidou; New York: Abrams, 2003.

"Aus der Heldenzeit des Autos: Ein Veteran des Volants öffnete uns zum Genfer Jubiläums-Salon sein Archiv." *Schweizer Illustrierte Zeitung*, Mar. 1955, 10–11.

"Aux temps héroïques de l'automobile, par le peintre J.-H. Lartigue." *Point de Vue*, 30 Sept. 1954, 7–11.

Avedon, Richard, ed. *Diary of a Century: Jacques-Henri Lartigue.* New York: Viking Press, 1970.

Avedon, Richard, et al. *Jacques-Henri Lartigue: Le choix du bonheur.* Paris: Association des Amis de Jacques-Henri Lartigue, 1992.

"Les Belles inventions de la famille Lartigue." *Paris-Match*, 13 June 1964, 154–59.

Blume, Mary. *Lartigue's Riviera.* Exh. cat. Paris: Flammarion, 1997.

"Al Bois de Boulogne come mezzo secolo fa." *Settimana Incom Illustrata*, 5 Dec. 1965, 46–51.

Borhan, Pierre, and Martine d'Astier. *Les Envols de Jacques Lartigue et les débuts de l'aviation.* Exh. cat. Paris: Association des Amis de Jacques-Henri Lartigue, 1989.

Bowen, Ezra. *Jacques-Henri Lartigue.* New York: Aperture, 1976.

Chapier, Henry. *Lartigue.* Paris: Belfond, 1981.

Chappey, Frédéric, et al. *L'Alchimiste du bonheur: Jacques-Henri Lartigue, artiste peintre.* Exh. cat. L'Isle-Adam: Musée d'Art et d'Histoire Louis Senlecq, 1994.

Coe, Brian. *Jacques-Henri Lartigue.* London: Macdonald and Co., 1984.

Coleman, A. D. "His Book Became a Bible." *New York Times*, 22 Oct. 1972, sec. 2, p. 39.

Cordesse, Maryse. "Jacques-Henri Lartigue." *Camera International* (Paris) 21 (summer 1989): 30–39.

"Courses d'hier. . . ." *Point de Vue*, 11 June 1955, 22.

Damade, Jacques. *Jacques-Henri Lartigue.* Exh. cat. Paris: Centre National de la Photographie, 1983.

———. "Jacques-Henri Lartigue: Vom Charme der Fotografie." *Fotografie* (Leipzig) 42 (Aug. 1988): 308–15.

Dargent, Françoise. "Lartigue, albums du bonheur: Les souvenirs de l'artiste, clé de voûte de l'oeuvre d'un génial amateur, exposés au Centre Georges-Pompidou." *Le Figaro*, 7 June 2003, 25.

Deschin, Jacob. "French Amateur: Candid Shots of 1905–22 Society Life at Modern Museum." *New York Times*, 7 July 1963, sec. 2, p. 14.

———. "From a French Boy's Picture Album." *New York Times*, 21 Aug. 1966, 20.

———. "Diverse Shows at Cologne." *New York Times*, 23 Oct. 1966, sec. 2, p. 34.

Duponchelle, Valérie. "Lartigue, 'l'empailleur de bonheur': Son premier album d'artiste en herbe et quelque soixante tirages des années 60 rarissimes font l'événement à la galerie Bellier." *Le Figaro*, 9 May 2003, 22.

Esterow, Milton. "Lartigue at 90." *Artnews*, Jan. 1985, 104–6.

Flint, Peter. "Lartigue Is Dead, Photographer, 92." *New York Times*, 13 Sept. 1986, 9.

Foch, Elisabeth. *Lartigue's Winter Pictures*. Paris: Flammarion; London: Thames and Hudson, 2002.

Fondin, Jean. *Boyhood Photographs of J.-H. Lartigue: The Family Album of a Gilded Age*. Paris: Ami Guichard, 1966.

"Un Français raconte la belle époque à l'amérique." *Paris-Match*, 30 May 1964, 162–66.

Fremont-Smith, Eliot. "Books of the Times: La Belle Epoque, Handsomely Recalled." *New York Times*, 20 July 1966, sec. 2, p. 39.

———. "Books of the Times: Over the Counter and Under the Tree." *New York Times*, 9 Dec. 1966, sec. 2, p. 45.

Frizot, Michel. *Lartigue: 8 x 80*. Exh. cat. Paris: Delpire Éditeur, 1975.

———. *Le passé composé: Les 6 x 13 de Jacques-Henri Lartigue*. Exh. cat. Paris: Association des Amis de Jacques-Henri Lartigue, 1987.

Galerie Municipale du Château d'Eau. *J. H. Lartigue*. Exh. cat. Toulouse: Galerie Municipale du Château d'Eau, 1975.

Galleria Gottardo. *Jacques Henri Lartigue*. Exh. cat. Lugano, Switzerland: Galleria Gottardo, 1996.

Gett, Trevor. "In Search of Lartigue." *British Journal of Photography* 144 (27 Aug. 1997): 12–13.

Goldberg, Vicki. *Jacques Henri Lartigue: Photographer*. Boston: Little, Brown and Co., 1998.

Gruen, John. "Photography at 2 Museums: More than 'Push the Button.'" *New York Herald Tribune*, 7 July 1963, 5.

Grundberg, Andy. "A Precocious Artist Who Was No Naif." *New York Times*, 28 Nov. 1982, sec. 2, p. 27.

———. "A Passion for Wheels, Wings and Engines." *New York Times*, 18 Jan. 1987, sec. 2, p. 31.

Guerrin, Michel. "Jacques-Henri Lartigue jusqu'à plus soif." *Le Monde*, 6 Aug. 1997, 19.

———. "Entretien avec Martine d'Astier, directrice de la Donation Lartigue." *Le Monde*, 7 June 2003, 30.

———. "Lartigue mis en page par lui-même." *Le Monde*, 7 June 2003, 30.

Herscher, Georges. *The Autochromes of J. H. Lartigue, 1912–1927*. Exh. cat. New York: Viking Press, 1981.

Hill, Paul, and Tom Cooper. "Henri-Jacques Lartigue" [*sic*]. *Camera*, Apr. 1975, 37.

Hopkinson, Amanda. "Just Celebrating: Paris Shows Brassaï, Cartier-Bresson and Lartigue." *Creative Camera* 6 (1989): 28–31.

"Jacques-Henri Lartigue par lui-même." *Camera International* (Paris) 32 (spring 1992): 72–81.

"Jacques Lartigue, jeune reporter de la belle époque." *L'Officiel de la photographie et du cinéma* 154 (Sept.–Oct. 1967): 293–95.

Jauffret, Magali. "Photographie: Le Centre Georges-Pompidou expose les albums photos inédits de cet 'amateur professionnel.'" *L'Humanité*, 21 June 2003, 41.

Jellinek, Roger. "Shutterbug at Seven" (review of *Boyhood Photographs of J.-H. Lartigue*). *New York Times Book Review*, 7 Aug. 1966, 6–7.

Johnson, Ken. "Jacques Henri Lartigue." *New York Times*, 20 Oct. 2000, sec. 2, p. 40.

Junker, David E. "Jacques-Henri Lartigue: A Correction." *History of Photography* 19 (summer 1995): 179–80.

Kelen, Jacqueline. *Jacques-Henri Lartigue: l'oeil de l'oiseleur*. Paris: Desclée de Brouwer, 1985.

Kozloff, Max. "Mercurial Quietude: Cartier-Bresson and Lartigue." *Art in America*, Jan. 1972, 68–79.

"Lartigue, dernière mise au point." *La Libération*, 13–14 Sept. 1986, 34–35.

Lartigue, Florette. *Jacques-Henri Lartigue: La traversée du siècle*. Paris: Bordas, 1990.

Lartigue, Jacques-Henri. *Les Femmes*. New York: E. P. Dutton and Co., 1974.

———. *J. H. Lartigue et les autos et autres engins roulants*. Paris: Éditions du Chêne, 1974.

———. *Mon livre de photographie*. Paris: Flammarion, 1977.

———. *Les Femmes aux Cigarettes*. New York: Viking Press, 1980.

———. *Bonjour Monsieur Lartigue*. Exh. cat. Paris: Association des Amis de Jacques-Henri Lartigue, 1980.

———. *Tennis (1910–1926)*. Exh. cat. Rome: Centre Culturel Français de Rome, Edizioni Carte Segrete, c. 1983.

———. *Les Femmes*. Exh. cat. London: Olympus Gallery, c. 1984.

———. *Madame France*. Exh. cat. Paris: Association des Amis de Jacques-Henri Lartigue, 1993.

———. *Imprints of Joy: Vintage Photographs from the Collection of Madame Lartigue*. Exh. cat. New York: Edwynn Houk Gallery, 2000.

Lavergne, Pascal de. *Lartigue au pays de la Côte basque: Les Traversées d'un corps-image, essai*. Exh. cat. Paris: Séguier, 2002.

Livingston, Kathryn. "Still Lives Run Deep: Probing Lartigue's Heart and the Art of Jan Groover." *American Photographer*, June 1987, 22–24.

"Le Match de Deux Grands Virtuoses." *Photo* (Paris), Apr. 1969, 36–42.

McBride, Stewart. "The Last Sunny Days of Lartigue." *American Photographer*, Aug. 1987, 56–64.

Michelet, Guy. "Quel sera l'aspect des avions que Lartigue photographiera dans 45 ans, en l'an 2000?" *Point de Vue*, 10 Feb. 1955, 19–20.

Monterosso, Jean-Luc. "Jacques-Henri Lartigue: Sur les ailes du temps." *Cimaise* 36 (June–Aug. 1989): 61–64.

Moore, Kevin. "Jacques-Henri Lartigue et la naissance du modernisme en photographie." *Études photographiques* 13 (July 2003): 7–34.

Nin, Anaïs. "Diary of a Century." Book Review. *New York Times Book Review*, 21 Feb. 1971, 4–5.

Nuridsany, Michel. "Jacques-Henri Lartigue: un regard émerveillé." *L'Actualité*, 14 Sept. 1986, 1.

Ollier, Brigitte. "Prodigue Lartigue." *La Libération*, 5 June 2003, 32.

"Paris au féminin: cinquante ans après, le photographe est revenu au Bois." *Marie Claire*, Mar. 1966, 12.

"La Parisienne à travers les miroirs du temps." *L'Illustré* (Lausanne), 15 Sept. 1966, 44–48.

"Photographie: La 'Belle Époque.'" *Le Monde*, 3 Jan. 1964, 7.

"Photographies de Lartigue." *Car and Driver*, Sept. 1962.

"Picasso Inconnu, par Jacques Lartigue." *Point de Vue*, 3 Sept. 1955, 10–11.

"Playing with Smoke: Photographs by Jacques-Henri Lartigue." *Esquire*, Dec. 1979, 109–12.

Porter, Allan. "Paris 1900." *Camera* 45 (Dec. 1966): 8–27.

Ribeton, Olivier. *Jacques Henri Lartigue au pays basque*. Anglet: Atlantica, 2002.

Rice, Shelley. "L'Empailleur de bonheur." In *Jacques-Henri Lartigue: Le choix du bonheur*. Paris: Association des Amis de Jacques-Henri Lartigue, 1992.

———. "Remembrance of Images Past." *Art in America*, Nov. 1992, 122–29.

Riding, Alan. "Lartigue's Albums: The Well-Lensed Life." *New York Times*, 6 July 2003, sec. 2, p. 27.

Roegiers, Patrick. "Jacques-Henri Lartigue: The Legend of the Century." *Katalog* (Odense, Denmark) 7, no. 1 (Sept. 1994): 3–11.

———. "La mort de Jacques-Henri Lartigue: La légende du siècle." *Le Monde*, 14 Sept. 1986, 13–14.

———. "'Les tourments du funambule:' Jacques-Henri Lartigue, dessinateur, peintre et photographe." Unpublished essay. Association des Amis de Jacques-Henri Lartigue, Paris, 1994.

"Le Salon Permanent de la Photo." *Point de Vue*, 26 Aug. 1960, 18–19.

Sansone, J. G. "Jacques Lartigue, peintre, photographe et magicien ou le rêve d'un petit garçon." *Le Provençal* (St.-Tropez), 8 July 1965, 6.

Shirey, David. "Lartigue, a Record of a Long Life in Photographs." *New York Times*, 17 Oct. 1972, 32.

"Soixante ans ont passé au Bois de Boulogne. . . ." *Le Soir Illustré* (Brussels), 11 Aug. 1966, 54–59.

Stevens, Nancy. "The Child's Eye Opens Wider." *The Village Voice*, 1 Dec. 1975, 108.

Szarkowski, John. "Le Début de Jacques-Henri Lartigue." In *Jacques-Henri Lartigue: Le choix du bonheur*. Paris: Association des Amis de Jacques-Henri Lartigue, 1992.

———. *The Photographs of Jacques Henri Lartigue*. Exh. cat. New York: Museum of Modern Art, 1963.

Tournier, Michel. "J.-H. Lartigue: Le Piège d'Oeil." *L'Oeil*, Dec. 1974, 38–43.

"Toute l'aviation dans une vie d'homme." *Point de Vue*, 10 Feb. 1955, 15–18.

"Watching the Birdies, 60 years on." *Weekend*, 9–15 Mar. 1966, 3–5.

Wolf, Laurent. "Le Regard heureux de Lartigue sur le siècle le plus noire de l'histoire." *Le Temps*, 14 June 2003.

Wood, Gaby. "If It Moves, Shoot It." *Observer Review*, 24 Dec. 2000, 14.

"The World Leaps Into an Age of Innovation: Boy's camera records decade's dash and daring." *Life*, 29 Nov. 1963, 65–72.

Other Sources

"À l'amateur photographe." *Annuaire général de la photographie, France, Belgique, Suisse* (1892): 3–10.

Abel, Richard. *French Cinema: The First Wave, 1915–1929*. Princeton, N.J.: Princeton University Press, 1984.

Abrahams, Adolphe. "Sport et chambre noire." *Photo-Revue*, 13 Feb. 1910, 55–56.

Albert, Pierre, and Gilles Feyel. "Photography and the Media: Changes in the Illustrated Press." In *A New History of Photography*, ed. Michel Frizot. Cologne: Könemann, 1998.

L'Amateur photographe, revue illustrée de la photographie dans le monde entier. Paris, 1884–1901.

Annuaire général de la photographie, France, Belgique, Suisse. Paris: Plon, 1892–93.

Annuaire général et international de la photographie, 1897. Paris: Plon, 1897.

Apprill, Christophe. *Le Tango argentin en France*. Paris: Anthropos, 1998.

Ariès, Philippe. *Centuries of Childhood: A Social History of Family Life*. Trans. Robert Baldick. New York: Knopf, 1962.

Armes, Roy. *French Cinema*. London: Secker and Warburg, 1985.

Armstrong, Matthew. "On Public Hanging." *Art Press* 201 (Apr. 1995): 41–45.

L'Art et la Mode, journal de la vie mondaine. Paris: Charles Chantal, 1880–1967.

Auer, Michel. *The Illustrated History of the Camera, from 1839 to the Present*. Trans. D. B. Tubbs. Boston: New York Graphic Society, 1975.

L'Auto-vélo. Paris: Henri Desgrange, 1900–1944. (The title was changed to *L'Auto* at a later date.)

"L'Aviation est-elle dangereuse?" *Je sais tout*, 15 Apr. 1911, 309–18.

Bachollet, Raymond, et al. *Paul Iribe*. Paris: Denoël, 1982.

Barthes, Roland. "The Death of the Author" (1968). In *Image, Music, Text*, trans. Stephen Heath. New York: Hill and Wang, 1977.

———. "Myth Today." In Roland Barthes, *Mythologies* (1957), trans. Annette Lavers. New York: Hill and Wang, 1972.

———. "Rhetoric of the Image." In *Image, Music, Text*, trans. Stephen Heath. New York: Hill and Wang, 1977.

Baschet, Eric, ed. *L'Epopée de l'aviation*. Les grands dossiers de l'Illustration: Histoire d'un siècle, 1843–1944. Paris: SEFAG and l'Illustration, 1987.

Belgrad, Daniel. *The Culture of Spontaneity: Improvisation and the Arts in Postwar America*. Chicago: University of Chicago Press, 1998.

Benjamin, Walter. "The Work of Art in the Age of Mechanical Reproduction" (1936). In *Illuminations: Essays and Reflections*, ed. Hannah Arendt. New York: Schocken Books, 1968.

Bergeret, A., and F. Drouin. *Les Récréations photographiques*. Paris: Charles Mendel, 1891.

Bernard, Denis, and André Gunthert. *L'Instant rêvé: Albert Londe*. Nîmes: Éditions Jacqueline Chambon, 1993.

Bishop, Helen Gary. "Looking for Mr. Winogrand." *Aperture* 112 (fall 1988): 36–59.

Boden, Karin, et al. *Paris Belle Époque, 1880–1914*. Exh. cat. Kulturstiftung Ruhr, Essen. Recklinghausen: Verlag Aurel Bongers, 1994.

Boillot, Georges. "Les Joies de la vitesse." *La Vie au grand air*, 7 Dec. 1912, 937–39.

Boivin, Ernest. "La Photographie d'art: Composition d'un tableau photographique." *L'Amateur photographe*, 1 Feb. 1888, 57–60.

Bonnelle, Madeleine, and Marie-José Meneret. *Sem*. Périgueux: Pierre Fanlac, 1979.

Bottomore, Stephen. "Shots in the Dark: The Real Origins of Film Editing." In *Early Cinema: Space, Frame, Narrative*, ed. Thomas Elsaesser and Adam Barker. London: British Film Institute, 1990.

Bourdieu, Pierre. *Photography: A Middle-Brow Art* (1965). Trans. Shaun Whiteside. Cambridge: Polity Press, 1990.

Bourdon, Georges. *La Renaissance athlétique et Le Racing Club de France*. Paris: Le Racing Club de France, 1906.

Bourlet, Carlo. "Looping the Loop." *La Vie au grand air*, 21 Mar. 1903, 178–79.

Boutet de Monvel, Roger. "Le Sentier de la Vertu." *Femina*, 1 July 1914, 395–98.

Braun, Marta. *Picturing Time: The Work of Etienne-Jules Marey (1830–1904)*. Chicago: University of Chicago Press, 1992.

———. "Movement and Modernism: The Work of Etienne-Jules Marey." In *Marey: Pionnier de la synthèse du mouvement*. Exh. cat. Beaune: Musée Marey; Paris: Réunion des Musées Nationaux, 1995.

Brewster, Ben. "Deep Staging in French Films, 1900–1914." In *Early Cinema: Space, Frame, Narrative*, ed. Thomas Elsaesser and Adam Barker. London: British Film Institute, 1990.

Brown, Théodore. "Photographie stéréoscopique: Du choix du sujet." *Photo-Revue*, 1 Oct. 1905, 108–10.

Bruno, G. *Le Tour de la France par deux enfants: Devoir et patrie* (1885). Paris: Librarie Classique Eugène Belin, 1976.

Bunnell, Peter, ed. *A Photographic Vision: Pictorial Photography, 1889–1923*. Salt Lake City: Peregrine Smith, 1980.

Byers, Paul. "Photography in the University." *Infinity*, Jan. 1963, 12–14.

Cabanne, Pierre. "Le Grand Triomphe des Photographes." *Elle*, 22 Oct. 1979, 110–21.

Callahan, Sean. "The First Viceroy of Photography." *American Photographer*, June 1978, 24–31.

Carette, Mme. "La Parisienne vue de dos." *Femina*, 15 Feb. 1901, 2–3.

———. "Vers le Bois: III. À pièd." *Femina*, 15 July 1901, 242–43.

Cartier-Bresson, Henri. *The Decisive Moment: Photography by Henri Cartier-Bresson*. New York: Simon and Schuster, 1952.

Cate, Phillip Dennis, ed. *The Graphic Arts and French Society, 1871–1914*. Exh. cat. New Brunswick, N.J.: Rutgers University Press, 1988.

"Ce qui se fait en une heure." *La Vie au grand air*, 19 Jan. 1902, 37–38.

Chaplot, C. *La Photographie récréative et fantaisiste: Recueil de divertissements, trucs, passe-temps photographiques*. Paris: Charles Mendel, 1904.

Chaux, Paul. *La Photographie instantanée par les appareils à main*. Paris: E. Bardin, 1894.

Chéroux, Clément. "Les Récréations photographiques: Un répertoire de formes pour les avant-gardes." *Études photographiques* 5 (Nov. 1998): 72–96.

———. *Fautographie: Petite histoire de l'erreur photographique*. Crisnée, Belgium: Éditions Yellow Now, 2003.

Chiarenza, Carl. "Standing on the Corner . . . Reflections upon Winogrand's Photographic Gaze: Mirror or Self or World?" *Image* 34 (fall/winter 1991): 16–51.

———. "Standing on the Corner . . . Reflections upon Winogrand's Photographic Gaze: Mirror or Self or World?" *Image* 35 (spring/summer 1992): 24–45.

Cholvy, Gérard, and Nadine-Josette Chaline, eds. *L'Enseignement catholique en France aux XIXe et XXe siècles*. Paris: Éditions du Cerf, 1995.

Coe, Brian, and Paul Gates. *The Snapshot Photograph: The Rise of Popular Photography, 1888–1939*. London: Ash and Grant, 1977.

Coleman, A. D. *Light Readings: A Photography Critic's Writings, 1968–1978*. Oxford: Oxford University Press, 1979.

Collins, Douglas. *The Story of Kodak*. New York: Abrams, 1990.

Comoedia Illustré. Paris, 1908–14; 1919–36.

Le Comptoir Général de Photographie. Manual and Catalogue. Exposition Universelle de 1900: Grand Prix, Section de Photographie. Paris: L. Gaumont, 1900.

Crary, Jonathan. *Techniques of the Observer: On Vision and Modernity in the Nineteenth Century*. Cambridge, Mass.: MIT Press, 1995.

Crimp, Douglas. "The Museum's Old/The Library's New Subject" (1981). In *The Contest of Meaning: Critical Histories of Photography*, ed. Richard Bolton. Cambridge, Mass.: MIT Press, 1989.

———. *On the Museum's Ruins*. Cambridge, Mass.: MIT Press, 1993.

Dacier, Émile. "La Photographie et les sports." *Annuaire général et international de la photographie, 1908* (Paris: Plon, 1908): 401–26.

Daix, Pierre. "La Photographie." *Quotidien de Paris*, 1 Dec. 1980, 16–17.

"Dans les greniers de l'Histoire." *L'Express*, 3–9 May 1980, 159–61.

Davis, Keith. *An American Century of Photography: From Dry-Plate to Digital: The Hallmark Photographic Collection*. Kansas City, Mo.: Hallmark Cards Inc., 1995.

De Duve, Thierry. "Time Exposure and Snapshot: The Photograph as Paradox." *October* 5 (summer 1978): 113–25.

De Fleurac, L. "Professionnels ou amateurs?" *La Vie au grand air*, 9 Feb. 1907, 94.

De Fouquières, André. "Qu'est-ce qu'un gymkhana?" *Je sais tout*, 15 Aug. 1905, 93–102.

"De la Composition." *Photo-Magazine*, July–Dec. 1905, 201–2.

De Veigy, Cédric. "La Main-d'oeuvre de la photographie: petite histoire de la saisie de la photographie par des amateurs non avertis munis d'appareils à main." Master's thesis, Université de Paris I, Panthéon Sorbonne, Paris, 1999.

Dell, Virginia. "John Szarkowski's Guide." *Afterimage* 12 (Oct. 1984): 8–11.

Derex, Jean-Michel. *Histoire du Bois de Boulogne: Le Bois du roi et la promenade mondaine de Paris*. Paris: L'Harmattan, 1997.

Deschin, Jacob. "Goals for a Photography Center." *Popular Photography*, May 1962, 10.

———. "Director at Modern: Successor to Steichen Discusses His Plans." *New York Times*, 15 July 1962, sec. 2, p. 10.

———. "5-Year Museum Selection." *New York Times*, 7 Aug. 1966, 21.

———. "John Szarkowski: Photography as Interpreter." *Popular Photography*, Sept. 1967, 18, 22.

Dieudonné, Robert. "Chiens de dames." *Femina*, 1 June 1906, 245–46.

Dillaye, Frédéric. *La Théorie, la pratique et l'art en photographie avec le procédé au gélatino-bromure d'argent*. Paris: Librairie Illustrée, 1891.

———. *L'Art en photographie, avec le procédé au gélatino-bromure d'argent*. Paris: Librairie Illustrée, 1896.

———. *Les Nouveautés photographiques*. Paris: Librairie Illustrée, Jules Tallandier, 1907.

Dingus, Rick. *The Photographic Artifacts of Timothy O'Sullivan*. Albuquerque: University of New Mexico Press, 1982.

Dister, Alain. "Les Clichés du patrimoine." *Le Nouvel Observateur*, 15 Sept. 1980, 11.

Donnay, Maurice. "Mouvements de femmes." *Femina*, 15 May 1906, 234.

Downes, Bruce. "Photography: A Definition." *Infinity*, Jan. 1962, 13–15.

Duncan, Carol, and Alan Wallach. "MoMA: Ordeal and Triumph on 53rd Street." *Studio International* 194 (1978): 48–57.

Durniak, John. "Can Johnny Take Pictures?" *Popular Photography*, Nov. 1961, 49–50.

———. "The Double Exhibition Explosion." *Photography Annual 1970*. New York: Ziff-Davis, 1971: 7–8.

Duvernois, Henri. "L'Élégance dans les sports." *Je sais tout*, 15 June 1905, 607–13.

Eder, Josef Maria. *La Photographe instantanée: Son application aux arts et aux sciences*. Trans. from German to French by O. Campo. Paris: Gauthier-Villars, 1888.

Eisinger, Joel. *Trace and Transformation: American Criticism of Photography in the Modernist Period*. Albuquerque: University of New Mexico Press, 1995.

Elderfield, John. "The Precursor." In *The Museum of Modern Art at Mid-Century: At Home and Abroad*. Studies in Modern Art 4. New York: Museum of Modern Art, 1994.

Elsaesser, Thomas, and Adam Barker, eds. *Early Cinema: Space, Frame, Narrative*. London: British Film Institute, 1990.

"Elevons nos enfants pour en faire des hommes: Le carnet physique obligatoire." *La Vie au grand air*, 15 Mar. 1917, 34–35.

Emery, H. *La Photographie artistique, comment l'amateur devient un artiste*. Paris: Charles Mendel, 1900.

"En combien de temps peut-on faire le tour de Paris?" *La Vie au grand air*, 24 Jan. 1903, 56–57.

English, Donald. "Political Uses of Photography in the Third French Republic, 1871–1914." Ph.D. diss., University of Washington, 1984.

"Entre nous: Aux photographes, amateurs et professionels." *La Vie au grand air*, 14 Jan. 1904, 24.

L'Éventail et la fourrure chez Paquin, dessins de: Paul Iribe, George Barbier, Georges Lepape. Paris: Maquet, 1911.

Excelsior, journal illustré quotidien. Paris: Pierre Lafitte, 1910–40.

"Fait Divers." *Feuilles* 3 (winter 1982–83).

Faroux, C. "Déformations photographiques, Illusions ciné-matographique." *La Vie au grand air*, 16 Nov. 1907, 352.

Femina. Paris: Pierre Lafitte, 1901–14; 1917–20.

Fineberg, Jonathan. *The Innocent Eye: Children's Art and the Modern Artist.* Princeton, N.J.: Princeton University Press, 1997.

———, ed. *Discovering Child Art: Essays on Childhood, Primitivism and Modernism.* Princeton, N.J.: Princeton University Press, 1998.

Fineman, Mia. *Other Pictures: Anonymous Photographs from the Thomas Walther Collection.* Exh. cat. Santa Fe: Twin Palms Publishers; New York: Metropolitan Museum of Art, 2000.

Finkel, Candida. "Photography as Modern Art: The Influence of Nathan Lyons and John Szarkowski on the Public's Acceptance of Photography as Fine Art." *Exposure* 18 (1982): 22.

Flament, Albert. "Le Balcon de Femina: La psychologie du Bois." *Femina*, 15 May 1907, 218–19.

———. "Le Balcon de Femina: Le triomphe des amateurs." *Femina*, 15 Oct. 1907, 462.

———. "La Journée d'une élégante à St. Moritz." *Je sais tout*, 15 Nov. 1910, 447–58.

Flossie. "Sous le fin réseau des voilettes." *Femina*, 15 Feb. 1912, 8.

Ford, Colin, ed. *The Story of Popular Photography.* Bradford: National Museum of Photography, Film and Television, 1989.

Foucault, Michel. "What Is an Author?" (1969). In *Art in Theory, 1900–1990: An Anthology of Changing Ideas*, ed. Charles Harrison and Paul Wood. Oxford: Blackwell Publishers, 1992.

Franc-Nohain. "En vacances, en vacances." *Femina*, 15 Aug. 1913, 437–41.

Frantz-Reichel. "Le Saut dans les sports." *Je sais tout*, 15 Mar. 1908, 155–62.

Frizot, Michel, and Sylvain Roumette. *Early Color Photography.* Exh. cat. New York: Pantheon Books; Paris: Centre National de la Photographie, 1986.

———. *Le Temps d'un mouvement: Aventures et mésaventures de l'instant photographique.* Exh. cat. Paris: Centre National de la Photographie, 1986.

———. "Comment on marche: De l'exactitude dans l'instant." *La Revue du Musée d'Orsay* 48, no. 4 (spring 1997): 74–83.

———. "Speed of Photography: Movement and Duration." In *A New History of Photography*, ed. Michel Frizot. Cologne: Könemann, 1998.

Fuschen, J. "La Leçon de Patinage." *Femina*, 15 Jan. 1903, 417–18.

Galassi, Peter. *Pleasures and Terrors of Domestic Comfort.* Exh. cat. New York: Museum of Modern Art, 1991.

———. *American Photography, 1890–1965: From the Museum of Modern Art.* Exh. cat. New York: Museum of Modern Art, 1995.

Garçon, François. *Gaumont: A Century of French Cinema.* Trans. B. Alderman and J. Dickinson. New York: Gallimard, 1994.

Gardner, Howard. *Artful Scribbles: The Significance of Children's Drawings.* New York: Basic Books, 1980.

Gastine, L. "Sur la composition." *Photo-Revue*, 29 Jan. 1905, 35–37.

Gaubert, Ernest. "Les Plages comiques." *Je sais tout*, 15 Aug. 1911, 95–102.

Gaudreault, André. "Film, Narrative, Narration: The Cinema of the Lumière Brothers." In *Early Cinema: Space, Frame, Narrative*, ed. Thomas Elsaesser and Adam Barker. London: British Film Institute, 1990.

Gaudriault, Raymond. *La Gravure de mode féminine en France.* Paris: Éditions de l'amateur, 1983.

Gautier, G. "La Photographie du cheval." *Photo-Magazine*, 18 Dec. 1910, 193–99.

Gautrand, Jean-Claude. *Publicités Kodak, 1910–1939.* Exh. cat. Paris: Contrejour, 1983.

———. "Photography on the Spur of the Moment: Instant Impressions." In *A New History of Photography*, ed. Michel Frizot. Cologne: Könemann, 1998.

Gefter, Philip. "Whose History of Photography Is It Anyway?" *Photo Metro* (San Francisco) 8, no. 78 (Apr. 1990): 3–20.

Giard, E. *Lettres sur la photographie, spécialement écrites pour la jeunesse des écoles et les gens du monde.* Paris: Charles Mendel, 1896.

Gitlin, Todd. *The Sixties: Years of Hope, Days of Rage.* New York: Bantam Books, 1989.

Glenisson, Jean, and Ségolène Le Men, eds. *Le Livre d'enfance et de jeunesse en France.* Bordeaux: Société des Bibliophiles de Guyenne, 1994.

Goursat, Georges [Sem]. *Célébrités contemporaines et la Bénédictine.* Paris: Devamesz, n.d.

———. *Tangoville.* Paris: Succès, 1913.

———. *Le Vrai et le faux chic.* Paris: Succès, 1914.

Green, Jonathan. *American Photography: A Critical History, 1945 to the Present.* New York: Harry N. Abrams, 1984.

———, ed. *The Snapshot* (single-theme issue), *Aperture* 19 (1974).

Greenberg, Reesa. "MoMA and Modernism: The Frame Game." *Parachute* (Montreal) 42 (Mar.–May 1986): 21–31.

Greenough, Sarah. "'Of Charming Glens, Graceful Glades, and Frowning Cliffs': The Economic Incentives, Social Inducements, and Aesthetic Issues of American Pictorial Photography, 1880–1902." In *Photography in Nineteenth-Century America*, ed. Martha Sandweiss. New York: Abrams, 1991.

Gruen, John. "The Reasonably Risky Life of John Szarkowski." *Artnews*, Apr. 1978, 66–70.

Grundberg, Andy. "An Interview with John Szarkowski." *Afterimage* 12 (Oct. 1984): 12–13.

Guibert, Hervé. "Entretien avec Agathe Gaillard: Spéculations sur la photographie." *Le Monde*, 27 Dec. 1979, 14.

Guilbaut, Serge. *How New York Stole the Idea of Modern Art: Abstract Expressionism, Freedom, and the Cold War.* Chicago: University of Chicago Press, 1983.

———. *Reconstructing Modernism: Art in New York, Paris, and Montreal, 1945–1964.* Cambridge, Mass.: MIT Press, 1990.

Guitry, Sacha. *If Memory Serves: Memoires of Sacha Guitry.* Trans. Lewis Galantière. Garden City: Doubleday, 1935.

Gunning, Tom. "New Thresholds of Vision: Instantaneous Photography and the Early Cinema of Lumière." In *Impossible Presence: Surface and Screen in the Photogenic Era*, ed. Terry Smith. Sydney: Power Publications, 2001.

———. "'Primitive' Cinema: A Frame-Up? Or, the Trick's on Us." In *Early Cinema: Space, Frame, Narrative*, ed. Thomas Elsaesser and Adam Barker. London: British Film Institute, 1990.

———. "The Cinema of Attractions: Early Film, Its Spectator and the Avant-Garde." In *Early Cinema: Space, Frame, Narrative*, ed. Thomas Elsaesser and Adam Barker. London: British Film Institute, 1990.

Gunthert, André. "Introduction à la photographie instantanée." In *La Révolution de la photographie instantanée, 1880–1900.* Exh. cat. Paris: Bibliothèque Nationale de France/Société Française de Photographie, 1996.

Hahn, Otto. "Le Tourbillon des images." *L'Express*, 9–15 Aug. 1980, 20–21.

Hall-Duncan, Nancy. *Histoire de la photographie de mode.* Paris: Éditions du Chêne, 1978.

Hambourg, Maria Morris. "Atget, Precursor of Modern Documentary Photography." In *Observations*, ed. David Featherstone. Carmel: Friends of Photography, 1984.

Hambourg, Maria Morris, et al. *The Waking Dream: Photography's First Century: Selections from the Gilman Paper Company Collection.* Exh. cat. New York: Metropolitan Museum of Art, 1993.

Hamelle, Paul. "Comment les jeux deviennent des sports." *La Vie au grand air*, 28 July 1906, 548.

Harbutt, Charles. "The Harbutt Workshop: Part Two, The Shutter." *Modern Photography*, Feb. 1976, 94–96.

Haworth-Booth, Mark. "John Szarkowski: An Interview." *History of Photography* 15 (winter 1991): 302–7.

Herz, Nat. "Steichen's Successor: John Szarkowski." *Infinity*, Sept. 1962, 5–11, 25.

Holt, Richard. *Sport and Society in Modern France.* London: Macmillan Press, 1981.

Horrell, William. "Photography Instruction in Higher Education." *Infinity*, July 1964, 13–36.

———. "Teachers of Photography in Colleges and Universities." *Infinity*, Nov. 1964, 25–28.

"Les Illogismes de la mode." *Femina*, 1 Aug. 1912, 440.

L'Illustration. Paris, 1843–1944.

Izouard, Charles. "Opinions: Qu'est-ce qu'un amateur sérieux?" *Photo-Revue*, 24 Apr. 1910, 135–36.

Je sais tout. Paris: Pierre Lafitte, 1905–39.

Juin, Herbert. *La France 1900 vue par les frères Séeberger.* Paris: Pierre Belfond, 1979.

Jussim, Estelle. *Visual Communication and the Graphic Arts: Photographic Technologies of the Nineteenth Century.* New York: R. R. Bowker, 1974.

Kelsey, Robin. "Photography in the Field: Timothy O'Sullivan and the Wheeler Survey, 1871–1874." Ph.D. diss., Harvard University, 2000.

Kimmelman, Michael. "Revisiting the Revisionists: The Modern, Its Critics, and the Cold War." In *The Museum of Modern Art at Mid-Century: At Home and Abroad.* Studies in Modern Art 4. New York: Museum of Modern Art/Abrams, 1994.

Knyff, René de, et al. "Le Style? En quoi consiste-t-il?" *La Vie au grand air*, 15 Nov. 1913, 961–63.

Kouwenhoven, John. *The Arts in Modern Civilization.* New York: Norton, 1948.

———. "Living in a Snapshot World." In *Half a Truth Is Better than None.* Chicago: University of Chicago Press, 1982.

Kramer, Hilton. "Boom in Art Photography Poses Problem in Expertise." *New York Times*, 22 Sept. 1975, 37.

———. "John Szarkowski's 'History of Photographic Pictures.'" *The New Criterion* 8 (May 1990): 5–8.

Krauss, Rosalind. "Photography's Discursive Spaces: Landscape/View." *Art Journal* 42 (winter 1982): 311–19.

Lafitte, Pierre. "La Vie au grand air." *La Vie au grand air*, 8 Apr. 1898, 4.

———. "Notre programme." *Excelsior*, 16 Nov. 1910, 2.

Lagny, Michel, et al. *Les Vingt premières années du cinéma français.* Actes du collogue international de la Sorbonne nouvelle, 4, 5 et 6 novembre, 1993. Paris: Presses de la Sorbonne Nouvelle, 1995.

Le Men, Ségolène. *Les Abécédaires français illustrés du XIXe siècle.* Paris: Éditions Promodis, 1984.

Le Roy, Georges. "L'Effort athlétique analysé par l'image." *La Vie au grand air*, 9 Aug. 1913, 652–53.

Leighton, Patricia. "Cubist Anachronisms: Ahistoricity, Cryptoformalism, and Business-as-Usual in New York." *The Oxford Art Journal* 17, no. 2 (1994): 91–102.

Leiris, Michel. *Manhood: A Journey from Childhood into the Fierce Order of Virility* (1939). Trans. Richard Howard. Chicago: University of Chicago Press, 1992.

Lepape, Georges, and Pierre Corrard. *Modes et manières d'aujourd'hui.* Paris: Maquet, 1912–14.

Lesy, Michael. *Time Frames: The Meaning of Family Pictures*. New York: Pantheon Books, 1980.

Lifson, Ben. "Garry Winogrand's American Comedy." *Aperture* 86 (1982): 32–39.

Londe, Albert. *La Photographie instantanée: Théorie et pratique*. Paris: Gauthier-Villars, 1886.

———. *La Photographie moderne, pratique et applications*. Paris: G. Masson, 1888.

———. "La Crise photographique." *Le Chasseur Français*, 1 Mar. 1908, 24–27.

Lütry, Max. "Quelques règles de l'art de la composition." *Photo-Revue*, 16 Mar. 1910, 75–77.

Lynes, Russell. *Good Old Modern: An Intimate Portrait of The Museum of Modern Art*. New York: Atheneum, 1973.

———. *The Lively Audience: A Social History of the Visual and Performing Arts in America, 1890–1950*. New York: Harper and Row, 1985.

Malcolm, Janet. "Photography: Diana and Nikon." *New Yorker*, 26 Apr. 1976, 133–37.

Malvern, S. B. "Inventing 'Child Art': Franz Cizek and Modernism." *British Journal of Aesthetics* 35, no. 3 (July 1995): 262–72.

Milady. "Nos parisiennes en voiture." *Femina*, 1 Oct. 1901, 322.

La Mode Illustrée, journal de la famille. Paris, 1860–1937.

Modes et manières d'aujourd'hui. Paris, 1912–14, 1919.

Mortane, Jacques. "Impressions de Vitesse." *La Vie au grand air*, 4 July 1908, 14–15.

Moulin, Raymonde. "Le Double jeu de l'unique et du multiple." *Le Monde*, 4 Mar. 1975, 26.

Mulvey, Laura. *Visual and Other Pleasures*. London: Macmillan, 1989.

Musée Carnavalet. *Sem: Collections du Musée Carnavalet*. Exh. cat. Paris: Musée Carnavalet, 1979.

Le Musée des Arts et Traditions Populaires. *Le Fait divers*. Exh. cat. Paris: Réunion des musées nationaux, 1982.

"The Museum of Modern Art at 50." *Artnews*, Oct. 1978, passim.

The Museum of Modern Art, New York: The History and the Collection. New York: Harry N. Abrams/Museum of Modern Art, 1984; repr. 1997.

La Nature. Paris: Masson, 1873–1962.

Nesbit, Molly. "The Use of History." *Art in America*, Feb. 1986, 72–83.

———. *Atget's Seven Albums*. New Haven, Conn.: Yale University Press, 1992.

"The New MoMA: A New Era?" *Artnews*, May 1984, 51–78.

Nicholson, Geoffrey. *Le Tour: The Rise and Rise of the Tour de France*. London: Hodder and Stoughton, 1991.

Nickel, Douglas. "John Szarkowski: An Interview." *History of Photography* 19 (summer 1995): 135–42.

———. *Snapshots: The Photography of Everday Life, 1888 to the Present*. Exh. cat. San Francisco: San Francisco Museum of Modern Art, 1998.

———. "History of Photography: The State of Research." *The Art Bulletin* 83 (Sept. 2001): 548–58.

"Nos nouveaux concours sportifs: Notre second concours, le cliché gagnant." *La Vie au grand air*, 5 May 1904, 355.

Nuridsany, Michel. "La Photographie rivalise enfin avec la peinture." *Le Figaro*, 10 June 1972, 22.

———. "La Photographie sur le marché de l'art." *Le Figaro*, 4 May 1977, 32.

———. "Contribution à une histoire de la photographie." *Le Figaro*, 25 July 1977, 18.

———. "De l'or dans la pellicule." *Le Figaro*, 16 Feb. 1980, 8.

———. "Situation de la photographie." *Art Press*, Sept. 1980, 16–17.

O'Brian, John. "MoMA's Public Relations, Alfred Barr's Public, and Matisse's American Canonization." *RACAR (Revue d'art canadienne)* 18 (1991): 18–30.

"Le Papier couché, miroir des belles gravures." *Je sais tout*, 15 Nov. 1906, 421–26.

Parmegiani, Claude-Anne. *Les Petits français illustrés, 1860–1940: L'Illustration pour enfants en France de 1860 à 1940, les modes de représentation, les grand illustrateurs, les formes éditoriales*. Paris: Éditions du cercle de la librairie, 1989.

Perego, Elvire. "Intimate Moments and Secret Gardens: The Artist as Amateur Photographer." In *A New History of Photography*, ed. Michel Frizot. Cologne: Könemann, 1998.

Perrot, Michelle, ed. *A History of Private Life*. Vol. 4: *From the Fires of the Revolution to the Great War*. Trans. Arthur Goldhammer. Cambridge, Mass.: Harvard University Press, 1990.

Petit, H. "Variations sur un thème connu: La Panne." *La Vie au grand air*, 15 May 1909, 310.

Phillips, Christopher. "The Judgment Seat of Photography" (1982). In *The Contest of Meaning: Critical Histories of Photography*, ed. Richard Bolton. Cambridge, Mass.: MIT Press, 1989.

"Photography & Professionals: A Discussion." *The Print Collector's Newsletter* 4, no. 3 (July–Aug. 1973): 54–60.

"Photography & Professionals: Same Time, Five Years." *The Print Collector's Newsletter* 9, no. 3 (July–Aug. 1978): 78–86.

"Photography & Professionals III." *The Print Collector's Newsletter* 14, no. 3 (July–Aug. 1983): 82–91.

"Photography & Professionals IV." *The Print Collector's Newsletter* 19, no. 3 (July–Aug. 1988): 81–91.

Photo-Magazine, complément illustré de Photo-Revue. Paris, 1904–14.

Pinel, Vincent. *Louis Lumière, inventeur et cinéaste*. Paris: Nathan, 1994.

Platt, Susan Noyes. "Modernism, Formalism, and Politics: The 'Cubism and Abstract Art' Exhibition of 1936 at The Museum of Modern Art." *Art Journal* 47 (winter 1988): 284–95.

Poivert, Michel. *Le Pictorialisme en France*. Exh. cat. Paris: Éditions Hoëbeke/Bibliothèque Nationale de France, 1992.

Poivert, Michel, et al. *La révolution de la photographie instantanée, 1880–1900.* Exh. cat. Paris: Bibliothèque Nationale de France/Société Française de Photographie, 1996.

Powell, Rob. "John Szarkowski." *The British Journal of Photography* 132 (20 Dec. 1985): 1422–26.

Prade, Georges. "Les Vitesses de l'homme." *La Vie au grand air,* 18 Mar. 1899, 316–18.

Przyblyski, Jeannene M. "Archive or Art?" Book Review. *Art Journal* 58 (summer 1999): 115–18.

Ravidat, Maurice. "Les Sports au château." *La Vie au grand air,* 15 Oct. 1898, 160–62.

———. "L'Allée des Acacias." *La Vie au grand air,* 21 May 1899, 424–26.

———. "Un Geste de la parisienne." *Femina,* 1 Nov. 1903, 719.

Raynor, Vivien. "The Szarkowski Generation." *Horizon,* Sept. 1978, 76–81.

Rearick, Charles. *Pleasures of the Belle Epoque: Entertainment and Festivity in Turn-of-the-Century France.* New Haven, Conn.: Yale University Press, 1985.

Reyner, Albert. *Manuel pratique du reporter photographe et de l'amateur d'instantanés.* Paris: Charles Mendel, 1903.

Rittaud-Hutinet, Jacques. *Auguste et Louis Lumière: Les 1000 premiers films.* Paris: Philippe Sers Éditeur, 1990.

Rivière, Max. "La Maison des magazines." *Femina,* 13 Apr. 1907, 173–76.

"La Robe pantalon." *Femina,* 15 Feb. 1911, 100–101.

Rosenblum, Robert. *1900: Art at the Crossroads.* Exh. cat. New York: Guggenheim Museum/Abrams, 2000.

Rothstein, Arthur. "On Creativity: An Interview with John Szarkowski." *U.S. Camera,* May 1963, 8–9.

Rozet, Georges. "L'Athlétisme et le sport dans l'art moderne." *La Vie au grand air,* 26 Feb. 1910, 141.

Salt, Barry. "Film Form, 1890–1906." In *Early Cinema: Space, Frame, Narrative,* ed. Thomas Elsaesser and Adam Barker. London: British Film Institute, 1990.

Sauvage, Major. "Le Saut comparé de l'homme et du cheval." *La Vie au grand air,* 23 Mar. 1906, 242.

Shattuck, Roger. *The Banquet Years: The Arts in France, 1885–1918.* New York: Harcourt, 1958.

Silver, Kenneth. "The Witness." *Art in America,* Oct. 1988, 148–57.

Silverman, Willa Z. *The Notorious Life of Gyp, Right-Wing Anarchist in Fin-de-Siècle France.* New York: Oxford University Press, 1995.

"Le Snobisme: Exaspération de l'élégance." *Je sais tout,* 15 Mar. 1908, 261–66.

"Les Soldats de l'instantané." *Je sais tout,* 15 Dec. 1906, 587–94.

Solomon-Godeau, Abigail. "Canon Fodder: Authoring Eugène Atget" (book review). *The Print Collector's Newsletter* 16 (Jan.–Feb. 1986): 221–27.

Spont, Henry. "Gymkhana sur la glace." *Femina,* 1 Feb. 1906, 57–58.

Stange, Maren. "Photography and the Institution: Szarkowski at the Modern." *The Massachusetts Review* 19, no. 4 (winter 1978): 693–709.

Staniszewski, Mary Anne. *The Power of Display: A History of Exhibition Installations at the Museum of Modern Art.* Cambridge, Mass.: MIT Press, 1998.

Steichen, Edward. *A Life in Photography.* New York: Museum of Modern Art/Doubleday, 1963.

Sternberger, Paul Spencer. *Between Amateur and Aesthete: The Legitimization of Photography as Art in America, 1880–1900.* Albuquerque: University of New Mexico Press, 2001.

Stockhammer, L. *La Stéréoscopie rationelle.* Paris: Charles Mendel, 1913.

Stockhammer, L., et al. *Essais de stéréoscopie rationelle.* Paris: Charles Mendel, 1907.

Stokes, Philip. "The Family Photograph Album: So Great a Cloud of Witnesses." In *The Portrait in Photography,* ed. Graham Clarke. London: Reaktion Books, 1992.

Szarkowski, John. *The Idea of Louis Sullivan.* Minneapolis: University of Minnesota Press, 1956.

———. *The Face of Minnesota.* Minneapolis: University of Minnesota Press, 1958.

———. "Photographing Architecture." *Art in America,* summer 1959, 84–89.

———. *The Photographer and the American Landscape.* Exh. cat. New York: Museum of Modern Art, 1963.

———. *The Photographs of Jacques Henri Lartigue.* Exh. cat. New York: Museum of Modern Art, 1963.

———. *André Kertész: Photographer.* Exh. cat. New York: Museum of Modern Art, 1964.

———. *The Photographer's Eye.* Exh. cat. New York: Museum of Modern Art, exhibition 1964; catalogue 1966.

———. "Photography and the Mass Media." *Aperture* 13 (1967): unpaginated.

———. "The Under-Collected Art." *Arts Yearbook* 9 (1967): 132–37.

———. *The Animals: Garry Winogrand.* Exh. cat. New York: Museum of Modern Art, 1969.

———. "Bill Brandt." *Modern Photography,* Oct. 1970, 84–90.

———. "Photography and the Private Collector." *Aperture* 15 (summer 1970): unpaginated.

———. "The Art of Photography." In *Compton Yearbook.* Chicago: F. E. Compton Co., 1971.

———. "Eugène Atget: The Simplicity of Genius." *Modern Photography,* Jan. 1973, 68–73.

———. "The Study of Photography: 'Touching the Broader Issues of Modern Art.'" *Artnews,* Sept. 1973, 50–55.

———. *From the Picture Press.* Exh. cat. New York: Museum of Modern Art, 1973.

———. *Looking at Photographs*. New York: Museum of Modern Art, 1973.

———. "Atget's Trees." In *One Hundred Years of Photographic History in Honor of Beaumont Newhall*, ed. Van Deren Coke. Albuquerque: University of New Mexico, 1975.

———. "A Different Kind of Art." *New York Times Magazine*, 13 Apr. 1975, 16–19.

———. *William Eggleston's Guide*. Exh. cat. New York: Museum of Modern Art, 1976.

———. "The Content of Photographs." In *Photography Within the Humanities*, ed. Eugenia Parry Janis and Wendy Mac-Neil. Danbury, N.H.: Addison House Publishers, 1977.

———. *Mirrors and Windows: American Photography since 1960*. Exh. cat. New York: Museum of Modern Art, 1978.

———. *American Landscapes: Photographs from the Collection of The Museum of Modern Art*. Exh. cat. New York: Museum of Modern Art, 1981.

———. "Photography and America." In *The Art Institute of Chicago Centennial Lectures*. Chicago: Contemporary Books, 1983.

———. "Photography." In *The Museum of Modern Art, New York: The History and the Collection*. New York: Harry N. Abrams/Museum of Modern Art, 1984.

———. "The Signature of Penn." *American Photography* 12, no. 4 (1984): 38–61.

———. *The Photographs of Josef Albers: A Selection from the Collection of the Josef Albers Foundation*. Exh. cat. New York: American Federation of the Arts, 1987.

———. *Winogrand: Figments from the Real World*. Exh. cat. London: Thames and Hudson, 1988.

———. *Photography until Now*. Exh. cat. New York: Museum of Modern Art, 1989.

———. *Jan Groover: Photographs*. Exh. cat. Boston: Bulfinch Press, 1993.

———. "Dorothea Lange and Paul Taylor." In *Dorothea Lange: American Photographs*. Exh. cat. San Francisco: San Francisco Museum of Modern Art/Chronicle Books, 1994.

———. "The Family of Man." In *The Museum of Modern Art at Mid-Century: At Home and Abroad*. Studies in Modern Art 4. New York: Museum of Art, 1994.

———. "Mr. Bristol's Barn: With Excerpts from Mr. Blinn's Diary." *DoubleTake* 3, no. 2 (spring 1997): 90–95.

———. *Ansel Adams at 100*. Exh. cat. Boston: Little, Brown, 2001.

Szarkowski, John, and Maria Morris Hambourg. *The Work of Atget*. 4 vols. Exh. cat. New York: Museum of Modern Art, 1981–85.

Szarkowski, John, and Shoji Yamagishi. *New Japanese Photography*. Exh. cat. New York: Museum of Modern Art, 1974.

Tennis et Golf. Paris, 1914, 1920–39.

Thistlewood, David. "The MoMA and the ICA: A Common Philosophy of Modern Art." *British Journal of Aesthetics* 29, no. 4 (autumn 1989): 316–28.

Thooris, Dr. "Les Bases de l'éducation physique." *La Vie au grand air*, 22 Mar. 1913, 209.

Thornton, Gene. "Are All These Art?" *New York Times*, 8 July 1973, 28.

———. "The Place of Photography in the Western Pictorial Tradition: Heinrich Schwarz, Peter Galassi and John Szarkowski." *History of Photography* 10 (Apr.–June 1986): 85–98.

Troy, Nancy. *Couture Culture: A Study in Modern Art and Fashion*. Cambridge, Mass.: MIT Press, 2003.

Turner, Bryan S. "A Note on Nostalgia." *Theory, Culture & Society* 4 (1987): 147–56.

———. "Nostalgia, Postmodernism and the Critique of Mass Culture." *Theory, Culture & Society* 5 (1988): 509–26.

Vaughan, Dai. "Let There Be Lumière." In *Early Cinema: Space, Frame, Narrative*, ed. Thomas Elsaesser and Adam Barker. London: British Film Institute, 1990.

Vidal, Léon. *Manuel du touriste photographe*. Paris: Gauthier-Villars et Fils, 1889.

La Vie au grand air. Paris: Pierre Lafitte, 1898–1922.

Villers, Paul. "Les Peuples s'amusent." *Je sais tout*, 15 Sept. 1911, 237–43.

Weber, Eugen. "Gymnastics and Sports in *Fin-de-Siècle* France: Opium of the Classes?" *American Historical Review* 76, no. 1 (Feb. 1971): 70–98.

———. *France: Fin de Siècle*. Cambridge, Mass.: Harvard University Press, 1986.

———. *My France: Politics, Culture, Myth*. Cambridge, Mass.: Harvard University Press, 1991.

Weiss, Dr. Georges. "L'Education physique dans les lycées." *La Vie au grand air*, 22 Mar. 1913, 201.

Westerbeck, Colin, and Joel Meyerowitz. *Bystander: A History of Street Photography*. Boston: Bulfinch Press, 1994.

Williams, Alan. *Republic of Images: A History of French Film-making*. Cambridge, Mass.: Harvard University Press, 1992.

Woodbury, Walter. *Photographic Amusements*. New York: Scovill and Adams, 1896.

Woodward, Richard B. "Picture Prefect." *Artnews*, Mar. 1988, 168–71.

Wright, Gordon. *France in Modern Times*. 5th ed. New York: W. W. Norton, 1995.

X. "La Création et le lancement d'un magazine." *Je sais tout*, 15 May 1905, 491–97.

Zeldin, Theodore. *A History of French Passions*. Vol. 2: *Intellect, Taste and Anxiety*. Oxford: Oxford University Press, 1977.

Zwingle, Erla. "John Szarkowski." *American Photographer*, Nov. 1987, 80–86.

INDEX

NOTE: Photograph titles given in parentheses are those used in the 1963 MoMA exhibition (see also Appendix B).

Abbott, Berenice, 188
Adams, Ansel, 188, 199, 201, 244n.24; *Moon-rise, Hernandez*, 252n.28
Adhémar, Jean, 192
albums, of Lartigue, 11, 65, 68–69, 129, 146–47, 229n.98, 231n.155, 232n.158, 242n.64; on aviation, 59, 231n.155; first notebook, 45–51, 58, 139, 146, 229n. 100 and 101, 231n.155, 242n.64; revisions of, 11, 68, 222, 231n.134; pages: *Grand Prix of the A.C.F.*, pl. 81, 150–51, 223n.7; *Nice*, pl. 25, 65; *Paris, Snow*, pl. 23, 63–64; *Tupy*, pl. 35, 85–87, 93
L'Amateur photographe, 23, 29, 34, 41, 71, 131, 135, 226nn. 45 and 49, 228n.76
Annuaire des amateurs de photographie, 24–25, 27
Annuaire général de la photographie, 29, 38; "At the Beach," pl. 19, 56; "Prints obtained with the 'Detective,'" pl. 8, 37–38
Aperture, 166, 198, 244n.24
Arbus, Diane, 188
Atget, Eugène, 183, 187–89, 198, 249n.114, 250n.121; *Atget's Trees*, 250n.123; *At the Tambour, 63, quai de la Tournelle*, pl. 93, 188; *The Work of Atget*, 250n.121
Aubert, Marius, 10, 25, 218, 221, 224n.7
Avedon, Richard, 207, 222, 251n.2; *Diary of a Century: Jacques-Henri Lartigue*, 199, 207, 209, 222, 236n.87, 245n.51

Baldoni, Jean, 151, 233n.15
Barr, Alfred, 176; *Cubism and Abstract Art*, 177–79, 248n.92
Barrow, Thomas, 200
Barthes, Roland, *Mythologies*, 146
Beaton, Cecil, 207–9; *Audrey Hepburn in My Fair Lady*, pl. 97, 208

Belgrad, Daniel, *The Culture of Spontaneity*, 163–64
Bellocq, E. J., 249n.114
Benjamin, Walter, 134, 241n.29
Bergeret, A., with F. Drouin, *Les Récréations photographiques*, 52, 230n.118
Bergson, Henri, 229n.111
Bibi. *See* Lartigue, Madeleine
Bibliothèque Nationale, Paris: and Lartigue, 192; and photography, 167–68, 210–11
Bichonnade. *See* Van Weers, Madeleine
Biclo. *See* Haguet, Jean
Bischof, Werner, 167, 244nn. 21 and 26
Bobino. *See* Ferrand, Robert
Boissy, Gaby, photographed by Lartigue, *Alice Clairville and Gaby Boissy, Ave. du Bois*, pl. 64, 116–17
Boivin, Ernest, 31
Bonnard, Pierre, 75, 165, 233n.16
Bottomore, Stephen, 135
Boubat, Edouard, 210
Bouboutte. *See* Van Weers, Marthe
Bourcart, Marguerite ("Guitty"), 218; photographed by Lartigue, caught in surf, 55, 123
Bourdieu, Pierre, 227nn. 55 and 56
Bourgeois, Madeleine, 218
Boutet de Monvel, Bernard, cover for *Femina*, 116
Boyer, Patricia Eckert, 75
Brandt, Bill, 188
Brassaï, 167–68, 188, 211, 244nn. 23 and 26
Broadwater, Henry ("Rico"), 62, 218; photographed by L. Ferrand, *September, Rouzat*, pl. 2, 26–27; photographed by Lartigue, *James and Rico*, 59, 102
Brodovitch, Alexey, 170
Bunnell, Peter, 200

Callahan, Harry, 200
camera and camera equipment companies: J. Audouin, 56; Ermanox, 163; FNAC, 210; Glyphoscope Richard, 24; Jumelle, 56–58, 228n.66; Klapp, 25, 61, 66; Klapp-Nettel, 61–62; Krauss-Zeiss, 24, 61; Leica, 66, 163, 202, 231n.146; Nettel, 97, 231n.139; Nikon, 202, 210; Vérascope stereo, 58, 225n.27, 227n.66. *See also* Eastman Kodak Company; Gaumont camera company; Lumière brothers; Pathé brothers
cameras, motion-picture, 130, 240n.5; Cinématographe, 93, 130, 135, 139, 236n.84; Pathé, 130–31, 240n.8, 243n.68
cameras, used by Lartigue: Block-Notes Gaumont, 58–61, 63, 65, 143, 231n.135; Cinématographs, 130, 143, 148, 150, 221, 235n.58, 236nn. 85 and 87, 240n.13, 242n.66; Folding Kodak Brownie No. 2, 58, 60, 231n.136; J. Audouin, 13 x 18 cm, 56, 230n.130; Jumelle, 56–58, 191; Klapp-Nettel, 61–62, 97, 143, 157; Nettel, Lacour-Berthot lens, 80; Pathé Professionel, 131, 151, 243n.68; Spido-Gaumont stereo, 58, 60; Takir-Klapp, Krauss-Zeiss lens, 61, 143; Vérascope stereo, 58, 231n.136
Capa, Cornell, 198, 249n.103, 252n.32
Capa, Robert, 167
Carette, Mme., 118–19
Caro. *See* Roussel, Caroline
Cartier-Bresson, Henri, 66, 167–68, 183, 188, 210–11, 229n.99, 231nn. 148 and 153, 244n.26, 245–46n.55; compared to Lartigue, 8, 68, 163, 183, 186, 189
Cayron, Jules, "Movements of Women," 239n.161
Cécél. *See* Lartigue, Marcel

Chaplin, Charlie, 122, 132, 240n.12

Chaplot, C., 230n.114; *La Photographie récréative et fantaisiste*, 53–55, 121, 142

Charlie Hebdo, cartoon about Lartigue, 209

Chaux, Paul, 39–40, 67–68; *La Photographie instantanée par les appareils à main*, 29, 226n.51, 228n.86

Chenal, Marthe, 243n.78; photographed by Lartigue, 116

Chevalier, Maurice, 221

cinema, 9, 50, 129–59, 216; and films by Lartigue, 95, 151–53, 155, 221; and instantaneous photography, 126, 129, 135–39, 141, 157–59; Lartigue's interest in, 50, 95, 126, 129–59, 240n.5, 250n.129; studios for, 132, 152–53, 240n.5; and trick photography, 131, 142. *See also* Lumière brothers; Méliès, Georges; Pathé brothers

Clairville, Alice, 116; photographed by Lartigue, *Alice Clairville and Gaby Boissy, Ave. du Bois*, pl. 64, 116–17

Clergue, Lucien, 210

Coburn, Alvin Langdon, 65, 231n.145

Coco: nickname for Lartigue, 62, 218. *See also* Lartigue, Marcelle

Cocteau, Jean, photographed by Lartigue, 166, 222, 244n.19

Cohen, Mark, 201–3, 251n.8, 252n.33

Coke, Van Deren, 200

Coleman, A. D., 199, 250n.123, 252n.22

Connell, Will, 251n.16

Coubertin, Pierre, Baron de, 98–100

Crary, Jonathan, 133–34

Dacier, Émile, 97–98

Dandolo, "A. M. Fischof, Winner of the Grand Steeplechase of Paris," pl. 48, 104

Dédé. *See* Haguet, André

Degas, Edgar, 125, 250n.127

Delanoue, Suzanne, 108

Delpire, Robert, 167, 211, 231n.138, 244nn. 21 and 26

Demachy, Robert, 38, 226n.48; *Severity*, pl. 3, 30–31

Demeny, Georges, 95

Deschin, Jacob, 181

Desgranges, Henri, *L'Auto*, 237n.102

Deslys, Gaby, photographed by Lartigue, 125

de Veigy, Cédric, 28, 36, 40–41, 228n.70

diaries, of Lartigue, 10–11, 23, 68–69, 146–50, 155, 199, 206–7, 221, 237n.110, 243n.69; arrangement of images in, 148–51, 153–58; on cinema, 131–33, 147–48, 152–58, 240n.15; on his father as photographer, 18–19, 23; pages: "June Notes," pl. 83, 156–57; 9

February 1911, pl. 80, 149; 26 September 1913, pl. 82, 154–55

Didi. *See* Rauch, Didi de

Dieudonné, Albert, 100

Dillaye, Frédéric, 38–39; *L'Art en photographie*, 29, 33, 226n.42; "Big Effects," *Principes et pratique d'art en photographie*, pl. 9, 30, 42

Dion, Albert, marquis de, 233n.19, 237n.102

Doisneau, Robert, 167, 211, 244nn. 23 and 26

Domergue, Jean-Gabriel, 165, 233n.15

Dongen, Kees van, 165, 221

Downes, Bruce, 180, 248n.99, 252n.18

drawings, by Lartigue, 46, 64, 86, 93, 129, 238n.131, 253n.51; of airplane spirals, 64, 95, 236n.88; *Avenue du Bois*, pl. 52, 64, 107–8; after caricatures, 107, 238nn. 131 and 141; of dogs, 116, 239n.150; of fashion, 113, 232n.2; *The Fashion of April, 1908*, 113; *The Fashion of October, 1908*, pl. 57, 111, 113; *May*, pl. 24, 64; woman and dog, pl. 62, 116

Drouin, F., with A. Bergeret, *Les Récréations photographiques*, 52, 230n.118

Dudu. *See* Giquel, Julie

Du, Camille, 96, 151, 218; photographed by Lartigue, 232n.3

Durniak, John, 252n.18

Duvernois, Henri, "Elegance in Sports," 100

Eastman, George, 32, 200, 227n.58; *The Kodak Primer*, 32

Eastman Kodak Company, 31–32, 78, 168, 225–26n.41, 231n.140; and "Bobby's Kodak" (film), 121–22; Brownie, 24, 32, 58, 227n.58, 231n.147; Bull's Eye, 32; Daylight Kodaks, 32; Folding Brownie Kodak No. 2, 58, 230n.131; Folding Pocket Kodak, 32; four guidelines of, 227n.58; 100-Shot, 32; Pocket Kodak, 32; publications of, 227n.61

Eder, Josef Maria, *La Photographie instantanée*, 29, 35–36

Edison, Thomas, 131, 240n.2, 241n.18

education programs, photography, 199–200, 202–3, 251n.16, 252nn. 18, 19, and 22

Edward VII, portrait by Sem, 100

Eggleston, William, 198, 251n.8

Elderfield, John, 175, 182

Emery, H., 229n.96, 242n.60

Evans, Walker, 188

L'Excelsior, 72, 80; Lartigue photographs for, 81

Excursionists, 23–24, 28, 34, 226n.49, 227–28n.66

exhibitions, of Lartigue photographs: Bibliothèque Nationale, Paris, 210–11; *Bonjour*

Monsieur Lartigue, Grand Palais, Paris, 212, 222, 254n. 73 and 79; *Lartigue: 8 x 80*, Musée des Arts Décoratifs, Paris, 211, 222, 244n.26; *Lartigue: L'Album d'une vie*, Centre Georges Pompidou, Paris, 9–10, 215; at New York galleries, 195, 201–2; at Paris galleries, 166, 222; at Photokina, Cologne, 195, 222; of vintage prints, 215. *See also* Museum of Modern Art, New York, *The Photographs of Jacques Henri Lartigue*

Faivre, Abel, 110

Feitler, Bea, ed., *Diary of a Century: Jacques-Henri Lartigue*, 199, 207, 245n.51

Femina, 9, 109, 114, 116–18, 120, 237n.117, 239n.151; "Beauty and the Beast," pl. 63, 116–17

Ferrand, Louis ("Loulou"), 62, 93, 218; *September, Rouzat*, pl. 2, 26, 27; photographed by Lartigue: with bicycle, 59; *Bobsled Race, Louis, Jean*, pl. 26, 67–68, 145, 172, 220; *Pont-de-l'Arche, Louis*, pl. 12, 49–51, 139, 146–47; *Pont-de-l'Arche, Zissou, Robert, Louis . . . and Me*, pl. 13, 50–51, 230n.130; *Portrait of Louis*, 59

Ferrand, Robert ("Bobino"), 62, 218; photographed by Lartigue, *Pont-de-l'Arche, Zissou, Robert, Louis . . . and Me*, pl. 13, 50–51, 230n.130

Feuillade, Louis, *Les Vampires*, 132–33

Le Figaro, 165, 211–12, 232nn. 1 and 9

Flament, Albert, "The Triumph of Amateurs," 103

Follétête, Casimir, 225n.36

Follétête, Victor (?) ("Plitt"), 7, 26–27, 62, 218, 225nn. 36 and 38; dog of (Tupy), 85, 93; and motion pictures, 151–53; and photography, 26–27, 58, 60, 151, 225n.27, 231n.136

Fondin, Jean, *Boyhood Photographs of J.-H. Lartigue*, 199, 250n.130, 252n.33

Foucault, Michel, 192

Fourtier, H., 230n.118; "spirit photograph," pl. 14, 52

Frank, Robert, 167, 188, 198, 244n.26

Freund, Gisèle, 211

Friedlander, Lee, 188, 198, 251n.8

Gance, Abel, 221

Gassmann, Pierre, 171–72, 245n.54, 246n.60

Gaumont camera company, 24, 231n.140, 243n.3; Block-Notes, 25, 58, 66, 78, 231n.131; Spido-Gaumont, 25, 61; Spido-Gaumont stereo, 58

Gens d'Images, L'Association des, 166–67, 221, 244n.21; exhibitions by, 166, 222, 244n.23

Giard, Emile, 38, 43, 229n.99; *Lettres sur la photographie,* 29, 35, 233n.20; *Le Livre d'or de la photographie,* 29

Gibson, Ralph, 201–2

Giquel, Julie ("Dudu"), 218; photographed by Lartigue, *My Nanny Dudu,* pl. 20, 56–58, 91, 93

Giraudoux, Jean, 99

Giscard d'Estaing, Valéry, 254n.79; Lartigue portrait, 211, 222

Givenchy, marquis de, 108, 221, 238n.134

Golo, 218; photographed by Lartigue, *Simone and Golo, Parc de Saint-Cloud,* pl. 47, 102, 123

Gowin, Emmet, 198, 201

Granowsky, Alexis, *Les Aventures du roi Pausole,* 221

Green, Jonathan, *The Snapshot,* 198

Greenberg, Clement, 180

Grosset, Raymond, 166, 170–73, 244n.17, 245n.49, 245–46n.55

Guitry, Sacha, 221

Guitty. *See* Bourcart, Marguerite

Gunning, Tom, 50, 121–22, 135, 141–42, 147, 241n.20

Gunthert, André, 29, 40–41

Gyp (pseud. of Comtesse de Martel), 103

Haguet, André ("Dédé"; Lartigue's cousin), 7, 62, 152, 218; photographed by Henri Lartigue, *Pont-de-l'Arche, with Zissou, Aunt Yéyé, Dédé, Marcelle,* pl. 6, 36, 40; photographed by Lartigue, *Dédé, Renée and Jean, Rouzat, September,* 68, 145

Haguet, Auguste (Lartigue's grandfather), 20–21; photographed by Nadar, 21

Haguet, Eugénie (Lartigue's grandmother), 20, 58; photographed by Henri Lartigue, *Paris, in the Bois de Boulogne . . . ,* pl. 94, 58, 162, 190–91

Haguet, Geneviève ("Aunt Yéyé"; Lartigue's aunt), 36, 218; photographed by Henri Lartigue, *Pont-de-l'Arche, with Zissou, Aunt Yéyé, Dédé, Marcelle,* pl. 6, 36, 40

Haguet, Jean ("Biclo"; Lartigue's cousin), 62, 218; photographed by Lartigue: *Dédé, Renée and Jean, Rouzat, September,* 68, 145; *Jean, Rouzat,* 144; *Rouzat, Jean,* 145

Haguet, Marcelle (Lartigue's cousin), 218; photographed by Henri Lartigue, *Pont-de-l'Arche, with Zissou, Aunt Yéyé, Dédé, Marcelle,* pl. 6, 36, 40; photographed by

Lartigue, *Marcelle Haguet, Chateau de Rouzat,* 123, 144

Haguet, Renée (Lartigue's cousin), 218; photographed by Lartigue, *Dédé, Renée and Jean, Rouzat, September,* 68, 145

Haguet, Robert ("Ubu"; Lartigue's cousin), 218

Harbutt, Charles, 203–4

Hare, Chauncey, 248n.92

Hattersley, Ralph, 199

Heinecken, Robert, 200, 202

Herbert, Robert, 240n.170

Heyman, Ken, 247–48n.87

Hiro (Yasuhiro Wakabayashi), 207, 222, 251n.2

L'Illustration, 71–73, 85, 93–95, 109, 114, 120, 230n.114, 232n.1, 239n.164; "All of Paris, Avenue du Bois," pl. 51, 106–7; "Chez Elle," pl. 67, 120; "A Conversation in the Clouds," pl. 30, 76; "Feminine Silhouettes at the Tennis Championship," pl. 68, 120; "At the Grand Steeplechase, Auteuil," pl. 59, 113–14; "Mercury," pl. 43, 92–93; "The 'Voisin' of Paulhan above the Orge," pl. 34, 86

International Center of Photography, New York, 198–99, 249n.103

Je sais tout, 9, 72–73, 78–80, 82, 92, 101; "On the Hood of a Speeding Automobile," pl. 31, 79–80; Thisbé perfume ad, pl. 65, 118

Junker, David, 223n.7, 235n.70

Kandinsky, Wassily, 248n.92

Kätchen, 218; photographed by Lartigue, 59

Keaton, Buster, 122, 240n.12

Kennedy, John F., 206, 222, 253n.49

Kern, Edward, "The Last Years of Splendor," 204

Kouwenhoven, John, 247nn. 78 and 85, 251n.3

Krause, George, 247–48n.87

Kubler, George, 187

Lafitte brothers, 132; Film d'Art company of, 241n.46

Lafitte, Pierre, 71–73, 132, 232n.9, 237n.106

Lafitte publishing house, 72–81, 104, 232nn. 4 and 9, 233n.13

Lancret, Mary, 116; photographed by Lartigue, *Mary Lancret, Avenue des Acacias, Paris,* 116, 144

Lange, Dorothea, 249n.114

Laroze, Hubert, 26, 225n.35

Lartigue, Charles (Lartigue's grandfather), 224n.15

Lartigue, Dani (Lartigue's son), 221

Lartigue, Florette (née Orméa, Lartigue's third wife), 48–49, 51, 166, 170–71, 215, 221–22, 223n.4, 230n.120, 244nn. 16 and 19, 254n.1; photographed by Lartigue, *Florette, Catherine, Hiroko, Avenue des Acacias,* pl. 96, 194, 206–7

Lartigue, Henri (Lartigue's father), 7, 17–22, 165, 191; as amateur photographer, 8, 17–19, 21–29, 31–33, 36–37, 41, 43–52, 64, 68, 71, 93, 97, 125, 146, 229nn. 97 and 98; assisting Lartigue, 32, 46–51, 60, 64–65, 69, 93, 151, 221, 231n.156; cameras owned by, 24–25, 48, 58, 60–61, 243n.3; and cinema, 50, 93, 131, 229n.109; filming motion pictures, 25, 151, 236n.85; photographed by L. Ferrand, *September, Rouzat,* pl. 2, 26, 27; photographed by Lartigue: *Mars, Voyage en auto,* 145, 185; *Mon père et mon frère en promenade en Auvergne,* 236n.87; *Pont-de-l'Arche, Mama and Papa,* 46; *Zissou as a Phantom,* pl. 15, 52–53, 230nn. 120 and 121

Lartigue, Henri, photographs by: *Ambleteuse,* pl. 1, 17–18, 35; *July, Châtelguyon,* pl. 5, 33–34; *Paris, in the Bois de Boulogne, Grandmother, Mother, Zissou, and Me with My Jumelle, Photo by Papa,* pl. 94, 58, 162, 190–91; *Pont-de-l'Arche,* pl. 7, 6, 37, 43, 93; *Pont-de-l'Arche, with Zissou, Aunt Yéyé, Dédé, Marcelle,* pl. 6, 36, 40

Lartigue, Henry (Lartigue's great-uncle), 224n.15

Lartigue, Jacques Henri, life of: birth, 17, 129, 221, 250n.130; childhood, 10, 12, 17–20, 23, 45, 206; death, 222; donation of archives to the state, 10, 13, 212, 215, 222, 223n.4, 254n.73; Legion of Honor, award of, 168, 222, 245n.34; military service, 81, 96, 221, 236n.92; 1962 visit to New York, 8, 170–72, 209, 222. *See also* albums, of Lartigue; diaries, of Lartigue; drawings, by Lartigue; exhibitions, of Lartigue photographs; paintings, by Lartigue; writing, by Lartigue

Lartigue, Jacques Henri, photographs by: *Alice Clairville and Gaby Boissy, Ave. du Bois,* pl. 64, 116–17; *Anna la Pradvina, Ave. du Bois de Boulogne (Avenue des Acacias, Paris),* pl. 61, 114, 115–16, 196; *Auvergne Auto Rally (Gordon Bennett Cup Race),* pl. 77, 142, 144, 185, 231n.136; *Avenue des Acacias,* pl. 95, 116, 125, 204–5,

207; *Avenue des Acacias* (Avenue des Acacias, Paris), 144; *Beach at Trouville*, 184, 231n.136; "A Beautiful Smash by Canet," 72; *Biarritz*, pl. 44, 93–94; *Bichonnade, Rouzat*, pl. 16, 54–55, 59, 214; *Bobsled Race, Louis, Jean* (Bobsleigh on wheels invented by Lartigue), pl. 26, 67–68, 145, 172; *Le Bobsleigh à roues de Zissou, après le virage de la grille* (Maurice Lartigue on his "bobsleigh," Chateau de Rouzat), 185; *Bouboutte, Rouzat*, pl. 10, 16, 43–45, 59; cats at play, 66; *The Championship of France*, pl. 45, 95, 128, 236n.87; *Combegrasse, Edmund Allen* (Meeting of glider enthusiasts in the Puy de Dome), 186; *Day of the Drag Races at Auteuil* (The Race Course at Auteuil, Paris), pl. 58, 112–14, 145, 185, 223n.7, 239nn. 142 and 145; *Dédé, Renée and Jean, Rouzat, September* (Andre, Renee and Jean Haguet, Chateau de Rouzat), 68, 145; dirigible over Paris, 63; *Downhill Race*, pls. 17 and 18, 55–56; Eiffel Tower series, 65; *Étretat*, pl. 54, 109–10; *Étretat, juillet* (Mme. Roussel and her friends at Villerville), 186; *Flat Tire in Soumoulou* (Peugeot Touring Car), 144; *Florette, Catherine, Hiroko, Avenue des Acacias*, pl. 96, 194, 206–7; frontispiece, *La Vie au grand air*, pl. 27, 71–72; *In front of the Pavillon Dauphine, at the Club de l'Etrier, Paris*, 238n.134; *The Grand Prix of the A.C.F.* (Grand Prix of the Automobile Club of France, Dieppe), pl. 38, 66, 86, 88–89, 91, 143, 145, 151, 186, 235n.70; *James and Rico*, 59; *Jean, Rouzat* (Jean Haguet, Chateau de Rouzat), 144; *June, Paris* (Race Course, Nice), 145; *Kätchen*, 59; "Le Looping," 85; *At Luna Park*, 59; *Mardi-Gras*, 58; *Mars, Voyage en auto, Papa à 80 km. à l'heure* (Henri Lartigue driving), 145, 185; *Monaco*, 246n.68; *Mon père et mon frère en promenade en Auvergne* (Maurice and Henri Lartigue, Auvergne), 236n.87; *My Cat Zizi*, 56, 59; *My Cousin Bichonnade*, 58; *My Garden, Pont-de-l'Arche*, 56; *My Nanny Dudu*, pl. 20, 56, 57–58, 91, 93; naval battles, Rouzat, 102; *Oléo*, 58; *Oléo and Zissou Trying to Dance the Cakewalk*, pl. 70, 62, 122; *Orléans* (Motorcycle), 144; *Paris, Avenue des Acacias* (Avenue des Acacias, Paris), 114, 145; *Paris, June*, pl. 72, 124–25; (Lartigue?) *Pont-de-l'Arche* (cat in a landscape), pl. 11, 46–48; (Lartigue?) *Pont-de-l'Arche, Louis*, pl. 12, 49–51, 139, 146–47; *Pont-de-l'Arche,*

Mama and Papa, 46; (Lartigue?) *Pont-de-l'Arche, Zissou, Robert, Louis . . . and Me*, pl. 13, 50–51, 230n.130; *Portrait of Louis*, 59; *At the Races, Auteuil*, pl. 50, 104, 105–6, 125; *At the Races, Auteuil* (At the Races, Auteuil, Paris), pl. 78, 143–44, 172; *At the Races, Nice*, 246n.68; *A Reduced Model*, pl. 22, 60–61, 83; *Rouzat, Jean* (Jean Haguet, Chateau de Rouzat), 145; *Rouzat, Marcelle* (Marcelle Haguet, Chateau de Rouzat), 123, 144; *Sentier de la Vertu* (Bois de Boulogne, Paris), pl. 56, 70, 111, 144; *In the Sentier de la Vertu*, pl. 73, 125–27; *September, Étretat* (The Beach at Pourville), 185, 231n.136; *Simone and Golo, Parc de Saint-Cloud*, pl. 47, 102, 123; *Simone, Rouzat*, pl. 71, 123, 172; *Suzanne Lenglen at the Racing Club*, pl. 69, 120–21; tennis players, 95, 236n.87; toys on the floor, 63; *12 juin, Paris* (Mary Lancret, Avenue des Acacias, Paris), 116, 144; *Villerville, Cousin Caro and M. Plantevigne* (The Beach at Villerville), pl. 66, 35, 119–20, 145, 184, 231n.136; *Villerville, Simone* (Simone Roussel on the Beach at Villerville), 185, 231n.136; women smoking, 123–25; (Lartigue?) *Zissou as a Phantom*, pl. 15, 52–53, 230nn. 120 and 121; *Zissou, Rouzat* (Maurice Lartigue, Chateau de Rouzat), pl. 32, 82–83, 145, 184–85; *Zissou Takes Off*, pl. 21, 59–61, 93; *The Zissou 24* (Glider constructed by Maurice Lartigue, Chateau de Rouzat), pl. 33, 84–86, 144. *See also* albums, of Lartigue

Lartigue, Joseph (Lartigue's great-grandfather), 224n.15

Lartigue, Madeleine ("Bibi"; née Messager, Lartigue's first wife), 218, 221, 243n.9; painted by Lartigue, 165; photographed by Lartigue, 123

Lartigue, Marcel ("Cécél"; Lartigue's uncle), 218; photographed by Henri Lartigue, *Ambleteuse*, pl. 1, 17–18, 35

Lartigue, Marcelle ("Coco"; née Paolucci, Lartigue's second wife), 219

Lartigue, Marie (née Haguet; Lartigue's mother), 7, 20–21, 59, 69, 72, 93, 96, 131, 218; and Lartigue's albums, 45–47, 68; photographed by Henri Lartigue, *Paris, in the Bois de Boulogne . . .*, pl. 94, 58, 62, 190–91

Lartigue, Maurice ("Zissou" or "Zyx"; Lartigue's brother), 7, 17, 20–21, 62, 72, 81, 149, 168, 218, 224n.7; and airplane con-

struction, 72, 84–85; photographed by Henri Lartigue: *Ambleteuse*, pl. 1, 17–18, 35; *July, Châtelguyon*, pl. 5, 33–34; jumping with an umbrella, 55; *Paris, in the Bois de Boulogne . . .*, pl. 94, 58, 162, 190–91; *Pont-de-l'Arche, with Zissou, Aunt Yéyé, Dédé, Marcelle*, pl. 6, 36, 40; photographed by Lartigue: 52, 82–83, 85, 93; with a bicycle, 59; in a Hispano-Suiza, 150; with a kite, 59; *Maurice and Henri Lartigue, Auvergne*, 236n.87; *Maurice Lartigue on his "bobsleigh," Chateau de Rouzat*, 185; *Oléo and Zissou Trying to Dance the Cakewalk*, pl. 70, 62, 122; *Pont-de-l'Arche, Zissou, Robert, Louis . . . and Me*, pl. 13, 50–51, 230n.130; *Zissou as a Phantom*, pl. 15, 52–53, 230nn. 120 and 121; *Zissou, Rouzat*, pl. 32, 82–83, 145, 184–85, 220; *Zissou Takes Off*, pl. 21, 59–61, 93

Lartigue, Véronique (Lartigue's daughter), 221

Laurens, Jean Paul, 221, 236n.89

Lavalière, Eve, drawn by Lartigue, 238n.131

Lelong, René, "The Grand Prix of the A.C.F.," pl. 36, 88

Lemagny, Jean-Claude, 210

Lenglen, Suzanne, 237n.106; photographed by Lartigue, *Suzanne Lenglen at the Racing Club*, pl. 69, 120–21

Lennard, Erica, 202

Lepape, Georges, 233n.15

Lesseps, M. de, 152

Liebling, Jerome, 247–48n.87

Life magazine, 166–67, 176, 180, 197, 200, 203–4, 248nn. 98 and 99; Lartigue feature and photographs in, pl. 85, 8, 170–73, 195, 204, 206, 209, 215, 222, 245nn. 43, 52, and 53, 253n.49; "The Last Years of Splendor," 204; "The World Leaps into an Age of Innovation," pl. 85, 172–73

Linder, Max, 131–32, 240n.12; photographed by Lartigue, 131

Lippmann, Gabriel, 25–26, 221, 225n.33

Londe, Albert, 28–29, 37–38, 40; *La Photographie instantanée*, 29; *La Photographie moderne*, 29

Loubet, Emile, president of France, photographed by Lartigue, 63

Loulou. *See* Ferrand, Louis

Lumière, Auguste, 131, 240n.16

Lumière brothers, 129–32, 135–36, 140–41, 229n.110, 240n.2; and autochromes, 243n.77; and Cinématographes, 130; Étiquette Bleue plates, 136, 240n.2; guide to

Lumière brothers *(continued)*
composition, 136; in photographs, 135; films: *Baby's First Steps,* 136; *Baby's Lunch,* 131, 137; *Boat Leaving the Harbor,* 131, 140, 241–42n.47; *Buffalo Bill: Cowboys,* pl. 75, 138–39; *Child and Dog,* pl. 74, 136–37; *Fountain at the Tuileries,* 139; *The Gardener,* 240n.13, 241n.20; *London, Boats on the Lake at St. James Park,* 136; *Team Pulling a Truck,* pl. 76, 140; *Weeds,* 131; *Workers Leaving the Lumière Factories,* 141

Lumière, Louis, 131, 240n.16, 241n.17

Lyons, Nathan, 200

Macchiati, Lorenzi, 74–75

Maddox, Richard Leach, 226n.42

Madeleine. *See* Bourgeois, Madeleine

Malcolm, Janet, 196–98, 251n.12

Man Ray, 168, 244n.23; *To Francis Picabia at Great Speed,* pl. 39, 89–90

Marcelle. *See* Haguet, Marcelle

Marey, Étienne-Jules, 28, 41, 95, 131, 241n.18; *Le Mouvement,* 229n.99

Mazibourg, Carle de, 108, 119

Méliès, Georges, 131–32, 137, 140–42, 151, 241n.20; *The Attack on Master Labori,* 140, 241n.46; *The House of the Devil,* 131; *Trip to the Moon,* 131, 141, 229n.109, 240n.13

Mendel, Charles, 27

Messager, André, 73, 221, 243n.9

Michals, Duane, 201–2

Model, Lisette, 198

Modern Photography, 180, 203

Moholy-Nagy, László, 168, 199

Monterosso, Jean-Luc, 212

Montesquiou, Robert, Count de, 73

Morath, Inge, 167, 244n.26

Mortane, Jacques, 81, 234n.36

Mumler, William, 52

Museum of Modern Art, New York, 174–77; Department of Photography, 164, 175–76, 243n.6, 248n.93, 249n.111; and photography, 166–67, 180–81, 188, 195, 198, 200, 243n.6, 247n.74; and the precursor exhibition, 182, 249n.107; exhibitions: *Cubism and Abstract Art,* 177–79, 248n.92; *The Family of Man,* 184, 247n.74; *Five Unrelated Photographers,* 179–80, 183; *From the Picture Press,* 176, 249n.114; *Mirrors and Windows,* 176, 179–80, 188, 248n.92; *The Photographer and the American Landscape,* 187; *The Photographer's Eye,* 191, 196. *See also* Museum of Modern Art, New York, *The Photographs of Jacques Henri Lartigue*

Museum of Modern Art, New York, *The*

Photographs of Jacques Henri Lartigue, 8–10, 12–13, 58–59, 68, 143–45, 147, 163–93, 195, 222, 229n.100; catalogue for, 171–72, 182, 206–7, 245n.52, 250n.130; and Collection Lartigue photographs, 173–74, 246n.65; format of photographs in, 143, 173, 245n.54; installation of, pls. 88–92, 183–87; planning of, 170–74, 209; prints made for, 69, 171–73, 239n.144, 245nn. 53 and 54, 246n.60; selection of works for, 184, 249n.113, 250n.128

Muybridge, Eadweard, 28, 41, 131, 226n.46, 241n.18

Nadar, 32, 211; portrait of Auguste Haguet, 21

Nadar, Paul, 32

Naef, Weston, 196, 251n.4

La Nature, 22, 52, 230n.118; "spirit photograph," pl. 14, 52

Newhall, Beaumont, 175, 199–200, 243n.6, 244n.24

Nietzsche, Friedrich, *The Use and Abuse of History,* 164–65

Nuridsany, Michel, 211–12

Oléo. *See* Van Weers, Raymond

O'Sullivan, Timothy, 187–89, 198, 249nn. 114 and 119

paintings, by Lartigue, 95–96, 129, 165–66, 168, 221, 236n.90, 253n.67; education in, 95, 221, 236n.89; exhibitions of, 165, 221–22, 244n.16

Pathé brothers, 95, 130–32, 236n.81; cameras of, 130–31, 240n.8, 243n.68; Cinéma Pathé, 240n.15; and Lartigue, 151–53, 221, 240n.5

Pathé-Journal, 132, 153, 240n.15

Perle, Renée, 215, 221, 244n.11, 254n.1

Le Petit Journal, 71, 230n.114, 232n.1, 233n.13

Le Petit Parisien, 71, 232n.1

Photo-Club de Paris, 24, 29, 31, 226n.49; bulletin of, 29, 135

Photo-Gazette, 23, 29, 71

La Photographie récréative, 71

Photo-Magazine, 29, 42, 51

Photo-Revue, 25, 96, 227n.62; "Stereograph with Complete Range of Intermediate Points," pl. 79, 144

Pic (nickname for Lartigue), 62, 218, 238–39n.141

Picasso, Pablo, 165–66; photographed by Lartigue, 166, 222

Pictorialists, 24, 28–31, 38, 41, 125, 226nn. 48 and 49, 227n.55, 230n.117

Plantevigne, M., photographed by Lartigue, *Villerville, Cousin Caro and M. Plantevigne,* pl. 66, 35, 119–20, 145, 184, 231n.136

Platt, Susan Noyes, 247n.84

Plécy, Albert, 166–68

Plitt. *See* Folletête, Victor (?)

Point de Vue, Images du Monde, pl. 84, 166–69, 172, 222; features on and photos by Lartigue, 168–69, 172, 222, 223n.10, 244n.29; "In the Heroic Days of the Automobile," pl. 84, 168–69

Poiret, Paul, 233n.15

Popular Photography, 180–81, 198, 203, 248n.99, 252n.18

Poulenc, 68–69; Krauss and Poulenc, 225n.35

Pradvina, Anna la (Arlette Prévost), 114; photographed by Lartigue, *Anna la Pradvina, Ave. du Bois de Boulogne,* pl. 61, 114–16, 196

Printemps, Yvonne, 221

Proust, Marcel, 103, 134, 229n.111

publication of Lartigue photographs, 71–72, 166, 221–22, 232n.2; in *L'Aurore,* 166; *Boyhood Photographs of J.-H. Lartigue,* 199, 207, 209, 222, 250n.130, 252n.33; in *Car and Driver,* 170, 222; *Diary of a Century,* 199, 207, 209; in *L'Excelsior,* 81; in *Fêtes et Saisons,* 166, 244n.18; in *L'Illustré,* 207; in *Life* magazine, pl. 85, 8, 170–73, 195, 204, 206, 209, 215, 222, 245nn. 43, 52, and 53, 253n.49; in *Lilliput,* 170; in *Paris-Match,* 209; Photo Poche, 211; in *Point de Vue,* pl. 84, 166–69, 172, 222, 223n.10, 244n.29; in *Schweizer Illustrierte Zeitung,* 169–70; in *Tennis et Golf,* 232n.3; Time-Life, commercial portfolio, 195, 215; in *La Vie au grand air,* pl. 27, 71–72, 81, 221, 232n.2; in *La Vie Catholique illustrée,* 166; in *Vogue,* 207

Puyo, Constant, 38

Rado, Charles, 170–71, 174, 209, 222, 245nn. 43 and 49, 246n.60

Raffaële, "Effect of a Fashionable Dress after an Instantaneous Photograph," pl. 60, 114

Rauch, Didi de, 152, 218

Rearick, Charles, 106–7, 130

Reichelt, M., 95, 132, 236n.81

Renée. *See* Haguet, Renée

Rexroth, Nancy, 198

Reyner, Albert, 29, 85–86, 90, 92, 235n.65; *Manuel pratique du reporter et de l'amateur d'instantanées,* 29, 77–78

Rico. *See* Broadwater, Henry

Riegl, Alois, 247n.84

Ronis, Willy, 210

Rosenblum, Walter, 251n.16

Rothschild, Baron de, 73

Roubille, Auguste: with Sem, "All of Paris, Avenue du Bois," pl. 51, 106–7; Thisbé perfume ad, pl. 65, 118

Rougé, M., "At the Beach," pl. 19, 56

Roussel, Caroline ("Caro"; Lartigue's cousin), 218; photographed by Lartigue, *Villerville, Cousin Caro and M. Plantevigne,* pl. 66, 35, 119–20, 145, 184, 231n.136

Roussel, Paul ("Toto"; Lartigue's cousin), drawn by Lartigue, 93, 218

Roussel, Simone (Lartigue's cousin), 116, 133, 218; photographed by Lartigue: with bulldogs, 116; *Étretat, juillet,* 186; *Simone and Golo, Parc de Saint-Cloud,* pl. 47, 102, 123; *Simone Roussel on the Beach at Villerville,* 185, 231n.136; *Simone, Rouzat,* pl. 71, 123, 172

Sabattier, L., 114; "Chez Elle," pl. 67, 120

Sabouret, Henri, 133, 237n.106

Santos-Dumont, 106–7

Schelcher, André, "A Conversation in the Clouds," pl. 30, 76

Scherman, David, 171

Séeberger brothers, 79, 108, 233n.22

Sem (pseud. of Georges Goursat), 92, 109, 125; cover, *La Vie au grand air,* pl. 49, 104; and Lartigue, 107, 221, 233n.15, 238–39n.141; portrait of Edward VII, 100; with Roubille, "All of Paris, Avenue du Bois," pl. 51, 106–7, 116; *Le Vrai et le faux chic,* pls. 53 and 55, 108–11

Seymour, David ("Chim"), 167

Shore, Stephen, 251n.8

Sieff, Jeanloup, 210

Siegfried, André, 21

Sigriste, "M. Farman in the Panhard-Levassor Automobile," pl. 37, 88

Simone or Sim. *See* Roussel, Simone

Simons brothers, pl. 31, 79–80, 86, 97, 233–34n.30, 234n.31; and Lartigue, 80–81, 125, 221, 234n.32, 238n.134; photographed by Lartigue, 80

Siskind, Aaron, 249n.111

Smith, G. A., *Santa Claus,* 158

Smith, Henry Holmes, 251n.16

Société Française de Photographie, 23, 32, 210

Solomon-Godeau, Abigail, 248n.95

Steichen, Edward, 175–77, 197, 247nn. 74 and 79, 249n.111; *The Family of Man,* 184, 247n.74

Stein, Gertrude, 176

Stieglitz, Alfred, 9, 197–98; "Twelve Random Don'ts," 32

Strand, Paul, 175

Sullivan, Louis, *The Idea of Louis Sullivan,* 248n.95

Szarkowski, John, 8, 164–93, 246n.57; and Collection Lartigue photographs, 173–74; as curator of Lartigue exhibition, 170–73, 181–86, 222; as curator of photography, MoMA, 164, 175–79, 181–83, 188, 191, 193; on *Life* publication of Lartigue, 172; and the precursor exhibition, 182, 186–87; theories of photography, 186–92, 196, 199, 202–3, 248nn. 92 and 95, 252n.31; and vernacular tradition in photography, 176, 179, 187–91, 196–97, 251n.3; writings and exhibitions: article, *Art in America,* 181; *Atget's Trees,* 250n.123; "The Debut of Jacques Henri Lartigue," 174; *Five Unrelated Photographers,* 179–80, 183; *From the Picture Press,* 176, 249n.114; *The Idea of Louis Sullivan,* 248n.95; *Looking at Photographs,* 176, 196; *Mirrors and Windows,* 176, 179–80, 188, 248n.92; *The Photographer and the American Landscape,* 187; *The Photographer's Eye,* 191, 196; *Photography until Now,* 248n.95; *The Work of Atget,* 250n.121

Tcherkowski, Countess, photographed by Lartigue, 125

Thornton, Gene, 196

Tissandier, Gaston, 22

Tit, Tom, 51, 230n.114

Toto. *See* Roussel, Paul

Tress, Arthur, 202

Tuchman, Barbara, 216

Tupy (Plitt's dog), 85, 93, 218; photographed by Lartigue, *Tupy,* pl. 35, 85–87, 93

Ubu. *See* Haguet, Robert

Uelsmann, Jerry, 201–3

L'Univers illustré, 135

Van Monckhoven, Désiré, 226n.42

Van Weers, Madeleine ("Bichonnade"; Lartigue's cousin), 7, 55, 152, 218; photographed by Lartigue: *Bichonnade, Rouzat,* pl. 16, 54–55, 59, 214; clinging to a bridge, 123; flying down a stair, 55, 123; *My Cousin Bichonnade,* 58

Van Weers, Marthe ("Bouboutte"; Lartigue's cousin), 218; photographed by Lartigue, *Bouboutte, Rouzat,* pl. 10, 16, 43–45, 59

Van Weers, Raymond ("Oléo"; Lartigue's cousin), 62, 218, 238n.141; photographed by Lartigue: leaping chairs, 101–2, 123; *Oléo,* 58; *Oléo and Zissou Trying to Dance the Cakewalk,* pl. 70, 62, 122

Vidal, Léon, *Manuel du touriste photographe,* 29, 38, 228n.66

La Vie au grand air, 9, 61, 72–75, 80–82, 84–86, 88, 90–92, 95–97, 99, 101, 236n.95, 237n.104, 239n.157; Lartigue photographs for, pl. 27, 71–72, 81, 221, 232n.2; illustrations: "A. M. Fischof, Winner of the Grand Steeplechase of Paris," pl. 48, 104; cover by Macheçert, pl. 29, 75; cover by Sem, pl. 49, 104; "The Gordon Bennett Cup," pl. 40, 90–91; "Le Grand Prix de la République," pl. 28, 74–75; "The Grand Prix of the A.C.F.," pl. 36, 88; "A Great Kick of the Football," pl. 41, 92; "M. Farman in the Panhard-Levassor Automobile," pl. 37, 88; "Swedish Divers," frontispiece, pl. 42, 92–93

viewfinders, camera, 66–67, 227n.62, 231n.147

Wagstaff, Sam, 196

Weber, Eugen, 99

Weegee, 188

Wély, Jacques, "Ice-Skating," pl. 46, 100

Weston, Edward, 9, 196–98

White, Minor, 199–200, 244n.24, 247–48n.87

Williams, Alan, 139

Winogrand, Garry, 8, 179–80, 182, 186–89, 198, 201, 247–48n.87, 251n.8, 252n.31; *New York,* pl. 87, 178; *Opening, Frank Stella Exhibition, MoMA, New York,* pl. 86, 177

Witkin, Lee, 201

Wolf, Frank and Flo, 170

Woodbury, Walter, *Photographic Amusements,* 230nn. 118 and 121

Woodward, Richard, 179

Wright, Wilbur, 83, 234n.44; photographed by Lartigue, 223n.7

writing, by Lartigue, 129, 147, 155; memoirs, 18, 207, 253n.52

Yéyé, Aunt. *See* Haguet, Geneviève

Zecca, Ferdinand, 132

Zissou. *See* Lartigue, Maurice

Zizi (Lartigue's cat), 218; photographed by Lartigue, 56, 59

Zyx. *See* Lartigue, Maurice